HALF HUMANKIND

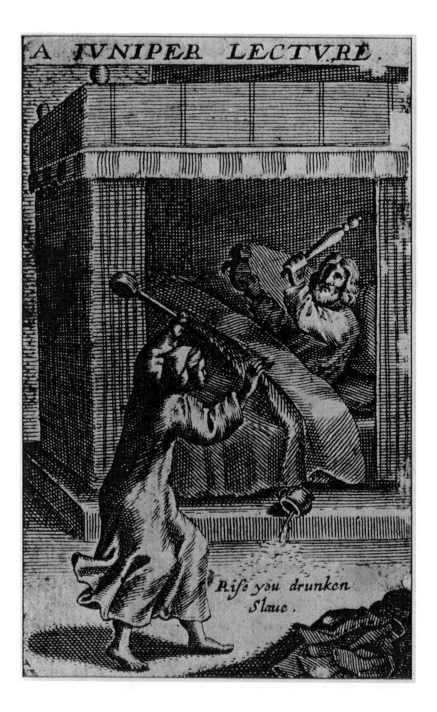

HALF HUMANKIND

Contexts and Texts
of the Controversy
about Women in England,
1540–1640

Katherine Usher Henderson
and
Barbara F. McManus

UNIVERSITY OF ILLINOIS PRESS

Urbana and Chicago

Illini Books edition, 1985

© 1985 by the Board of Trustees of the University of Illinois
Manufactured in the United States of America
P 9 8 7 6

Publication of this work was supported in part
by a grant from the Andrew W. Mellon Foundation.

This book is printed on acid-free paper.

LIBRARY OF CONGRESS CATALOGING IN PUBLICATION DATA

Henderson, Katherine U.
 Half humankind.

 Bibliography: p.
 Includes index.
 1. Women—England—History—16th century—Sources.
 2. Women—England—History—17th century—Sources.
 3. Women—England—History—16th century. 4. Women—
 England—History—17th century. I. McManus, Barbara F.,
 1942– . II. Title.
 HQ1149.G7H46 1985 305.4'0942 84-8611
 ISBN 0-252-01174-0

To Ellen, Matthew, Geoffrey, and Tracy Henderson
and
Ginger and Jack McManus

Contents

PART 1: THE CONTEXTS

PART 2: THE TEXTS

Acknowledgments

We gratefully acknowledge the assistance of our friends and colleagues, distinguished scholars and teachers who have read and commented on portions of the manuscript, helped us track down elusive references, and generously shared their specialized knowledge with us: professors of English literature Cynthia Griffin Wolff, Joseph Anthony Mazzeo, Robert Cluett, Elizabeth Bergen Brophy, M. Christopher Pecheux, and Joan Carson; professors of history Barbara J. Harris and Anne M. Bunting. The librarians of Gill Library of the College of New Rochelle, especially Rosemary Lewis and Fred Smith, gave tirelessly of their expertise to aid us in locating materials and tracing fugitive allusions. The professional staff of Columbia University's Butler Library, in particular Jack Noordhoorn of the microfilm room, extended every possible courtesy to us.

Our editor at the University of Illinois Press, Carole Appel, has been of immeasurable help to us during the various stages of preparation of the book. We thank Mary Elizabeth Tolhurst for her help with research and proofreading and Frances Miceli for her expert and indefatigable typing of the manuscript. We are indebted to our own institution, the College of New Rochelle, for funding the typing of the manuscript. Finally, we wish to thank our families—not only those to whom the book is dedicated, but also the three generations of our extended families—for their support and encouragement during the many months that we spent researching and writing *Half Humankind*.

Part 1
THE CONTEXTS

The Debate about Women

Your idle muse shall be franked up, for while it is at liberty,
most impiously it throws dirt in the face of half humankind.
(Constantia Munda, *The Worming of a mad Dog*)

Since the very beginnings of literature, "half humankind"—the female
of the species—has been an irresistible subject for the pens of the other
half. When men have been the subject of written scrutiny or attack,
they have been viewed primarily as individuals or as members of a
group (such as a profession, a social class, an ethnic group) rather than
as representatives of their half of the human race. Women, on the other
hand, have been repeatedly generalized into Woman, that fascinating
topic for diatribes or panegyrics. For convenient examples of this fact,
one has only to look at a dictionary of quotations: under "Woman"
one will find pages of statements characterizing the feminine sex (often
negatively), while most of the entries under "Man" apply to human
nature in general. In fact, until very recently the English language had
no word to denote "hatred of the male," although *misogyny* and *mis-
anthropy* have long been in use. Only the latest supplement of the *Ox-
ford English Dictionary* lists *misandry*, the logical counterpart of
misogyny.

The debate over women's worth has proved a staple of the Western
literary diet, and during the Renaissance the English middle class had
a distinct taste for this fare. Printers catered to this taste with pam-
phlet after pamphlet, some running into several editions. Indeed, in
one of the pamphlets in this anthology, Esther Sowernam testifies to

Connection b/w
class and production 3

the prevalence of such debates even on social occasions: "Being at supper amongst friends where the number of each sex were equal, as nothing is more usual for table talk there fell out a discourse concerning women, some defending, others objecting against our Sex." In table talk and pamphlet wars, woman provided the English Renaissance with a prolific topic for attack and defense.

Although the controversy in Renaissance England was but a single chapter in the long debate over women in Western literature, it is significant for a number of reasons, especially to the English-speaking reader. First, this period is a landmark because for the first time in England women began to write in their own defense and for the first time anywhere significant numbers of women began to publish defenses. Second, in this period the debate over women becomes more understandable to the modern reader. The language is more accessible than the Latin, European vernaculars, or Middle English in which earlier attacks or defenses were written. Furthermore, the Renaissance pamphlets reflect a life-style and an emphasis which is closer to our own; although they echo many medieval conventions and ideas, they were written for a middle-class audience living in an increasingly urban, commercial, and individualistic world. Finally, these Renaissance pamphlets show some tentative stirrings of feminism and prefigure certain modern feminist ideas. This anthology is designed to make accessible to the general reader of today documents in the debate about women which were intended for literate members of the gentry and mercantile classes in Renaissance England.[1] While these pamphlets make appealing reading in themselves, attesting to the perennial interest of the topic, it is hoped that their availability will contribute to an understanding of the development of feminist thought, shed new light on the imaginative literature of Renaissance England, and open a window on the middle-class culture and life of the period. However, a full understanding and appreciation of the pamphlets in this anthology requires a preliminary survey of some important early sources in the debate over women and a brief examination of the overall course of the popular English controversies on this topic from 1540 to 1640.[2]

The Inherited Tradition

Renaissance writers who wished to attack women found ample precedent in classical antiquity. At the end of the eighth century B.C., the

Greek poet Hesiod enshrined his personal misogyny in the mythic tale of Pandora, the first woman. After Prometheus stole fire from the gods and gave it to man, as a punishment Zeus created Pandora, whom Hesiod describes as "a sheer, impossible deception" characterized by "lies, and wheedling words of falsehood, and a treacherous nature." Not only did Pandora, by lifting the lid from a great jar, let loose upon the earth countless troubles, diseases, and wearisome labor, but she also originated the race of women, who "live with mortal men, and are a great sorrow to them, and hateful poverty they will not share, but only luxury."[3] Indeed, men had to pay a high price for the possession of fire, for Zeus decreed still another evil: the only way men can have the benefit of male children is through these deceitful, disruptive, and spendthrift women.

Less than a century later, another Greek poet, Semonides of Amorgos, wrote a long satiric poem cataloguing the many feminine faults by comparing various types of women to animals. This was apparently the first formal satire on women in European literature. Although this poem does admit a single good type of woman (derived from the bee), immediately after describing her Semonides echoes Hesiod's general condemnation of the female sex: "This is the worst plague Zeus has made—women; if they seem to be some use to him who has them, it is to him especially that they prove a plague" (lines 96–98).[4]

Much of the later Greek writing about women was hardly less negative than these early attacks, although it ranged in tone from the bawdy jesting of Aristophanes, the most famous writer of Greek Old Comedy, to the philosopher Aristotle's reasoned demonstration of the natural inferiority of women in all spheres of life. One can find misogynistic statements scattered throughout Greek literature; even Greek mythology reveals elements of hostility toward women.[5] This misogyny is frequently coupled with a disparagement of marriage: an influential treatise on marriage (now lost) attributed to Theophrastus, a disciple of Aristotle, advances many reasons why a wise man should never marry, but all the arguments stem ultimately from the concept that woman is an irretrievably flawed creature.[6]

Roman literature is generally less misogynistic than Greek literature, although Roman comedy has its share of jibes against wives and Roman love poetry includes many complaints against fickle and hard-hearted mistresses. However, the Sixth Satire of the Roman poet Juvenal (first century A.D.) constitutes a full-scale attack on women which

has been rarely matched in virulence. With revolting detail, Juvenal ex-coriates the insatiable lustfulness of women, their greed, jealousy, shallowness of character, cruelty, domineering behavior, religious fanaticism, vanity, and constant desire to trespass on masculine preserves by imitating gladiators, orators, and scholars. Indeed, even if a woman could be found who is free of all these vices, Juvenal would reject her:

> Let her be well-behaved, good-looking, wealthy and fertile,
> Let her have ancestors' busts and portraits all over her hallways,
> Let her be more intact than all the pre-ravished Sabines,
> Let her be a rare bird, the rarest on earth, a black swan—
> Who could endure a wife endowed with every perfection?
> .
> And is there any man such a prey to uxorious worship
> That he does not dread the wife he extols to the heavens,
> Does not hate her at least fourteen hours out of two dozen?[7]

Because of its length, comprehensiveness, and vehemence, Juvenal's satire provided a convenient source for many later attacks on women.

Writers on the opposite side of the question, however, found few models in classical antiquity and certainly no unequivocal defenses of women. For example, Euripides, a Greek tragedian of the fifth century B.C., presented many intelligent and forceful women on the stage; he dramatized the repression and futility that marred women's lives and composed in the *Medea* an indictment of men's treatment of women (especially lines 230–51, which begin "Of all things which are living and can form a judgment / We women are the most unfortunate creatures"[8]). This ringing statement, however, is placed in the mouth of a heroine who revenges herself upon her unfaithful husband by murdering four people, including her own two sons, and who says of woman, "When once she is wronged in the matter of love, / No other soul can hold so many thoughts of blood" (lines 265–66). In fact, although Euripides showed more empathy for women than any other ancient writer, many of his lines out of context sound misogynistic; only relatively modern critics have been able to rescue him from his centuries-old reputation as a woman-hater.[9]

The Greek philosopher Plato also gave more credit to women than most of the writers of antiquity. In the utopia which he envisions in the *Republic*, he proposes that women as well as men be included in the ruling class, the guardians; he advocates equal education for female

and male guardians and prescribes measures to free the women from the more burdensome aspects of childrearing. However, even in the *Republic* Plato never maintains that women are equal to men (for example, see 455 C–D), and his other works show considerably less sympathy for women.[10]

Besides the classics, the Bible provided an important source for both attackers and defenders of women in the Renaissance. Of course the Bible is not primarily about women, but the Old and New Testaments contain many generalizations about women as well as a rich vein of examples of both wicked and virtuous women. Attackers could look especially to Proverbs and Ecclesiastes for denunciations of harlots and quarrelsome wives and to Saint Paul for disparagements of marriage and justifications of the subservience of women. Defenders could cite the Song of Songs and the proverb of the virtuous wife (Proverbs 31:10–31) as well as scattered praises of women throughout the Bible. Because of the Bible's status as divinely inspired, even minor scriptural passages acquired immense importance.

The most influential biblical reference to woman, however, was the story of Eve: writers about women endlessly debated the significance of her method of creation, her role in the expulsion from Paradise, her punishment, and the promise of redemption made to her. The story of Eve has some striking parallels with the myth of Pandora (although the latter is more misogynistic), most notably the chronology of creation (woman *after* man) and the presentation of woman as the channel through which evil, pain, and laborious work entered the world. Pandora, however, could be dismissed as a pagan fancy, but Eve's fall and consequent subjection to man was the word of God and had to be taken into account.

Early Christian writing about women reflected the antifeminine bias of this biblical story in addition to a celibate aversion to sex and derogation of marriage. Early theologians presented women as attractive snares and sources of temptation who are inherently weaker than and inferior to men. Not only the vehement Tertullian, but also the milder Saint John Chrysostom and the scholarly Saint Augustine could be frequently cited against women. The most venomous statements against marriage and women, however, can be found in Saint Jerome's treatise *Against Jovinianus*, written at the end of the fourth century A.D. Jovinianus had dared to maintain that the states of marriage and virginity were of equal merit. As Jerome attempts to demonstrate the over-

whelming superiority of virginity, his savage denunciations of sexuality spill over into attacks on women, whom he identifies with sexual desire. In discussing Proverbs 30:15–16, for example, Jerome states, "It is not the harlot, or the adulteress who is spoken of; but woman's love in general is accused of ever being insatiable; put it out, it bursts into flame; give it plenty, it is again in need; it enervates a man's mind, and engrosses all thought except for the passion which it feeds." [11]

All these early works formed the basis of and supplied the authorities for much of the writing about women in Renaissance England. However, the Middle Ages made an important contribution by formalizing the literary debate over women's worth: medieval writers began mounting full-scale attacks on women which in turn prompted full-scale defenses. The controversy developed a set of conventions and motifs (stock examples and anecdotes, common interpretations, standard arguments) which were iterated and reiterated by authors on both sides of the question. Although the English Renaissance writers drew most heavily on the classical and biblical sources concerning women, this heritage was frequently viewed through the lens of these stylized medieval controversies, and this sometimes proved a refracting lens, changing the angle of vision or even distorting the original. For example, a favorite anecdote of the misogynists about Socrates and his shrewish wife Xanthippe was derived ultimately from the Greek biographer Diogenes Laertius: "When Xanthippe first scolded him and then drenched him with water, his rejoinder was, 'Did I not say that Xanthippe's thunder would end in rain?'" (2.36). [12] Later, however, Saint Jerome reported that Xanthippe "soused him with dirty water," [13] and Chaucer said that she "cast piss upon his head"; [14] it is Chaucer's version which appears in two of the pamphlets in this anthology (*Schoolhouse of women* and Joseph Swetnam's *Arraignment*).

Because of the volume and the highly traditional nature of the medieval controversies about women, we will single out only a few of the most influential works for discussion here. One prominent strain in medieval writing, especially love poetry, was the cult of courtly love, which idealized women and presented the love of women as an exalting and ennobling passion. But this code had its negative side, as lovers wrote bitter denunciations of women and love along with their poems of praise. In fact, a twelfth-century Frenchman, Andreas Capellanus, emulating the Roman poet Ovid, wrote in Latin a handbook on the art

of courtly love which included two books of detailed instructions on how to win and maintain love and one book on the rejection of love which is in effect an outright attack on women.

Another important strain in medieval thought was supplied by the celibate clergy, who were at best suspicious of women and more frequently openly misogynistic. The Christian philosopher Saint Thomas Aquinas, whose *Summa Theologica* attempted to create a synthesis of Christian theology and Aristotelian philosophy which would provide a framework for all knowledge, unfortunately imbued his synthesis with the antifeminine bias of each of its components. This clerical misogyny was only partly counterbalanced by the medieval cult and adoration of the Virgin Mary.

The early Christian attacks on marriage were also echoed in the Middle Ages, if often from a slightly more secular perspective. The twelfth-century Englishman John of Salisbury justified his criticism of marriage in the *Policraticus* by accusing women of cruelty, frivolity, and passionate lustfulness. Even more influential was Walter Map's "Letter from Valerius to Rufinus," included in his satirical prose miscellany *De nugis curialium* (*Courtiers' Trifles*). Purportedly written to dissuade a friend from marriage, this letter contains a solemn warning to fear all women as degrading, deceitful, and disobedient. The work is a compendium of many of the conventional devices of medieval attacks on women, including the propensity to argue primarily from anecdote and example.

Even the chivalric romances so popular in the Middle Ages contained some attacks on women, most notably the second half of the *Roman de la Rose*, written in the late thirteenth century by the French poet Jean de Meun. It was primarily this work which prompted a woman, the French poet Christine de Pisan, to champion her sex in writing. In 1399, Christine began her defense of women with a "Letter to the God of Love" in which she attacked Jean de Meun and wrote a spirited protest against all generalizing condemnations of women; this work initiated a literary debate which lasted several years. A highly intelligent, well-read woman who supported herself and her children by writing, Christine later produced a long formal defense of women entitled *Le livre de la cité des dames* (*The Book of the City of Women*). In this work her views are moderate and conservative, based on common sense and acknowledging the importance of custom; she does not seek to change the subordinate position of women in public and pri-

vate life. However, she does argue eloquently for the education of women, insisting upon their natural capabilities, dignity, and inherent worth.[15] As with most defenses (and attacks), a large part of the work comprises examples, stories about virtuous and illustrious women ranging from antiquity to her contemporaries. As a successful writer and "woman of letters," Christine was an anomaly; she herself apparently perceived this fact, since she wrote that her ill fortune at the death of her husband changed her "both body and will, / Into a natural, perfect man" so that she could survive and support her family.[16]

In England, the greatest of the medieval writers, the fourteenth-century poet Geoffrey Chaucer, wrote on both sides of the issue with brilliant irony and engaging wit, an indication not only of the essentially literary nature of the controversy but also of its wide appeal. For example, he begins his formal defense of women, *The Legend of Good Women*, with a dream-vision in which Cupid and Alcestis chide him for translating the *Roman de la Rose* and writing the tale of the faithless Cressida in *Troilus and Criseyde*, which they claim has caused men to lose trust in women. To atone for this "heresy" against love, the poet is commanded to write the stories of good women who were true in loving and of the false men who betrayed them, men who spent their lives seducing as many women as they could. Although Chaucer apparently planned to write nineteen or twenty such legends, mostly of mythological women, he broke off after only nine tales.

A large portion of Chaucer's *Canterbury Tales* deals with the subject of women and marriage. Termed today "the Marriage Group" and including the tales of the Wife of Bath, Clerk, Merchant, and Franklin, these tales and their prologues good-humoredly advance many of the misogynistic charges of earlier literature and also a few of the defenses.[17] The four tales all deal with the "fight for the breeches," the struggle for sovereignty in marriage, although Chaucer provides no clear-cut victor in this struggle. Both the Wife of Bath and her tale, for example, represent the motif of the disobedient wife who strives to rule her husband; however, although Dame Alice of Bath has all the bad qualities of her type, the sheer vitality of her personality and her zest for life ultimately make her a likable figure. On the other hand, the Clerk's tale of the patient Griselda presents an impossibly obedient and long-suffering wife, a veritable Job of the marriage bed. The Franklin's tale seems to close the debate on a note of reconciliation, with each marriage partner offering sovereignty to the other, for "love

will not be constrained by mastery."[18] Thus Chaucer's artistry, wit, and psychological insight rise above the conventions of his material and defy categorization in the controversy.

In the century after Chaucer, there was a definite increase in the number of treatises about women written in English, with disciples of Chaucer such as John Lydgate writing both attacks and defenses. The first half of the sixteenth century saw the publication of many English translations of Continental authors who wrote about women, including Christine de Pisan, the German Cornelius Agrippa, the Dutch humanist Erasmus, and the Spanish humanist Juan Luis Vives, whose advocacy of the liberal education of women exerted an important influence on the early Renaissance. In 1540 a disciple of these humanists, Sir Thomas Elyot, published a treatise in praise of women, *The Defense of Good Women*.[19] Composed in the form of a Platonic dialogue, this work answers typical misogynistic charges with praise of the modest, pious, obedient woman. While Elyot apparently envisions homemaking as the proper sphere of activity for most women, he does argue for the education of women and adduces classical examples of women who were active in the public sphere, especially Zenobia, ancient queen of Palmyra, who appears as a character in the dialogue.

The Pamphlet Wars in Renaissance England

The rousing popular controversies in Renaissance England about the nature of woman differed from previous writing on the topic in several ways. First, the rise of printing made possible an increase in the number of attacks and defenses and a wider dissemination of these to the middle-class populace of London, who were apparently increasingly eager for such reading matter.[20] Concomitantly, formal treatises on women became less aristocratic and courtly (reflecting the interests and concerns of the bourgeois reader) and also more secular (lessening their clerical emphasis while still drawing upon biblical sources and religious arguments). Third, with the wider dissemination of attacks on women the proportion of defenses began to rise, although the attacks were reprinted more frequently than the defenses. The "pamphlet wars" of formal attacks and defenses to which our selections belong clearly reveal these trends, although elements of "the woman question" can be found in all levels of literature at the time. In fact, these treatises provided a formal framework for the debate about

women and a reservoir of examples and arguments upon which writers of ballads and other types of poetry, popular drama, conduct books, and sermons could draw.

The first two documents in this anthology, *The Schoolhouse of women* and *Mulierum Paean*, began the pamphlet war which dominated the middle of the sixteenth century. The dating of both pamphlets and the authorship of the *Schoolhouse* are controversial,[21] since each contains a reference to the other and Edward Gosynhill, who wrote the *Paean*, seems to claim authorship of the *Schoolhouse* by imitating the dream-vision demand for "atonement" with which Chaucer opened the *Legend of Good Women*. The *Schoolhouse*, a long and comprehensive attack on women written in rhyme royal, reiterates the standard examples and arguments against women with a humorous, earthy, and sometimes vulgar spirit that undoubtedly contributed to the immense popularity of the piece, which ran through four editions between 1541 and 1572. Gosynhill's response, *The praise of all women, called Mulierum Paean* (conjecturally dated 1542), was also written in rhyme royal but is much more serious and sober in tone than the *Schoolhouse*, even citing in the margin chapter and verse for biblical references. Most of the defense is quite conventional, with the exception of a long passage that describes in realistic and homely detail the tribulations of childbirth and childrearing.

Another work that may have been written in response to the *Schoolhouse* was *A Dialogue defensive for women against malicious detractors* (1542), attributed to Robert Vaughan but possibly by Robert Burdet,[22] which employs the form of the medieval bird debate. In this poem a chattering magpie rails against women while a dignified falcon defends them; the falcon wins the debate through the restraint, logic, and common sense of his arguments.

The controversy simmered over the next decade as first Mary and then Elizabeth came to the throne. In 1558, the exiled Puritan John Knox published in Geneva *The First Blast of the Trumpet against the monstrous regiment of Women*, which was directed against the Catholic Queen Mary but appeared with singular ill timing not long before the accession of the Protestant Elizabeth. In this pamphlet, Knox passionately argues that a female ruler is an affront to nature, revealed religion, justice, and reason. Although Knox's work contains many elements of a general attack on women, John Aylmer's response in the next year can hardly be called a defense; while arguing for woman's

God-given right to rule, he simultaneously insists upon her basic weakness and inferiority to man.

In 1560, the *Schoolhouse* was reprinted together with a response by Edward More, *A Little and Brief treatise called the defense of women;* the same printer also issued a new edition of *Mulierum Paean*. More, the grandson of Sir Thomas More, apologizes for his lack of age and experience (he is a twenty-year-old bachelor) but cites his strong indignation at the *Schoolhouse*, which he had lately read. Writing in somewhat monotonous couplets, More adopts the stance of the chivalrous champion of women, but his defense has a patronizing tone, as when he argues that the devil tempted Eve before Adam "because he knew her feebleness, not able to resist; / . . . Her lack of strength and nothing else was cause of her forlore [moral ruin]" (Sig. A4ᵛ). He believes that because of the coldness of their climate Englishwomen are more chaste than Roman women, who are "proner to offend and to venery" (Sig. B1) because of the hot temperatures of Italy. More invokes the customary biblical and classical examples and concludes by terming women's reputation for shrewishness a slander. Women merely justifiably rebuke their husbands' drunken behavior, "and if they speak a little loud, men say straight-away they scold" (Sig. C4).

An anonymous attack called *The deceit of women* appeared near this time, although the work has not been definitively dated.[23] Copiously illustrated with clever woodcuts, this pamphlet contains a series of anecdotes about women who "look a crook" (Sig. A2), beginning with the story of Eve: "Thus was the most wisest and fairest man of the world deceived of his wife" (Sig. A3). Although "some women have an opinion and say that they be better than the men and will be men's masters . . . nowadays in the world," they do not heed God's commandment to Eve, "Ye shall be under the power of your husband, and he shall be your master and shall have Lordship over you" (Sigs. A3–3ᵛ). The pamphlet alternates biblical and classical tales with "new deceits of late days" in which lusty wives trick their husbands in various ingenious ways, all related with verve and a certain ribald charm.

Near the end of the sixties, C. Pyrrye wrote *The praise and Dispraise of Women*, containing two poems and a dialogue. The first poem attacks "monsters" of the feminine sex; the second, which is closely modeled on *Mulierum Paean*, defends women. The final dialogue explains how to select a good wife and avoid a bad one. After Pyrrye's rather undistinguished attempt at debate, the formal controversy was

quiescent for twenty years, although elements of attack and defense appear in other types of literature, notably in John Lyly's enormously popular prose romance *Euphues* (1578).

In 1589, however, the controversy erupted anew with Thomas Nashe's *The Anatomy of Absurdity*, whose subtitle announces "a brief confutation of the slender praises to feminine perfection." Provoked by the "Unsavory duncery" (Sig. A1) of the many works dedicated to women in the stationers' shops, Nashe ridicules the love poetry of the time, attacks the vices of women, and quotes misogynistic statements from many classical authorities. Nevertheless, the tone of the work is light, and Nashe does not confine his "absurdities" to women. Another work which appeared in the same year, Jane Anger's *Protection for Women*, responded in deadly earnest to attacks on women. This pamphlet (included in the anthology) is the first English defense written by a woman. Replying to a specific attack,[24] Anger argues her case with fierce partisanship and considerable wit, often turning her "protection" of women into an indictment of men.

The turn of the century saw a number of treatises in the controversy. In 1595, Stephen Gosson's *Quips for Upstart, Newfangled Gentlewomen* attacked women's cosmetics and elaborate apparel as evidence of moral depravity. In *The Praise of virtuous Ladies* (1597), Nicholas Breton wrote a graceful if sometimes dubious defense of women. Breton opens his pamphlet with a wry justification for turning his hand to "the praise of women, considering how little cause of commendation is found in a number of them" (Sig. R); he exercises his ingenuity by imagining what critics will say about him because he has composed a defense: "Some men may think that some one Woman hath hired me to flatter all; or else, by a flattering of all, I should hope of favor of some one. Some will say, 'Perhaps he hath a Woman to his mother'; some other, 'a Woman to his Mistress'; some other, . . . 'It is pity he was not made a woman'; and some, 'Oh, he is a good Woman's man.'" (Sig. R3ᵛ).

Breton gives a new twist to the story of Eve: since she was a part of Adam, "was she any other than himself that deceived himself?" (Sig. R3). Many of his defenses are clearly ironic: "Some will say women are deceitful, but they that say so be such as deceive themselves in Women to think them trusty" (Sig. S2). However, the tone of the whole is good-humored, full of tongue-in-cheek paradox and delight at his own cleverness; he even reverses the frequent attacker's promise

of later amends to women by concluding with a promise that he will make amends to men by writing *their* praises in the future.

Two imported works which closed the century testify to the continuing vitality of the debate over women on the Continent. *Of Marriage and Wiving* (1599) is a translation of a dialogue between the Italian writers Ercole and Torquato Tasso. The philosopher Ercole attacks women with a battery of classical authorities and a medieval repugnance for the female body. In women's defense, the poet Torquato effectively employs logic, common sense, examples, and a conviction that physical beauty is a reflection of inner spiritual beauty. In the same year there also appeared *A Woman's Worth*, presented as a translation from a French original, which follows the standard defense format.

Upon the death of Queen Elizabeth in 1603, James I came to the throne. That same year saw the publication of one of the wittiest of the antifeminist pieces, *The Bachelors' Banquet*, a loose translation of Antoine de La Sale's *Les quinze joyes de mariage* (*The Fifteen Joys of Marriage*), controversially attributed to Thomas Dekker by the *Short-Title Catalogue*.[25] In a lively and amusing fashion, the work dramatizes various typical marital stages, presenting in each chapter the marriage of a woman with a particular "humor" which proves destructive to her husband. Although the work satirizes many feminine faults (unfaithfulness, extravagance, gossiping, scolding), the main emphasis falls on women's ability to master their husbands: "This is, I say, a general imperfection of women—be they never so honest, never so kindly used, and have never so much wealth and ease—to strive for the breeches" (Sig. E3ᵛ).

Several defenses of women also appeared at the beginning of the new century. Besides the usual examples of feminine virtue, I. G.'s *An Apology for Womankind* (1605) proffers a defense of Eve based on her strength rather than weakness, a justification of female subjection on the grounds of social expediency rather than inferiority, an attack on war, and praises of women's philanthropy and charity. Lodowick Lloyd's *The Choice of Jewels* (1607), on the other hand, is a rather uninspired catalogue of classical, biblical, and historical examples of good women. A third defense, William Heale's *An Apology for Women* (1609), had a practical purpose: it is a sober and reasoned argument against wife beating. Although Barnaby Rich's *The Excellency of good women* (1613) also repeats many of the conventional ex-

amples of good women, it is as much a satire as a defense, since it criticizes the extravagance, pride, and aggressive behavior of modern wives.

A major pamphlet war broke out in 1615 with the publication of *The Arraignment of Lewd, idle, froward, and unconstant women*, published under the pseudonym Thomas Tell-Troth but very quickly associated with Joseph Swetnam, who was possibly a fencing master.[26] Since this was such a prominent controversy (Swetnam's pamphlet ran through ten editions by 1637 and provoked at least three defenses and a play), our anthology includes the *Arraignment* and two responses, those of Esther Sowernam and Constantia Munda. Swetnam's pamphlet borrows heavily from earlier works, especially John Lyly's *Euphues*; perhaps the immense popularity of the *Arraignment* was due to its inclusiveness and its decidedly middle-class emphasis and humor.[27]

Although Swetnam's subtitle claims his work is "hurtful to none," those who replied to his pamphlet obviously did not agree. The first defense to appear after Swetnam, Daniel Tuvil's *Asylum Veneris; or, A Sanctuary for Ladies* (1616), does not directly refer to the *Arraignment*, but its timing suggests some relationship. Although Tuvil's treatise at times sounds more like a satire than a defense, he does argue in favor of education and some public roles for women. The three direct responses to Swetnam, however, were more emphatic; significantly, all were written by women. The first of these to be published, *A Muzzle for Melastomus* (1617), was written by Rachel Speght, probably the daughter of schoolmaster Thomas Speght.[28] Apologizing for her "imperfection both in learning and age" (Sig. A4ᵛ) since she was not yet twenty, Speght says that she has challenged Swetnam because she did not perceive "any of our Sex to enter the Lists of encountering with this our grand enemy among men" (Sig. A4). When she advises women on the best response to Swetnam, she gives a clue to the temper of her own reply: "This I allege as a paradigmatical pattern for all women, noble and ignoble, to follow, that they be not inflamed with choler against this our enraged adversary, but patiently consider of him according to the portraiture which he hath drawn of himself, his Writings being the very emblem of a monster" (Sig. A4).

Although Speght does not neglect invective, her response is for the most part a patient refutation of Swetnam's charges and an attack on his style. Her subtitle terms the *Arraignment* both "Irreligious" and "Illiterate," and the main body of her pamphlet advances biblical arguments against Swetnam (with careful marginal citations). Some of her

defenses are rather weak, possibly because of her especially religious orientation; witness her explanation of why Eve was tempted first: "Where the hedge is lowest, most easy it is to get over, and she, being the weaker vessel, was with more facility to be seduced" (p. 4). Furthermore, since woman was made to be "but an *helper*," Speght censures those husbands who "lay the whole burden of domestical affairs and maintenance on the shoulders of their wives" (p. 12).

Speght appends to her main defense "Certain Queries to the baiter of Women" designed to demonstrate the "illiteracy" of his style, grammar, logic, and organization: "Whoso makes the fruit of his cogitations extant to the view of all men should have his work to be as a well-tuned Instrument, in all places according and agreeing, the which I am sure yours doth not" (p. 36).

Although it took considerable courage for Speght to respond to Swetnam in print, especially under her own name, the mildness of her defense did not satisfy other feminine champions (Sowernam, for example, criticized "the slenderness of her answer"). Later in 1617, two more responses to Swetnam were written under the pseudonyms Esther Sowernam (*Esther hath hanged Haman*) and Constantia Munda (*The Worming of a mad Dog*), Sowernam replying with reasoned and well-ordered argument and Munda with impassioned invective and impressive learning. The controversy finally culminated in an anonymous, cleverly written play, *Swetnam the Woman-Hater, Arraigned by Women* (1620), which uses as a subplot the comic discomfiture of Swetnam (alias Misogynos) at the hands of women.[29]

As the Swetnam affair began to cool, another pamphlet war was brewing, one which would mingle the literary debate with a real-life controversy. Since the end of the sixteenth century, satirists and preachers had been castigating women who adopted a masculine (or partially masculine) style of dress. In 1620, King James himself took up the cudgels against these women, ordering his clergy "to inveigh vehemently in their sermons against the insolence of our women and their wearing of broad-brimmed hats, pointed doublets, their hair cut short or shorn, and some of them stilettos or poniards, and such other trinkets of like moment."[30] Shortly afterward, the pamphleteers entered the fray with three works which couch the literary debate about women in the terms of style of dress: *Hic Mulier; or, The Man-Woman; Haec Vir; or, the Womanish Man;* and *Mulled Sack; or, The Apology of Hic Mulier to the late Declamation against her* (the first two of these are

included in this anthology). *Hic Mulier* violently attacks the masculine style of dress as unnatural and blasphemous, an outward sign of women's attempt to usurp masculine aggressiveness, authority, and sexual freedom; *Haec Vir* counterattacks with the figure of the effeminate fop. Presented in the form of a dialogue between the Man-Woman and the Womanish Man, *Haec Vir* offers some eloquent arguments for freeing women from the bonds of custom before it capitulates to the Renaissance belief in the necessity of proper distinctions between the sexes. The last pamphlet, *Mulled Sack*, capitalizes on the controversy by opening with an ironic poem to Hic Mulier and a letter by her; it then criticizes all forms of masculine behavior by women and effeminate behavior by men. However, the pamphlet is more of a general treatise on vice than a specific participant in the controversy over dress.

In 1620, Christopher Newstead's *An Apology for Women* was published; this defense of women was apparently unconnected with the debate over dress. In his dedicatory epistle, Newstead explains his decision to defend women through an unusual metaphor, casting himself in a feminine role when he characterizes his pamphlet as "my ill-looking Infant, the maidenhead (as I may so term it) of my invention, conceived in my brains by the frothy word of many Hyperbolizing self-conceitists who deem it their greatest grace to be able to disgrace women" (Sig. A2ᵛ). In his epistle to the reader, he deprecates the common habit of attacking women through jest: "But thou wilt say thy evil speeches of them proceeds from mirth; thou mayest as well say thou dost lie with them as belie them in jest. No intentions can make absolute evils good. Again, jests should be . . . pleasing, not piercing, neither continual. . . . We should use them as Spices, to season our talk, not as the subject of it. But may we say with Philippus the Jester that they have got such an habit in speaking ill of them in jest that they know not how to speak well of them in earnest" (Sigs. A3ᵛ–4).

Newstead took his own advice, producing a serious, well-reasoned, humanistic defense liberally seasoned with Latin and Greek quotations and classical learning. He writes to show that women surpass men in virtue, not in dignity or mastery; although woman (Eve) by her weakness first fell into sin, the order is now reversed: "Men were the more perfect by nature, but women now than they, by industry; and it is more difficult to re-obtain virtue than to keep it" (p. 3). Newstead organizes his pamphlet around a list of the virtues of women, begin-

ning with religious piety, continence, and chastity. A woman's chastity is more commendable than a man's because she is more subject to imperious physical desires: "By this they are most virtuous, that their minds should be sober amongst the riotous pleasures of their bodies" (p. 12). Newstead also objects to the double standard, arguing that men may "batter the walls" of a woman's chastity, but if she once yields, "black infamy shall overcloud and brand her reputation, not once touching his" (p. 15). The other feminine virtues Newstead discusses are fortitude and magnanimity, constancy and true love, lack of gluttony, "dexterical Wits," wisdom, beauty, and motherly qualities. Considered in the abstract, Newstead's is an admirable defense; but his tone, which tends to be deadening, and his style, which is heavily burdened with learned allusions, make it difficult to imagine that the work would have any impact on the audience which so eagerly bought up a pamphlet such as Swetnam's.

This serious and learned tone dominated the treatises of the next decade. The anonymous *A Discourse of the Married and Single Life* (1621) advises men against marriage because of the evils of women. Richard Ferrers in poetry (*The Worth of Women*, 1622) and Abraham Darcie in prose (*The Honor of Ladies*, 1622) defended women through innumerable examples; Thomas Heywood made a massive contribution to this compilation of the lives of virtuous women through his *Gunaikeion; or, Nine Books of Various History Concerning Women* (1624) and *The Exemplary Lives and memorable Acts of nine the most worthy Women of the World* (1640). William Austin's *Haec Homo* (1637) argues for the excellence of women and even tentatively posits the essential equality of male and female.

Our period ends, however, on a lighter note, with a final Renaissance pamphlet war occasioned by "lectures," a popular and humorous form for the dramatization of marriage relations. In 1639, John Taylor published both *A Juniper Lecture* (included in this anthology) and *Divers Crabtree Lectures*, which present women "lecturing" others on a variety of topics, mostly designed to illustrate women's shrewishness, lustfulness, extravagance, and other faults. Richard Brathwaite's *A Bolster Lecture* (1640) follows a similar format. The last formal treatise in our anthology, *The women's sharp revenge* (1640), written under the pseudonyms of Mary Tattlewell and Joan Hit-him-home, replies specifically to Taylor's pamphlets but is actually a response to misogyny in general. Although the prevailing tone of this lively pam-

phlet is light and humorous, it includes fervent protests against the double standard in sexual behavior and women's lack of education.

Thus in jest and in earnest, in treatises and table talk, the English Renaissance continued and even intensified the age-old debate about women. The period is especially significant for readers today because the silent half of humankind finally began to write in their own defense, and the female debaters infused the controversy with passion, conviction, and a new sense of purpose. In order to appreciate the achievement of these writers and the legacy which they have bequeathed to other women, we must grapple with two difficult questions about the pamphlets in this anthology: Were the pseudonymous authors really women and should the term *feminist* be applied to their positions?

Female Authorship

> Women are paid their due.
> No more shall evil-sounding fame be theirs.
> Cease now, you muses of the ancient singers,
> To tell the tale of my unfaithfulness;
> For not on us did Phoebus, lord of music,
> Bestow the lyre's divine
> Power, for otherwise I should have sung an answer
> To the other sex.
> (*Medea*, lines 419–29)

Both the female chorus of Euripides' *Medea* and Chaucer's Wife of Bath (lines 693–96) point out that the literary debate about women had been largely conducted by men. Although a few women on the Continent wrote in defense of their sex (most notably Christine de Pisan, but also women such as Hélisenne de Crenne and Laura Terracina), it was not until 1589 that an Englishwoman stretched "the lists [limits] of her modesty" (Anger) to pen a response to men's attacks. Jane Anger was the first, but soon other Renaissance Englishwomen followed her example: Rachel Speght, Esther Sowernam, Constantia Munda, Mary Tattlewell and Joan Hit-him-home (the last two women, authors of *The women's sharp revenge*, will hereafter be referred to as "Tattlewell"). Women in England had begun to "sing an answer to the other sex"; because they were pioneers, their songs deserve to be heard.

20

The ground-breaking nature of their achievement has led some twentieth-century scholars to question the female authorship of their pamphlets.[31] With the exception of Rachel Speght (and possibly Jane Anger), the names are obvious pseudonyms, and the writers are otherwise unknown; at the present time we have no independent evidence to prove beyond doubt that they were women. However, while definite proof either way is lacking, probability strongly supports our contention that these writers were indeed women, as they claimed.

First of all, there is no compelling reason to discount their claims to be women. Certainly some middle- and upper-class women of the time were educated enough to write these treatises; moreover, the Renaissance in England was a time of great religious and social change, a factor which might prompt individuals to question old limitations and try new roles. The successful reign of Elizabeth I provided a highly visible symbol of women's potential, a symbol which remained efficacious even after her death, as Esther Sowernam's tribute to her indicates.

Second, the hypothesis that these treatises were actually written by men is not logical. Men write under female pseudonyms when there is some definite benefit to be gained (in an area like the modern Gothic romance, for example, where female authors have established dominance), but in the Renaissance a female name on a defense treatise was an anomaly which would enhance neither the prestige nor the sales of the work. There was, however, ample precedent for men to write defenses of women either anonymously or under their own names; male authors even had a number of traditional poses to explain their writing of defense: courtly "champion" of the female sex (Edward More), righteous indignation at the excessive nature of the attacks (Christopher Newstead), Chaucerian "atonement" for previous attacks (Edward Gosynhill), and the sophisticated man of the world who defends with his tongue firmly in his cheek (Nicholas Breton). At this time there was simply no reason why men should choose to write defenses under female names.

Moreover, the consistency of tone, the attitude toward men, and the passionate conviction of these pamphlets support their authors' claims to be women. It is one thing for men to present a female point of view through characters in a drama or narrative; it is quite another to sustain an effective female pose in a first-person discussion which draws at least partially on experience and focuses on attitudes toward both sexes (note, for example, Gosynhill's difficulties in maintaining Venus's

point of view in *Mulierum Paean*). These pamphlets not only consistently employ the first-person pronouns ("we," "us women," "our sex") but also convincingly assert a feminine perspective; for example, one can easily imagine a woman writing the following words, but not a man: "If we clothe ourselves in sackcloth and truss up our hair in dishclouts, Venerians will nevertheless pursue their pastime. If we hide our breasts, it must be with leather, for no cloth can keep their long nails out of our bosoms" (Anger).

There is a zeal and conviction in these pamphlets that is absent from the defenses written by men, even the most eloquent of which are marked by a certain dispassionate detachment of tone. While these women were certainly aware of the literary nature of the controversy and fully employed its rhetoric and idiom, they took their defense of women seriously. Although Tattlewell's pamphlet is lighter than the others (in keeping with the humorous nature of the "lectures" which prompted it), much of the humor is the gently self-deprecating type exemplified in the pseudonyms ("tattle well and hit him home") and does not preclude a seriousness of purpose.

The moral outrage that characterizes these pamphlets often leads the women into a partisanship similar to that found in some of the male attacks on women but lacking in the male defenses. The female authors sometimes defend women through generalizing counterattacks on men; this approach is especially evident in Jane Anger, who begins her second epistle with the words, "Fie on the falsehood of men!" Calling men "our worst enemies," she maintains that "if a woman trust unto a man, it shall fare as well with her as if she had a weight of a thousand pounds tied about her neck and then cast into the bottomless seas." Tattlewell calls men "lime twigs of Lust and Schoolmasters of Folly," saying that "no living thing Created is so sottish, senseless, brutish, and beastly as most of them have been and are daily, nightly, and hourly in their drink." Anger unequivocally claims that men are "inferior unto us," Munda that woman is "the greatest part of the lesser world," and Tattlewell that women are "either men's betters or their equals." Sowernam equivocates slightly: "I will not say that women are better than men, but I will say men are not so wise as I would wish them to be to woo us in such fashion as they do, except they should hold and account of us as their betters."

It is highly unlikely that male authors would mount such generalizing attacks on their own sex; as Joseph Swetnam points out, "It is a

very hard winter when one Wolf eateth another, . . . and a most un-kind part it were for one man to speak ill of another." Male defenders of women like Edward Gosynhill admit that some men are evil and even that more men than women have offended. However, they do not condemn men in general; when they do describe women as "the most excellent creatures upon earth" (*Hic Mulier*), the praise, carefully limited to "good women" who keep their proper place, is not given at the expense of men. Even Christopher Newstead, who exalts women more than most male defenders, says that women surpass men in vir-tue because they have to struggle harder to overcome their natural imperfection.

Finally, these women were all conscious of their boldness in break-ing the tradition of feminine silence: Anger pictures men supposing that "there is not one amongst us who can or dare reprove their slanders and false reproaches"; Sowernam says that Swetnam has provoked her to "use more vehement speeches than may seem to correspond the natural disposition of a Woman"; Munda states that necessity compels her to speak "though feminine modesty hath confined our rarest and ripest wits to silence."

The fact that the women (with the exception of Speght) used pseud-onyms although most of the men in the controversy published either anonymously or under their own names also indicates the daring re-quired at this time for a woman to publish anything but works of a strictly devotional nature. In a famous passage from *A Room of One's Own*, Virginia Woolf dramatically portrays the reaction that awaited female authors even in the late seventeenth century. She cites several lines from a poet, Anne Finch, countess of Winchilsea:

> Alas! a woman that attempts the pen,
> Such a presumptuous creature is esteemed,
> The fault can by no virtue be redeemed.[32]

Her second example is from a letter of a young woman named Doro-thy Osborne, who is commenting on a new book by Margaret Caven-dish, duchess of Newcastle: "Sure the poor woman is a little distracted; she could never be so ridiculous else as to venture at writing books, and in verse, too. If I should not sleep this fortnight, I should not come to that."[33] When even ordinary women of the time saw the publication of a book by a woman as a symptom of mental instability, it is no won-der that women used pseudonyms; Constantia Munda gives a hint of

the pressures facing the female who would enter the pamphlet wars when she says that Swetnam "surmised that, inveighing against poor illiterate women, we might fret and bite the lip at you . . . but never durst in open view of the vulgar either disclose your blasphemous and derogative slanders or maintain the untainted purity of our glorious sex." In such climate of opinion, it would indeed be remarkable for a man to write under a female pseudonym.

In conclusion, since nothing in the tradition of the literary controversy indicates that men would write under female names and much suggests that they would not do so, and since the internal evidence of the pamphlets themselves points to female authorship, it seems reasonable to take these women at their word and thus pay tribute to their significant achievement: "Women are paid their due. / No more shall evil-sounding fame be theirs."

Feminism

Although the Renaissance pamphlet wars brought to print the first female defenders of women in English, the place of these controversies in the development of feminist thought is problematic. The anti-feminine treatises of this period contributed little that was really new to the debate about women. Their style does impart a distinctly Renaissance flavor to the works, but their content is mostly a repetition of misogynist claims dating back to antiquity. These Renaissance attacks did, however, disseminate the misogynist ideas more broadly among the literate members of the gentry and the mercantile classes; it was this widespread popularization of antifeminine claims, says Esther Sowernam, which finally prompted women to speak out: "Amongst the rabble of scurrile writers, this prisoner now present hath acted his part, whom albeit women could more willingly let pass than bring him to trial, and as ever rather contemn [scorn] such authors than deign them any answer, yet seeing his book so commonly bought up, which argueth a general applause, we are therefore enforced to make answer in defense of ourselves, who are by such an author so extremely wronged in public view."

This popularization brought with it some changes in emphasis, as the treatises began to deal less with the concerns of the celibate clergy and the aristocracy and more with arguments close to middle-class

hearts. Hence these pamphlets' attacks on marriage are based on claims of the torments women can bring to men (shrewishness, cuckoldry, economic ruin) rather than a religious exaltation of virginity and celibacy. Alongside the age-old picture of the woman as dangerous sexual temptress these pamphlets place the portraits of the scolding, domineering shrew and the vain spendthrift ruinously draining her husband's finances. These are not new images of women, for they appear as early as Hesiod, but they are given special prominence in the Renaissance attacks, presumably because of their particular appeal to the bourgeois audience of these pamphlets. Indeed, the *Schoolhouse*'s picture of an ambitious woman pushing her husband to an office beyond his capacities would seem to reflect a fear especially pertinent to the middle classes.

The defenses of the English Renaissance, on the other hand, did contribute something new to the controversy, the voices of women raised in public protest. Although a few women on the Continent had written defenses, they were widely scattered and (except for Christine de Pisan) little heeded. In the Renaissance, Englishwomen spoke up for the first time, and they spoke up in force (three in one year is a remarkable breakthrough when contrasted with centuries of silence). In fact, some of these women explicitly supported one another; although Sowernam criticized the "slenderness" of Speght's response, she approvingly cited one of her arguments, and Munda paid tribute to both Speght and Sowernam.

These voices are significant because they were among the earliest published *feminine* responses in the controversy, but we must also ask whether these and other defenses of the period can properly be termed *feminist*.[34] Among modern scholars grappling with the question of how precisely to define feminism, historian Hilda Smith has presented a definition which is free from the bias of a particular time period or feminist movement:

> I would like, therefore, to define feminism as a view of women as a distinct sociological group for which there are established patterns of behavior, special legal and legislative restrictions, and customarily defined roles. This definition includes the obvious corollary that women's roles and behavior are based on neither rational criteria nor physiological dictates. It assumes a process of indoctrination from earliest childhood, both by overt and co-

vert means, which determines the differing life styles of men and women. And, finally, it views the role of women as more restricted and less personally fulfilling than that of men.[35]

Using this definition as a starting point, then, we will discuss the degree of feminism in the defenses of this anthology.

There is no question that the authors of both attacks and defenses consider women as "a distinct sociological group"; the fact of female gender cuts across all other social, economic, or class distinctions. The clearest statement of this grouping can be found in Tattlewell's claim that women should be judged by their peers, whom she lists as "Sovereigns and Subjects, Court, City, Camp, and Country, . . . the Virgins, the Vestals, the Wives, the Widows, the Country wench, the Countess, the Laundress, the Lady, the Maid-Marion, the Matron, even from the Shepherdess to the Scepter." But all the pamphlets assume such a grouping; the frequent use of argument by example testifies to the habit of moving immediately from the specific to the general, from the individual to the sex as a whole.

These treatises present women from all classes as bound by certain "established patterns of behavior" and "customarily defined roles"; although they do not deal explicitly with the question of "legal and legislative restrictions," we know from other sources that Renaissance women were subject to such restrictions. The author of *Hic Mulier* groups together women from all social classes in his condemnation of women in masculine attire; although he treats somewhat sympathetically the noblewomen's desire for dress distinctions between classes, he maintains that their common bond as women is stronger than any other distinction in determining their proper dress and behavior. He is clearly thinking of all classes of women when he summarizes women's behavior and role by quoting several lines of poetry:

> Those Virtues that in women merit praise
> Are sober shows without, chaste thoughts within,
> True Faith and due obedience to their mate,
> And of their children honest care to take.

The misogynists, however, posit a rational, physiological, and religious basis for the restriction and subordination of women; reflecting the generally held opinion of the time, they justify woman's position on the basis of her mental incapacity (according to the *Schoolhouse*, woman's reasoning power is "not worth a turd," and she is "of body

much impotent"). Their most significant justification is religious and biblical, for Genesis records God himself commanding that Eve be subject to her husband: "Thy desire shall be to thy husband, and he shall rule over thee" (Genesis 3 : 16).

Because these opinions were so strongly and widely accepted in the Renaissance, with all the authority of both Church and State behind them, the defenders of women had to grapple with them as best they could. On the question of women's mental capacity, most take the position that women's minds are either equal to or better than men's. Gosynhill treats the issue lightly, through a pun on "mother wit," but Anger devotes a long passage to proving that woman's wisdom is "more excellent" than man's; Sowernam, Munda, and the female speaker of *Haec Vir* all offer themselves—their learning, their reasoned argumentation—as refutation of the charge of mental incapacity; Tattlewell argues that though women are "of a temper most capable of the best Impression," they have been kept from full development of their mental potential by lack of education.

The defenders in this anthology tend to avoid the physiological question, although the female speaker of *Haec Vir* refers to "Beauty" and "Frailty" as the champions of "poor weak women" and Sowernam does seem to assume the physical weakness of women, even using the term "the weaker vessel." Tattlewell, however, uses the same phrase to quite different effect ("we, whom they style by the name of weaker Vessels"), and Munda's aggressive stance and martial metaphors certainly do not suggest physical weakness.

The religious basis for female subordination caused the greatest difficulty in evolving a truly feminist perspective in the Renaissance, however. In an age when the Bible was interpreted strictly, the defenders could not discount that passage in Genesis. Therefore, although they argued that woman was as good as, if not better than man, they accepted men's rule over women as part of the God-given order of the world. Since a hierarchy among people was generally regarded as right and natural in the Renaissance, the obedience of one adult to another did not carry the stigma that it has acquired today. Thus Sowernam could make a virtue out of necessity, claiming that God ordered woman to obey "the more to increase her glory": "Obedience is better than Sacrifice, for nothing is more acceptable before God than to obey. Women are much bound to God to have so acceptable a virtue enjoined them for their penance."

While Tattlewell and Munda avoid the issue altogether, Anger and the female speaker of *Haec Vir* attempt to take a more feminist position with regard to this question, and they both do it by ignoring Genesis. Anger wields her marvellous sarcastic wit: first claiming "some sovereignty in us women which could not be in them men," she states that women are endowed with such "wonderful virtues" that "the Gods," in order to keep women from pride, "bestowed the supremacy over us to men, that of that Cockscomb he might only boast. And therefore, for God's sake let them keep it!" The female speaker in *Haec Vir* appears to deny any masculine sovereignty over women at all: "I was created free, born free, and live free; what lets [hinders] me then so to spin out my time that I may die free? . . . We are as freeborn as Men, have as free election and as free spirits; we are compounded of like parts and may with like liberty seek benefit of our Creations." However, by the end of the pamphlet she promises, "Then will we love and serve you; then will we hear and obey you; then will we like rich Jewels hang at your ears to take our Instructions." To the twentieth-century reader Hic Mulier's notion of equality between men and women scarcely seems radical, but the Renaissance reader, accustomed to think of relationships in hierarchical rather than egalitarian terms, was likely to consider male sovereignty requisite to a rationally ordered universe and thus to regard Hic Mulier's notion as irrational and extreme. Still, the perceptive seventeenth-century reader of this pamphlet must have sensed that its rhetorical weight lay with Hic Mulier's impassioned appeal for women's freedom from the constraints of custom. Because the appeal is logical, fervent, and sustained, while the retreat to the conventional view of women's place is brief and abrupt, one must ask why this retreat occurs at all. While the question cannot be definitively answered, there are several possibilities. The author may have been frightened of his (or her) own radical ideas; he may have realized that his audience was not ready for these ideas; or he may have feared either disapproval or actual punishment from the Crown, since James's conservative views on women were well known.[36]

According to Smith's definition of feminism, we must now consider whether these treatises view the role of women as "more restricted and less personally fulfilling than that of men," as designed for men's benefit and maintained through "a process of indoctrination." The treatises appear to accept the biblical mandate for female subordination, and

28

they do not protest against religious indoctrination. However, all the defenses deplore misogynistic attacks upon women as an attempt to force upon both sexes derogative conceptions of women's nature and behavior. Also, some of these pamphlets do present women's role as unfairly restricted for the benefit of men. Except for her style, Tattle-well sounds like a modern feminist as she complains that men restrict women's education in order to maintain the subordinate position of females and to enhance their value as sex objects:

> When we . . . have not that generous and liberal Education, lest we should be made able to vindicate our own injuries, we are set only to the Needle, to prick our fingers, or else to the Wheel to spin a fair thread for our own undoing, or perchance to some more dirty and debased drudgery. If we be taught to read, they then confine us within the compass of our Mother Tongue, and that limit we are not suffered to pass; or if (which sometimes happeneth) we be brought up to Music, to singing, and to dancing, it is not for any benefit that thereby we can engross [take] unto ourselves, but for their own particular ends, the better to please and content their licentious appetites when we come to our maturity and ripeness. And thus if we be weak by Nature, they strive to make us more weak by our Nurture; and if in degree of place low, they strive by their policy to keep us more under.

Both Anger and Gosynhill emphasize the strains and difficulties that the nurturing role imposes upon women and the benefits that it confers upon men:

> In the time of their sickness we cannot be wanted [dispensed with], and when they are in health we are for them most necessary. They are comforted by our means; . . . without our care they lie in their beds as dogs in litter.

> > Thus hath the mother all the care,
> > All the labor and disease,
> > Whereas the father doth what him please.

Tattlewell, Anger, and Sowernam also protest against the double standard of sexual behavior, which allows a man to take pleasure from a woman with impunity but then so indelibly brands the woman that "she is disparaged and utterly undone by it" (Sowernam). Sowernam even extends this double standard to cover drunkenness and other faults: "So in all offenses, those which men commit are made light and

as nothing, slighted over, but those which women do commit, those are made grievous and shameful."

The difference between these protests and a thoroughgoing feminist position, however, can be seen in the pamphlets' purpose: they call for praise and gratitude toward women rather than for change in women's roles. Gosynhill does not imply that men should share the nurturing function with women, but rather that they should be properly grateful (indeed, Swetnam reflects a common attitude of the time when he maintains that husbands who "meddle with" domestic matters "many times offend their wives greatly"). Sowernam, in fact, finds some justice in the double standard, arguing from the premise that women are by nature more pure and excellent than men and therefore more to be blamed when they fall. Only Tattlewell implies that women's status might be raised (through liberal education), and she does not elaborate this idea.

In their exaltation of women and their defense against the stereotype of the woman as lustful seductress, some of these treatises set up a counterstereotype of woman as naturally purer and more chaste than man: "Women were so chaste that, though they did marry and were married, it was more for propagation of Children than for any carnal delight or pleasure they had to accompany with men; . . . and surely if there had been any lawful way for them to have had Children without Husbands, there hath been, and are, and will be a numberless number of Women that would or will never be troubled with wedlock nor the knowledge of men" (Tattlewell). These writers sought to refute the prevalent view of female sexuality, which assumed that women were by nature sexually insatiable (as can be seen, for example, in Christopher Newstead's defense when he refers to "the riotous pleasures of their bodies"). However, this stereotype of the "pure" woman prefigured attitudes toward women which gained great currency in the nineteenth century and influenced feminist movements in England and America; in fact, one of the arguments for giving women the vote was that their purer natures would bring greater morality to government and society.

Only two of these pamphlets take a more radically feminist stance: Anger's *Protection for Women* and the early part of *Haec Vir*. Anger's aggressive position leads her to attack men as savagely as any modern militant feminist and to advocate a kind of separation from men:

"There is a continual deadly hatred between the wild boar and tame hounds; I would there were the like between women and men unless they amend their manners." As we have seen, Anger also manages to treat the concept of male supremacy rather contemptuously; however, she does not challenge the Bible directly, and the main focus of her argument is rather obsessively sexual.

Before her capitulation, the female speaker of *Haec Vir* presents the strongest feminist position in this anthology. She glorifies change and deplores the constrictions placed on women, maintaining that they stem only from "Idiot" custom and have no rational, physiological, or religious basis. Her speech resounds with the word "free" as she claims equality with men and demands the liberty to live as she chooses, bound only by the standards of reason and morality which also constrain men. Although she retreats from this position at the end of the treatise, the fact that such radical concepts were articulated at all in the Renaissance is in itself remarkable.

Thus it is clear that there were indeed elements of feminism in the defenses of women published during the English Renaissance. This feminism was tempered and shaped by the climate of opinion of the times, by the purpose of the pamphlets (to praise women and defend them against specific attackers), and by the traditions and conventions of defense literature. In the words of Joan Kelly: "Caught up in opposition to misogyny, the feminists of the *querelle* remained bound by the terms of that dialectic. What they had to say to women and society was largely reactive to what misogynists said about women. Yet the way beyond that resistance to misogyny had to lie through it. . . . To oppose misogyny was to initiate the long feminist struggle for women's full humanity and for the humanity of society as well."[37] Perhaps, as Hilda Smith maintains in *Reason's Disciples: Seventeenth-Century English Feminists*, women writers in England did not develop a fully feminist position until the latter half of the seventeenth century. Nevertheless, these defenses do allow us to hear the first English female speakers in the debate, women who revitalized the controversy through their logic, common sense, and fervent moral indignation. While these early defenders did not demand the changes that would have improved women's social and political position, they helped build the foundation for a more activist feminism by fostering in women the conviction of their own intellectual and moral worth.[38]

Methods of Argumentation

Since the mode of argumentation and the style of Renaissance pamphlets are quite different from those of twentieth-century writing, a closer examination of these features may help to clarify and illuminate these pamphlets for modern readers. The attacks on women in this anthology employ well-established and traditional methods of argument: example and anecdote, appeals to authority, analogy, invective, and jest. Ever since the Middle Ages, example and anecdote had been a favorite mode of attack by misogynists. Like their predecessors, the Renaissance pamphleteers point triumphantly to examples of wicked women as if they constitute positive proof that all women are depraved. This mode of argument by example reinforced the Renaissance love of type and stereotype; the tendency to present and interpret individuals as typical of the generality was so strong that John Taylor could attack all women simply by dramatizing the "lectures" of individual females, while the author of the *Schoolhouse* proves his statement that "whosoever weddeth a wife / Is sure of sorrow all his life" by telling the story of Socrates and Xanthippe. Drawing heavily upon biblical and classical stories, these authors indiscriminately mingle historical, literary, legendary, and mythical examples; some also draw upon folklore for stories like the woman with an aspen leaf for a tongue.

As is evident in our annotations of the treatises, the examples used by the attackers were often distorted or even totally inaccurate. These writers were most concerned to make emphatic and entertaining assertions; if the author of the *Schoolhouse* could condemn woman's lust as so insatiable that it even drove her to incest and at the same time humorously portray Lot's daughters "meddling with" their sleeping father to satisfy "the tickle in their tail," he certainly did not care about accuracy. Indeed, sometimes the errors reveal an intriguing pattern; for instance, four of the *Schoolhouse*'s examples of feminine lust (Byblis, Myrrha, Lot's daughters, Tamar) depict incestuous relations with a father or father-in-law, and all but one of these (Myrrha) involve misinterpretations of the original stories.

Another traditional mode of argument used by the antifeminist pamphleteers is the appeal to authority (again, primarily biblical and classical). Both the author of the *Schoolhouse* and Swetnam quote several proverbs; Swetnam also cites Moses, Saint Paul, Socrates, and

Ovid; the author of *Hic Mulier* quotes Seneca, Sophocles, and two Renaissance poets (Sir Thomas Overbury and Edmund Spenser), also naming God as the ultimate authority for sexual distinction by dress. In this mode, too, the attackers were not overly concerned with accuracy, so they used doubtful sources and frequently quoted out of context; Swetnam even misquotes God (as calling women "necessary evils").

To the modern mind, the strangest of the attackers' methods of argumentation is their habit of demonstrating by analogy, usually through the use of metaphors and aphorisms. For example, when John Taylor implies that an ugly woman can still satisfy passion, "for foul water will quench fire as well as fair," he is literalizing the symbolic equation between an ugly woman and foul water and between sexual passion and fire. Because the statement is true about fire and water, it is also true about women and passion. This sort of leapfrogging between fact and symbol, nourished by medieval theology and allegorical literature, is very prevalent in these Renaissance pamphlets. Of all the authors in this anthology, however, Joseph Swetnam relies most heavily on argument by analogy. One can find passages similar to the following anywhere in the *Arraignment:* "It is impossible to fall amongst stones and not to be hurt, or amongst thorns and not be pricked, or amongst nettles and not be stung. A man cannot carry fire in his bosom and not burn his clothing; no more can a man live in love but it is a life as wearisome as hell, and he that marrieth a wife matcheth himself unto many troubles."

The antifeminist treatises all blend these modes of argument with sheer invective against women (what the defenders like to call "railing"). For instance, in addressing the "unmarried wantons," Swetnam characterizes them as "more vile than filthy channel dirt fit to be swept out of the heart and suburbs of your Country." *Hic Mulier* uses this exaggerated railing style more frequently than the other attacks in this anthology: "You that are stranger than strangeness itself; . . . you that are the gilt dirt which embroiders Playhouses . . . and the perfumed Carrion that bad men feed on in Brothels: 'tis of you I entreat [treat] and your monstrous deformity."

Finally, these pamphlets attack women through jest, especially the *Schoolhouse* and *Juniper Lecture*. Although the author of the *Schoolhouse* initially announces that his chief purpose is to increase virtue and strike down vice, his final statement of purpose is closer to the

mark: he says he wrote that "the masculine might hereby / Have somewhat to jest with the femini[ne]." The poem is full of misogynist humor, sexual puns, and earthy stories, all related with obvious zest and a mischievous tone. Swetnam's humor is more heavyhanded: "Moses describeth a woman thus: 'At the first beginning,' saith he, 'a woman was made to be a helper unto man.' And so they are indeed, for she helpeth to spend and consume what man painfully getteth." He does, however, fitfully maintain a jesting spirit, and some of his lines are quite clever (e.g., "there is more belongs to housekeeping than four bare legs in a bed").

John Taylor's subtitle for *A Juniper Lecture* sets the flippant, irreverent tone for the whole: "With the description of all sorts of women, good and bad: From the modest to the maddest, from the most Civil to the scold Rampant, their praise and dispraise compendiously related." He serves notice immediately that nothing he says is to be taken seriously, addressing his first epistle to "as many as can Read, though but reasonably; it makes no great matter whether they understand or no." His lectures are bursting with linguistic humor—outrageous name-calling, metaphors, puns, and irony. A stupid suitor is a "brainless lump of ignorance"; a shrew "with her twittle-twattle" sows "discordant heartburning amongst her neighbors"; a faithless wife describes her success in "business" in the following terms: "For my better maintenance I Traded so well and had such good comings in that I made him wear an invisible Cuckoo's Feather in his Cap, and if occasion had been he could have made Hay with his head as well as with a Pitchfork."

Some of these modes of argument posed considerable difficulties for the defenders. After the male speaker in *Haec Vir* finishes ranting in the manner of the misogynist pamphlets, the female speaker responds, "Leave this lightning and thunder and come roundly to the matter; draw mine accusation into heads, and then let me answer." She astutely observes that invective is unanswerable, except in kind; he will have to clarify his accusation before she can frame a logical response. Jest, too, can be answered only with jest; the defender who responds seriously appears to lack all sense of humor (Sowernam's attempt to brand Swetnam's "helping" joke as "horrible blasphemy" is a case in point). Humor, however, can be a powerful weapon, more devastating than the sharpest logic, because it is insidiously ingratiating; we laugh, we remember, and we ultimately believe. Francis Lee Utley has called

jest "the civilized veneer for sex antagonism,"[39] and the female defenders perceived its power. In the words of Tattlewell: "We must confess that to jest is tolerable, but to do harm by jesting is insufferable; for it is too late to prevent ill after ill committed, or to amend wrong after injury received. Many things that are sweet in the Mouth may prove bitter in the stomach, and scoffs pleasant to the ear may be harsh to the better understanding." Furthermore, the very nature of the response form requires its writers to be constantly on the defensive, a posture which is harder to sustain than the offensive.

The defenders in this anthology devised various strategies to cope with these difficulties. All employed argument by example, assuming equally with the misogynists the validity of this type of proof but countering their examples with biblical and classical stories of virtuous women. Edward Gosynhill apparently tries to overwhelm his adversary by the sheer volume of his examples; although some of these are of rather dubious value to his position (for instance, Sarah, the daughter of Raguel, whose first seven husbands were strangled by a demon on their wedding nights), his examples from daily life are quite effective, especially his extended picture of a mother's nurturing. Besides offering examples of feminine virtue, the defenders criticize or reinterpret the attackers' examples: Munda says that there is no record of an ancient harlot Swetnam calls Theodora, but there was "a glorious Martyr of this name"; Sowernam castigates Swetnam as "both frantic and a profane, irreligious fool" for listing the Old Testament heroine Judith as a lewd woman. Moreover, Sowernam extends the catalogue of virtuous females to include women from fairly recent British history, culminating in the figure of Elizabeth I, whom she presents as "not only the glory of our Sex, but a pattern for the best men to imitate."

Like their adversaries, the feminist writers appeal to classical and later authorities; Plato is a favorite classical authority, cited by Anger, Sowernam, and Munda, but Aristotle, Protagoras, Horace, and others also appear, along with later poets like Ariosto.

Despite Tattlewell's protest that women are denied a "generous and liberal Education" and confined to their "Mother Tongue" in order to be rendered incapable of defending themselves, the female authors display impressive learning in these treatises. Besides the appeals to authority noted above, Anger and Sowernam sprinkle Latin maxims throughout their texts, and Tattlewell shows knowledge of English and

Continental love poets. But it is Constantia Munda (whose very pseudonym is an indication of her learning) who most brilliantly dazzles the reader with her knowledge and linguistic abilities, quoting in Greek, Latin, Italian, and French and revealing a sound knowledge of classical culture through the aptness of her quotations and her often deft allusion to their original contexts. Unlike that of Christopher Newstead, Munda's display of learning is neither pretentious nor stultifying; by subtly integrating her knowledge into the fabric of her treatise, she effectively demonstrates that women are indeed capable and worthy of a "generous and liberal Education."

Jane Anger repeatedly opposes misogynist invective with generalizing counterattacks on men; the other defenders do this occasionally. More frequently, however, they respond with *ad hominem* attacks on the motives, character, style, and morality of the antifeminist authors. (This mode of personal attack was traditional in Renaissance pamphlet wars, whether the issues were social, political, or religious; even a public figure like John Milton employed "character assassination" against his opponents.) The female defenders surmise that the male authors turned against women because of some bad experiences with "Italian Courtesans" (Anger), their "own familiar doxies" (Sowernam), or "a bad match, a Shrew, a Wanton, or the like" (Tattlewell).[40] Tattlewell calls Seldom Sober's father a Rag-gatherer and his mother "the daughter of a Dunghill," and even the more restrained Sowernam occasionally lashes out against Swetnam: "There was never a woman was ever noted for so shameless, so brutish, so beastly a scold as you prove yourself in this base and odious Pamphlet." The defender in this anthology who employs invective most frequently, most wittily, and most effectively is Munda; this is a major feature of her pamphlet's tone and style, as she herself warns the reader when she terms her treatise "no Confutation but a sharp Redargution [reproof] of the baiter of Women." In the following characteristic passage she manages to attack simultaneously Swetnam's style, physical appearance, personality, intelligence, character, and motives: "The crabbedness of your style, the unsavory periods of your broken-winded sentences, persuade your body to be of the same temper as your mind. Your ill-favored countenance, your wayward conditions, your peevish and pettish nature is such that none of our sex with whom you have obtained some partial conference could ever brook your dogged frumpard [scoffing] frowardness: upon which malcontented desperation you

hung out your flag of defiance against the whole world as a prodigious monstrous rebel against nature."

Jest is a mode of argument more suited to attacks than defenses; when one is on the defensive, humor often seems to undercut rather than reinforce one's position. Misogynist humor dates from antiquity, maintaining a certain consistency of tone and themes; modern jokes about wives, for example, sound very much like ancient ones. Feminist humor, on the other hand, did not develop a tradition until fairly recently, when the feminist position had become more acceptable (or at least more widely known). Therefore, throughout the history of the controversy defenders tended to adopt a serious tone (unless, like Nicholas Breton, they were writing ironically). Of the feminist pamphlets in this anthology, only Tattlewell makes much use of jest, although one can find barbed, sarcastic wit in both Anger and Munda. While Tattlewell's tone is passionately earnest when she praises women's chastity, attacks the double standard of sexual behavior, or deplores women's lack of education, she frequently mingles jest with seriousness. For example, she writes a wonderfully funny satire of the courtly lover in the figure of "Captain Compliment with his page Implement," but she concludes the passage with a serious warning against the falsehood of men. Nevertheless, although Tattlewell's humor adds to the pamphlet's appeal, her jesting somewhat dissipates its force. She elicits a smile when she describes a male seducer as an "enamored Toad," but Anger's "ravenous hawks" seem far more dangerous to women.

Although the slippery arguments of the attackers give the defenders little to sink their teeth into, they do seize upon specific errors to refute or elements of style to satirize. For example, all the women responding to Swetnam gleefully pounce upon his "necessary evils" blunder, and Munda decries his misquoting of a psalm. Criticism of style is an even more concrete mode of response, so some defenders castigate an attacker's manner as roundly as his matter. This was especially appropriate in the Renaissance, when it was generally agreed that style ought to be "a well-tuned Instrument, in all places according and agreeing" (Rachel Speght, p. 36) in order to present properly a harmony of thoughts. Thus, although Anger finds her adversary's style "pleasing," the female opponents of Swetnam all attack his style and manner of presentation. Sowernam correctly accuses him of wholesale thievery from works like *Euphues*; Munda echoes this accusation more em-

phatically and then devotes several pages to a perceptive stylistic criticism of the *Arraignment*, effectively mocking Swetnam's foolish and cliché-ridden metaphors, "doggerel rhymes," and constant contradictions. The fact that so much of Munda's response constitutes a discussion of style rather than ideas testifies not only to the Renaissance interest in stylistic questions but also to the difficulty of replying logically to Swetnam's modes of argument.

Nevertheless, some of the defenders do try to respond to the misogynist treatises with reason and common sense. In fact, all the defenses have a more rational basis than the attacks since they make far less use of argument by analogy; furthermore, several of the feminist treatises include some type of logical argumentation. Anger tries "like a scholar to prove our wisdom more excellent than theirs" by using deductive reasoning: "There is no wisdom but it comes by grace; this is a principle, and 'Contra principium non est disputandum' [there must be no argument against a principle]. But grace was first given to a woman, because to our lady: which premises conclude that women are wise. Now 'Primum est optimum' [the first is the best], and therefore women are wiser than men." Although by modern standards her premises are invalid and her syllogism faulty, nevertheless the attempt is admirable. Munda is more successful with logic, twice constructing valid syllogisms to point out Swetnam's logical inconsistencies and using common sense for an effective *reductio ad absurdum* of Swetnam's generalization about the antithesis between warlike man and unwarlike woman. These are isolated instances, however; only two of our pamphlets show a sustained attempt at logical organization and argument, *Haec Vir* and *Esther hath hanged Haman*.

The female speaker in *Haec Vir* forces her opponent to draw his accusation "into heads" and then takes up his charges one by one; using both inductive and deductive arguments, carefully defining her terms, insisting upon logical distinctions, and avoiding unsupported generalizations, she demolishes his contentions, brilliantly demonstrating that women in masculine attire violate nothing but custom, which ought not to be considered an absolute standard. However, when the male speaker falls back on religious authority, she immediately retreats, shifting the grounds of her argument to a demonstration that men have usurped the feminine clothing and behavior that he has presented as woman's "absolute inheritance." Ultimately, the treatise concludes with a change of clothing and a tacit reaffirmation of custom.

The most logically organized of all these feminist treatises is that of Esther Sowernam. Her opening epistle is a model of logical exposition, as she clearly and concisely explains the overall organization and purpose of her treatise. She also points out her principal modes of argument, claiming to "defend upon direct proof" through "examples, . . . authorities, customs, and daily experiences." Her approach throughout the pamphlet is solidly grounded in logic and common sense; her tone is calm and reasonable; even her invective is carefully controlled. Consider, for example, how she deals with Swetnam's charge that women are seductresses, luring men to ruin. She begins with a question: "Is holiness, wisdom, and strength so slightly seated in your Masculine gender as to be stained, blemished, and subdued by women?" Swetnam will not admit that women overwhelm men by being holier, wiser, and stronger than they; rather, he says, they ruin men through their beauty. But beauty in itself cannot cause harm; therefore women's beauty cannot be a direct cause of men's ruin, only what philosophers term "an accidental cause." Men are tempted by beauty only because of their own wantonness; when a man sees a lovely woman, he should "rather glorify God in so beautiful a work than infect his soul with so lascivious a thought." Thus Sowernam neatly turns Swetnam's argument back against himself: "Do not say and rail at women to be the cause of men's overthrow, when the original root and cause is in yourselves." Sowernam also uses logic to reveal the absurdity of Swetnam's favorite type of argument, analogy: "Woman was made of a crooked rib, so she is crooked of conditions; Joseph Swetnam was made as from Adam of clay and dust, so he is of a dirty and muddy disposition. The inferences are both alike in either: woman is not more crooked in respect of the one, but he is blasphemous in respect of the other." Thus Sowernam has written the most tightly organized, logical, and cogent of our defense treatises, providing in the process a concrete demonstration of the reasoning power of a woman.

Characteristics of Renaissance Style

The stylistic features of the pamphlets are drawn from the store of devices shared by all writers during the Renaissance period in England. Some of the treatises, for example, employ prose characterized by balanced construction (strings of parallel, symmetrical clauses

often introduced by the same or similar words), extensive use of similes and illustrations, antithesis, and alliteration.[41] Among these pamphleteers, Joseph Swetnam especially favors this mode of writing:

> And therefore, if a woman's face glitter and her gesture pierce the marble wall; or if her tongue be so smooth as oil or so soft as silk, and her words so sweet as honey; or if she were a very Ape for wit or a bag of gold for wealth; or if her personage have stolen away all that nature can afford, and if she be decked up in gorgeous apparel, then a thousand to one she will walk where she may get acquaintance. And acquaintance bringeth familiarity, and familiarity setteth all follies abroach [astir]; and twenty to one that if a woman love gadding but that she will pawn her honor to please her fantasy.

Swetnam's fondness for this type of prose helps to account for the prevalence of argument by analogy in his treatise; he continually subordinates logic to the demands of his style, striving for immediate effect rather than overall coherence of argument. Jane Anger also makes some use of this style, but in a more controlled, sharply focused, and concrete manner:

> Our tongues are light because earnest in reproving men's filthy vices, and our good counsel is termed nipping injury in that it accords not with their foolish fancies: our boldness rash, for giving Noddies [fools] nipping answers; our dispositions naughty, for not agreeing with their vile minds; and our fury dangerous, because it will not bear with their knavish behaviors.

Another feature of many Renaissance writers found in these pamphlets is the quality of *copia* (fullness, abundance), which often leads to excess, or overabundance. The two passages quoted above, with their excessive illustrations and lengthy series of clauses, demonstrate this stylistic quality, but it was not confined to prose, as can be seen in numerous lines from the *Schoolhouse*. This fullness of style was often coupled with a corresponding excess of statement; when the author of *Hic Mulier* castigates women for dressing in masculine attire, both his language and his claims are swept up in hyperbole:

> Come, then, you Masculine women, for you are my Subject, you that have made Admiration an Ass and fooled him with a deformity never before dreamed of; that have made yourselves stranger things than Noah's Ark unloaded or Nile engendered; whom to

name, he that named all things might study an Age to give you a right attribute; whose like are not found in any Antiquary's study, in any Seaman's travel, nor in any Painter's cunning.

This passage is an illustration of what Jane Anger perceived as excess in style: "Their minds are so carried away with the manner as no care at all is had of the matter. They run so into Rhetoric as oftentimes they overrun the bounds of their own wits and go they know not whither." In fact, these stylistic tendencies help to explain the exaggerated tone and sometimes extravagant overstatement present in many of these treatises, attacks and defenses alike.

There is another prominent characteristic of Renaissance writing which appears in the pamphlets of this anthology—verbal facility and sheer delight in manipulating the sounds, textures, and associations of words. One can observe this verbal play in the luxuriant metaphors, puns, and sound patterns (especially alliteration and rhyme) so prevalent in these pamphlets, both poetry and prose. For example, Tattlewell attacks the sexual double standard through a clothing metaphor, comparing a man's and a woman's sexual disrepute to a suit of delicate fabric and a suit of leather:

For the shame or scandal of a whoremonger is like . . . a Record written in sand, or like a suit of Tiffany or cobweb Lawn soon worn out, but the faults of a weak woman . . . are engraved in brass, and like a suit of Buff, it may be turned, and scoured, and scraped, and made a little cleanly, but it lasts the whole lifetime of the wearer.

Puns are particularly evident in these treatises, as indeed in all Renaissance literature. Sexual puns are favored by the antifeminists, especially Taylor and the author of the *Schoolhouse*, but feminist treatises contain them as well (Anger, for example, says that lustful men will "assay the scaling of half a dozen of us in one night"). The puns in these pamphlets range from the earthy to the intellectual; they are drawn from many different areas, including clothing, manufacture, and religion. They may depend on word sound, as in Taylor's pun on marriage, mirage, and "merry-age"; they may also be part of an elaborately constructed series, such as Tattlewell's extended puns on the root meanings of grammatical terms.[42]

These pamphleteers enjoy playing with the sounds as well as the meanings of words. Rhyme is not confined to poetry but also crops up

in prose, as in Swetnam's "she keeps herself blameless, and in all ill vices she would go nameless." But the most prominent sound pattern in these treatises is alliteration, the repetition of initial word sounds, sometimes in interlocking patterns:

> We languish when they laugh; we lie sighing when they sit singing, and sit sobbing when they lie slugging and sleeping. (Anger)

Although language today is much less exuberant (especially the language of discursive prose), all these verbal devices contribute greatly to the liveliness and appeal of the treatises in this anthology. It is important to remember, however, that in the Renaissance such verbal play was perfectly compatible with serious intent; the Renaissance author considered the entire range of the "well-tuned Instrument" of literary style appropriate for expository as well as imaginative writing.

NOTES

1. Two of the pamphlets in this anthology—*Hic Mulier* and *Haec Vir*—assume readers from among the nobility as well as the middle class, since they enjoin aristocratic women to relinquish masculine apparel.

2. This survey makes no pretense of comprehensiveness; it is intended to provide a background and context for the pamphlets in this anthology. The following sources present a fuller discussion of the topic. For an overview of the early sources of literary misogyny and its development throughout English literature, see Katharine M. Rogers, *The Troublesome Helpmate: A History of Misogyny in Literature* (Seattle: University of Washington Press, 1966). For the medieval period, see Francis Lee Utley, *The Crooked Rib: An Analytical Index to the Argument about Women in English and Scots Literature to the End of the Year 1568* (Columbus: Ohio State University Press, 1944). Ruth Kelso discusses the Renaissance debate about women, especially on the Continent, in her *Doctrine for the Lady of the Renaissance* (Urbana: University of Illinois Press, 1956), pp. 5–37; for the English Renaissance, see especially the thorough discussion of the controversy in Linda Woodbridge, *Women and the English Renaissance: Literature and the Nature of Womankind, 1540–1620* (Urbana: University of Illinois Press, 1984), as well as Louis B. Wright, *Middle-Class Culture in Elizabethan England* (Chapel Hill: University of North Carolina Press, 1935), pp. 465–507, and Carroll Camden, *The Elizabethan Woman* (Houston: Elsevier Press, 1952), pp. 241–71. Suzanne W. Hull discusses the Renaissance controversy from the perspective of works specifically dedicated to women in *Chaste, Silent & Obedient: English Books for Women 1475–1640* (San Marino: Huntington Library, 1982), pp. 106–26.

3. Hesiod related the myth of Pandora twice. The first lines quoted are from the *Works and Days*, lines 83, 78; the second are from the *Theogony*, lines 592–93. Both are translated by Richmond Lattimore in *Hesiod* (Ann Arbor: University of Michigan Press, 1959), pp. 27, 158.

4. Semonides, in *Females of the Species: Semonides on Women*, Hugh Lloyd-Jones, trans. (Park Ridge, N.J.: Noyes Press, 1975), p. 54.

5. Philip Slater has written a controversial psychoanalytic study of Greek mythology in which he attributes this hostility to the nature of Greek marriage and family structure, *The Glory of Hera: Greek Mythology and the Greek Family* (Boston: Beacon Press, 1968).

6. St. Jerome gives an extensive summary of this work, which he calls "worth its weight in gold," in his treatise *Against Jovinianus*, W. H. Freemantle, trans., in *A Select Library of Nicene and Post-Nicene Fathers of the Catholic Church*, ed. Philip Schaff and Henry Wace (1893; reprint ed., Grand Rapids, Mich.: Wm. B. Eerdmans Publishing Co., 1954), ser. 2, vol. 6, pp. 383–84.

7. Juvenal 6. 162–66, 181–83, in *The Satires of Juvenal*, Rolfe Humphries, trans. (Bloomington, Ind.: Indiana University Press, 1958), pp. 69–70.

8. Euripides, *Medea*, Rex Warner, trans., in *The Complete Greek Tragedies: Euripides I*, ed. David Grene and Richmond Lattimore (Chicago: University of Chicago Press, 1955), p. 67.

9. For an analysis of Euripides' complex presentation of women, see Philip Vellacott, *Ironic Drama: A Study of Euripides' Method and Meaning* (Cambridge: At the University Press, 1975), pp. 82–126.

10. Susan Okin, *Women in Western Political Thought* (Princeton: Princeton University Press, 1979), presents an excellent discussion of Plato's view of women.

11. Saint Jerome, *Against Jovinianus*, in *Library of Nicene and Post-Nicene Fathers*, 6:367. The proverb actually refers to the insatiability of "the barren womb."

12. Diogenes Laertius, *Lives of Eminent Philosophers*, R. D. Hicks, trans., 2 vols., rev. ed. (London: Heinemann, 1950), 1:167.

13. Saint Jerome, *Against Jovinianus*, in *Library of Nicene and Post-Nicene Fathers*, 6:384.

14. "Caste pisse upon his heed," "The Wife of Bath's Prologue," line 729 (*The Works of Geoffrey Chaucer*, ed. F. N. Robinson, 2nd ed. [Boston: Houghton Mifflin, 1957], p. 83).

15. Joan Kelly maintains that Christine, besides being the first female to publish a defense of her sex, brought a new focus to the debate about women: "Christine de Pisan reached what has come down to us as the first analysis of the sexual bias of culture. . . . She had initiated the *querelle des femmes* by refocusing the old medieval debate on marriage and satires on women onto the issue of misogyny itself and by opening this debate to women" ("Early Feminist Theory and the *Querelle des Femmes*, 1400–1789," *Signs: Journal of Women in Culture and Society* 8 [1982]: 14–15).

16. Christine de Pisan, *Le livre de la mutacion de fortune*, translated by

Leslie Altman in her essay "Christine de Pisan: First Professional Woman of Letters (1364–1430?)," in *Female Scholars: A Tradition of Learned Women before 1800*, ed. J. R. Brink (Canada: Eden Press, 1980), p. 11.

17. See George Lyman Kittredge, "Chaucer's Discussion of Marriage," in *Chaucer Criticism I: The Canterbury Tales*, ed. Richard Schoeck and Jerome Taylor (Notre Dame, Ind.: University of Notre Dame Press, 1960), pp. 130–39. W. W. Lawrence argues that "The Tale of Melibee" and "The Nun's Priest's Tale" should also be included in the group (*Chaucer and the Canterbury Tales* [1950; reprint ed., New York: Biblo and Tannen, 1969], pp. 119–44).

18. "Love wol nat been constreyned by maistrye," Geoffrey Chaucer, "The Franklin's Tale," line 764 (*Works of Geoffrey Chaucer*, p. 136).

19. In citing the texts and titles of Renaissance writings, we have modernized all but well-known literary works. See "A Note on Editorial Policy" at the beginning of part 2 of this book.

20. See Wright's analysis of popular literary taste, *Middle-Class Culture*, pp. 81–118.

21. For a summary of the evidence and various scholarly opinions, see Utley, *Crooked Rib*, pp. 250–57 and 291–95. See also Beatrice White, "Three Rare Books about Women," *Huntington Library Bulletin* 2 (1931): 169–71.

22. See Utley, *Crooked Rib*, pp. 272–76, and White, "Three Rare Books," pp. 165–69.

23. See Utley, *Crooked Rib*, pp. 122–23.

24. Possibly the lost *Boke his Surfeyt in love, with a farewel to the folies of his own phantasie* (1588), as suggested by Helen Andrews Kahin, "Jane Anger and John Lyly," *Modern Language Quarterly* 8 (1947): 31–35.

25. See F. P. Wilson, ed., *The Batchelars Banquet* (Oxford: Clarendon Press, 1929), pp. xxiii ff.

26. Coryl Crandall, ed., *Swetnam the Woman-Hater: The Controversy and the Play* (West Lafayette, Ind.: Purdue University Studies, 1969), p. 1. Swetnam's only other known book dealt with fencing, *The Schoole of the Noble and Worthy Science of Defence* (1617).

27. See Wright, *Middle-Class Culture*, pp. 487–88.

28. Ibid., p. 488.

29. For further discussion of this play, see the introduction to Crandall's edition, *Swetnam the Woman-Hater*, pp. 11–19.

30. Reported in a letter of John Chamberlain dated January 25, 1620, as quoted in Wright, *Middle-Class Culture*, p. 493.

31. For example, Moira Ferguson maintains that John Taylor may have written in response to his work under the pseudonyms of Mary Tattlewell and Joan Hit-him-home (*First Feminists: British Women Writers from 1578–1799* [Old Westbury, N.Y.: Feminist Press, in press]).

32. Virginia Woolf, *A Room of One's Own* (New York: Harcourt, Brace and World, 1929), p. 62.

33. Ibid., p. 65 (we have modernized the spelling and punctuation).

34. Both Joan Kelly and Moira Ferguson argue that these early female writers should be termed feminists. According to Kelly, although they lacked "a

vision of social movement to change events," they did create "not only a new body of ideas but also the first feminist theory: a stance, an outlook within which ideas develop, a 'theory' in the original sense of the term as a conceptual vision." She states that this early feminist theory comprised three fundamental points: (1) the early defenses were polemical, arising "as a dialectical opposition to misogyny"; (2) they focused on gender, claiming that the sexes are formed by culture as well as biology and protesting against "the societal shaping of women" to fit the defective notions of womanhood fostered by the misogynists; (3) "their understanding of misogyny and gender led many feminists to a universalist outlook that transcended the accepted value systems of the time" ("Early Feminist Theory," pp. 6–7). Ferguson cites some of these early pamphlets in her category of "reactive feminist polemic" and maintains that they helped to offset the "socio-cultural and psychological oppression" of women (*First Feminists*). On the other hand, Linda Woodbridge maintains that "the formal controversy may in fact have actively prevented the development of true feminist debate" (p. 133) by concentrating on moral and religious issues rather than social and economic ones and by employing the conventional arguments and *exempla* of the literary debate rather than focusing on real-life concerns and attempting to change women's position (*Women and the English Renaissance*). Woodbridge, however, seems to demand a sweeping and activist feminism quite foreign to the attitudes of the time and the nature of the defense genre; it is more appropriate to view the female writers of defense in the Renaissance as paving the way for a fuller feminism by demonstrating the worth and capabilities of women. Women had to find a sense of self-esteem within established value systems and to play the game by men's rules before they could challenge the old values and create their own rules.

35. Hilda Smith, "Feminism and the Methodology of Women's History," in *Liberating Women's History: Theoretical and Critical Essays*, ed. Berenice A. Carroll (Urbana: University of Illinois Press, 1976), p. 370.

36. Although the female speaker of *Haec Vir* retreats from her radical position at the end of the pamphlet, her emphasis on reason and attack on custom prefigure the arguments of the more consistent and thoroughgoing feminists of the late seventeenth and early eighteenth centuries, as analyzed in Hilda Smith's *Reason's Disciples: Seventeenth-Century English Feminists* (Urbana: University of Illinois Press, 1982).

37. Kelly, "Early Feminist Theory," pp. 27–28.

38. Suzanne W. Hull maintains that all the serious reading matter for women in the English Renaissance reinforced the prevailing doctrine of female inferiority: "Women were told over and over and over that they were inferior, that they had lesser minds, that they were unable to handle their own affairs. . . . Women heard no other side of the story, except through farce or fiction" (*Chaste, Silent & Obedient*, p. 140). However, although this was certainly true of the majority of Renaissance works, the passionate insistence of Anger, Sowernam, Munda, and Tattlewell upon the worth, even the superiority, of women must have raised the self-esteem of their female readers.

39. Utley, *Crooked Rib*, p. 27.

40. Joan Kelly views this type of attack as indicative of a new understanding of "male bias in the received culture": "Although they lacked a social analysis of male psychology, the realization that the received wisdom about women stemmed from particular psychosexual experiences, all of them male, gave feminists a critical perspective on the intellectual tradition that was, as far as I can see, unique" ("Early Feminist Theory," p. 19).

41. These devices also appear in the elaborate Renaissance prose style which has come to be known as "euphuistic" after its greatest popularizer, John Lyly, in his two prose romances *Euphues: The Anatomy of Wit* (1578) and *Euphues and His England* (1580).

42. Our annotations to the pamphlets point out and explain the most striking puns.

The Social Contexts

Popular Stereotypes and Real Women

Two of the antifeminist writers in this anthology repeat the old joke that a woman has but two faults: she neither does well nor says well. Indeed, these writers accuse her of all manner of evil; she is described as lustful, deceitful, shrewish, domineering, extravagant, proud, vain, and selfish. So general are the attacks on woman that at times one seems to be reading a mere catalogue of vices, an endlessly random list of faults. In fact, however, the faults fall into clusters; although some faults appear in more than one group, each cluster represents a distinct stereotype of woman.

Perhaps the most heavily stressed stereotype is that of the seductress: the image of woman as enticing, sexually insatiable, and deceitful in the service of her lust. Swetnam characterizes women as "lascivious and crafty" and asserts: "The Devil himself hath not more illusions to get men into his net than women have devices and inventions to allure men into their love. And if thou suffer thyself once to be led into fool's paradise (that is to say, the bed or closet wherein a woman is), then I say thou art like a bird snared in a lime bush, which the more she striveth, the faster she is." Almost equally prominent in these treatises is the figure of the shrew: the image of woman as willful, scolding, and domineering. In *A Juniper Lecture* John Taylor argues that a man should marry any kind of evil woman rather than a scold, for "she will be melancholy malicious, and her most study shall be to be ill-conditioned; she will mump, hang the lip, swell like a Toad that hath lain a year under a woodpile, pout, lower, be sullen, sad, and dogged; she will knit the brows, frown, be wayward, froward, cross, and

untoward on purpose to torment her husband." Finally, there is the vain woman who must have jewels and new gowns; many of her faults, such as extravagance and ambition, are caused by her pride and vanity. The author of the *Schoolhouse* testifies that "the Peacock is proudest of his fair tail / And so been all women of their apparel." A vain woman causes suffering to her husband by refusing sex unless she obtains her desire, by forcing him to work harder to earn more, and by spending all that he earns: "The pride of a woman is like the dropsy, for as drink increaseth the drought of the one, even so money enlargeth the pride of the other. . . . Thou must discharge the Mercer's book and pay the Haberdasher's man, for her hat must continually be of the new fashion and her gown of finer wool than the sheep beareth any" (Swetnam).

Many of the misogynistic writers perceive women as combining the worst traits of all three of these negative stereotypes; a vain woman may also be lecherous, or she may become a scold in order to obtain the gowns and jewels she wants. In *A Juniper Lecture* we find a "lecture" by a shrewish, lusty young widow who has received a proposal of marriage from an old man; convinced that he would be impotent, she refuses him scornfully: "I will have a Husband that shall be always provided like a Soldier . . . with his Match lighted and cocked bolt upright and ready to do execution, not like a Dormouse, always sleeping."

The feminist pamphlets in this collection are all to some extent defensive—that is, they seek to defend women by refuting the images of the female sex contained within the misogynistic treatises. The feminist writers claim that men are as vain as women and assert that women are scolds only when reproving a man for his manifold vices (they also point out that Swetnam is himself a shrew for his biting invective against women). But the stereotype that they refute the most vigorously is that of woman as seductress, and they do so by presenting a precisely parallel stereotype of man as seducer. To the male seducer they attribute all the traits assigned to the seductress by the antifeminist writers: deceit, guile, and relentless lust. To gratify his bestial desire, a man will flatter, bribe, promise marriage, even threaten suicide. "To bring a woman to offend in one sin," Sowernam asks, "how many damnable sins do they commit?" Women are warned against men in the same terms used to warn men of women: "Hereafter stop your ears when they protest friendship," Jane Anger wrote, "lest they come to an end . . . whereby you fall without redemption."

Thus the feminist authors see women as chaste, sexually innocent creatures whose virtue is assailed by crafty and lustful men. A love of chastity, even virginity, is viewed by Mary Tattlewell as an innately feminine trait when she argues that women marry "more for propagation of Children than for any carnal delight or pleasure." The defenders of women provide numerous examples of women who valued chastity as much as life itself: the story of Susanna from the Old Testament Apocrypha and the classical tale of Lucretia are favorite examples.

Two other views of woman, related to her image as sexually pure and yet distinct from it, are embodied in the feminist pamphlets. Woman is seen as nurturer of both husband and children; to this role she brings love, patience, and diligence. When a baby is born, "the man may lie and snore full fast, / When that the wife must watch and wake, / Out of the bed her arms cast, / The cradle to rock till they both ache" (Gosynhill, *Paean*). Not only do women nurture their husbands and children in the ordinary course of their daily lives; both history and the Bible provide innumerable examples of women who have sacrificed their own safety, and even their lives, to preserve the lives of those they love.

Finally, women in the feminist treatises are seen as especially pious and close to God—in particular, as more favored by God than are men. Gosynhill, Sowernam, and Tattlewell all present biblical evidence of a special, close relationship between women and God. God sent children to many women past the childbearing age who longed for them. The New Testament abounds with women who were greatly loved by God and who returned a deep devotion to Him: Elizabeth, Anna, Martha, and Mary Magdalene, among many others. Old Testament heroines Judith, Deborah, and Esther performed heroic feats by the grace of God. All of these instances of God's favor toward individual women serve to suggest the moral and spiritual worth of women in general. Thus the feminist authors counter the negative stereotypes of women found in the misogynistic treatises with different, positive stereotypes.

Generalizing images with conventional characteristics, all stereotypes threaten to interfere with one's perception of the depth and complexity of real individuals; they are particularly tempting because their formulaic attributes can be easily understood and applied to diverse situations. While intelligent Renaissance men and women did not—at least in their rational moments—believe that every woman fit one of

the stereotypes found in these documents, for men who saw women as a puzzle the stereotypes represented a kind of solution; for a man facing a problem with a specific woman a stereotype might appear to explain the difficulty. In 1590 Bishop Overton, attempting to reconcile the earl of Shrewsbury and his wife after a long estrangement, invoked the stereotype of the shrew in a punning letter to the earl: "But some will say . . . that the countess is a sharp and bitter shrew. . . . Indeed, my good lord, I have heard some say so, but if shrewdness or sharpness may be a just cause of separation . . . I think few men in England would keep their wives long; for it is a common jest, yet true in some sense, that there is but one shrew in all the world, and every man hath her. . . . I doubt not but your great wisdom and experience hath taught you to bear some time with a woman as with the weaker vessel."[1] Overton implies that all wives speak bitter words to their husbands and that their shrewishness is ultimately attributable to moral weakness. While his tone is conciliatory, he describes the same stereotype that appears in each of the misogynistic treatises in this anthology.

Neither the negative nor the positive stereotypes of women that form the basis of the treatises were new in the Renaissance. Examples of the shrew, seductress, and vain woman, as well as positive images of chaste, holy, and nurturing women, can be found in both classical and medieval literature. It is not the novelty but rather the pervasiveness of these images of women in popular, aristocratic, and religious writings of the Renaissance that is noteworthy. Why were these particular stereotypes so persistently stressed in this period? In every age there is a relationship between society's values and activities and its stereotypes of women. In some cases the relationship seems fairly clear; in others it is problematic. It seems safe to assume, for example, that the medieval image of the beautiful noblewoman who expected heroic martial feats of her lover became scarcer in the Renaissance because the era of knightly crusades had ended; both literature and society became increasingly urban and middle class. However, the social contexts of other images of women are more difficult to clarify, as for example the highly complex relationship between English Renaissance culture and the almost obsessive concern with women's chastity in both popular and aristocratic literature. Nevertheless, an attempt to probe the connections between the popular stereotypes of women and the social behavior and ideals of the time will illuminate both the pamphlets and the culture which produced them.

Roger Thompson places first in his list of popular stereotypes in Stuart England "that of the woman who was all tongue: the straight blabbermouth, or the gossip and scandalmonger, or the shrew or scold."[2] If women were acquiring more freedom and independence during the English Renaissance, the task of explaining the prominence of the shrew would be less difficult, for the figure tends to appear at times of increasing freedom for women. The years between 1910 and 1930 were a time of struggle and triumph for American women: they acquired the vote; they enjoyed wider social and sexual freedom; they entered the professions in unprecedented numbers. During this period the image of the bitch, the modern version of the shrew, figures prominently in the fiction of the foremost male authors, including Sinclair Lewis and Ernest Hemingway. It is striking that the bitch in this fiction is not a professional woman competing with men but typically, like the Renaissance shrew, a married woman who controls, nags, and expresses contempt for her husband. Like the antifeminist pamphlets, the fiction of Hemingway and Lewis implies that male/female relationships succeed when women submit to men (Hemingway's most fulfilled heroines—Catherine Barkley, for example—live for and through their men) and fail when women are in control. Feminist theory has proposed that male writers in this period depicted strong women negatively because they feared the erosion of patriarchal dominance.[3]

However, we cannot account for the prominence of the shrew stereotype in Renaissance England by tidy explanations of expanded female autonomy, for we simply do not have sufficient evidence that women as a group gained significant additional liberty. While earlier historians often assumed that women did experience enlarged freedoms,[4] more recent historians have emphasized developments after 1500 that curtailed women's independence. Pearl Hogrefe believes that, because of sweeping economic changes quite beyond any individual's control, fewer women worked in large or small businesses after 1500. Lawrence Stone cites Renaissance political and religious developments that tended to reinforce patriarchy: the analogy between the family and the state, now governed by a strong central monarchy; the Protestant doctrine that the head of the household—that is, the husband or father—was responsible for the religious and moral conduct of wife, children, and servants; and changes in property laws that accorded the head of the household greater freedom in the disposition of his property.[5]

The question whether the Renaissance Englishwoman had more or less autonomy than her predecessors is a complex and vexed one; we simply know too little about women's lives in the period to answer it definitively. Hilda Smith's statement about the paucity of our information about women's lives in the seventeenth century is equally true of women in the sixteenth century:

> Seventeenth-century women can still be seen only obliquely through fragments of information about a few women, statistical generalizations about women living in particular locales, and analogous materials from women living in similar conditions throughout early modern Europe. . . . Women's work was seldom recorded in guild records, their education in academic rolls, or their market and social gatherings in town or club minutes. We are only beginning to create a portrait of their lives through isolated remarks in contemporary letters and diaries, or the eulogistic information in funeral sermons on women, and to gain some sense of the more general characteristics of women's life cycle and life expectancy from demographic materials.[6]

Probably the soundest speculation as to the causes of the pervasive stereotype of the shrew in the English Renaissance will be based upon factual data, however fragmentary that data may be. Two of the pamphlets—*Hic Mulier* and *Haec Vir*—reveal that numbers of women were adopting elements of masculine dress in defiance of both custom and King James. Also, Englishwomen were defending their sex for the first time in print as well as publishing other kinds of nonreligious writings (e.g., tracts on motherhood and translations of romances). We know that the women in masculine dress were considered rebellious; in 1620 King James ordered his clergy to preach against their "insolence." Women authors may have been regarded as usurpers of the male prerogative to express feelings and ideas in public. The rebellious and assertive behavior of the small percentage of women who engaged in these activities may have created widespread concern among men about the possibility of a general female rebellion against male dominance. This concern could account for the explicit mocking of the figure of the shrew in Renaissance literature and culture; authors who mocked the shrew (including the misogynistic authors in this anthology) sought to maintain patriarchy by demonstrating to women that loud and aggressive behavior was unacceptable and communicating to men that they need not take the demands of such women seriously.

In fact these messages were communicated to men and women even more directly by the numerous conduct books that flowed steadily off the presses in the period, designed primarily for the literate *bourgeoisie*. In the middle-class household, according to Louis B. Wright: "the husband was recognized as the primary earner of wealth, while upon the wife devolved the duty of the thrifty utilization of the income for the comfort of her household. Therefore the wife became, acknowledged or unacknowledged, the factor determining the success of the individual home. If the wife were a railing shrew, a slattern, an extravagant, gossipy, or faithless creature, the domestic efficiency and happiness so earnestly desired by every worthy husband would be jeopardized."[7] While one may with justice question Wright's easy acceptance of the misogynist's categories of women, his description of the division of labor and responsibility between husband and wife, taken for granted by all the authors of English conduct books, is relevant to all of the negative stereotypes found in the pamphlets. In the second of Taylor's *Juniper* lectures a shrewish wife berates her husband for expecting her to tend his shop in addition to caring for their home and children while he spends his days in the alehouse with his friends: "Do you think I can sell your Wares or know the prices of them when your Customers come? Let them look to your shop that will, for I will not. . . . As soon as you were up and ready, then to the Alehouse to your companions, to some Game or other for your Morning's Draught of strong liquor, when I (poor wretch) must be at home with a cup of small Beer of four shillings price and be glad of it, too, or else I must drink water."

While the speaker appears to have some justification for her complaints, by the standards of the domestic conduct books she is nevertheless guilty of insubordination, for these books mandate silence as a virtue appropriate for women under almost all circumstances. Robert Cleaver (*A Godly Form of Household Government*, 1598) directs a woman to "stand in a reverend awe" of her husband, even if she has just cause for anger: "Yet she must bear it patiently and give him no uncomely or unkind words for it, but evermore look upon him with a loving and cheerful countenance; and so rather let her take the fault upon her than seem to be displeased."[8] Henry Smith in *A Preparative to Marriage* (1591) insists that "Husbands must hold their hands [abstain from wife-beating] and wives their tongues."[9]

Silence is urged upon the girl as well as the wife. In the *New Cate-*

chism, which provides rules of conduct for the maiden, the preacher Thomas Becon advises the young woman that she "be not full of tongue and of much babbling. . . . Except the gravity of some matter do require that she should speak or else an answer is to be made, . . . let her keep silence. For there is nothing that doth so much commend, advance, set forth, adorn, deck, trim, and garnish a maid as silence." [10] For both girl and wife, silence is recommended as a virtue in itself as well as a feature of the general requirements of modesty and obedience. The silent maiden cannot challenge her parents' orders; the silent wife is not likely to obtain mastery over her husband or flirt (at least verbally) with her neighbor's husband. From the pulpit and the printing press, Renaissance Englishwomen were enjoined to avoid contentious discourse and persuaded that silence enhanced their feminity. They were even subject to punishment by the Ecclesiastical Courts for shrewish behavior: in Oxfordshire in 1621 a woman named Barbara Jackson was brought before the court as "a common scold and sower of discord." [11]

While it is doubtful that all women were as consistently passive and silent as they were exhorted to be, clearly many women accepted silence as a feminine ideal, for even the female authors in our anthology, who exercised considerable daring in publishing their works, find it necessary to explain their departures from this ideal. Constantia Munda acknowledges silence as "our greatest ornament; but when necessity compels us, 'tis as great a fault and folly 'loquenda tacere, ut contra gravis est culpa tacenda loqui' [to keep silent about things which should be spoken, as on the other hand it is a serious fault to speak about things which should be kept silent]." Jane Anger claims that men have presumed too much upon "our honest bashfulness," yet she confesses her treatise a product of "rashness," betraying the same anxiety of being thought a shrew that Shakespeare's Paulina expresses in *The Winter's Tale* ("I have showed too much / The rashness of a woman" 3.2.218–19).

Even women publishing works far more conventional than polemical pamphlets felt constrained to provide elaborate explanations. Dorothy Leigh, author of a conduct book written for her sons (*The Mother's Blessing*, 1616), explains that she writes to fulfill the will of the boys' dead father that they be "well-instructed" in the duties of a Christian: "Wherefore, setting aside all fear, I have adventured to show my imperfections to the view of the world, not regarding what

censure for this shall be laid upon me, so that herein I may show myself a loving Mother and a dutiful wife."[12] Anger, Munda, Sowernam, and Tattlewell were defying the code of silence for women with a bolder kind of writing, one which challenged the pronouncements of men; it is hardly surprising that they used pseudonyms.

The stereotype of the seductress in our pamphlets is even more complex than that of the shrew, if only because Renaissance attitudes toward female sexuality in general differed from contemporary ones. The Renaissance viewed woman as possessed of a powerful, potentially disruptive sexuality requiring control through rigid social institutions and carefully nurtured inhibitions within the woman herself. Except for certain conservative writers, the Renaissance man and his female contemporary saw the sexuality of woman as morally acceptable so long as its expression was confined to the conventional form of sexual intercourse within marriage and no attempt was made to prevent pregnancy. Under these conditions, it was expected that a good woman would want and enjoy intercourse: we recall Shakespeare's Desdemona, urging the Venetian Senate to allow her to accompany Othello to Cypress in order that the marriage may be consummated: "If I be left behind, / A moth of peace, and he go to the war, / The rites for why I love him are bereft me" (1.3.250–52). We consider ourselves sexually liberated today, but few new brides would confess to sexual appetite before the English Parliament or the United States Senate.

If male and female sexual drives were accepted in the Renaissance, then what is the psychological origin of the stereotype of the seductress, and why did women evolve a parallel stereotype of the seducer? A partial answer probably lies in the fact of rather late marriage combined with strict prohibitions against premarital intercourse. The myth that Renaissance people married in their teens, fostered by Shakespeare's *Romeo and Juliet* and a few well-known aristocratic marriages that took place between teenagers, has been decisively shattered by recent historians who have culled extensive statistics from records of applications for marriage licenses. In Elizabethan and Jacobean England the average age of the bride was twenty-four; that of the groom was twenty-eight. (Among nobles the ages were slightly—not substantially—lower.) The reasons for the relatively late age of marriage were largely economic; a man could not afford to marry until he could establish his own household: a journeyman, for example, even after he

had completed his training in his early twenties, had to earn and save or inherit enough money to set up his own establishment, while a peasant needed enough land to support a family.[13]

Thus young people were forced either to defy the prohibitions of church, family, and employer and risk pregnancy or to repress their sexual desires until they could afford to marry. Psychology has demonstrated that to deny powerful feelings is often easier than to deal with them, and one of the most common ways of denying one's feelings is projecting them onto someone else. It seems likely that in seeing the opposite sex as lustful Renaissance men and women were dealing with their own unruly sexual feelings by projecting them onto each other.

The psychological mechanism of projection is doubtless one cause for the parallel stereotypes of the seductress and the seducer. There is another, more historical cause for the former stereotype, however. Conventional wisdom in Renaissance England conformed to the attitude (which can be traced as far back as classical Greece and Rome) that women, unlike men, had an inexhaustible capacity for sexual pleasure. The author of *Schoolhouse* claims that "a woman's watergate" is insatiable, and Swetnam maintains that because of their importunate sexual needs women cannot live without men. Stone attests that "the capacity of the female for multiple orgasms far exceeding the male ability to keep pace" was well known in the Renaissance and served as basis for the belief that women were readily and frequently sexually aroused. It was precisely because of the passionate nature of the female that preachers like Thomas Becon deemed it "requisite that all Godly maidens do refrain themselves from keeping company with light, vain, and wanton persons whose delight is in fleshly and filthy pastimes as singing, dancing, leaping, skipping, playing, kissing, whoring, etc."[14] Most people believed that a woman's strong sexuality could and would be controlled so long as she avoided occasions of temptation and led a life of piety and prayer. Misogynistic writers, however, exploited the belief in her strong sexual appetite, using this notion to blame her for all unsanctioned sexual behavior.

The defenders of women had to respond to the attackers' claim that women were universally lecherous, and they could not realistically do so by asserting that fornication and adultery simply did not exist. The line of defense that most feminist authors chose was counterattack: women who succumbed to sexual sin, they argued, were victims of the deceit and flattery of men, deceit practiced in the service of lust. Men,

Key to reading pamphlets

↓

women arguing their right to be seen as equal creatures.

Anger charged, are "nothing better than brute beasts." In exonerating their sex, the feminist pamphleteers not only set forth a stereotype of men as lecherous seducers; they also created an alternative stereotype of women as naturally, inherently chaste: "Our virginity makes us virtuous; . . . and our chastity maketh our trueness of love manifest" (Anger).

Of the actual sexual behavior of women in Renaissance England, it is safe to assume that women were neither as chaste as their defenders claimed nor as promiscuous as their attackers charged. A women's sexual behavior in the English Renaissance depended upon her social class, her family circumstances, and, of course, upon her individual personality and character.

Despite the fact that woman's sexual appetite was generally considered more immoderate than man's, in the middle and upper classes fornication and adultery were considered less reprehensible in men than in women. Juan Luis Vives in *The Instruction of a Christian Woman* stated that unchastity in a woman is "like in a man, if he lack all that he should have. For in a woman the honesty [chastity] is in stead of all."[15] The reasons for this vehement insistence upon female chastity in the upper social classes are well known. If a woman had lovers before she married or if she strayed from the marriage bed, the legitimacy of an heir to land, money, or title might be called into question. Furthermore, the wife's body was her husband's property; it was not legally hers to give to another. Since affection often failed to develop in the arranged marriages of the aristocracy and the upper middle class, the husband frequently formed liaisons with lower-class women and fathered bastards by them, while the wife was counseled by her parents and friends to ignore her husband's sexual adventures.[16]

In the middle of our period, however, around the turn of the century, Puritan preachers and conduct books began to challenge the double standard of sexual morality. At the same time some conduct books began to urge parents not to force their children into marriages arranged for money or land.[17] It is difficult to determine how much impact these sermons and domestic handbooks had upon male sexual conduct, but Stone notes that "bastards largely disappeared from aristocratic wills, and far greater discretion seems to have been exercised in the degree of public recognition afforded to a mistress."[18]

The double standard does not appear as a significant factor in the official punishments meted out for sexual offenses by the Ecclesiastical

Courts (persons presented to these courts were primarily from the middle and lower classes). Records from the church courts reveal that while English attitudes in the Renaissance toward pre- and extra-marital sexual experience were not as permissive as contemporary ones, neither were they as harsh as the obsession with female chastity (and unchastity) in our pamphlets might lead us to expect. The most common offense to be called to the attention of the courts was prenuptial fornication; the charge for this offense was ordinarily brought against a couple if a child was born within six months of the marriage ceremony. The penalty for prenuptial fornication usually consisted of a fine or open confession in a church. Unmarried couples appearing before the court on the charge of fornication were usually persuaded to marry; fornicators and adulterers were often directed to stand in the market place on market day wearing a white sheet.[19] While charges of fornication and adultery were often brought by neighbors (or, in cases of adultery, by the "injured party"), the records occasionally suggest voluntary confession:

> Chipping Barnet, Hertfordshire, 1606. The said Agnes Wright upon Sunday 28 of August at the beginning of the second lesson in Morning Prayer did present herself in the middle alley of the Church of Chipping Barnet, near the seat of the Minister, covered in white, and there like a penitent and sorrowful sinner stood till the end of the second lesson, at which time kneeling down upon her knees she confessed that she had grievously offended Almighty god in committing fornication with one Edward Fisher of London, praying to God to forgive her and the Congregation to pray for her.[20]

Because bastard children constituted a serious drain on the financial resources of the parish, the parents of bastards were more severely punished than fornicators or adulterers; often they were "stripped to the waist and whipped through the street at a cart's tail."[21] An unusual case of twin bastards attributed to different fathers is recorded in Rusper, Sussex, in 1621: "We present that Fortune West is delivered of two children; and she saith that Henry Smith now of Horsham and William Walter late of Rusper are fathers, and that they lay with her, one one night and the other the next night."[22] (The response of the court to this medical anomaly is not indicated.)

Statistics compiled by Peter Laslett indicate that during the period

1590–1640 in England the numbers of illegitimate children baptized varied from 3 to 7 percent of total baptisms, depending upon the town; the statistics do not differ radically from those compiled for England and Wales in 1955.[23]

While men and women convicted of fornication or adultery were officially punished equally by the law, the feminist pamphlets claim that the woman suffered more emotional shame and community disapproval. The "idea that female honor depended upon a reputation for premarital chastity and marital fidelity was one which was most effectively internalized in the middling ranks of society";[24] it is not surprising, therefore, that these pamphlets exalt chastity as woman's preeminent virtue. More women than men brought lawsuits for slander against the charge of unchastity in the church courts.[25] The husband's honor was also involved in such charges, since a cuckold suffered serious loss of dignity and prestige in his community. "No pain so fervent, hot nor cold, / As is a man to be called Cuckold," wrote the author of *Schoolhouse*, who testified that the rage of a man dubbed a cuckold is "worse than ye named him heretic." Both his sexual prowess and his mastery over his wife were impugned; he became the butt of jests and was considered unsuitable for public office.[26]

There seems to be no fully satisfactory explanation for the close identification of chastity with honor in the middle-class woman. Possibly it was considered a trait crucial to distinguish her from the lower-class woman; certainly middle-class men and women were more self-conscious about this distinction than the aristocracy, who could claim titles and land going back many generations. In any case, it is important to note that the chastity of the Renaissance woman, unlike that of the Victorian woman, was not attributed to a low level of sexual desire; rather it was seen as the product of conscious and virtuous self-control.

The stereotype of the vain woman in the treatises appears to have two distinct, if related, origins: first, it reflects the misogynist conviction that an attractive woman will be unchaste; and second, it reflects the anxiety of men (especially middle-class men) that their wives will jeopardize the fiscal health of their households through neglect of their domestic duties and through the purchase of expensive clothing.

The first of these concerns is explicitly articulated in several of the pamphlets in this anthology: the author of the *Schoolhouse* charges that women "in their glasses pore and pry, / Plait and plant, and their

hairs hue" with the sole purpose "to allure the masculine." The author of *Hic Mulier*, who was deeply perturbed about sexual immorality in women, objected in particular to "bared breasts seducing" and "the very Art of Painting, which to the last age shall ever be held in detestation." The conduct books of the period also warn women to avoid the use of cosmetics and clothing that leaves the breasts bare; many of them add "curled hair" to the list of abuses.[27] Vives's *The Instruction of a Christian Woman* enjoined the wife to "make thy soul gay with virtue, and he shall kiss thee for thy beauty." Vives did concede that a wife might adorn herself if her husband wished, but he regarded husbands as foolish to encourage costly dress and painting, since they served as temptations to other men and thus endangered marital fidelity.[28] Behind all of these directives lies a sense that a woman's strong sexual urges render her chastity a precarious virtue requiring constant protective vigilance.

In addition to jeopardizing female chastity, the satisfaction of vanity consumed both time and money and thus violated two of the chief themes of every conduct book published in our period: thrift and industry. Samuel Rowlands's *The Bride* (1617) lists avoiding extravagance as the third duty of a wife: "For many idle housewives, London knows, / Have by their pride been husbands' overthrows."[29] The thrifty and industrious traits recommended to wives are quite the opposite of those attributed to women by their attackers. Swetnam charges that women spend "the most part of the forenoon painting themselves and frizzling their hairs," and Taylor's proud wife threatens her husband, "If thou wilt not bestow a new-fashioned Hat on me, I'll bestow an old-fashioned Cap upon thee."

One reason that middle-class men in the period were pervasively concerned with women's vanity of dress was doubtless their fear that their wives and daughters would emulate the elaborate and costly dress of the noblewoman. The Elizabethan lady dressing for an outing wore above the waist a chemiselike smock beneath a corset stiffened with whalebone or wood stays called busks. Below the waist she began with a farthingale, a skirt stiffened with hoops of wire, wood, or whalebone; over the farthingale she wore a petticoat. Her outside dress or kirtle consisted of a separate bodice on top and a skirt on the bottom. An opening in the bodice was filled by a detachable stomacher; the triangular opening in the skirt was filled by an accessory called the forepart. As her final garment she put on a gown (perhaps of taffeta

with a velvet lining) open in front, hanging from the shoulders to the ground.[30]

Many middle-class women in London must have had occasion to observe the rich and colorful apparel of their social betters. We know that some did imitate this apparel, for the aristocratic woman speaker in *Hic Mulier* complains bitterly of the obliteration of class distinctions in dress. During Elizabeth's reign sumptuary laws were passed that forbade "persons who do not have land or fees over 200 on the subsidy books" to wear "leopard skin, velvet, silk nether-stockings, or gold, silver, or silk pricking." The most sumptuous fabrics of all—gold or silver cloth and sables—were prohibited to any woman lower than a countess. Clearly the laws were passed in an attempt to maintain visible class distinctions, but they must have been difficult to enforce. At least one visitor to London in the early seventeenth century did note a distinct difference in dress between gentlewomen and the wives of citizens, however. Fynes Moryson in *An Itinerary* (1617) reported that citizens' wives wore a belted gown gathered at the back and a skirt decorated with many borders, with an apron over the front. He observed that the headdresses of middle-class wives were similar to those of noblewomen (a linen coif topped with a small silk or beaver hat), but the practice of bared breasts was confined to gentlewomen. Young gentlewomen, he remarked, occasionally wore no headdress but a wig adorned with "buttons of gold, pearls, and flowers of silk or knots of ribbon."[31]

While the clothing of women in the family of a country freeholder was much simpler than that of aristocratic women, it could not be described as drab. Adam Martindale, a seventeenth-century minister from a yeoman family in south Lancashire, described in his diary the restrictions imposed upon the dress of his sister Jane:

> Freeholders' daughters were then confined to their felts, petticoats, and waistcoats, cross handkerchiefs about their necks and white cross-clothes upon their heads, with coifs under them wrought with black silk or worsted. 'Tis true the finest sort of them wore gold or silver lace upon their waistcoats, good silk laces (and store of them) about their petticoats, and bone laces or works about their linens; but the proudest of them below the gentry durst not have offered to wear an hood or a scarf (which now every beggar's brat that can get them thinks not above her) no, not so much as a gown till her wedding day.[32]

Despite the deprivation of the gown, Jane's best attire was colorful and even (by the standards of today) elaborate.

Unless they were strict Puritans, Elizabethan and Jacobean women enjoyed elegant clothing and accessories; but, as several of the defenders of women point out and any number of portraits of courtiers of the period attest, so did Elizabethan and Jacobean men. Possibly many middle-class women did stretch their household budgets to buy fashionable clothes, but for every merchant who disapproved of these expenditures there was doubtless another whose pride was gratified, for his wife's display served as highly visible evidence of his commercial success.

The negative stereotypes of women found in the pamphlets are more accurately seen as a reflection of the fears and frustrations of Renaissance Englishmen than as a description of the Englishwomen of the time. While a small number of women may have rebelled against their passive role, the stereotype of the shrew betrays the male fear that women in general (or their own wives or daughters in particular) may attain dominance within the family through verbal and behavioral aggressiveness. The stereotype of the seductress represents an attempt to project disruptive sexual feelings and the responsibility for sexual conduct onto women, while that of the vain woman reveals two fears—of sexual betrayal and of economic disaster.

The positive stereotypes of women found in the feminist pamphlets must also be seen primarily as aspirations and ideals rather than as descriptions of the lives of real women. The image of women as pure, chaste creatures occasionally seduced by lustful men was created as a defense against the image of the seductress and served a parallel purpose, to project the responsibility for sexual "sin" onto men. The view of women as closer to God than men is naive if not actually arrogant, but it, too, was partly defensive, for the feminist writers sought to refute the general misogynistic condemnation of women as evil. The corollary image of women as pious and devout, found especially in the eulogies, may be a partial truth, for religion was the one public sphere in which women were encouraged to play an active role (through almsgiving and attendance at church). Religion was also the one area in which all literate women could read and study widely without fear of reproach; they could even publish their devotions, confessions, or meditations (as numerous Englishwomen did) without anticipating the disapproval that led Anger, Munda, and Sowernam to use pseudo-

nyms. (In 1578, when Margaret Tyler published her translation of a Spanish romance, she pleaded with the reader in her preface, "But amongst my ill willers, some I hope are not so straight that they would enforce me necessarily either not to write or to write of divinity."[33]) While religion thus provided women with socially commendable modes of activity and self-expression, there is not sufficient evidence to conclude that their piety and religious devotion were either more intense or more genuine than that of men in the period.

The stereotype of the nurturing woman doubtless also represents a partial truth, for both men and women regarded the care of children, the preparation of meals, and the nursing of the ill as exclusively the woman's duty. Yet differences of individual character and social class determined the extent to which a woman fulfilled these duties. Many women purchased freedom from the task of breastfeeding their babies by hiring wet nurses, despite the higher rate of infant mortality among babies nursed by hired women.[34] Some women—as well as men—beat their children mercilessly, and we can guess that not all cared for their husbands in the manner urged upon them by domestic conduct books.[35] At the same time we have eloquent testimony of deeply devoted wives and mothers in writings of both men and women from the period. One of the most moving of these writings is the *Miscellanea* of Elizabeth Grymeston, published in 1604; those portions of the book offering guidance to her son, revealing both literary sophistication and profound affection, remind us of the emotional risk that a parent took in loving a child at the time, for the son to whom she wrote was the only remaining child of the nine she had borne.[36]

Clearly, there were many women in the Renaissance who internalized and sought to fulfill the ideals embodied in the positive images of women in our feminist pamphlets. As Cynthia Griffin Wolff has observed in her perceptive article on stereotypes of women in literature, "Nature often imitates art. When a society gives its sanction, even its praise, to stereotyped images of womanhood, the women who live in that society form their own self-images accordingly. A stereotype may become . . . an image of reality that even women seek to perpetuate."[37]

Eulogies and Condemnations

In the English Renaissance nature did indeed imitate art, for the popular stereotypes of women which were so pervasive in the polemical

pamphlets frequently influenced reports about actual persons and events as well. The readers who eagerly bought up the attacks and defenses looked to other pamphlets in the stationers' shops for "news" about the real world, and these pamphlets indicate that the stereotypes colored the perceptions and even affected the behavior of at least some men and women of the time. Most Renaissance reportorial pamphlets dealing with women were either eulogies of women who had recently died or accounts of the deeds of women who had been condemned and executed on various charges. They lack the objectivity for which modern news reports strive because they were intended to instruct and edify as much as to inform. Thus their attitudes toward women, like those found in the formal treatises, reflect the fears and ideals of the middle-class audience for whom they were written. Carefully read, these pamphlets also reveal glimpses of the effects of stereotyping upon the lives of their female subjects.

This anthology contains three eulogies and three condemnations which are representative of the popular reportorial pamphlets of the period. The eulogies all deal with women of the upper middle classes. *Monodia* is a eulogistic poem about Helen Branch, a draper's daughter who rose from the ranks of the wealthy mercantile class to marry a man who became Lord Mayor of London and was eventually knighted. In *A Pattern for Women*, Lucy Thornton, the wife of a member of the lowest rank of the gentry in Suffolk ("Roger Thornton, Esquire") is eulogized by her pastor. The subject of *The Honor of Virtue*, Elizabeth Crashaw, was "brought up as a Gentlewoman . . . like to be of great estate"; she married William Crashaw, a minister who at one time was preacher at the Inner Temple in London and whose son by a previous marriage, Richard Crashaw, became a prominent religious metaphysical poet. After Elizabeth died in childbirth, her husband published a summary of the sermon delivered at her funeral and a collection of elegies written by his friends.

These eulogies all present their subjects as models of womankind; Lucy Thornton's pamphlet is even entitled *A Pattern for Women*. The three women are praised for their roles in the domestic and religious spheres; the only public function they are allowed is almsgiving, which is really an extension of their nurturing role. The eulogies of men of similar wealth and position in the Renaissance show a much more active and public emphasis; for example, even the youthful Edward King, immortalized in Milton's pastoral elegy *Lycidas*, was lamented

as a loss to poetry, learning, and the church, although his twenty-five years of life had offered promise but little actual accomplishment.[38] In varying degrees, the women in these eulogies are presented primarily in terms of the stereotypes of "good women" advanced in the feminist defenses: as pure and chaste, as nurturing, and as especially pious and close to God.

The image of chastity is stressed least in the picture of Lucy Thornton, although she was obviously a faithful wife. We are told, however, that "she despised the ornaments of vanity, which other women so much delight in; her outward habit did show the inward lowliness and modesty of her mind." Helen Branch's early life is presented as a pattern for maids, for "so well she spent her virgin days / That Envy's self saw nothing to dispraise." Although chastity is not the primary source of her praise in this eulogy, the poem does demonstrate how important it was for a woman of her station to maintain her reputation for purity: when she was widowed for the second time after at least sixty years of marriage, it was still necessary for her to remain "sequestered from much conversation [society]" in order to "shield her life safe from all shot of slander."

It is Elizabeth Crashaw who is most thoroughly presented in the role of the pure and chaste woman. Her eulogies reverberate with scarcely disguised amazement that she did not fit the stereotype of the vain, lustful woman. She had all the qualifications—beauty, gentle birth, wealth, numerous "young gallants" as suitors—and when she chose to marry a minister "twice her own age," his parishioners immediately predicted that she would be his ruination ("it being the common conceit that by this marriage they had lost a good Preacher"). But Crashaw belied the misogynists' contention that a fair woman is necessarily unchaste. The funeral sermon speaks of "her extraordinary love and almost strange affection to her husband, . . . as is too rare to find in one of her age, person, and parts." Her husband mentions her "rare conjunction" of "Beauty with Chastity"; one of her elegists praises her for quenching the lustful fires "that boil in the veins of wanton Beauties." To everyone's surprise, she was not even vain, opting for "comeliness in attire" and rejecting "both youth and bravery's [finery's] golden Rays." Thus, primarily because of what she did *not* do, Elizabeth Crashaw is chracterized as "an honor of her Sex: blest virtue's pride, / True beauty's pattern, mighty nature's wonder."

Crashaw is also praised for her nurturing role. She is twice termed a

"Phoenix" because she gave up her own life to bear a child, and she is also commended for "her singular motherly affection to the child of her predecessor" and her care for her husband's health. Although Thornton is called "a mother by nature, a mother by grace," her nurturing role is shown primarily in "her love of almsdeeds, which she plentifully performed to the poor," seeing that the hungry were fed, the naked clothed, and the sick visited. Helen Branch, after losing four children and two husbands, turned her nurturing to "godly alms and liberal pensions," benefiting not only the poor, prisons, hospitals, asylums, and the drapers' guild, but also the universities of Cambridge and Oxford.

All three women also fit the positive stereotype of the pious woman who is especially close to God. Branch passed the last years of her life "in holy meditation / In thanks and prayer unto Christ our Lord." Crashaw combined "Godliness with Comeliness"; "religion was her soul's delight," and her piety encouraged her clergyman husband "to do more than ever he did," even beginning a special morning religious exercise for his parishioners. But the stereotype of the pious woman has its most interesting ramifications in the case of Lucy Thornton, whose religious zeal apparently bordered on fanaticism. She was always "seen with the forwardest about the Lord's Service." She studied the Scriptures thoroughly and frequently quoted from them; she was constantly admonishing and instructing others, "stoutly (even beyond the strength of her sex) opposing sin and maintaining virtue in those that were about her." When she fell seriously ill, "she lay in her sickbed as in heaven, full of heavenly speeches and heavenly comfort." Indeed, the description of her last days suggests a kind of will to die ("now she would wholly be settled to heaven"). Rejecting all suggestions of recovery and resisting all efforts to revive her, "her eyes being shut and teeth set," she finally attained her desire. Thornton's story reveals how a woman could embrace a positive stereotype such as that of the pious woman and use it as an acceptable outlet for her native aggression and domineering tendencies.

Thornton's eulogy also raises the question of sovereignty in marriage, opposing the ideal of the humble, submissive wife to the misogynists' stereotype of the shrew. In order for a Renaissance woman's portrayal to be positive, she had to be depicted as dutiful and obedient to men. Crashaw was "modest, humble, fair, discreet"; "from a child she never offended her parents." Branch spent at least sixty years as a de-

voted wife before becoming "her self's commander," but her independence was still constrained by the need to preserve a spotless reputation. John Mayer, Thornton's pastor, felt so strongly about the issue of sovereignty that in the midst of his eulogy he launched into a tirade against "unruly wives," going so far as to deny them the hope of salvation. Even in a eulogy Mayer was compelled to acknowledge Thornton's aggressive tendencies, but he insisted upon her achievement of humility and submissiveness: "She strove against the sharpness of her natural disposition, and by striving did attain a great measure of meekness and gentleness. . . . She was anointed with due subjection to her own husband."

Although these eulogies thus present "good" women in terms of the same stereotypes advanced in the feminist defenses, they describe their subjects as exceptional women, ideals to which other women should aspire but will rarely attain, while the defenses argue that such women represent the norm of womanhood. The condemnations, however, tend to deal with their subjects in a manner similar to the misogynistic treatises, as representative of the general nature and tendencies of womankind. *The Arraignment and burning of Margaret Ferneseede* tells the story of a London bawd who was executed for the murder of her shopkeeper husband; *A pitiless Mother* describes how Margaret Vincent, a "gentlewoman" living in a town outside of London, murdered two of her small children to save their souls, since she had converted to Catholicism but they were being raised as Protestants. *The Wonderful Discovery of the Witchcrafts of Margaret and Philippa Flower* relates how three poor rural women, Joan Flower and her two grown daughters, were convicted of tormenting an earl and his family through witchcraft. Although the crimes for which these women were executed may seem exceptional to us, the pamphlets portray the women as representative examples of feminine frailty and depravity. This is most clearly seen in *A pitiless Mother*, which states that Vincent's story "may well serve for a clear looking Glass to see a woman's weakness in: how soon and apt she is won into wickedness, not only to the body's overthrow but [also to] the soul's danger." Explicitly or implicitly, therefore, these condemnations support misogynistic attitudes toward women in general. They not only present their subjects in terms of the negative feminine stereotypes found in the formal attacks on women, but they also treat them as the mirror opposites of the positive stereotypes. (Only the negative stereotype of the vain, idle,

spendthrift woman is missing in these condemnations, and that may be because these particular pamphlets deal with women of relatively low social class, position, and wealth; even Vincent, who is termed a gentlewoman, has but a single servant.)

Just as all the women in the eulogies accept the principle of male dominance, so all of the condemned women flout masculine sovereignty in some way. Joan Flower and her daughters were not under the control of any man since all were unmarried, and they refused to acknowledge even the earl's right to rule their lives. They agreed to serve the devil so that they might "easily command what they pleased" and wield "artificial power to do what mischief they listed [wished]." Although Margaret Vincent killed her children out of religious fanaticism, the struggle for supremacy in her marriage was clearly an important underlying motive. In her youth she fit the stereotype of the submissive woman, "being discreet, civil, and of a modest conversation," but the pamphlet characterizes her later behavior by words such as "obstinate," "stubborn," and "willful." After her conversion to Catholicism, she attempted to persuade her husband to the same beliefs, but he accounted her "undutiful to make so fond [foolish] an attempt, many times snubbing her with some few unkind speeches which bred in her heart a purpose of more extremity." Indeed, Margaret's own words indicate that her husband's refusal to listen to her strongly influenced her decision to kill her children: "Oh Jarvis, this had never been done if thou hadst been ruled and by me converted." When the author of the pamphlet compares her to "a fierce and bloody Medea," he is confirming this position, for Medea killed her sons in order to exact vengeance upon her husband. Finally, Margaret Ferneseede is accused of the ultimate challenge to masculine sovereignty, the murder of her husband. Even her manner of execution is an affirmation of the principle of male supremacy, for she was burned at the stake for the "treason" of killing her husband, while a man who had killed his wife would have been simply hanged for murder.[39]

The stereotype of the willful, scolding, domineering shrew is thus prominent in all of the condemnations in this anthology, but it appears most fully in the characterization of Margaret Ferneseede. According to her servant, she had lived with her husband "in all disquietude, rage, and distemperature"; her husband himself called her "a devilish woman" who barred him of his rightful "possession and command" of the house at Irongate (although she had apparently purchased this

house with her own money earned from prostitution, upon her marriage to Anthony Ferneseede it would have legally become his property). Furthermore, the author of the pamphlet describes her "hardened heart" which could show no grief at the death of her husband. A shrew to the end, "thinking to outface truth with boldness and sin with impudence," she made even her fellow prisoners miserable with her continual swearing and scolding. Although the author relates her "great show of repentance for her life past," he presents the fact that she still "obstinately denied" the murder of her husband as but further evidence of her inveterate willfulness.

Ferneseede also fits the stereotype of the unchaste and sexually insatiable woman. Not caring "into what bed of lust her lascivious body was transported," she consumed her youth in "more than bestial" prostitution, until age and a dwindling number of customers turned her into a bawd, running "a most abominable and vile brothel house, poisoning many young women with that sin wherewith her own body long before was filthily debauched." According to the testimony of her servant boy, "she had ever since her marriage in most public and notorious manner maintained a young man with whom (in his view) she had often committed adultery." Indeed, her sexual behavior is an important part of the evidence used to convict her of her husband's murder.

This stereotype of the lustful woman also figures significantly in the story of the Flowers, for the author of the pamphlet links their sexual activity and imaginings with their guilt as witches. He relates that Joan Flower filled her house with "debauched and base company," while Philippa was a lustful seductress with a "bewitching" hold on her victim, Thomas Simpson, who "had no power to leave her and was, as he supposed, marvellously altered both in mind and body since her acquainted company." Moreover, the "indecencies" which prompted the countess to dismiss Margaret Flower from the castle with forty shillings severance pay may well have been sexual.[40] There are also unmistakable sexual elements in the imagery describing the women's pact with the devil ("which filthy conditions were ratified with abominable kisses") and relationship with their familiars (Margaret confessed that she had spirits sucking "under her left breast" and "within the inward parts of her secrets").

Just as the stereotype of the lustful female counters the positive image of the pure and chaste woman, and the shrew that of the sub-

missive and compliant woman, so the subjects of these condemnations are also portrayed in terms which reverse the picture of woman as nurturing, pious, and especially close to God. Ferneseede apparently had no children, and instead of nurturing her husband she allegedly attempted to poison his broth. The Flowers were accused of tormenting and killing the earl's children and rendering him and his wife sterile. Vincent, however, was the most shocking violator of the nurturing image, as she "purposed to become a Tigerous mother and so wolfishly to commit the murder of her own flesh and blood," actually strangling two of her own children.

Finally, the stories in these condemnations reverse the positive religious image of woman advanced in the feminist defenses. Ferneseede was obviously not a pious woman, and the Flowers' lack of proper religion was one of the elements that led their neighbors to suspect them as witches, for Joan was "full of oaths, curses, and imprecations irreligious and, for anything they saw by her, a plain Atheist." Instead of being especially close to God, the Flowers are presented as especially close to the devil, and their initiation as witches is described as a parody of a religious ceremony. Margaret Vincent presents an especially dramatic mirror reversal of the positive religious image of woman. The description of her early religious involvement sounds remarkably similar to that of Lucy Thornton: "The Gentlewoman, being witty and of a Ripe understanding, desired much conference in religion and, being careful (as it seemed) of her soul's happiness, many times resorted to Divines [clergymen] to have instructions to salvation." Like Thornton, Vincent grew fanatical in her religious beliefs and practice. Thornton's convictions, however, remained within acceptable Protestant boundaries, while Vincent converted to Catholicism, "a blind belief of bewitching heresy." Thus, although one can sense a certain uneasiness in Mayer's eulogy of Thornton, her portrayal remains positive, while Vincent's becomes negative and is presented as evidence that excessive piety and religious study are dangerous for women because of their inherent mental and moral weakness, "for they [Catholics] have such charming persuasions that hardly the female kind can escape their enticements, of which weak sex they continually make prize of and by them lay plots to ensnare others, as they did by this deceived Gentlewoman."

In conclusion, then, we can see how these reportorial pamphlets reinforced the negative (and, to a lesser extent, the positive) images of

women found in the formal treatises. However, even though the stereotypes in these eulogies and condemnations are so pervasive that we can barely see the individual outlines of the real women who were their subjects, a between-the-lines scrutiny does offer occasional glimpses of the stereotypes' effect on these women's lives. For example, despite her wealth and position, Helen Branch's life was channeled within the narrow boundaries of acceptable feminine behavior and constantly limited by the need to maintain her reputation for purity. The amazement which echoes through the eulogies of Elizabeth Crashaw suggests that she must have had to prove her virtue and discretion continually to everyone because she appeared to be so well fitted for the stereotype of the vain and wanton beauty. And Lucy Thornton apparently made herself repeatedly ill in her efforts to suppress her natural aggressiveness and conform to the image of the humble and submissive woman: "She was not a little troubled for her frailties and falls, being always glad when the Lord took the matter into his own hands by chastizing her with sickness." In fact, one feels that if her religion had not given her domineering tendencies some outlet, she might have lost her mental balance.

Margaret Vincent was not so fortunate, since her religious fanaticism took a course that was not acceptable to her husband or to society. Thus it appears that her thwarted religious aspirations and the covert struggle for sovereignty within her marriage finally destroyed her mental stability and drove her to kill her children. The Flowers were victimized by the association of the stereotypes of the shrewish and unchaste woman with the popular image of the witch, for it was their unruly behavior and sexual activity that first led their neighbors to suspect them of witchcraft. Finally, Margaret Ferneseede's steadfast denial of complicity in her husband's death (even at the moment of execution, when she had absolutely nothing to gain by such a denial) is taken by the author of her pamphlet as one more example of her shrewish nature rather than as a possible indication of her innocence of the charge. Because she fit the stereotype of the unchaste, scolding woman so well, she was immediately believed to be a murderess. Although the kind of circumstantial evidence which convicted her was considered appropriate legal proof at the time, her story, like the others in this anthology, demonstrates the pervasiveness of these feminine stereotypes in Renaissance England and gives an indication of their power to influence the lives of real women.

71

Women and Marriage

The misogynistic pamphlets in this anthology attack woman for deceiving, harassing, and bankrupting her husband; the feminist pamphlets depict woman as nurturing, aiding, and faithfully loving her husband: in both cases the woman is a wife. With the exception of the *Witchcrafts of Margaret and Philippa Flower*, each of the eulogies and condemnations has a married woman as its subject; moreover, to a large extent each defines the woman's virtue or vice in terms of her marital relationship. In the English Renaissance the assumption that a woman would marry was so universal that it was seldom explicitly articulated. A document which does express this assumption is *The Law's Resolution of Women's Rights* (1632); its anonymous author wrote of women, "All of them are understood either married or to be married; . . . the Common Law here shaketh hand with Divinity."[41] Because marriage was presumed to be the only vocation for a woman, in looking for connections between the pamphlets and the lives of real women we must examine the institution of marriage.

When England broke with the Church of Rome during the reign of Henry VIII, celibacy and virginity lost much of their force as ideals, and marriage was accorded greater status and dignity. Changes in political and social life at this time conspired to focus attention on marriage as not simply an inferior alternative to celibacy, but rather as a religious state ordained by God to provide companionship to men and women and to supply the commonwealth with a new generation of good citizens and good Christians.[42] Lawrence Stone, writing of the Reformation in England, asserts that "the married state now became the ethical norm for the virtuous Christian."[43] Throughout the late sixteenth and early seventeenth centuries both Puritan and Anglican sermons and theology stressed the sanctity of marriage, as did the numerous treatises on marriage and the family published in our period. While both sermons and treatises viewed the purposes of marriage as the containment of sexual drives and the begetting of children, they also stressed the need for harmony and mutual tolerance. Most clergymen presented the ideal marriage as a "high, holy, and blessed state of mutual understanding and comradeship."[44]

If marriage was an ethical norm, it was also an economic imperative for most people. Among the aristocracy marriage was a way of consol-

idating land and wealth. It was even more crucial economically for the middle and lower classes, as Lawrence Stone testifies:

> Among artisans, shopkeepers, smallholders, and unskilled labor-ers . . . husband, wife and children tended to form a single eco-nomic unit, like the crew of a ship, in which the role of the wife was critical. When the husband was away, she looked after his af-fairs for him. On a smallholding, she . . . managed the dairy and poultry side of the business, and marketed the produce. If there was cottage industry, she was in charge of spinning the yarn, knit-ting, glove-stitching and lace-making.[45]

Writing of the family of an actual independent London baker in 1619, Peter Laslett affirms that "economic organization was domestic orga-nization" and describes the essential duties of the wife, who not only managed the household but also served as a surrogate mother to the two female servants and two male apprentices to the baker, all of whom lived and worked as integral parts of a single family.[46]

The shop of a merchant or craftsman was ordinarily part of or adja-cent to his home; this arrangement is clearly assumed in Taylor's sec-ond *Juniper* lecture, in which the wife is indignant because her hus-band expects her to wait on his customers in addition to preparing his meals and caring for their children. While the wealthiest of London's merchants in this period may have had the means to do without the labor of a wife, the majority of middle- and lower-class men through-out England needed a wife to make their economic enterprises viable. "No single man . . . would usually take charge of the land, any more than a single man would often be found at the head of a workshop in the city." In the economic society of the English Renaissance, "mar-riage . . . was the entry to full membership."[47]

It is significant that most of the treatises in this anthology assume that the choice of a marriage partner belongs to the individual and not his or her parents or influential family members. In *Schoolhouse* the young woman being tutored by the old gossip wishes that she had lis-tened to her friends' advice before marrying, but Swetnam speaks out strongly against arranged marriages, and in *A Juniper Lecture* we read of only one arranged marriage, that of a young woman to Oliver Littlegood. (That particular lecture may be seen as a parody of ar-ranged marriages because, while the girl's father wants her to marry

Littlegood because of his wealth, her mother urges the marriage be-
cause he is a fool who may be easily duped and manipulated.) The
prevalent assumption of the pamphlets that people make their own
marriages is evidence of both their predominantly middle-class audi-
ence (among the nobility it was still customary for parents to arrange
marriages) and of the increasing social and religious support for free-
dom of choice. Stone affirms that Tudor Protestants opposed "the
strongly commercial attitude to marriage which had been prevalent in
the late middle ages and the early sixteenth century, in which bride
and groom had been bartered by their parents without their consent."[48]

Many of the pamphlets warn men and women to exercise care and
caution in selecting a mate, since their choice will be binding until
death. In the English Renaissance divorce as we understand it—as the
legal right to remarry—did not exist. (When Renaissance writers be-
fore Milton use the term *divorce* they are referring to the action or
status that we would call legal separation.) A marriage could be dis-
solved only through annulment, and the English ecclesiastical laws
made annulment, as well as legal separation, very difficult for either
party. The beautiful Penelope Devereux, sister of the earl of Essex and
the inspiration for Sir Philip Sidney's Stella, was married by arrange-
ment to Lord Rich in 1581. By 1589 she was the mistress of Sir Charles
Blount; in 1605, after she had borne Blount several children, she was
granted a decree of divorce from Rich. Although the decree did not
carry the right of remarriage, William Laud performed a marriage
ceremony for Penelope and Blount in the same year. Since the cere-
mony violated canon law, it did not legitimize Blount's children, and
Laud regretted his action for the rest of his life. The marriage was re-
garded as bigamous, and Penelope was no longer received at court.[49] In
the reign of James I, Lady Frances Howard, despite the substantial in-
fluence of her family at court, had to endure a lengthy trial in which
she claimed virginity and the earl to whom she had been married as a
child conceded impotence before their marriage was annuled.[50]

If ending a marriage was so difficult for the nobility, for the middle-
class person it was well-nigh impossible. In fact, the ecclesiastical
courts expended as much effort to reconcile and reprimand married
persons living apart as they expended to punish adulterers. ("Sussex,
1623. We present John Cocke and his wife for living apart one from
another."[51]) While the courts attempted to promote marital harmony
by resolving the problems that led to separation, they refused to legiti-

mize separation even when it was not the product of marital discord—as, for example, in the case of an elderly couple whose children by previous marriages could not get along.[52] In a society in which marriage was regarded as an irreversible religious and legal bond, it is little wonder that both misogynists and defenders compared the unhappy marriage to the torments of hell.

Despite the rarity of annulment or legal separation, the duration of the average marriage in Renaissance England was short, for the majority of marriages were interrupted by the early death of either husband or wife. Available evidence suggests that the median duration of a first marriage in England in 1600 was twenty-two years. Many widows and widowers remarried; in about one-fourth of all marriages performed in England in our period either the bride or the groom had been married before.[53] These facts explain why many of the misogynistic pamphlets address the question whether to marry a widow: Swetnam strenuously advised men not to marry a widow, for "if she be rich she will look to govern, and if she be poor, then art thou plagued both with beggary and bondage." Swetnam also argued that a widow would constantly compare her live husband unfavorably with her dead one, and Taylor's newly married widow does just that: "Thou art a very sloven and a nasty beast to him and art not worthy to carry guts to a Bear." In response to Swetnam's contention that "a widow she is framed to the conditions of another man and can hardly be altered," Sowernam concludes logically that any undesirable behavior in a widow must therefore be the fault of her first husband.

Conduct books published for widows in the period show an almost obsessive concern for the chastity and decorum of their behavior. Either implicitly or explicitly, they contend that a young widow is more prone to sexual license than an unmarried girl (the contention is apparently based upon the assumption that, having had sexual experience, she will be too weak to resist fleshly temptations). Thomas Becon advises remarriage as the only course that enables a young widow to avoid unchastity, "for how light, vain, trifling, unhonest, unhousewife-like, young widows have been in all ages and are also at this present day experience doth sufficiently declare."[54] Earlier Catholic writers were less in favor of remarriage than later Protestant ones: in the seven chapters devoted to the widow in *The Instruction of a Christian Woman* Juan Luis Vives recommends that she bury all joy and pleasure with her husband, living a cloistered life in which her chief concern is

to conduct her household and raise her children precisely as her husband would have wished.[55] This ideal is reflected in the examples provided in *The women's sharp revenge* of widows who lived their entire lives in chaste fidelity to the memories of their husbands.

In practice, the widow had more freedom and autonomy than either the married woman or the unmarried girl; she controlled her own financial affairs and was accountable for her behavior to neither husband nor parents. It is probable that a large percentage of middle-class women who conducted their own businesses in this period were widows who acquired the necessary knowledge and skills during their husbands' lifetimes. A woman married to a member of a guild retained certain rights after his death; the widow of a printer, for example, was likely to continue the business, for the license to print, granted to only twenty-two firms, passed automatically to her (and to her second husband, should she remarry). Records of the Stationers' Company reveal that many books in the period were printed by Elizabeth Alde and by the widow of R. Wolfe, and "the statutes of the Carpenters' Company for November 10, 1607, clearly indicate that widows could retain the husband's apprentices upon his death."[56]

The final *Juniper* lecture, delivered by Mistress Littlegood, an old woman who had buried four husbands before she was forty, may be seen as a parody of advice to widows in the conduct books. Instead of avoiding all public affairs, as the widow was enjoined to do, Mistress Littlegood reports that "at the fortnight's end of my second Widowhood, to drive away grief I would sometimes see a Play and hear a Bearbaiting." Instead of speaking of her deceased husbands with reverence, she pays them dubious compliments: her second husband, she attests, was "worth his weight in burnt Silk," while her third "did as much good here whilst he lived and was as necessary a member as the fifth Wheel in a Coach." Having vowed never to remarry, she confides to her friends, "I have not been troubled these thirty-two years with so grievous a burden as a Husband."[57]

The occasion of Mistress Littlegood's lecture, a social gathering at her home where her friends came to eat, drink, and gossip about their neighbors and husbands, is similar to gatherings described in *The Schoolhouse of women*, whose author complains of wives' chronic laziness:

> "Come in, good gossip, and keep me chat;
> I trust it shall do me great ease."

Complain of many a sundry disease;
"A gossip's cup between us twain"
Till she be gotten up again.

While no servants appear in Taylor's lecture, Mistress Littlegood, whose husbands had been craftsmen, appears to have sufficient means to live comfortably; the gossips in *Schoolhouse* were probably middle-class, for they have servants who bring refreshments to their guests.

The misogynist treatises' depiction of wives as constant gadabouts raises the question whether middle-class women in this period had a social life independent of their husbands. Many conduct books urged marrried women to stay at home in order to preserve their reputations and avoid temptations to sin. Samuel Rowlands's *The Bride* advises the wife to "be no gadding gossip up and down / To hear and carry tales amongst the rest / That are the news reporters of the town."[58] Robert Burton cites the maxim that a woman should leave her home only three times in her life—to be baptized, to be married, and to be buried—but he concedes this rule is perhaps too strict.[59] Accounts of Continental visitors to England in the period suggest that the married Englishwoman had more freedom than her counterpart in other countries; the Dutchman van Miteren writes:

Although the women there are entirely in the power of their husbands except for their lives, yet they are not kept so strictly as they are in Spain or elsewhere. Nor are they shut up, but they have the free management of the house. . . . They go to market to buy what they like to eat. They are well dressed, fond of taking it easy, and commonly leave the care of household matters and drudgery to their servants. . . . All the rest of their time they employ in walking or riding, in playing at cards and otherwise, in visiting their friends and keeping company, . . . and all this with the permission and knowledge of their husbands.[60]

It may be that the wife's leisure, like her clothes, was becoming a status symbol in which upper middle-class men could take pride.

Van Miteren's remarks on the activities of married Englishwomen begin with the assertion that "the women there are entirely in the power of their husbands except for their lives." All of the domestic conduct books published in England in our period, even those most sympathetic to women, assert the authority of the husband over the wife. Some writers derive this authority from the accounts of the crea-

tion and fall in Genesis; others derive it from the intellectual, moral, and physical superiority of men.[61] The well-known preacher William Whately, author of *A Bride-Bush; or, a direction for married persons* (1619), cites both reasons for the husband's sovereignty when he admonishes women, "If ever thou purpose to be a good wife, and to live comfortably, set down this with thyself: mine husband is my superior, my better; he hath authority and rule over me; nature hath given it to him . . . God hath given it to him."[62] *The Homily on Marriage*, which the Crown required to be read in church from 1562 onwards, stressed the natural inferiority of women: "The woman is a weak creature not endued with like strength and constancy of mind; therefore, they be the sooner disquieted, and they be the more prone to all weak affections and dispositions of mind, more than men be; and lighter they be, and more vain in their fantasies and opinions."[63] Like the conduct books, the *Homily* left no doubt that the wife owed her husband unquestioning submission and obedience.

As we pointed out in chapter 1, the feminist pamphlets in this anthology deal with the issue of male sovereignty in several different ways. What we may note here is that the women who published defenses were challenging the notion of women's mental inferiority by their very act of writing. So insistent were many sermons and conduct books on the subordination and fundamental inferiority of women that our feminist pamphlets may have been written partly in response to them as well as to the formal treatises attacking women. Even John Taylor may have found at least one conduct book insufferably pompous: Reverend William Gouge in the popular *Of Domestical Duties* announced it unseemly for wives to address their husbands by their Christian names and unthinkable for them to employ such base terms as *Grub* or *Rogue;* he recommends the simple title *Husband* as most appropriate.[64] In his lectures Taylor is careful to have wives use the mode of address recommended by Gouge (except, of course, when in anger they address their husbands as "you drunken sot, you piss-pot").

The sovereignty of the husband did not imply that the wife had no autonomy; it meant that she had only the degree of autonomy that he saw fit to give her. Most of the domestic conduct books advise granting the wife considerable freedom in managing the household; for example, *Of Domestical Duties* maintains that, while the husband is official head of the household, "he ought to make her a joint Governor of the Family with himself."[65] Even Swetnam admits that "the rule and

government of the house belongeth to the wife" and mocks husbands who "will set hens abroad, season the pot, and dress the meat." While the husband's authority was not appropriately exercised in daily household matters, it was supreme in economic, moral, and religious ones; Lawrence Stone believes that the Reformation strengthened patriarchy within the family by assigning to the husband the role of spiritual leader and counselor which had belonged to the parish priest under Catholicism.[66]

The moral and spiritual subordination of the wife was institutionalized in the laws of Tudor and Stuart England. While domestic handbooks differed on the advisability of wife beating (Swetnam first advocated, then opposed wife beating in the *Arraignment*), the practice was sanctioned by law. The author of *The Law's Resolution of Women's Rights* attests that a man may beat "an outlaw, a traitor, a Pagan, his villein, or his wife because by the Law Common these persons can have no action," but then cautions that "he shall neither do nor procure to be done to her . . . any bodily damage, otherwise than appertains to the office of a husband for lawful and reasonable correction." Regarding property ownership, the same document states baldly, "That which the husband hath is his own" and "That which the wife hath is the husband's."[67] Lawrence Stone stresses the limitations upon the wife's property rights:

> At this time a woman's legal right to hold and dispose of her own property was limited to what she could specifically lay claim to in a marriage contract. By marriage, the husband and wife became one person in law—and that person was the husband. He acquired absolute control of all his wife's personal property, which he could sell at will. By a judicial interpretation, a husband's debts became by law a prior charge on his wife's jewels and other personal property, although it is fair to add that the husband also became responsible for his wife's debts.[68]

In practice, some married women did hold and manage property, often through the marriage contracts of which Stone speaks. Bess of Hardwick, who at the age of seven had only forty marks as a marriage portion, was four times married and four times widowed; each time, either through jointure (property settled upon the bride before the marriage by the bridegroom's family) or through the provisions of her husband's will, she acquired more property. When her fourth husband

died she was the wealthy countess of Shrewsbury, owner of manors and richly furnished castles.[69] Bess, however, was unusually shrewd, aggressive, and (in the material sphere) fortunate.

While both the laws and the moral and religious dogmas of Renaissance England insisted upon the subordination of the wife to her husband, there were certainly different patterns of authority and dominance in actual practice. Although the records of church courts reveal many cases of husbands who abused their authority by severely beating their wives, they also describe cases of husbands who claimed that their wives repeatedly disobeyed them or even threatened them with violence.[70] Stone cites the many ways in which a wife might attain dominance: "Their monopoly of certain work responsibilities, their capacity to give or withhold sexual favors, their control over the children, their ability to scold, all gave them useful potential levers of power within the home."[71] Stone here describes, although in a more neutral and objective fashion, the same routes to power that the misogynists complained of bitterly. While these modes of achieving power involve manipulation or bullying, the society that decreed female submission gave no other alternatives to the woman married to an insensitive or overbearing husband.

There were also marriages characterized by mutual trust and generosity, marriages in which dominance was not a critical issue. Even allowing for the exaggeration common to eulogies, one guesses that the marriage of William and Elizabeth Crashaw conformed to such a pattern. She married him for love; she helped him serve his congregation; and his grief upon her death seems genuine. The marriage of Mildred Cooke and William Cecil, while historians do not agree upon its "happiness," is striking for the degree to which husband and wife supported each other and shared common goals. A classical scholar, Mildred taught her husband's sons by his first marriage and never resented the fact that his son by his first wife rather than her son Robert inherited as the elder son. As her husband rose to great political power under Elizabeth, Mildred gave him the benefit of her astute insights into the character of the monarch and her considerable talents as hostess, which included the ability to speak fluently in Latin with his diplomatic visitors from the Continent. Despite the early deaths of most of her own children, she accepted into her household numerous wards, usually very young men whose parents hoped for her husband's political patronage. The queen visited them frequently and often stayed for

long periods.[72] One suspects that such a woman behaved toward her husband much like Shakespeare's Portia in the *Merchant of Venice*. Upon becoming engaged to Bassanio, the wealthy and accomplished Portia tells him that she has committed her gentle spirit to his "to be directed / As from her lord, her governor, her king" (3.2.164–65). Shortly after their engagement she takes the initiative to travel to Venice disguised as a lawyer in order to extricate Antonio from his life-threatening bond to Shylock. She does not ask Bassanio's permission to go, and he does not reprove her when he learns what she has done. Probably more than one Renaissance wife who signed her letters to her husband "your obedient servant" saw no reason to rebel against the outward forms of submission so long as her freedom of action was intact and her real relationship with her spouse was one of mutual tolerance, affection, and respect.

Women and Education

To understand why educational opportunities for girls and women in our period were vastly inferior to those for boys and men, we must briefly consider the Renaissance philosophy of the purposes of education. The Catholic humanist Juan Luis Vives, who profoundly influenced prevailing ideas of women's education between 1540 and 1600, defined the desired liberal arts as "those which are necessary for the aims of either this or the eternal life," those which "will either advance piety or be of service to . . . the uses of life."[73] This dual formulation of the goals of education—to make one a more virtuous Christian and to prepare one for his roles in life—is also found in the writings of the Puritan humanist John Milton at the end of our period. In a famous passage from his essay "Of Education," Milton describes the first aim of education: "The end then of learning is to repair the ruins of our first parents by regaining to know God aright, and out of that knowledge to love him, to imitate him, to be like him, as we may the nearest by possessing our souls of true virtue, which being united to the heavenly grace of faith makes up the highest perfection." If the first goal of education is to "know God aright," the second, equally stressed by Milton, is readiness for the active life on this earth: "I call therefore a complete and generous education that which fits a man to perform justly, skillfully, and magnanimously all the offices, both private and public, of peace and war."[74] The second function of education is pre-

paring a man for his role in society—as clergyman, lawyer, statesman, or soldier in the service of the state.

A woman, however, did not enter a profession or (except in rare cases) play a significant public role in society; an education designed to prepare her for her role in life, therefore, had to be oriented toward the private and domestic spheres. The education of an aristocratic woman should further her social graces, including singing and probably playing a musical instrument, while the education of a middle-class woman should make her a competent wife and mother, able to cook, preserve, spin, sew, and supervise servants. Only the first goal of education—advancing Christian piety and virtue—could be invoked to justify the liberal education of women; yet this goal could also be used to limit that education, by determining that any subjects which did not contribute to religious virtue had no place in a woman's program of study.

Women were not admitted to the universities, whose function was to prepare men to be clergymen or statesmen; nor were they admitted to the vast majority of the schools which prepared boys for entrance to a university. Early humanist treatises which addressed the topic of education for girls assumed that they would be educated at home by tutors, and that their education would be confined to those authors and works fostering the Christian virtues, especially those essential for a woman, piety and chastity. By far the most influential treatises on women's education were three written by Vives, *Instruction of a Christian Woman* (1523), *Plan of Studies for a Girl* (1524), and *Duty of Husbands* (1529). Vives, a Spanish scholar who had studied under Erasmus, was brought to Henry VIII's court to direct the studies of the Princess Mary at the urging of her mother, Queen Catharine of Aragon. Richard Hyrde, tutor to the children of Thomas More, translated Vives's two earliest treatises from Latin into English and published them in 1540. By 1600 the treatises had appeared in five English editions as well as thirty-five editions in other languages.[75]

Depending upon the passage cited, Vives's views seem either liberal or conservative. By far the greater portion of *Instruction of a Christian Woman* is devoted to instructing the woman in conduct appropriate to her role as wife or widow; chastity and obedience are stressed throughout the work. Even a princess, he felt, should learn to weave in flax and wool, "two crafts yet left of that old innocent world, both profitable and keepers of temperance."[76] His specific ideas of the books

that a woman should and should not read are found in two chapters in the *Instruction* and some briefer sections of the *Duty*. He recommends the moral philosophers for their efficacy in subduing women's tumultuous passions; for this purpose, a woman should read Plato, Cicero, Seneca, Plutarch, and Aristotle. She should read the Bible and the church fathers, and, if she likes poetry, Christian poets such as Prudentius and Ararus. While not entirely comfortable with rhetoric, Vives will allow it to be part of a woman's study, since Quintilian and Jerome praised certain Roman women for eloquence. Since women will neither govern nor teach, they have no need of history, grammar, or logic—subjects which are important for men. Under no circumstances should a woman be allowed to read romances, for they deal with illicit love and impossible feats of arms; the Greek and Latin love poets must also be prohibited, for they would only stir up beastly lust. (In fact, Vives would banish romances and love poets from a man's education as well.) The criterion for selecting books for women is determined by the goal of their education: "the study of wisdom, which doth instruct their manners and inform their living, and teacheth them the way of good and holy life."[77]

While Vives's curriculum for women is hardly generous by our standards, he had a liberalizing influence in England for two reasons: first, he took the education of women seriously; second, he believed that women could and should learn Latin and Greek, since a carefully monitored classical education would work together with Christian teachings to develop a virtuous character.

Thomas More, Vives's contemporary at the English court, inspired in his European travels by the famous learned women of Italy, decided that his three daughters would receive the same classical education as his son. While admiring Vives's ideas, he went even further in the program of study that he established in his home. His daughter Margaret proved the most brilliant of his children; she not only mastered Latin and Greek, but acquired some knowledge of philosophy, logic, rhetoric, and the sciences of astronomy and physics.[78] After her marriage Margaret allowed her translation of Erasmus's treatise on the *Paternoster* to be published; in the introduction to her translation, Richard Hyrde ardently defended women's education. Margaret also saw that her own five children received a sound classical education, thus beginning a tradition that continued for generations in many aristocratic English households and is evidenced in one of the pamphlets in this

anthology, where Constantia Munda thanks her mother for the valued gift of a liberal education. While Margaret Roper engaged highly qualified tutors in Greek and Latin for her children, in less affluent households the mother may have actually taught her children herself.

The learning, piety, and poise of More's daughters converted his close friend Erasmus into a supporter of classical education for women. Erasmus embodied his support in a colloquy, *The Abbot and the Learned Woman*, in which the educated Magdalia vanquishes the abbot's objections to women's education with logic and eloquence. To the abbot's contention that a woman's duty is to stay home and care for her children Magdalia responds that through books a woman gains wisdom to instruct her children and manage her household. When the abbot retorts that the teaching of Latin to women is not traditional, Magdalia responds with an attack on custom, "the mistress of all evil practices,"[79] that anticipates the criticism made by the female speaker in *Haec Vir* in this anthology.

Kelso maintains that the educational ideals of Vives, More, and Erasmus "worked like leaven through the century,"[80] influencing teachers and scholars and producing a small group of Elizabethan women noted for their thorough classical training. The Reformation did not diminish the impact of these Catholic humanists upon women's education for some time; in fact, many of the women who benefited from their ideas were ardent Protestants. Queen Catherine Parr, last of the wives of Henry VIII, herself supervised the education of Prince Edward and Princess Elizabeth, insisting that they learn Latin as well as French and Italian. In fact, the Queen's sister Anne once wrote Roger Ascham that her education and that of her sister had been modeled after Thomas More's program of study for his children.

Ascham, who became tutor to Elizabeth, wrote of the rigorous academic schedule she followed at the age of sixteen: "The beginning of the day was always devoted by her to the New Testament in Greek, after which she read select orations of Isocrates and the tragedies of Sophocles. . . . For her religious instruction she drew first from the fountains of scripture and afterwards from St. Cyprian, the 'Commonplaces' of Melancthon, and similar works which convey pure doctrine in elegant langauge." He testified to her complete fluency in French, Italian, and Latin and remarked that she spoke Greek "moderately well."[81] Elizabeth ignored Vives's injunction against the study of government for women; she read Xenophon, the orations of Aeschines

and Demosthenes in Greek, and Machiavelli's *The Prince*. One of the few English noblewomen who had opportunity to use her education to serve her nation, Elizabeth upon becoming queen discoursed with European diplomats in Latin, French, and Italian.[82]

The four daughters of Sir Anthony Cooke, tutor to King Edward VI, were almost as famous as Elizabeth for classical learning. The eldest, Mildred, mentioned previously for her marriage to William Cecil, Lord Burghley, conversed fluently with European statesmen in Latin. Her sister Anne acquired a distinguished reputation for learning through her published translations from Italian and Latin, particularly her translation of Bishop Jewel's *Apology for the Church of England*. Anne also supervised the early education of her sons, one of whom, Francis Bacon, made perhaps the most significant contribution to intellectual history of any Englishman in the Renaissance. In 1548, in a preface to Princess Mary's translation of Erasmus's *Paraphrase of the Gospel of St. John*, Nicholas Udall remarks on the large number of noblewomen who had relinquished "vain pastimes" and "courtly dalliance" for a disciplined program of both biblical and classical studies.[83] Nevertheless, it was still the case that serious classical students among English noblewomen in the sixteenth century were outnumbered by women in their social class whose education was limited to literacy in English and a modicum of French and music.

The lower a woman's position on the social scale, the less likely was she to participate in the classical education advocated by More and Vives. There were women from the lower gentry who became proficient in Latin and Greek, however, and an even larger number who could read and write Latin but not Greek. Jane Anger, whose pamphlet in this anthology abounds with Latin quotations, signed herself "Jane Anger, Gentlewoman." Esther Sowernam does not directly indicate her social class, but her references to her legal affairs in London and her "repair into the Country" suggest that she, too, may be a Gentlewoman; her defense reveals not only fluency in Latin but also knowledge of classical authors and culture. One of the best examples of a classically trained woman from the lower gentry is Elizabeth Grymeston, daughter of Martin Bernye, a justice of the peace in Norfolk. The fact that her father eventually lost his commission as a justice for attending a mass in his manor house has led to the speculation that Elizabeth may have been educated by Jesuits sheltered by Bernye in his home. While we know little about Elizabeth's childhood, records show

that she married Christopher Grymeston in 1584, while he was at Caius College, Cambridge. After Christopher entered the law school Gray's Inn in 1593, the couple probably moved to London. Elizabeth bore nine children before her death in 1603; portions of her *Miscellanea*, which consists principally of gracefully written prayers and meditations, are letters to her only surviving child. Not only does the *Miscellanea* include numerous Latin quotations; it also "frequently paraphrases Gregory, Jerome, Ambrose, Augustine, Seneca, Virgil, Terence, Pindar, and others," weaving Elizabeth's classical learning and her deep Christian piety into an impressive tapestry of genuine maternal and religious feeling.[84]

Most scholars sense a change of attitude toward women's education around the turn of the century. In England, the Protestant reformers emphasized different educational materials from those of the Catholic humanists. While humanists like More and Vives sought to reconcile the Greek and Roman classics with the early church fathers, the reformers were more concerned with the Bible, both the Old and New Testaments. Protestant leaders believed that women as well as men should be able to read the Bible, but a rigorous education in Latin and Greek was not necessary to achieve this end. While one can point to numerous examples of well-educated women in England between 1600 and 1640, in most cases their education did not follow the classical model established by More and Vives.[85]

Another reason for declining enthusiasm over the idea of the classically educated woman was doubtless "the disjunction between these ideas and the reality of women's lives. . . . A society that continued to treat women as the property of their fathers and husbands found it difficult to think of them as intellectual equals."[86] Even in the sixteenth century the ideal of the classically educated woman had existed in tension with the pervasive notion of women's inferior mental capacity. After the death of Queen Elizabeth, a woman who had fully integrated her liberal education with her private and public life, misogynists did not hesitate to proclaim publicly their views of women's intellectual weakness. Sir Thomas Overbury, courtier in the reign of James I, asserted in *A Wife* (1614) that "books are a part of Man's Prerogative" and suggested that too much learning made women mentally unstable. The father of Lady Anne Clifford forbade her to study languages, and Sir Ralph Verney wrote to the father of Nancy Denton in the mid-seventeenth century, "Let not your girl learn Latin nor shorthand. The

difficulty of the first may keep her from that vice, for so I must esteem it in a woman."[87]

Two women whose lives and writings clearly reflect the ambivalence of the period towards the education of women are Elizabeth Jocelyn (1596–1622) and Elizabeth Tanfield Cary (1585–1639). Elizabeth Brooke Jocelyn was raised and educated by her maternal grandfather, Bishop Caderton of Lincoln, who instructed her in languages, history, and religion. Fearful that she would not survive the birth of her first child, she left a tract for her husband describing her aspirations for the child. She outlines in detail the education that she would wish for a male child whom she hopes would become a minister of the church. While the portion of her tract dealing with a son is clear and straightforward, her feelings about a daughter's education reflect a confusion born of intense ambivalence:

> I desire her bringing up to be learning the Bible, as my sisters do, good housewifery, writing, and good works; other learning a woman needs not, though I admire it in those whom God hath blest with discretion. Yet I desired not so much in my own, having seen that sometimes women have greater portions of learning than wisdom, which is of no better use to them than a mainsail to a flyboat, which runs under water. But where learning and wisdom meet in a virtuous disposed woman, she is the fittest closet of all goodness. She is, indeed; I should but shame myself, if I should go about to praise her more. But, my dear, though she have all this in her, she will hardly make a poor man's wife. Yet I leave it to thy will. If thou desirest a learned daughter, I pray God give her a wise and religious heart, that she may use it to his glory, thy comfort, and her own salvation.[88]

Oscillating between fear that learning in a woman can be useless (or even dangerous, since it renders her unsuited to marriage with a poor man) and conviction that learning can reinforce virtue, the passage tells us much about the internal conflicts that Elizabeth herself experienced as an educated woman in a society that felt grave reservations toward such women.

Elizabeth Tanfield Cary, noteworthy as the first Renaissance Englishwoman to publish an original play (*The Tragedy of Miriam, the Fair Queen of Jewry*, written when she was seventeen), demonstrated in her childhood a compelling determination to acquire an education. Her parents seemed to believe that English and French were sufficient

education for a girl, but having mastered these subjects by the age of five, Elizabeth taught herself Spanish, Italian, Latin, and Hebrew without benefit of a tutor. "She read so incessantly at night," wrote her daughter in a biography of Elizabeth, "that her mother forbade the servants to give her candles. But she bought candles at half a crown apiece of the servants and at twelve was £100 in their debt, a debt which she paid on her wedding day."[89] Her daughter also testifies to the breadth of her mother's self-education, affirming that she read ancient and modern poetry, history, and moral philosophy, and offering as examples Seneca, Plutarch, and Pliny among the ancients and Montaigne and Francis Bacon among modern writers. Elizabeth Tanfield Cary is probably the most outstanding example we know of a self-educated Renaissance Englishwoman.

To turn from consideration of the numerous individual women in our period who achieved a sound liberal education to the general level of female literacy in England could hardly be more sobering. Church court records from the various dioceses provide a measure of writing literacy, for witnesses were required to sign their names. In East Anglia between 1580 and 1640 approximately 95 percent of female witnesses were unable to sign their names; in London during the same period about 90 percent of women could not write their signatures. Since depositions were taken from all levels of society, we cannot conclude that women of the lower classes were overrepresented in the samples.[90] While the social class of female witnesses was not recorded, the occupation of male witnesses was; a comparison of the illiteracy rate of all women with that of men from different social levels indicates that only laborers had a lower writing literacy than women considered as a group.[91]

Several kinds of evidence suggest that many Englishwomen who could not write were nevertheless able to read. Some grammar schools that accepted girls probably dismissed them before teaching them to write; records from Banbury Grammar School in 1594 specify that while a certain number of girls would be admitted, no girls would remain "above the age of nine nor longer than they may learn to read English."[92] Even girls who had no formal schooling may have taught themselves to read at home with minimal assistance from a brother or parent; the same family member may have been unwilling to spend the additional time necessary to teach the child to write, especially if writing literacy was considered less important. The most compelling ar-

gument for a higher rate of reading literacy among women than the figures about writing literacy would suggest, however, is made by Suzanne W. Hull, who demonstrates that growing numbers of books published in this period were addressed to female readers. While at least 163 books in about 500 editions were aimed at a female audience between 1475 and 1640, 85 percent of these were published in the last seventy years of the period. Authors and booksellers must have become increasingly aware of women readers, for some books whose first editions were not specifically addressed to women were retitled or rewritten for women in subsequent editions; for example, Thomas Tusser's *A Hundred Good Points of Husbandry*, first published in 1557, reappeared five years later in an expanded edition entitled *A Hundred Good Points of Husbandry Lately Married unto a Hundred Good Points of Housewifery*. Hull concludes that between 1570 and 1640 nearly half a million volumes intended primarily for female readers were printed and sold. It seems clear from this substantial evidence that reading literacy among women in London was significantly higher than the 10 percent writing literacy indicated by church court records.[93]

More men than women possessed the ability to write because parents were more willing to hire tutors for their sons, and especially because formal schooling was more available to boys than to girls. While many girls attended elementary schools, they usually remained for a briefer period than their brothers; in 1581 Richard Mulcaster wrote that "young maidens ordinarily share" the earliest stages of boys' schooling. Some educators, believing that young girls belonged at home, disapproved of their attending school at all: the 1637 Founder's Rules for Thomas Saunders's School at Uffington assert that "whereas it is the most common and usual course for many to send their daughters to common schools to be taught together with and amongst all sorts of youths, which course is by many conceived very uncomely and not decent, therefore the said schoolmaster may not admit any of that sex to be taught in the said school." The 1590 rules of Harrow also explicitly state that girls may not be admitted to the school.[94]

Some Protestant reformers were concerned about the scarcity of educational opportunities for lower- and middle-class girls. The most vocal was Thomas Becon, who wrote in his *New Catechism*, "If it be thought convenient . . . that schools be set up for the right education and bringing up of the youth of the male kind, why should it not be thought convenient that schools be built for the godly instruction of

and virtuous bringing up of the youth of the female kind? Is not the woman the creature of God as well as the man, and as dear to God as the man?[95] Inspired by Luther, Becon nevertheless offered the same argument for educating girls that Thomas More had used to justify the program of study he implemented for his daughters: girls as well as boys are endowed by God with the gift of reason, which, cultivated by the right education, will produce the fruits of faith and virtue.[96]

In the reign of James, Anglican religious authorities became increasingly disturbed by the large numbers of Catholic parents who were sending their children abroad to be educated in the Catholic faith. This concern, together with that of the Protestant reformers, created a climate receptive to the notion of English schools for girls, and in the early seventeenth century such schools began to appear, although their curriculum was seldom as religious as the authorities would have wished.

While the boarding schools for girls that began to appear around 1615 taught their pupils reading, writing, music, and sometimes French, needlework and dancing also occupied a prominent place in the curriculum. Records from the Court of Aldermen at Stepney show that in 1628 an orphan ward of the court, Anne Heather, was committed to Mrs. Freind's School to be taught "her needle, writing, music, and other qualities" for an annual charge of £21. So many boarding schools for girls opened in the Hackney neighborhood of London in the first fifty years of the century that the district eventually became known as the "Ladies' University of Female Arts." A Hackney school directed by Mrs. Salmon is remembered today chiefly as the place where Katherine Philips, who was to become famous as a poet and central figure of a literary circle, began her formal schooling in 1639 at the age of eight. While some of the schools remained small enterprises run by a matron who hired a schoolmaster to teach academic subjects, some became fairly large institutions. Mrs. Perwich's School taught 800 girls from every part of England in the seventeen years after its founding in 1643. This school was especially known for its excellent musical curriculum; well-known London musicians and composers taught there, and the founder's daughter, Susanna Perwich, developed such proficiency as a violinist that musicians of the stature of Henry Lawes came to her performances. Susanna in fact became her mother's assistant at the school, leading an orchestra of lutes and viols and im-

parting to young pupils her skills in dancing, calligraphy, cooking, acountancy, and fine embroidery.[97]

The girls' boarding schools which grew up in both London and the country after 1615 were certainly one significant factor in the dramatic increase in writing literacy among women during the seventeenth century, as shown by church court records. The approximately 10 percent rate of writing literacy among London women between 1580 and 1640 had risen to about 48 percent by the 1690s; records of country women show a lesser but still substantial increase in writing literacy.[98] While the schools taught the basics of reading and writing, however, they lacked the rigorous instruction in classical languages and literature and the emphasis on Christian piety that humanists from More to Milton considered essential to sound education. Some Puritans charged that the boarding schools engendered pride and wantonness rather than Christian humility, and many of these schools ceased to flourish after the Puritans came to power in 1640.[99]

Mary Tattlewell, author of *The women's sharp revenge*, attacked the female curriculum from a more radical perspective. Tattlewell believed that women's education, by omitting the classical training necessary for entrance to a university, served to maintain male supremacy: "If we be taught to read, they then confine us within the compass of our Mother Tongue, and that limit we are not suffered to pass. . . . And thus if we be . . . in degree of place low, they strive by their policy to keep us more under." She also charged that the emphasis on music and dancing molded women to serve as the sexual and aesthetic objects of men's appetites: "If . . . we be brought up to Music, to singing, and to dancing, it is not for any benefit that thereby we can engross [take] unto ourselves, but for their own particular ends, the better to please and content their licentious appetites when we come to our maturity and ripeness." While Tattlewell's views of women's education constitute only a brief section of her pamphlet, these views were profoundly radical. She saw the inadequacies of women's education as a result of sexual politics, as a political strategy through which men not only maintained their ascendancy, but also manipulated women by endowing them with graces which men found both entertaining and sexually satisfying.

Tattlewell's few pages on education are revolutionary in their analysis of the ways in which women's education served the ends of men

rather than those of women; while implying that women should be admitted to the universities, however, she did not specifically describe an educational program that would better serve women's needs. Almost another half century passed before Mary Astell in *A Serious Proposal to the Ladies* (1694) advocated the founding of a private college where women could receive an advanced education equal in quality to that given to men at Oxford and Cambridge. Astell felt the same contempt for the state of women's education that Tattlewell expressed; she mocked the low expectations parents and guardians had for their daughters, wanting them to know only "their Catechism and a few good Sentences, to read a chapter and say their Prayers, though perhaps with as little understanding as a Parrot."[100] Although *A Serious Proposal* went through four editions and elicited much positive and negative response, it did not succeed in raising money for the college that Astell desired. Mary Astell was approximately two centuries ahead of her time; Girton College for women, affiliated with Cambridge University, was incorporated in 1874, although women were not granted the same degrees that Cambridge men received until 1948.[101]

The education of women can serve feminist movements in two ways: by opening professional doors to women and by rendering them better able to formulate and defend feminist positions. In the Renaissance, both the professions and their means of access were firmly closed to women, and the meager education available to most women was ill suited to sharpening their wits for intellectual skirmishes with men. Tattlewell protested against the prominence of the needle and the spinning wheel in women's education because sewing and spinning did not help women to "vindicate our own injuries." Although the pamphlets in this anthology demonstrate that at least a handful of women in Renaissance England were well educated enough to be able to defend their sex in a persuasive and engaging manner, it was to be centuries before full educational opportunities were offered to the feminine half of humankind.

NOTES

1. Quoted in Pearl Hogrefe, *Women of Action in Tudor England* (Ames, Iowa: Iowa State University Press, 1977), pp. 69–70. All quotations from Renaissance writings (except for well-known literary works), whether cited

from the original or from secondary sources, have been modernized according to the principles outlined in "A Note on Editorial Policy" at the beginning of part 2.

2. Roger Thompson, *Women in Stuart England and America* (London: Routledge and Kegan Paul, 1974), pp. 8–9.

3. See Dolores Barracano Schmidt, "The Great American Bitch," *College English* 32 (1971): 900–905.

4. Louis B. Wright asserts that "the break with medieval conventions . . . greatly increased woman's liberties" and that "more widely distributed wealth, which so rapidly multiplied the middle class, . . . augmented the responsibilities and obligations of women" (*Middle-Class Culture in Elizabethan England* [Chapel Hill: University of North Carolina Press, 1935], pp. 202–3).

5. Hogrefe, *Women of Action*, p. xix; Lawrence Stone, *The Family, Sex and Marriage in England 1500–1800* (New York: Harper & Row, 1977), pp. 152–56.

6. Hilda Smith, *Reason's Disciples: Seventeenth-Century English Feminists* (Urbana: University of Illinois Press, 1982), p. 20. For an excellent bibliographical essay dealing with the lives of Englishwomen in this period, see Rosemary Masek, "Women in an Age of Transition 1485–1714," in *The Women of England from Anglo-Saxon Times to the Present: Interpretive Bibliographical Essays*, ed. Barbara Kanner (Hamden, Conn.: Archon Books, 1979), pp. 138–82.

7. Wright, *Middle-Class Culture*, p. 201.

8. Robert Cleaver, *A Godly Form of Household Government*, p. 214, quoted in Chilton Latham Powell, *English Domestic Relations 1487–1653: A Study of Matrimony and Family Life in Theory and Practice as Revealed by the Literature, Law, and History of the Period* (New York: Columbia University Press, 1917), p. 154.

9. Henry Smith, *A Preparative to Marriage*, p. 58, quoted in Wright, *Middle-Class Culture*, p. 208.

10. Thomas Becon, *Works*, 1564, pt. 1, quoted in Powell, *English Domestic Relations*, p. 155.

11. S. A. Peyton, ed., *The churchwarden's presentments in the Oxfordshire peculiars of Dorchester, Thame and Banbury*, Oxfordshire Record Society 10 (1928), quoted in *Before the Bawdy Court: Selections from Church Court and Other Records Relating to the Correction of Moral Offences in England, Scotland and New England, 1300–1800*, ed. Paul Hair (New York: Barnes & Noble, 1972), p. 72.

12. Dorothy Leigh, *The Mother's Blessing*, sigs. A5–7, quoted in *The Paradise of Women: Writings by Englishwomen of the Renaissance*, ed. Betty Travitsky (Westport, Conn.: Greenwood Press, 1981), p. 56.

13. Peter Laslett, *The World We Have Lost* (New York: Charles Scribner's Sons, 1965), p. 83.

14. Stone, *Family, Sex and Marriage*, p. 495; Becon, *Works*, 1564, pt. 1, quoted in Powell, *English Domestic Relations*, p. 155.

15. Juan Luis Vives, *The Instruction of a Christian Woman*, trans. Richard Hyrde (London: Thomas Powell, 1557), p. xvii', quoted in Margaret Mikesell, "The Formative Power of Marriage in Stuart Tragedy," *Modern Language Studies* 12, no. 1 (Winter 1982): 40.

16. Stone, *Family, Sex and Marriage*, p. 501.

17. Wright, *Middle-Class Culture*, p. 209.

18. Stone, *Family, Sex and Marriage*, pp. 502–3.

19. Hair, *Before the Bawdy Court*, pp. 232–33; Stone, *Family, Sex and Marriage*, p. 519.

20. H. R. Wilton Hall, ed., *Records of the Old Archdeaconry of St. Alban's: a calendar of papers 1575–1637*, St. Alban's and Hertfordshire Architectural and Archaeological Society, 1908, quoted in Hair, *Before the Bawdy Court*, pp. 44–45.

21. Stone, *Family, Sex and Marriage*, p. 520.

22. H. Johnstone, ed., *Churchwardens' presentments (17th Century)* Part I, *Archdeaconry of Chichester*, Sussex Record Society 49 (1947–48), quoted in Hair, *Before the Bawdy Court*, p. 94.

23. Laslett, *World We Have Lost*, p. 134.

24. Stone, *Family, Sex and Marriage*, p. 504.

25. Hair, *Before the Bawdy Court*, p. 252.

26. Stone, *Family, Sex and Marriage*, pp. 503–4. See also the perceptive, detailed discussion of cuckoldry and marriage in Coppélia Kahn, *Man's Estate: Masculine Identity in Shakespeare* (Berkeley: University of California Press, 1981), pp. 119–46.

27. Alexander Niccholes, *A Discourse of Marriage and Wiving*, 1615, cited in Wright, *Middle-Class Culture*, p. 217.

28. Quoted in Ruth Kelso, *Doctrine for the Lady of the Renaissance* (Urbana: University of Illinois Press, 1956), pp. 107–8.

29. Samuel Rowlands, *The Bride*, ed. A. C. Potter (Boston, 1905), quoted in Wright, *Middle-Class Culture*, p. 219.

30. Carroll Camden, *The Elizabethan Woman* (Houston: Elsevier Press, 1952), pp. 219–22. This brief description of a noblewoman's attire omits her headwear, collars (or ruffs), jewelry, and footwear; it is included here only to give some notion of the complexity and elegance of clothing worn by the upper-class woman.

31. *Articles for the due execution of the Statutes of Apparel*, 1562, and Proclamation by the Queen [against excess in apparel], 1577, both cited in Camden, *Elizabethan Woman*, pp. 235–36; Moryson, quoted in Camden, *Elizabethan Woman*, p. 223.

32. *The Life of Adam Martindale*, ed. R. Parkinson (Chetham Society, 1845), pp. 6–7, quoted in Doris Mary Stenton, *The English Woman in History* (New York: Macmillan Co., 1957), p. 110.

33. Margaret Tyler, preface to Diego Ortunez de Calahorra, *A mirror of princely deeds and knighthood* (London: T. East, 1578), quoted in Travitsky, *Paradise of Women*, p. 146.

34. Stone, *Family, Sex and Marriage*, p. 81.

35. In *The Schoolmaster* (1570), Roger Ascham describes a meeting with the well-educated thirteen-year-old Lady Jane Grey at which she contrasted the gentleness of her tutor with the harshness of her parents: "For when I am in the presence of either father or mother . . . I am so sharply taunted, so cruelly threatened, yea presently sometimes with pinches, nips, and bobs and other ways which I will not name for the honor I bear them, . . . that I think myself in hell" (quoted in Myra Reynolds, *The Learned Lady in England 1650–1760* [Boston: Houghton Mifflin Co., 1920], p. 15).

36. Elizabeth Grymeston, *Miscellanea*, in *The Female Spectator: English Women Writers before 1800*, ed. Mary R. Mahl and Helene Koon (Bloomington: Indiana University Press, 1977), pp. 52–58.

37. Cynthia Griffin Wolff, "A Mirror for Men: Stereotypes of Women in Literature," in *Woman: An Issue*, ed. Lee R. Edwards, Mary Heath, and Lisa Baskin (Boston: Little, Brown and Co., 1972), p. 207.

38. In the *Obsequies to the Memory of Edward King*, Samson Briggs terms him "one whom the Muses courted"; J. Cleveland calls him a "University" whose learning was "bottomless"; and Henry King states that "both Church and State / Join in this loss" (spelling and punctuation modernized). For a discussion of *Lycidas* in relation to the other elegies in the *Obsequies*, see George Williamson, "The Obsequies for Edward King," *Seventeenth Century Contexts*, rev. ed. (Chicago: University of Chicago Press, 1969), pp. 132–47.

39. Stenton, *English Woman in History*, p. 65.

40. "This unusually large severance pay suggests that Margaret's real fault may have been to become a little too popular with male members of the household" (Barbara Rosen, ed., *Witchcraft* [New York: Taplinger Publishing Co., 1972], p. 372). Rosen's work is an excellent compilation of witch pamphlets and other materials relating to witchcraft in Elizabethan and Jacobean England.

41. *The Law's Resolution of Women's Rights*, quoted in Thompson, *Women in Stuart England*, p. 115. Not all women did marry, of course. Thompson argues that for a variety of reasons there was a surplus of marriageable women in seventeenth-century England. Lawrence Stone discusses the percentages of women from different social classes who never married in *Family, Sex and Marriage*, pp. 42–47.

42. See John K. Yost, "The Value of Married Life for the Social Order in the Early English Renaissance," *Societas* 6 (1976): 25–37.

43. Stone, *Family, Sex and Marriage*, p. 135.

44. Wright, *Middle-Class Culture*, p. 208.

45. Stone, *Family, Sex and Marriage*, p. 199.

46. Laslett, *World We Have Lost*, pp. 1–4.

47. Ibid., pp. 11–12.

48. Stone, *Family, Sex and Marriage*, p. 137.

49. Pearl Hogrefe, *Tudor Women: Commoners and Queens* (Ames, Iowa: Iowa State University Press, 1975), pp. 88–89.

50. For details of the elaborate annulment proceedings which terminated

the first marriage of Lady Frances Howard see G. P. V. Akrigg, *Jacobean Pageant; or, The Court of King James I* (Cambridge: Harvard University Press, 1962), pp. 180–86.

51. Johnstone, ed., *Churchwardens' presentments*, quoted in Hair, *Before the Bawdy Court*, p. 107.

52. Hair, *Before the Bawdy Court*, p. 245.

53. Stone, *Family, Sex and Marriage*, pp. 55–56.

54. Becon, *Works*, pt. 1, quoted in Powell, *English Domestic Relations*, p. 158.

55. Kelso, *Doctrine for the Lady of the Renaissance*, pp. 128–29.

56. Camden, *Elizabethan Woman*, p. 146.

57. The authors of conduct books state that a widow will mourn even a harsh husband with tears and laments, will keep him alive by respectful remembrance, and will not leave home unless accompanied by a mature female companion. (See Kelso, *Doctrine for the Lady of the Renaissance*, pp. 128–31.)

58. Rowlands, *The Bride*, quoted in Wright, *Middle-Class Culture*, p. 219.

59. Burton, cited in Camden, *Elizabethan Woman*, p. 125.

60. William B. Rye, *England as Seen by Foreigners*, p. 77ff., quoted in Powell, *English Domestic Relations*, p. 175.

61. See Powell, *English Domestic Relations*, pp. 152–53.

62. William Whately, *A Bride-Bush*, quoted in Stone, *Family, Sex and Marriage*, p. 151.

63. *The Homily on Marriage*, quoted in Stone, *Family, Sex and Marriage*, p. 198.

64. William Gouge, *Of Domestical Duties*, quoted and discussed in Wright, *Middle-Class Culture*, p. 222.

65. Ibid.

66. Stone, *Family, Sex and Marriage*, pp. 154–55.

67. Quotations from *The Law's Resolution of Women's Rights* are taken from Stenton, *English Woman in History*, p. 62.

68. Stone, *Family, Sex and Marriage*, p. 195.

69. Hogrefe, *Women of Action*, pp. 59–81.

70. Hair, *Before the Bawdy Court*, p. 244.

71. Stone, *Family, Sex and Marriage*, p. 199.

72. Hogrefe, *Women of Action*, pp. 3–36.

73. *Vives: On Education*, a translation of the *De Tradendis Disciplinis*, ed. Foster Watson (Cambridge, 1913), quoted in Joan Simon, *Education and Society in Tudor England* (Cambridge: At the University Press, 1967), p. 118.

74. John Milton, "Of Education," 1644, in *John Milton: Complete Poems and Major Prose*, ed. Merritt Y. Hughes (New York: Odyssey Press, 1957), pp. 631–32.

75. Smith, *Reason's Disciples*, p. 41.

76. Vives, *Instruction of a Christian Woman*, quoted in Smith, *Reason's Disciples*, p. 43.

77. Vives, *Instruction*, quoted in Kelso, *Doctrine for the Lady of the Renaissance*, p. 72.

78. Phyllis Stock, *Better than Rubies: A History of Women's Education* (New York: G. P. Putnam's Sons, 1978), pp. 49–50.

79. Erasmus, *The Abbot and the Learned Woman*, in *Select Colloquies*, ed. Merrick Whitcomb, p. 179, quoted in Reynolds, *Learned Lady*, p. 12.

80. Kelso, *Doctrine for the Lady of the Renaissance*, p. 74.

81. Quotations from Ascham are from Dorothy Gardiner, *English Girlhood at School: A Study of Women's Education through Twelve Centuries* (Oxford: University Press, 1929), p. 183.

82. Gardiner, *English Girlhood at School*, p. 184.

83. Reynolds, *Learned Lady*, pp. 12–13 and 17–18.

84. Mahl and Koon, *Female Spectator*, pp. 52–53. According to Joan Kelly ("Early Feminist Theory and the *Querelle des Femmes*, 1400–1789," *Signs: Journal of Women in Culture and Society* 8 [Autumn 1982]: 4–28), literate women who shared in humanist learning developed a feminist awareness of their disadvantaged position when they discovered "that the universal ideal of *humanitas* . . ., the notion of education as cultivating the human in man, was not meant for "man" male and female anymore than were the occupations of the literati" (p. 8).

85. Travitsky, *Paradise of Women*, p. 5. Esther Sowernam and Constantia Munda both reveal extensive classical learning in their pamphlets, but although their treatises were published after 1600, it is likely that they received their educations before the turn of the century.

86. Barbara J. Harris, *Beyond Her Sphere: Women and the Professions in American History* (Westport, Conn.: Greenwood Press, 1978), p. 15. Although the principal subject of this book is the relationship between feminist movements in America and American professional women, its first chapter ("An Ideology of Inferiority," pp. 3–31) is an excellent analysis of European attitudes toward the intellectual abilities of women from the medieval period through the eighteenth century.

87. Quoted in Reynolds, *Learned Lady*, pp. 23–24.

88. *The Mother's Legacy to Her Unborn Child*, 1624, quoted in Reynolds, *Learned Lady*, p. 30.

89. Quoted in Reynolds, *Learned Lady*, p. 33.

90. David Cressy, "Literacy in Seventeenth-Century England: More Evidence," *Journal of Interdisciplinary History* 8 (1977): 147–48.

91. Smith, *Reason's Disciples*, p. 25.

92. Quoted in Gardiner, *English Girlhood at School*, p. 200.

93. Suzanne W. Hull, *Chaste Silent & Obedient: English Books for Women 1475–1640* (San Marino: Huntington Library, 1982), pp. 1–10 and 130–31.

94. Quoted in Gardiner, *English Girlhood at School*, p. 200.

95. Thomas Becon, *New Catechism*, quoted in Stock, *Better than Rubies*, pp. 68–69.

96. Reynolds, *Learned Lady*, p. 9.

97. Gardiner, *English Girlhood at School*, pp. 210–13.

98. Cressy, "Literacy in Seventeenth-Century England," p. 146.

99. Smith, *Reason's Disciples*, p. 24.

100. Mary Astell, *A Serious Proposal to the Ladies*, quoted in Smith, *Reason's Disciples*, p. 128.

101. Stock, *Better than Rubies*, pp. 180–81.

The Literary Contexts

The images of women found in the popular pamphlets of the controversy pervaded the culture of Renaissance England and influenced the lives of real women. These images—both the positive and the negative stereotypes—are also persistently woven into the fabric of the traditional literature of the period. The process of tracing them in this literature illuminates both the individual work, as we see how each poet or playwright uses the images according to his own genius, and the cultural context within which the work exists. The relationship between the popular stereotypes of women so bluntly depicted in the pamphlets and the more subtle delineations of women in the imaginative literature of the period is a dynamic one, for the poets and playwrights, aware of the stereotypes in the minds of their contemporaries, could exploit the expectations of the audience in a variety of ways. They could use a negative stereotype for satiric purposes, as Ben Jonson often did; they could show the tragic consequences of ready stereotyping, as Shakespeare did in *Othello* and *The Winter's Tale*; they could create a static, stereotyped woman and then explore the complexity of male reactions to her, as both Sidney and Shakespeare did in their sonnet sequences. The popular controversy over women in the English Renaissance thus offers a fruitful and hitherto unexplored context within which to examine the imaginative literature of the period.[1]

Popular Stereotypes and Renaissance Poetry

The two stereotypes of women found in the pamphlets that appear most frequently in the poetry of the period are the opposite images of

the seductress and the unassailably chaste woman. In the sonnet sequences which flourished in England between 1580 and 1600—a time when Petrarch reigned supreme as master of love poetry throughout Europe—the lady, like Petrarch's Laura, was conventionally the exemplar of chaste beauty, unresponsive to the humble pleas or direct seduction attempts of the devoted poet/lover. Some of the sonneteers defied these conventions, however, either by inverting the image of the chaste woman or by rejecting the poet/lover's role of humble suppliant. In Samuel Daniel's sonnets (*To Delia*) an abject suitor speaks to a conventionally cold mistress, but the poet/lover in many of Michael Drayton's sonnets rejects the convention of passive humility: "Since there's no help, come, let us kiss and part—/ Nay, I have done: you get no more of me."[2] Many poets played with the form and its conventions without creating a true sequence—that is, without giving consistent characterization to either a woman or the poet/lover. Three major poets did write true sequences, however; each one created a "lady" who fits one of the stereotypes found in the pamphlets.

In Sir Philip Sidney's *Astrophil and Stella* (1591) the virtue of Stella, a married woman living at court, is unassailable. She admits to loving Astrophil but repeatedly rebukes his sexual passion and urges him to embrace her own ideal of noble restraint:

> . . . love she did, but loved a Love not blind,
> Which would not let me, whom she loved, decline
> From nobler course, fit for my birth and mind:
> And therefore by her Love's authority,
> Willd me these tempests of vaine love to flie,
> And anchor fast my selfe on Vertue's shore.[3]

Although her marriage is not entirely happy, she never wavers in her determination to remain faithful to her husband; she thus embodies the firm chastity that Anger, Sowernam, and Tattlewell saw as a natural trait of women.

Astrophil, unlike Stella, is given a complex character: a well-educated young courtier who knows that his love is wrong and also knows that it could ruin his career at court, he displays a vast range of attitudes toward Stella, himself, and his courtly responsibilities. At times his voice is intelligent, rational, and dignified; at times he is a silly, besotted lover sending Stella poems that resemble the "stewed Anagrams" and "broiled Sonnets" with which Mary Tattlewell testified she was

courted in her youth. When he happens upon Stella sleeping he loses control, kissing and biting her, recalling Anger's description of men "ravished with the delight of those dainties which allure and draw the senses of them to serve us, whereby they become ravenous hawks, who do not only seize upon us, but devour us."

Stella is the firm, still center of the universe of the sequence; Astrophil revolves around her, now adoring, now elated, now despairing, until he finally accepts her loving rejection and turns his energies to the "nobler course" of service to the courtly ideals to which she has directed him. She remains the heavenly body that defines his orbit, however, thus demonstrating the positive power of the chaste woman attested to in the feminist treatises, the power to stabilize any man with a capacity for virtue. (Sowernam points out that parents with "wild and riotous" sons try to find them good wives in order to reform them.)

In sharp contrast to Stella, the major female figure of Shakespeare's sonnet sequence (1609), the Dark Lady, fits precisely the stereotype of the seductress found in the antifeminist pamphlets; she is enticing, deceitful, and promiscuous, and the poet/lover is obsessed with her:

> Thou blind fool, Love, what dost thou to mine eyes
> That they behold and see not what they see?
> They know what beauty is, see where it lies,
> Yet what the best is take the worst to be.
> If eyes, corrupt by overpartial looks,
> Be anchored in the bay where all men ride,
> Why of eyes' falsehood hast thou forged hooks,
> Whereto the judgment of my heart is tied?
> Why should my heart think that a several plot,
> Which my heart knows the wide world's common place?
> Or mine eyes seeing this, say this is not,
> To put fair truth upon so foul a face?[4]

With similar language Swetnam warned men against the wanton, the faithless woman who is "a common hackney for everyone that will ride; a boat for everyone to row in." Swetnam stressed the fact that such a woman can have a disastrous impact upon a man's mind, destroying his judgment and clouding his perception of beauty just as the judgment and vision of Shakespeare's lover have been impaired by his infatuation. In the Renaissance, chastity was considered requisite to "true" beauty in a woman; the surface beauty of a wanton woman was

regarded as a thin veneer concealing a fundamental moral ugliness. The Dark Lady may be outwardly beautiful, but her promiscuity renders that beauty an illusion ultimately shattered: "For I have sworn thee fair, and thought thee bright, / Who art as black as hell, as dark as night" (Sonnet 147).

According to Swetnam, the man seduced by a lustful, faithless woman placed in jeopardy the well-being of his mind, his body, and his soul. "The heat of the young blood of these wantons," he wrote, "chants your minds and enfeebleth your bodies with diseases; it also scandaleth your good names, but most of all it endangereth your souls." Many of the sonnets addressed to the Dark Lady derive their emotional and poetic power from the tension between the lover's fierce sexual obsession with her and his guilty conviction that the affair places his mind and soul both at risk. He is simultaneously aware of both moral degradation and keen sensual pleasure:

> For, thou betraying me, I do betray
> My nobler part to my gross body's treason;
> My soul doth tell my body that he may
> Triumph in love; flesh stays no farther reason,
> But, rising at thy name, doth point out thee,
> As his triumphant prize. Proud of this pride,
> He is contented thy poor drudge to be,
> To stand in thy affairs, fall by thy side
> No want of conscience hold it that I call
> Her "love" for whose dear love I rise and fall.
> (Sonnet 151)

In this sonnet the male physical changes that precede and follow sexual intercourse provide the speaker with the paradox that his physical "rising" represents a spiritual "falling."

Shakespeare used the stereotype of the seductress in these poems as occasion to explore the condition of sexual obsession in a man of conscience. While the stereotype he invoked is the mirror opposite of that represented by Astrophil's chaste Stella, both poets employed the static figure of the woman as a means through which the poet/lover measured and examined his own moods, conflicts, and values—in fact, his essential character.

Edmund Spenser in his sonnet sequence *Amoretti* (1595) links the qualities of beauty, chastity, and holiness in the lady in a manner that echoes and illustrates the positive images of women found in the femi-

nist pamphlets. Just as Tattlewell insisted that a pure and beautiful woman is "the perfect image of her Creator, the true glory of Angels," so Spenser's poet/lover sees in his "divinely wrought" lady a "glorious image of the makers beautie."[5] The lover boldly compares her eyes to God Himself: "Then to the Maker selfe they likest be, / whose light doth lighten all that here we see" (sonnet 9). In contrast to the convention of the beautiful woman from whose eyes Cupid shoots arrows that inflame the lover with lust, he describes his lady's eyes as sending forth angels who calm his raging sexual passion:

> Thrugh your bright beames doth not the blinded guest
> shoot out his darts to base affections wound:
> but Angels come to lead fraile mindes to rest
> in chast desires on heavenly beauty bound.
> <div align="right">(Sonnet 8)</div>

Her beauty arouses desire, but her strong chastity tames and controls it.[6]

The lady's manner and appearance paradoxically combine the humility appropriate to a created being with a majesty directly reflected from the Creator Himself:

> In that proud port [bearing], which her so goodly graceth,
> whiles her faire face she rears up to the skie:
> and to the ground her eie lids low embaseth,
> most goodly temperature [proportion] ye may descry,
> Myld humblesse mixt with awfull majesty.
> <div align="right">(Sonnet 13)</div>

Her chaste beauty elicits from the poet/lover reverence for the craftsmanship of God, the ultimate Artist:[7]

> When I behold that beauties wonderment,
> And rare perfection of each goodly part:
> of natures skill the onely complement,
> I honor and admire the makers art.
> <div align="right">(Sonnet 24)</div>

The emphasis that Spenser places on the lady as the masterwork of the Creator is found in Munda, Sowernam, and Tattlewell. Munda attacked Swetnam for arraigning woman, whom the "Pantocrator would in his omniscient wisdom have to be the consummation of his blessed week's work, the end, crown, and perfection of the never sufficiently

glorified creation." Sowernam also claimed that God created woman "to add perfection to the end of all creation" and, as Spenser did implicitly through the figure of the lady in the *Amoretti*, she challenged the antifeminist association of beauty with unchastity:

> Might not a man as easily, and more honestly, when he seeth a fair woman which doth make the best use that she can to set out her beauty, rather glorify God in so beautiful a work than infect his soul with so lascivious a thought? And for the woman, who having a Jewel given her from so dear a friend, is she not to be commended rather that in the estimate which she showeth she will as carefully and as curiously as she may set out what she hath received from Almighty God, than to be censured that she doth it to allure wanton and lascivious looks?

These passages from the feminist pamphlets illuminate a facet of the *Amoretti* that has been problematical for many readers: the juxtaposition of sensuous descriptions of the lady's body with the lover's insistence upon the essential chastity of his desires. If, as the feminist writers maintain, the woman is God's masterpiece, then her sexuality is an integral part of that creation, and the lover's recognition of that sexuality is simply part of his appreciation of God's handiwork. The following sonnet on the lady's breasts, for example, some readers have taken as evidence of the lover's unbridled sensuality:

> Was it a dreame, or did I see it playne,
> a goodly table of pure ivory:
> all spred with juncats, fit to entertayne
> the greatest Prince with pompous roialty?
> Mongst which there in a silver dish did ly
> twoo golden apples of unvalewd price:
> .
>
> Exceeding sweet, yet voyd of sinfull vice,
> That many sought yet none could ever taste,
> sweet fruit of pleasure brought from paradice
> by Love himselfe and in his garden plaste.
> Her brest that table was so richly spredd,
> my thoughts the guests, which would thereon have fedd.
>
> <div align="right">(Sonnet 77)</div>

The poem certainly bespeaks sexual desire, but it is controlled by the lover's strong sense of the lady's purity. Like the "fair woman" in

Sowernam's example, Spenser's lady does not hesitate to display her beauty, the "Jewel given her from so dear a friend"; the sensuous nature of that beauty arouses both desire and admiration in the lover, but his "thoughts" may visit her physical beauty without dishonor.

Spenser saw no irreconcilable tension between the lady's strong virtue ("her mind adornd with vertues manifold") and the specifically sexual nature of her beauty. In fact, he regarded sexual love that was sanctified by marriage as a reflection of God's love for man, just as he saw his lady's beauty as a reflection of divine beauty: "So let us love, deare love, lyke as we ought, / love is the lesson which the Lord us taught" (sonnet 68). Unlike Astrophil's Stella, Spenser's Elizabeth was unmarried; thus he was free to court her openly, with the honorable intention of marriage. To have actually brought the bride to the altar would have sharply violated the conventions of the sonnet sequence; Spenser did, however, publish "Epithalamion," the celebration of his bride and his wedding day, together with *Amoretti*, and in sonnet 65 he envisions marriage as an ideal state characterized by "simple truth and mutuall good will" as well as the "spotlesse pleasure" of sexual intimacy. Like the authors of the feminist pamphlets, Spenser believes that marriage must be based upon mutual trust and not, as the misogynists claim, upon restraints imposed on the wife by her husband. While Sidney and Shakespeare used popular stereotypes of women to reveal the complex attitudes and feelings of the men who loved them, Spenser blended the images of the chaste and the holy woman to portray a courtship in which the tension between body and spirit is resolved through the prospect of harmonious marriage.

Unlike the sonnets of Sidney and Spenser, the love poetry of John Donne does not employ the voice of humble suppliant to a chastely beautiful woman. Donne did, however, use the popular images of women in a variety of ingenious ways. One group of poems in his *Songs and Sonnets* plays with the image of woman as promiscuously faithless found in the antifeminist treatises. So hyperbolically does Donne treat the conventions of this image, however, that in some cases he is almost certainly teasing the stereotype, perhaps to question its validity or reveal its absurdity. In "Song: Goe, and catche a falling starre," the speaker tells the reader that he could "ride ten thousand daies and nights" and still not find a single woman who is both fair and faithful:

If thou findst one, let mee know,
 Such a Pilgrimage were sweet,
Yet doe not, I would not goe,
 Though at next doore wee might meet,
Though shee were true, when you met her,
And last, till you write your letter,
 Yet shee
 Will bee
False, ere I come, to two, or three.[8]

In "The Indifferent," Donne parodies the sermonizing attitude that excoriates promiscuous women by condemning instead those few who are faithful. Of these obstinately faithful women he demands:

 Will no other vice content you?
Will it not serve your turn to do, as did your mothers?
Have you old vices spent, and now would finde out others?
 Or doth a feare, that men are true, torment you?
 Oh we are not, be not you so,
 Let mee and doe you, twenty know.
 Rob mee, but binde me not, and let me goe.

 (P. 42)

In "Change," one of Donne's *Elegies*, the speaker asserts that women are "more hot, wily, wild" than foxes or goats and thus faithless by nature. He argues the right of a woman to take more than one lover and the folly of possessiveness in men:

 If a man bee
Chain'd to a galley, yet the galley' is free;
Who hath a plow-land, casts all his seed corne there,
And yet allowes his ground more corne should beare.

 (P. 20)

The poem is fraught with ambivalence towards women's fickleness, viewed as liberating yet also as bestial.

While women in Donne's poetry seldom embody all the features of the stereotype of the seductress, they may intensely reflect certain aspects of it. In "Loves Alchymie," for example, sexual intercourse is rejected as devastatingly expensive to men: "Our ease, our thrift, our honor, and our day, / Shall we, for this vaine Bubles shadow pay?" (Similarly, Swetnam claims that sexual involvement with women produces "only shame, grief, and repentance.") The cynical speaker in

"Loves Alchymie" sees his sexual partner as merely dead flesh: "Hope not for minde in women; at their best / Sweetnesse and wit, they'are but *Mummy*, possest" (p. 81).

Donne's "Communitie" suggests his awareness of the controversy over women—in particular, of the fundamental question of women's good or evil that the treatises addressed. The speaker in the poem argues from the premise that women are morally indifferent objects:

> If then at first wise Nature had
> Made women either good or bad,
> Then some wee might hate, and some chuse,
> But since shee did them so create,
> That we may neither love, nor hate,
> Onely this rests, All, all may use.
>
> If they were good it would be seene,
> Good is as visible as greene,
> And to all eyes it selfe betrayes:
> If they were bad, they could not last,
> Bad doth it selfe, and others wast,
> So, they deserve nor blame, nor praise.
>
> (Pp. 33–34)

Since women are not moral beings, men's relations with them are not a moral issue, but simply a practical one analogous to eating:

> But they are ours as fruits are ours,
> He that but tasts, he that devours,
> And he which leaves all, doth as well:
> Chang'd loves are but chang'd sorts of meat,
> And when hee hath the kernell eate,
> Who doth not fling away the shell?
>
> (P. 34)

Donne is poking fun at the controversy through the casually exploitative attitude of the speaker, and the poem may be viewed as an outrageous answer to both misogynists who urged men to shun women and feminists who urged men to respect them. The view that women are merely edibles to satisfy the male appetite is of course even more contemptuous than the view that they are dangerous and destructive, but the exaggerated flippancy of the poem's tone points to an ironic intention.

Donne's group of poems attacking women is balanced by an equally

large group of poems celebrating the spiritual and physical joys of trusting, mutual love. In poems like "The Good-morrow" and "A Valediction: Forbidding Mourning" neither man nor woman is stereotyped; they are rather individuals in an exalted, deeply private relationship. Donne does draw on positive images of women in three sequential religious poems, however. Probably in 1610, the year of her death, Donne wrote a funeral elegy for Elizabeth Drury, the fifteen-year-old daughter of Sir Robert Drury of Hawstead, who was to become Donne's friend and patron; the elegy was followed by longer poems on the first and second anniversaries of her death. In each of these poems Donne presented the young woman as the embodiment of religious, moral, and aesthetic perfection; in the two latter poems, known as the *Anniversaries*, she becomes through her perfection the agent of man's conversion from love of the world to love of God.

The poems combine the positive stereotypes of the chaste, beautiful woman and the holy woman, the same stereotypes that inform the eulogies in this anthology. The eulogies can help a modern reader to understand the *Anniversaries* precisely because they are far less complex in their ideas and language, while sharing a fundamentally similar notion of the ideal woman. The ideal woman is first of all chaste; both Donne and the authors of the eulogies hint that their subjects differed from the "typical" woman in their purity. Donne writes that Elizabeth Drury died "Cloath'd in her Virgin white integrity; / For mariage, though it doe not staine, doth dye."[9] George Williams, author of one of the elegies to Elizabeth Crashaw, notes that she transcended the lust to which many beautiful women are subject:

> If love, if zeal, if ever chaste desires
> Kept virtue's lore and quenched the Paphian fires
> That boil in the veins of wanton Beauties, she
> Engrossed all this by her fair modesty.

In "An Anatomy of the World: The First Anniversarie," Donne also suggests that in order to attain true virtue Elizabeth Drury had to overcome not only the general stain of original sin, but also the particular heritage of female weakness:

> She in whom vertue was so much refin'd,
> That for Allay unto so pure a minde
> Shee tooke the weaker Sex, she that could drive
> The poysonous tincture, and the stayne of *Eve*,

> Out of her thoughts, and deeds; and purifie
> All, by a true religious Alchimy.
>
> <div align="right">(Lines 177–82)</div>

Like the authors of the eulogies to Elizabeth Crashaw, which stress her "rare conjunction" of "Beauty with Chastity," Donne links the beauty of his subject with her sexual purity in language implying that the two qualities are often *not* reconciled: "And shee made peace, for no peace is like this, / That beauty and chastity together kisse" ("Of the Progres of the Soule: The Second Anniversarie," lines 363–64).

Perhaps even more than her beauty and chastity, the *Anniversaries* stress the holiness of Elizabeth Drury. She "kept by diligent devotion, / Gods Image, . . . / Within her heart"; she "dreamt devoutlier, then most use to pray; / Who being heare fild with grace, yet strove to bee, / Both where more grace, and more capacitee / At once is given" ("The Second Anniversarie," lines 455–57 and 464–67). The sermon for the funeral of Elizabeth Crashaw describes her as possessed of a similar ethereal holiness: "She longed to leave this life and rejoiced to think or speak or hear of the life to come." John Mayer finds a similar quality in Lucy Thornton, who on her deathbed commanded her servants "not to trouble her with any worldly affairs, for now she would wholly be settled to heaven." The author of *Monodia* also insists on the piety of his subject, Helen Branch, who in the last years of her life "passed her time in holy meditation." Like Elizabeth Drury, the three women described in the eulogies are presented as zealous in their worship and love of God.

Because these women were chaste and holy, they are models for the living. Elizabeth Crashaw is exalted as the "honor of her Sex"; Helen Branch is a "godly, virtuous and religious Matron / For maids, and wives, and widows all a pattern." At the conclusion of "The Second Anniversarie" Donne invokes Elizabeth Drury, "Thou shouldest for life, and death, a patterne bee" (line 524).

Donne did not know Elizabeth Drury; he took the occasion of her death to write poems that interweave political, scientific, and theological ideas in a verse sermon on the theme of *contemptus mundi*. The more conventional eulogies in this anthology, sharing as they do Donne's concept of the perfect woman, suggest that he chose a woman as the unifying symbol of the poem because the conventional Renaissance ideal of woman (chaste, passive, and holy) neatly suited the

theme, while the ideal of Renaissance man (liberally educated, skilled in arms, contributing actively to society) would not have been appropriate. The life of a model woman (and especially of a girl) was so private, so free of ambition as to suggest a contempt for the larger world, and Donne was able to use the sexual purity of Elizabeth Drury to illuminate by contrast the corruption and decay of the world.

Of all lyric poets of the English Renaissance, Donne's work offers the greatest range of attitudes towards women. While he transcended the popular stereotypes of women in an important group of poems that celebrate the wonder and joy of mutual love that is both physical and spiritual, his work includes poems which scorn women and poems of profound sexual disillusion. The *Anniversaries* stand as emblem of this ambivalence, for although they elevate a young woman into a symbol of all beauty and all virtue, they nevertheless participate in a theological tradition which lays upon women the heavier burden of blame for the generally fallen condition of humankind:

> They were to good ends, and they are so still,
> But accessory, and principall in ill.
> For that first mariage was our funerall:
> One woman at one blow, then kill'd us all,
> And singly, one by one, they kill us now.
> We doe delightfully our selves allow
> To that consumption; and profusely blinde,
> We kill our selves, to propagate our kinde.
> ("The First Anniversarie," lines 103–10)

Even within the passage are contradictions: Donne concedes that women are "to good ends," yet they "kill" men through sexual intercourse (playing upon the Renaissance pun on death as orgasm); he asserts that intercourse is bad because it shortens men's lives (referring as he did in "Love's Alchymie," to the popular Renaissance superstition that a man's life was shortened by one day each time he had intercourse), yet good because it propagates the race. The passage defines women as the misogynistic pamphlets did—as "necessary evils"—and can be reconciled with the exaltation of Elizabeth Drury as the embodiment of all perfection only through an understanding of the period's ambivalence toward women.

The positive image projected on to Elizabeth Drury in the *Anniversaries*, like the negative image of woman as fickle seductress that

Donne portrayed in some of his love poetry, was an integral part of his culture. He could play with the image of the seductress in his *Songs and Sonnets*, humorously argue that women have a right to be such, point out that men might want the privilege of fickleness too, and be confident that his reader would recognize the stereotype and appreciate the joke. In the *Anniversaries* he could invoke the stereotype of chaste, holy woman and trust that at least some of his readers would see within this image the more complex ideas of the poems.

It is perhaps not surprising that the poet and dramatist Ben Jonson did not understand or appreciate Donne's elaborate praise of Elizabeth Drury, for Jonson's poetic aims and style stood at the opposite pole from those of his contemporary.[10] While Donne was establishing the metaphysical style with its extended, intellectual metaphors and abrupt shifts of thought and tone, Jonson sought to recreate classical forms in lyrics characterized by neatness of imagery and metrical regularity. Whereas Donne exaggerated the popular stereotypes of women to shock and tease his audience, Jonson fulfilled his reader's expectations by building lyrics upon recognizable stereotypes. In one of a loosely connected series of poems entitled "A Celebration of Charis," the speaker expresses rapturous admiration of the lady's purity with a series of metaphors: "Have you seene but a bright Lillie grow / Before rude hands have touch'd it? / Ha'you mark'd but the fall o'the Snow / Before the soyle hath smutch'd it?"[11] In the final poem of the series, however, the speaker, in contrast to the chaste Charis, is portrayed as a grossly sensual and vain woman who defines her "ideal" lover with a crudeness that the misogynistic pamphlets often attributed to women:

> For his Mind, I doe not care,
> That's a Toy, that I could spare:
> Let his Title be but great,
> His Clothes rich, and band [ruff] sit neat,
> Himselfe young, and face be good,
> All I wish is understood.
> What you please, you parts may call,
> 'Tis one good part I'ld lie withall.
>
> (P. 131)

Because Jonson seldom departed from the conventional forms and themes of love poetry, the images of women appear in his poetry much as they did in the pamphlets, without undercutting irony.

The influence of Donne and Jonson on both secular and religious poetry resounded throughout the seventeenth century. In love poetry the model of Jonson led to conventional, stereotyped women, often described with consummate formal elegance:

> Ask me no more where Jove bestows,
> When June is past, the fading rose;
> For in your beauty's orient deep
> These flowers, as in their causes, sleep.
> (Thomas Carew, "A Song")[12]

Donne's varied love poetry exerted influence in several directions, including that of outrageous parody. In a lyric originally written for a play, Sir John Suckling mischievously converts Jonson's image of the pure woman into its opposite, that of the fickle, sensual woman: "Hast thou seen the down i'th'air / When wanton blasts have tossed it. / Or the ship on the sea / When ruder winds have crossed it? / . . . oh, so false, so false, is she!" (pp. 271–72).

The poetry of Robert Herrick, one of the most gifted of the "sons of Ben," serves well to illustrate how the popular controversy over women and the traditional literature of the period can be mutually illuminating, for it reflects a concern with women's adornment that is at once light-hearted and serious. Many of Herrick's lyrics view the elegant dress of women from the perspective of the enraptured lover: "Whenas in silks my Julia goes, / Then, then (me thinks) how sweetly flows / That liquefaction of her clothes" (p. 142). Herrick's lover celebrates the very behavior that the misogynists deplored, the time and art expended by the woman on her appearance. In "Art above Nature, to Julia" he proclaims that he is allured not only by her "Lawny Films" and "airy silks," but also by her various elaborate hairdos, "Tresses bound / Into an oval, square or round, / And knit in knots far more than I / Can tell by tongue, . . ." (p. 135). In Herrick's view (best elaborated in "The Lily in a Crystal") the beauty of nature needs to be softened and ordered by art, while the art of women's dress needs to be animated by nature.

The authors of the misogynistic pamphlets believed that women wanted costly garments to seduce men, that they lavished money and time on their appearance because of both vanity and lust; the writers of conduct books generally shared this view. It is thus striking that Herrick, a devout Anglican clergyman, did not perceive a beautifully

dressed woman as necessarily either proud or unchaste. The speaker in his poetry responds to Julia with a controlled sexual desire as well as an aesthetic appreciation of her beauty, suggesting that it is possible for a man to be captivated by the grace and beauty of a woman without either party resorting to orgies of lust.

Poetry in the century covered by this anthology reflects the images of women and the issues surrounding women found in the popular pamphlets of the time. While examples of all six stereotypes that dominate the popular controversy can be found in the poetry, the three most pervasive are the seductress, the chaste woman, and the holy woman. Similarly, many of the questions debated in the pamphlets are persistent topics in the poetry: Are women capable of chastity and fidelity? Are beauty and chastity compatible in women? Is their pride a vice or a virtue? Do they influence men for good or for evil? While most of the love poetry concerns an individual woman, the issues that surround her are those debated in the controversy. This fact has significant implications not only for the literature, but also for the social history of the period, for while the pamphlets were written for the widest possible audience, most of the poetry was written for a smaller group of aristocratic and courtly readers. In fact, *Astrophil and Stella* and Donne's love poems circulated only in manuscript until after their authors' deaths, and some scholars believe that Shakespeare never intended that his sonnets should be printed at all.[13] The persistence of these issues and stereotypes in poetry written for the highest classes of society—although the poetry sometimes mocks the stereotypes and often treats them with more subtlety than did the authors of the pamphlets—shows them to have been part of the intellectual heritage of the elite as well as of the middle-class English person of the time.

Popular Stereotypes and Renaissance Drama

From the most aristocratic courtier to the lowliest apprentice, Elizabethans and Jacobeans were avid playgoers, and in our period all forms of drama flourished, some designed for a particular audience and some for all classes of society. There were plays and masques written specifically for presentation at court (Jonson's masque of *Hymenaei*, for example, performed at Whitehall to celebrate the marriage of Frances Howard to the earl of Essex); plays performed publicly but

appealing primarily to a courtly audience (John Lyly's *Endymion*, an allegorical drama in which the hero aspires to heavenly love); plays favored by the middle class because they celebrated the virtues of a craftsman or a tradesman (*George a Greene, The Pinner of Wakefield*, probably by Robert Greene). Especially during the reign of Elizabeth, much drama was attended and applauded by all ranks of society; the plays of William Shakespeare are the best example of the universal appeal of the robust Elizabethan theater.

The treatises in this anthology have rich and numerous connections with all varieties of Elizabethan and Jacobean drama, from the aristocratic, allegorical masque to the popular comedies performed at the Globe Theater and its predecessors. With the exception of a number of history plays in which women play only minor roles, the negative and positive images of women found in the pamphlets figure prominently in the drama. (In view of the absence of female actors from the public stage, the prominence of women's roles constitutes an irony best explained in terms of the period's passionate interest in women.) Like the poet, the playwright used the images according to his own genius and his particular dramatic purposes. Through brief discussion of several plays by William Shakespeare, Ben Jonson, and Thomas Dekker, we will discover how three major dramatists of varying temperaments exploited, tested, and in some cases transcended the stereotypes embodied in the treatises.

The large body of feminist criticism of Shakespeare's plays is testimony to the variety and complexity of his women and to the central roles they play in his comedies and tragedies. Our discussion will concentrate on three of his mature dramas in which the negative images of woman as seductress and woman as shrew are accepted by his leading male characters, who then project these images onto the women closest to them. So obdurately fixed are the stereotypes in the minds of these Shakespearean heroes that they act on the presumption of their truth. The actions of the men and the reactions of the women constitute a major source of dramatic tension and conflict in these plays; they also create suffering for both sexes, pain that demonstrates that men and women must strive to see each other as unique individuals. The outcome of the play's action in most cases vindicates the woman and points up the dangers of ready belief in a stereotype.

In *Othello* Shakespeare's tragic hero is manipulated by his trusted subordinate Iago to believe that his wife fits the stereotype of the se-

ductress. Many critics have pointed out Iago's diseased sexuality: his view of sexual intercourse as bestial, his distrust of his own wife, his blindness to any redeeming qualities in women. What the antifeminist treatises help us to see, in addition, is why Othello accepted not only the allegation that Desdemona was having an affair with Cassio but also a vision of her character as fundamentally deceitful and corrupted by lust ("I took you for the cunning whore of Venice / That married with Othello" [4.2.88–89]), a vision of woman already present in the popular imagination of the time.[14]

Iago foists this vision upon Othello, persuading him that women in general betray their husbands: "There's millions now alive / That nightly lie in those unproper beds / Which they dare swear peculiar" (4.1.69–71) and "In Venice they do let heaven see the pranks / They dare not show their husbands; their best conscience / Is not to leave't undone, but kept unknown" (3.3.202–4). Iago's debased view of the female sex is found in *The Schoolhouse of women:* "Yet shall another man come aloft; / Have you once turned your eye and back" and in the *Arraignment*, where Swetnam describes faithless women "holding up to all that come not much unlike a Barber's chair, that so soon as one knave is out another is in." Once Othello is won over to this view of Desdemona, he considers himself her victim and her murder no more than justice.

Desdemona's innocence is mute testimony to the falseness of Iago's stereotype of women; more articulate testimony is provided by his wife Emilia, who, in response to Desdemona's naive denial that any woman would commit adultery, informs her that many women do:

> But I do think it is their husbands' faults
> If wives do fall. Say that they slack their duties
> And pour our treasures into foreign laps;
> Or else break out in peevish jealousies,
> Throwing restraint upon us; or say they strike us,
> Or scant our former having in despite—
> Why, we have galls, and though we have some grace,
> Yet have we some revenge.
>
> (4.3.89–96)

Emilia is of course thinking of Othello's jealousy and of the recent public occasion on which he struck Desdemona, but it is significant that she defends female sexual behavior with the same arguments used by Tattlewell in defending adulterous women: "Some (by the harsh usage

of their too unkind husbands) have been driven to their shifts hardly; some, having had the hard misfortune to match with such Coxcombs as were jealous without a cause, have by their suspicious, dogged, and crabbed dealing towards their wives given too often and too much cause to make their jealousy true." Even more explicitly than Emilia, Tattlewell makes the point that male jealousy can be a "self-fulfilling prophecy"—that is, the woman being treated like an adulteress by her husband is likely to become one.

Continuing her speech, Emilia maintains that women have the same motives (a taste for variety and pleasure) and the same justification (human frailty) for adultery as men do: "The ills we do, their ills instruct us so" (4.3.106). Jane Anger put the matter more bluntly in a verse which, like Emilia's speech, may serve as a warning to men:

> Deceitful men with guile must be repaid,
> And blows for blows who renders not again?
> The man that is of Cuckold's lot afraid,
> From Lechery he ought for to refrain;
> Else shall he have the plague he doth forlorn
> and ought (perforce constrained) to wear the horn.

The feminist treatises offer two answers to the stereotype of the evil seductress: the first is an image of woman as naturally, fundamentally chaste; the second is an assertion that women fall only through the deceitful seductiveness or bad example of men. *Othello* is of course a drama and not a treatise, but nonetheless the leading female characters present these same two responses to the jealous fury of Othello: Desdemona's inability even to imagine an unchaste woman, and the more worldly Emilia's explanation of the unchaste wife in the context of the example set by men.[15]

In *Hamlet* Shakespeare again dramatizes, through the relationship of Hamlet and Ophelia, the dire consequences of the male projection of the stereotype of the lustful woman. Once Hamlet perceives his mother as guilty of lechery in her hasty marriage to Claudius, he concludes that all women are sexually corruptible; when he encounters Ophelia in act 3, he attacks her with dark predictions of her future sexual conduct. After demanding of her whether she is both honest (chaste) and fair, he advises her that "your honesty should admit no discourse to your beauty"; when she is puzzled, he explains, "for the power of beauty will sooner transform honesty from what it is to a

bawd than the force of honesty can translate beauty into his likeness" (3.1.111–14). He then intensifies his attack, bidding her, "Get thee to a nunnery!" with a probable pun on the slang meaning of "nunnery" as brothel.

As countless critics have pointed out, Hamlet's motives and state of mind in this scene are problematic. He may be angry at Ophelia for having followed her father's order to refuse to see him; he may know that he is being observed and wish to confuse or intimidate Claudius and Polonius. But whatever his motives, it is striking that he predicts Ophelia will commit the same sin of which he feels his mother guilty and that he does so with the language and the ideas of the misogynistic treatises: "He that hath a fair wife and a whetstone every one will be whetting thereon; and a Castle is hard to keep when it is assaulted by many, and fair women are commonly catched at" (Swetnam).

Hamlet also excoriates Ophelia for using cosmetics, a subject found in virtually all antifeminist literature of the period, inevitably linked with charges of sexual looseness. The author of *Hic Mulier*, urging women to eschew masculine dress, exclaims, "Away then with these disguises and foul vizards, these unnatural paintings and immodest discoveries!" Hamlet addresses Ophelia with scorn: "I have heard of your paintings too, well enough. God hath given you one face, and you make yourselves another" (3.1.144–46). Not only does he level at Ophelia most of the misogynistic charges found in the popular controversy; he also adopts the manner of crude invective found in so many pamphlets: "If thou wilt needs marry, marry a fool, for wise men know well enough what monsters you make of them" (3.1.139–41). The response of the innocent Ophelia does not address the specific charges, but rather laments Hamlet's fall from dignity and courtliness into both the substance and the manner of a ranting misogynist: "O what a noble mind is here o'erthrown! / The courtier's, soldier's, scholar's, eye, tongue, sword" (3.1.153–54).

One irony of Hamlet's perception of Ophelia as seductress is that Polonius earlier characterized *him* as seducer in much the same terms as Anger and Tattlewell warned women against the deceits of men. When Ophelia tells her father that Hamlet has bound his love for her with "all the holy vows of heaven," Polonius dismisses the vows as "springes to catch woodcocks" and explicitly invokes the double standard of sexual behavior: "With a larger tether may he walk / Than may be given you" (1.3.125–26). Laertes, although willing to concede

that Hamlet may genuinely love his sister, tells Ophelia that the prince is constrained in his choice of a wife by considerations of state and warns her that she would be irreparably damaged, like the bud of a flower attacked by a cankerworm, if she should yield her virginity to him. Both men do Hamlet a disservice, for evidence within the play indicates that his love is honorable. Ophelia is confused by her father's stereotyped view of Hamlet—"I do not know, my lord, what I should think" (1.3.104)—and this confusion marks the beginning of her estrangement from Hamlet, an estrangement which contributes to her madness and subsequent death by leaving her completely isolated after the death of her father. In *Hamlet*, reciprocal sexual stereotyping serves only to compound pain and tragedy.

In Shakespeare's tragicomedy *The Winter's Tale*, Leontes, king of Sicilia and chief protagonist of the play, casts two women in the negative stereotypes found in the antifeminist pamphlets. He sees his wife Hermione as an evil seductress who is not only having an affair with his best friend Polixenes but also aiding her lover in a plot to take his throne. He regards Paulina, wife of his lord Antigonus and friend to Hermione, as purely a shrew: loud, imperious, and irrationally critical. Since we have not thus far noted the appearance of the shrew in the traditional literature, this brief discussion will focus on the relationship of Leontes and Paulina.

The confrontation between them occurs in Leontes' court; when Paulina enters, carrying the infant whom she hopes to use as an argument for Hermione's innocence, a weary Leontes has been contemplating revenge against his wife, speculating that perhaps he could restore his peace of mind by her execution. Paulina addresses him respectfully throughout their entire dialogue, while Leontes falls from regal and courtly language into the shrill invective of the misogynist pamphlets as he castigates both Paulina and her husband:

> Will you not push her out? [To Antigonus] Give
> her the bastard,
> Thou dotard, thou art woman-tired, unroosted,
> By thy Dame Partlet here.
>
> .
> A callat [scold]
> Of boundless tongue, who late hath beat her husband,
> And now baits me!
>
> (2.3.72–74, 89–91)

By perceiving Paulina as a shrew and Antigonus as weak and henpecked, Leontes is able to avoid a direct response to her rational assertions of Hermoine's innocence. When Leontes turns on Antigonus—"thou art worthy to be hanged, / That wilt not stay her tongue"—Antigonus answers him with one of the most popular jokes of the English Renaissance: "Hang all the husbands / That cannot do that feat, you'll leave yourself / Hardly one subject" (2.3.108−10).

The complementary images of the shrew and her helpless husband that Leontes projects onto Paulina and Antigonus resemble those of the misogynistic treatises. Swetnam claims that the husband of a shrew is justified in beating her: "As a sharp bit curbs a froward horse, even so a cursed woman must be roughly used." Similarly, Antigonus several times refers to his wife as a horse: "When she will take the rein, I let her run; / But she'll not stumble" (2.3.50−51). Taylor in *A Juniper Lecture* describes the shrew: "Her delight is chiefly to make debate abroad and to be unquiet at home. . . . It is meat and drink to her to exercise her spleen and envy, and with her twittle twattle to sow strife, debate, contention, division, and discordant heartburning amongst her neighbors. . . . The pride of such a Jade is not to be endured."

Paulina of course is not a shrew; she is rather a woman with the courage that all of Leontes' lords lack, the courage to tell him that he has slandered the honor of his wife and children. She is a complex character with a capacity for deep loyalty and enduring love as well as righteous indignation. Part of her complexity is ambivalence at her own assertiveness; when she observes Leontes' grief at the death of his son and the presumed death of his wife, she apologizes to him by casting herself into a stereotype—"Alas, I have showed too much / The rashness of a woman" (3.2.218−19). Leontes responds by acknowledging, "Thou didst speak but well." He knows that, had he listened to her, he would not have lost his wife and child. When he realizes the magnitude of his mistakes, he takes Paulina as his most trusted advisor, calls her "my true Paulina" (5.1.81), and vows never to remarry without her consent. As he once ignored her words, so he commits himself to respecting all words she shall utter in the future. *The Winter's Tale* is thus another drama revealing the ways that negative stereotyping can interfere with true perception and just action.

Partly because the drama of Ben Jonson is more satirical in intent than that of Shakespeare, many of Jonson's plays portray women as actually embodying the negative or positive stereotypes found in the

treatises rather than as merely perceived by others in stereotypical terms. In *Volpone* (1607) Lady Politic Wouldbe is the quintessentially vain woman who also possesses traits of the shrew. We first meet her as she waits for her audience with Volpone, fussing about her clothes and demanding of her maid, "Is this curl / In his right place, or this?"[16] Toward Volpone she adopts a more courteous tone, but she reveals a ludicrous intellectual vanity in advising him what to take for his ailments, what to read, even how to spend his time. When Mosca enters, Volpone begs for deliverance from "my madame with the everlasting voice" (3.4.5); Mosca invents a story about seeing Lord Politic Wouldbe with "the most cunning courtesan of Venice" and Lady Politic beats a hasty retreat.

Meeting Lord Politic in the street conversing with the gentleman traveler, Lady Politic assumes that the young man is the courtesan in disguise:

> Come, I blush for you, Master Wouldbe, ay;
> And am ashamed you should ha' no more forehead [shame]
> Than thus to be the patron, or St. George,
> To a lewd harlot, a base fricatrice [prostitute],
> A female devil in a male outside.
>
> (4.2.52–56)

Her abusive tone resembles that of one of Taylor's shrews, the jealous wife lecturing to her husband: "I have heard of your jovial meetings with your Queans and Sluts abroad; . . . by your lewd course and company you are made a laughing-stock to your Neighbors, and I poor woman to be pointed at as I go along the street."[17] Lord Politic, the complementary stereotype of the browbeaten husband, limply acquieses in his wife's mistake: "Nay, / And you be such a one / I must bid adieu / To your delights."

The foil to Lady Politic in *Volpone* is the beautiful Celia, stereotype of the chaste woman who values her honor above even her life. Normally as silent, passive, and obedient as Lady Politic is loquacious and aggressive, Celia is one of the few characters whom Volpone and Mosca cannot manipulate, for she has no weaknesses to which they can appeal. Brought to Volpone's residence on the pretense of a social occasion, abandoned there by her husband, Celia pleads with her seducer:

> If you have touch of holy saints, or heaven,
> Do me the grace to let me 'scape. If not,
> Be bountiful and kill me.
>
> (3.7.243−45)

She closes her speech with a promise to pray for him if he will only relent. In response to her impassioned plea, Volpone prepares to rape her; she is saved by the intervention of Bonario, the young man who is her virtuous male counterpart in the drama.

Celia speaks only five lines in the remaining scenes of the play; four of them refer to heaven, mercy, or God. When publicly exonerated of guilt, she cries, "How ready is heav'n to those that pray!" (5.12.5). In the corrupt and debased world of *Volpone*, she alone prays; only for her is heaven a reality. A chaste, holy woman, she is a type of the Roman Lucretia or the biblical Susanna, exemplars of chastity repeatedly invoked by authors of the feminist treatises.

Further development of the character of Celia would not have served Jonson's satirical purpose in *Volpone*. He created Celia and Bonario as contrasts to the wickedness and stupidity of the main characters and as tokens of hope for a better society after the Volpones, Moscas, and Corvinos of the world have been destroyed by their own ruthless greed and ambition. It is noteworthy, however, that for his image of masculine virtue, he made Bonario actively courageous, while for a corresponding image of feminine virtue he made Celia chaste, holy, and, except when her chastity was threatened, silent and obedient.

Several years after the first production of *Volpone*, Jonson wrote the comedy *Epicoene* or *The Silent Woman* (first performed in 1609), whose cast includes a group of women who display not only the vanity, bossiness, and intellectual pretensions of Lady Politic, but also a rampant, overt promiscuity. This play has close ties with the feminist controversy in Renaissance England and in particular with *Hic Mulier* and *Haec Vir*, for it reflects the idea that once a woman violates one convention of her traditional role, she falls into orgies of lust and vanity. The three women—Madam Haughty, Madam Centaure, and Mrs. Mavis—are founding members of a kind of college that is described by Truewit, a young gallant, in the first scene of the play: "an order between courtiers and country-madams, that live from their husbands and give entertainment to all the Wits and Braveries o' the time, . . . cry down or up what they like or dislike in a brain or fashion with

most masculine or rather hermaphroditical authority, and every day gain to their college some new probationer."[18] It is not known whether the portrait of the "Ladies Collegiate" is based upon a group of real London women, but it is clear that Jonson was satirizing behavior that he considered inappropriate for women.

The Collegiate Ladies can be viewed as combining two of the negative stereotypes of women found in the misogynistic pamphlets, the lustful woman and the vain woman. Even more specifically, however, they are comic versions of the unnatural women depicted by the author of *Hic Mulier* as "Masculine in Mood, from bold speech to impudent action," the women addressed scornfully by that author for having "laid by the bashfulness of your natures to gather the impudence of Harlots . . . and buried silence to revive slander." Although it is not clear from the text of the play whether the Collegiate Ladies wear masculine dress, it is clear that they wear what they wish, and their living arrangements (they live completely separate from their husbands in a "college" that resembles a brothel more than a place of learning) constitute a violation of the social norm which is as shocking as masculine dress. In their behavior, in any case, they fit precisely the image of the "masculine" woman of *Hic Mulier:* they are impudent, aggressive, promiscuous, and given to elaborate use of cosmetics.

In inviting the new bride of Morose to join their order, the Ladies openly defend their promiscuity, rationalizing it by the classical notion of *carpe diem:* "We are rivers that cannot be called back, madam: she that now excludes her lovers may live to lie a forsaken beldam in a frozen bed" (4.3.39–41). They appear most sexually depraved (and most ridiculous) in the final act, when Haughty and Centaure compete in an attempt to seduce Dauphine, the young hero of the play. Their vanity, established both by their own behavior and by others' descriptions of them, is often linked with their predatory sexuality; Clerimont says of the Lady Haughty: "There's no man can be admitted until . . . she has painted and perfumed and washed and scoured, but the boy here, and him she wipes her oiled lips upon like a sponge" (1.1.77–80). The image of women as thoroughly lustful is articulated in the play by Captain Otter, who avers that "wives are nasty, sluttish animals" (4.2.53–54), and also by Truewit, who tells Morose that London boasts not a single chaste woman.

Since the bride of Morose is actually a young man disguised as a

girl, the play's cast includes, besides the Collegiate Ladies, only one woman: Mrs. Otter, the very essence of a shrew. Mrs. Otter has complete sovereignty over her husband, whom she allows half a crown a day and three suits of apparel a year; the instrument of her authority is clearly and simply her tongue. Jonson presents the Otters as an inversion of a true marriage, in which the wife submits willingly to her husband's authority while he in turn exercises this authority with a protective gentleness. The Collegiate Ladies, together with the cowardly and effeminate knights John Daw and Amorous La Foole, represent the inversion of an entire courtly social order which dictates that men should demonstrate manliness in feats of arms and horsemanship, while ladies should be chaste, modest, and decorous in their behavior. The play also suggests that women who live apart from the husbands or fathers who should rule them live in a condition of unrestrained lust and vanity.

The belief that in a truly ordered society men and women accept entirely different roles (of which clothes are the symbol) is held by both the male and, ultimately, the female speaker in *Haec Vir;* the idea that once a woman violates one convention of her role she is rendered incapable of self-government and becomes a spendthrift and a wanton is central to *Hic Mulier*. The notion that women in groups exercise a mutually corrupting influence by teaching each other how to deceive and control their husbands is prominent in both *Schoolhouse of women* and *A Juniper Lecture*. Madam Haughty, Madam Centaure, Mrs. Mavis, and Mrs. Otter thus embody, either individually or collectively, virtually every negative stereotype of women found in the misogynistic treatises.[19]

While the body of Shakespeare's drama contains more complex, individualized women than does Jonson's, it is not the case that Shakespeare never stereotyped women while Jonson always did. When Shakespeare wanted to represent the pristine innocence of a new generation, as he did in the tragicomedies, he created stereotypes of the chaste maiden (Miranda in *The Tempest* is a good example), while Jonson's wonderful pig-woman Ursula in *Bartholomew Fair* defies any easy categorization. Yet without doubt Jonson was more given to stereotypes of women than most major poets and dramatists of the period.[20] It is instructive to contrast his drama on this point with that of his contemporary and occasional co-author Thomas Dekker, for

Dekker teased and tested the Renaissance stereotypes of women, ex-aggerating them, inverting them, and even exposing them as essentially false.

Dekker's plays do include examples of conventional stereotypes, usually the wives of artisans, merchants, or tradesmen from the London middle class. In *The Shoemakers' Holiday* (1600), for example, Margery, wife of the play's hero Simon Eyre (a shoemaker who rises to become Lord Mayor of London), is depicted as a frivolous woman excited by her husband's success because of its implications for her wardrobe: "Art thou acquainted with never a fardingale-maker, nor a French-hoode maker, I must enlarge my bumme, ha ha, how shall I looke in a hoode I wonder?"[21] (The author of the *Schoolhouse* charged that men are forced to seek higher positions because "the wife would have a tail / Come raking after, and a bonnet black, / A velvet head.") Unlike the vain women in Jonson's *Epicoene*, however, Margery is fundamentally good-natured, neither scheming nor lustful nor resentful of the insults that her husband heaps upon her.

Women play a larger role in *The Honest Whore*, parts 1 and 2, dramas in which Dekker (who probably collaborated with Thomas Middleton on part 1) takes usually rigid stereotypes and makes them flexible and fluid. Bellafront, a whore when the play opens, not only turns honest when she falls in love with Count Hippolito, but also delivers lectures to her former clients on the evils of lechery. Since Hippolito loves another, she allows herself to be wed to her first lover, Matheo, who in part 2 turns out to be a reckless scoundrel. Hippolito, now married to Infelice, suddenly feels an irresistible sexual attraction for Bellafront, but that honest woman has become a type of the patient Griselda, forgiving her husband his abuse of her and remaining loyal to him throughout. In part 1 Bellafront had attempted to sway Hippolito from his steadfast devotion to Infelice; in part 2 their roles are completely reversed. Dekker also plays with stereotypes in the secondary plot of *The Honest Whore*, part 1. In this plot Viola Candido gains no satisfaction from her shrewish behavior because her husband, a linen draper, endures with patience every stratagem she devises to vex him. Candido himself transcends two stereotypes—henpecked husband and covetous merchant—to become at the play's conclusion an eloquent spokesman for charity, patience, and forgiveness.

Collaborating with Thomas Middleton, Dekker created in *The Roaring Girl* (1610) one of the most attractive women in Renaissance com-

edy, Moll Cutpurse.²² Like Paulina in *The Winter's Tale*, Moll is an antistereotype—in this case of the manlike women attacked in *Hic Mulier*—who reveals the inadequacy of stereotyping as a mode of defining character. A single woman who goes where she wishes and dresses as she chooses (usually in elements of masculine attire), Moll is thoroughly admirable, free without being promiscuous and assertive without being shrewish. In the course of the play's action she aids Sebastian and Mary, the young lovers whose parents oppose the match, saves her friends from being cheated by rogues, and gives a sound drubbing to the lecherous gallant Laxton. While some characters in the play perceive her accurately, the less sympathetic characters describe her with language that anticipates *Hic Mulier:*

> A creature . . . nature hath brought forth
> To mocke the sex of woman.—It is a thing
> One knowes not how to name, her birth began
> Ere she was all made. Tis woman more then man
> Man more then woman, and (which to none can hap)
> The Sunne gives her two shadowes to one shape.
>
> (1.2.130–35)

Because of her dress and behavior (she smokes and frequents taverns), many obtuse characters assume that Moll is dishonest in both Renaissance senses of the word, when in fact she is physically a virgin and morally a revealer of truth in the play. While the tone of Moll's speech is more often playful or witty than angry, she displays righteous indignation when abused. When Laxton gives her gold, thinking to buy sexual favors, she first attacks all men who slander women's reputations and then addresses herself to him:

> But why good fisherman,
> Am I thought meate for you, that never yet
> Had angling rod cast towards me? cause youl'e say
> I'me given to sport, I'me often mery, jest.
> Had mirth no kindred in the world but lust?
> O shame take all her friends then: but how ere
> Thou and the baser world censure my life,
> Ile send them word by thee, . . .
> .
> Tell them 'twere base to yeeld where I have conquer'd.
>
> (3.1.97–106)

Laxton thoroughly deserves the beating he receives, but Moll has no animosity toward men in general and in fact counts many among her good friends. However, Moll is alone and content at the play's end, unlike the traditional Renaissance heroine of comedy, who inevitably marries even if, like Shakespeare's Beatrice, she has vowed to remain single. Moll never wavers from her view that marriage for a woman means loss of autonomy: "I have the head now of myselfe, and am man enough for a woman, marriage is but a chopping and changing, where a maiden looses one head, and has a worse in its place" (2.2.40–44).

Epicoene and *The Roaring Girl*, plays first performed only a year apart, reveal the extremes of attitude in the English Renaissance toward women who stepped outside their traditional role of subservience to men. Jonson's drama presents the Collegiate Ladies as monsters of depravity, while Moll Cutpurse in *The Roaring Girl* is respected and admired (even Sir Alex, who wants to see her hanged at the beginning of the play, apologizes to her at the end). It seems safe to assume that in the Renaissance individual attitudes toward assertive, articulate women lay somewhere between these poles of condemnation and respect. Ambivalent feelings about strong, independent women are reflected in many major plays which we lack space to discuss—Shakespeare's *Macbeth* and *Antony and Cleopatra*, for example, and Webster's two masterpieces, *The White Devil* and *The Duchess of Malfi*. Examination of the heroines of these dramas in the context of the feminist controversy of the period raises tantalizing questions. In the case of Lady Macbeth, for instance, was Shakespeare attempting to show the guilt and weakness that can lie beneath a shrewish, bullying exterior? The Lady Macbeth of act 1 uses all the tactics of the stereotypical shrew to persuade her husband to the murder of Duncan, reminding him of his promise and accusing him of unmanly fear. Then the stereotype suddenly shatters into horror and pathos, as the confident shrew becomes a madwoman whose entire life has slipped from her control.

Of the six major images of women presented in the formal treatises, this brief survey has revealed in Renaissance poetry and drama all but one—the positive image of the nurturing woman. Representations of women caring for children (or anyone more helpless than they) are rare in the traditional literature of the English Renaissance. There are mothers in Shakespeare's plays who care deeply about their children (Hermione in *The Winter's Tale*, for example, and the Dowager Countess in *All's Well That Ends Well*), but other traits of these women

(in the case of Hermione, her patience and stoicism under trial) are stressed more than their nurturing qualities.[23]

Several reasons for the absence of this image may be suggested. First, most traditional literature concerned royal or aristocratic men and women, and women of these classes had servants who performed the routine tasks of caring for the children: Hermione plays with her son, but when she grows tired she has him whisked off by one of her ladies. Second, while the image of the nurturing woman was a positive one, it was not sentimentalized in the Renaissance as it was in later centuries. The nurturing tasks described by Gosynhill and Anger—bringing broth to one's ill husband, changing an infant's diapers, washing clothes for both husband and children—are difficult and exhausting. Willingness to play this role was perceived by the authors as appropriate for a woman, but it was not seen as ennobling her in the way that chastity and holiness do.

Whether appearing as an exalted image of chastity (like Sidney's Stella) or exhibiting a convincing complexity of character (like Shakespeare's Emilia), women figure prominently in every major genre of Renaissance literature. The images of women that we have examined in a few poems and plays are also found in the imaginative prose of the period, both brief prose forms such as the "character" and elaborate forms like the pastoral romance. It is the drama, however, which most clearly reveals the abiding interest in these images among every segment of the English population. The audience of Renaissance drama was far wider than that for poetry or the pamphlets, for it included the large segment of the population who could not read. On a day when all nine public theaters in Shakespeare's London were open, it was theoretically possible for 10 percent of the population to attend.[24] The drama was in Shakespeare's day what the cinema is today, a truly popular art form which both shaped and reflected popular modes of perceiving women. The presence of both stereotypes and antistereotypes of women in this art form suggests both a universal awareness of the stereotypes and a trenchant challenge to their validity on the part of dramatists of the stature of Dekker, Middleton, and Shakespeare.

NOTES

1. For an intelligent and thorough discussion of sex roles, transvestite disguise, and misogyny in English literature from 1540–1620 (with particular emphasis on the drama) see Linda Woodbridge, *Women and the English Renaissance: Literature and the Nature of Womankind, 1540–1620* (Urbana: University of Illinois Press, 1984), chapter 7–12. These chapters are especially valuable for their evidence of fluctuations and trends in the literary portrayal of women that occurred within this eighty-year period. While Woodbridge's analyses of particular texts are generally perceptive, however, her theories can be questioned. In chapter 5, for example, her attempts to demonstrate the influence of the formal controversy about women on imaginative literature are highly speculative. The fact that literary works often employed the same *exempla* as the treatises does not constitute evidence of influence, since these *exempla* were part of the common intellectual heritage of the period.

2. Michael Drayton, *Idea* (1619) in *English Renaissance Poetry: A Collection of Shorter Poems from Skelton to Jonson*, ed. John Williams (New York: W. W. Norton & Co., 1963), p. 219. All our quotations from well-known literary works follow the editorial policy of the edition cited.

3. Sir Philip Sidney, sonnet 62, in *The Poems of Sir Philip Sidney*, ed. William A. Ringler, Jr. (Oxford: Clarendon Press, 1962), p. 196.

4. William Shakespeare, sonnet 137, in *The Signet Classic Shakespeare: The Sonnets*, ed. Sylvan Barnet (New York: New American Library, 1965), p. 177. All subsequent quotations from Shakespeare's poetry and plays are taken from the *Signet Classic* editions.

5. Edmund Spenser, sonnet 61, in *The Minor Poems*, vol. 2, ed. Charles Grosvenor Osgood and Henry Gibbons Lotspeich (1947), vol. 8 of *The Works of Edmund Spenser: A Variorum Edition*, ed. Edwin Greenlaw et al. (Baltimore: Johns Hopkins Press, 1932–), p. 220.

6. For some of our insights into the relationship of lover and lady in the *Amoretti* we are indebted to William Nelson, *The Poetry of Edmund Spenser* (New York: Columbia University Press, 1963), pp. 84–97.

7. We are grateful to Harriet Hawkins for reminding us that many of the sonnets of the *Amoretti* incorporate the familiar Renaissance idea (derived from Neoplatonism) that the appreciation of a woman's beauty can lead to the contemplation and worship of God, the creator of all natural beauty. However, it should be noted that whereas the Christian Neoplatonists regarded the admiration of earthly beauty as simply a low rung on the ladder which ascended to God, Spenser refuses to disparage sexual love and in fact exalts its role in Christian marriage in the *Epithalamion*.

8. John Donne, "Song: Goe, and catche a falling starre," in *John Donne: The Elegies and the Songs and Sonnets*, ed. Helen Gardner (Oxford: Clarendon Press, 1965), pp. 29–30. All subsequent quotations from the love poetry of Donne refer to this edition.

9. John Donne, "A Funerall Elegie," lines 75–78, in *John Donne: The Anniversaries*, ed. Frank Manley (Baltimore: Johns Hopkins Press, 1963), p. 84.

All subsequent quotations from the *Anniversaries* refer to this edition.

10. According to William Drummond, Ben Johnson termed the *Anniversaries* "profane and full of Blasphemies" and remarked "if it had been written of ye Virgin Marie it had been something." Donne responded to Jonson that he described "the Idea of a Woman and not as she was." These quotations are taken from Frank Manley's introduction to his edition of the *Anniversaries*, p. 7.

11. Ben Jonson, "Her Triumph" from "A Celebration of Charis in Ten Lyrick Peeces," in *The Complete Poetry of Ben Jonson*, ed. William B. Hunter, Jr. (New York: W. W. Norton & Co., 1963), p. 125.

12. Thomas Carew, "A Song," in *Ben Jonson and the Cavalier Poets*, ed. Hugh Maclean (New York: W. W. Norton & Co., 1974), p. 184. Quotations from Suckling and Herrick also refer to this edition.

13. In the introduction to the edition cited above (note 4), W. H. Auden writes, "How the sonnets came to be published—whether Shakespeare gave copies to some friend who then betrayed him, or whether some enemy stole them—we shall probably never know. Of one thing I am certain: Shakespeare must have been horrified when they were published" (p. xxxvi).

14. For a perceptive discussion of the relationship of Iago and Othello in the context of Renaissance ideas of cuckoldry see Coppélia Kahn, *Man's Estate: Masculine Identity in Shakespeare* (Berkeley: University of California Press, 1981), pp. 119–46.

15. Bianca, the third major female character, is a prostitute, yet she is treated with some sympathy by Shakespeare. In fact, she appears more capable of genuine love for Cassio than he for her. For an excellent article on the division of attitudes between the men and the women in the play, see Carol Thomas Neely, "Women and Men in *Othello*: 'What should such a fool / Do with so good a woman?'" in *The Woman's Part: Feminist Criticism of Shakespeare*, ed. Carolyn Ruth Swift Lenz, Gayle Greene, and Carol Thomas Neely (Urbana: University of Illinois Press, 1980), pp. 211–39.

16. Ben Jonson, *Volpone*, act 3, sc. 4, lines 2–6, 10–13, in *Ben Jonson: Volpone*, ed. Alvin B. Kernan (1962), p. 109, in *The Yale Ben Jonson*, ed. Alvin B. Kernan and Richard B. Young (New Haven: Yale University Press, 1962–). All subsequent quotations from *Volpone* refer to this edition.

17. John Taylor, "A Lecture of a Wife which was very jealous of her Husband," in *A Juniper Lecture*, pp. 39–42. The quotation is from a passage that is not included in this anthology.

18. Ben Jonson, *Epicoene*, act 1, sc. 1, lines 69–74, in *Ben Jonson: Epicoene*, ed. Edward Partridge (1971), p. 32, in *The Yale Ben Jonson*. All subsequent quotations from *Epicoene* refer to this edition.

19. For an excellent article connecting *Epicoene* to the antifeminism of Jonson's England and demonstrating Jonson's use of Ovid and Juvenal in the play see Barbara Baines and Mary C. Williams, "The Contemporary and Classical Antifeminist Tradition in Jonson's *Epicoene*," *Renaissance Papers* (2977), pp. 43–59.

20. We are inclined to agree with Katherine M. Rogers's statement about

Jonson in *The Troublesome Helpmate: A History of Misogyny in Literature* (Seattle: University of Washington Press, 1966). Rogers writes, "Of the major writers of the Renaissance, Jonson comes the closest to misogyny. His works are conspicuously full of attacks on female failings and conspicuously deficient in portrayals of good women and of romantic love" (p. 132).

21. Thomas Dekker, *The Shoemakers' Holiday*, in act 3, sc. 2, lines 32–34, *The Dramatic Works of Thomas Dekker*, ed. Fredson Bowers (Cambridge: The University Press, 1953) vol. 1, p. 51.

22. In an intriguing article, "Feminists in Elizabethan England," Susan C. Shapiro points out that the prologue to *The Roaring Girl* suggests that many women in Renaissance England were engaging in activities conventionally restricted to men (*History Today* [November 1977]: 703–11). With the exception of Moll, however, the "Roaring Girls" described by Dekker and Middleton are cast into negative stereotypes, two of which are variants of the lustful woman and the vain woman. The authors distinguish three categories of "Roaring Girls":

> One is shee
> That roares at midnight in deepe Taverne bowles,
> That beates the watch, and Constables controuls;
> Another roars i'th day time, sweares, stabbes, gives braves,
> Yet sells her soule to the lust of fooles and slaves.
> Both these are Suburbe-roarers. Then there's (besides)
> A civill Citty-Roaring Girle, whose pride,
> Feasting, and riding, shakes her husbands state,
> And leaves him Roaring through an iron grate. [of debtors' prison]
> None of these Roaring Girles is ours: shee flies
> With wings more lofty.
> (*The Dramatic Works of Thomas Dekker*, vol. 3, p. 12)

Thus Moll, like the real women in the eulogies in this anthology, is seen as an *exception* to the generally negative categories to which women are assigned. The citizens' wives in the play, Mistress Gallipot and Mistress Openwork, also demonstrate aspects of both shrew and seductress, but it must in fairness be added that the gallants who encourage them to deceive their husbands are shallow and irresponsible. The gullible citizens' wives serve as foil to Moll, highlighting by contrast her courage and intelligence.

23. Spenser presents an image of a nurturing woman in book 3 of *The Faerie Queene*, where he describes Belphoebe patiently nursing Timias back to health, but the allegorical signficance of the incident lies in her chastity: by curing the wound in his thigh, she transforms his lust into love. Similarly, in book 1, canto 10, stanzas 30–31, Spenser describes the figure of Charissa, a woman nursing "a multitude of babes" simultaneously, but Charissa is an allegorical representation of Christian charity.

24. Norman N. Holland, *The Shakespearean Imagination: A Critical Introduction* (Bloomington: Indiana University Press, 1964), p. 4.

Part 2
THE TEXTS

A NOTE ON EDITORIAL POLICY

The period covered by this anthology, 1540–1640, includes the most significant Renaissance controversies on the nature of woman. We employed several criteria in selecting these pamphlets from the rich vein of popular writings about woman in this period. All our selections have a lively appeal for the modern reader; moreover, all represent the popular literature of the period, directed specifically to a middle-class audience. The first part of the anthology contains formal treatises from the numerous pamphlet wars of the time, including the most influential and widely read of the attacks on women and the defenses which are best written and most significant in terms of the development of feminist ideas. For the second part, we have chosen representative eulogies and condemnations which reveal the ways in which feminine images and stereotypes from the controversy influenced reports about the lives of real women.

In transcribing and editing the pamphlets in this anthology, we used the earliest edition available on microfilm (see our selected bibliography of pamphlets from the controversy) for all but *The Schoolhouse of women*, for which we collated Petit's 1541 edition with King's 1560 edition in an effort to establish the most readable text; in the case of divergences, we adopted the reading which made the most sense in context. Since we could not include all the pamphlets in their entirety, we summarized the omitted sections in order to give a sense of the whole. The summaries are generally of relatively minor parts of the pamphlets; only in John Taylor's *Juniper Lecture* did we summarize the majority of the work. We wished to include this lengthy pamphlet because it prompted *The women's sharp revenge*, and we believe that the two "lectures" we have transcribed suffice to give the flavor of the work.

In order to make the pamphlets more understandable to the non-

specialist, the texts have been modernized according to the following principles:

1. Spelling has been modernized and regularized throughout, although archaic verb endings have been retained. In the case of obsolete words, we have used the preferred spelling in the *Oxford English Dictionary* wherever possible.

2. Punctuation has been modernized as far as possible, although the original texts do not always conform to strict rules of sentence structure. In altering punctuation, therefore, we have striven primarily for clarity of meaning rather than exact conformity with grammatical technicalities.

3. Italics have been retained only where modern practice would employ them.

4. Capitalization largely follows that of the original text, since we believe that the capitalization of words in the Renaissance was often a form of emphasis; retaining the old capitalization helps to preserve the flavor of the original texts without affecting their clarity. The only changes we have made in this area involve capitalizing proper nouns and initial words when our punctuation changes have created new sentences.

5. Titles of Renaissance writings have been modernized according to the above principles except for well-known literary works such as *The Faerie Queene*, where we have followed accepted practice. We have included a selected bibliography of pamphlets from the controversy which lists the titles in their original form, along with their printers' names and *Short-Title Catalogue* numbers.

6. Quotations from other Renaissance writings have also been modernized according to the above principles except for citations from well-known literary works. In this case we have adopted the editorial policy of the edition cited.

We have annotated all the texts included in this anthology, explaining archaic or obsolete words or word usages (in accordance primarily with the *Oxford English Dictionary*); translating all foreign words or phrases not already translated in the original text; clarifying references to persons, things, or events; and pointing out particularly interesting puns, errors, or misinterpretations in the text. These notes are intended to help the nonspecialist understand, enjoy, and appreciate the pamphlets.

The Controversy

¶ Here begynneth
a lytle boke named
the Schole house
of women: wherin euery man
may rede a goodly prayse
of the condicyons of
women.

The yeare of our Lorde:
M.D.XLІ.

§. Here beginneth a little book named *the Schoolhouse of women.*
wherein every man may read a goodly praise of the conditions of women.
[1541?]

The proverb old whoso denieth
In my conceit[1] doth greatly err;
Both wit and discretion ill he applieth,
That thing of truth would debar.
Howbeit that[2] folk presume so far
Whereby the truth is often blamed,
Yet in no wise truth may be shamed.

A fool of late contrived a book
And all in praise of the femini[ne];
Whoso taketh labor it to overlook[3]
Shall prove all is but flattery.
Paean[4] he calleth it: it may well be
The Peacock is proudest of his fair tail
And so be all women of their apparel.[5]

Wherefore as now in this treatise,
Whatso be said in rude sentence,
Virtue to increase and to lay vice
Is chief occasion of my pretense,[6]

1. Opinion.
2. Although.
3. Read through.
4. This is a reference to *Mulierum Paean* by Edward Gosynhill [1542?]; the second stanza of the *Paean* also contains a reference to this poem, leading some scholars to argue that Gosynhill wrote both works (as he himself seems to claim in the *Paean*). However, the authorship of the *Schoolhouse* is still controversial, despite its attribution to Gosynhill by the *Short-Title Catalogue*.
5. A pun on Paean and peahen.
6. No matter what is said in ignorant opinion, my chief purpose is to increase virtue and strike down vice.

And where that truth is, is none offense.
Whoso, therefore, that blameth me,
I say he deemeth wrongfully.

 Perchance the women take displeasure
Because I rub them on the gall;
To them that good be, peradventure,[7]
It shall not be material.
The other sort, no force at all:[8]
Say what they will or bend the brow,
Themself shall prove my saying true.

 Each other man in general,
And namely those that married be,
Give evident testimonial,
Affirming the same (if I would lie),
And thus report that femini[ne]
Been evil to please and worse to trust,
Crabbed and cumbrous when themself lust.[9]

 Have tongue at large, voice loud and shrill,
Of words wondrous, passing store,[10]
Stomach stout, with froward will,
And namely when ye touch the sore
With one bare word or little more,
They flush and flame, as hot as fire,
And swell as a toad for fervent ire.

[Women never remember praise, "so light of ear they be and sour," but they never forget criticism. They are also full of duplicity, evasions, and excuses. Although women's reason is "not worth a turd" since they are dominated by the senses, yet they constantly hinder men from speaking and insist on having the last word: "Reason will they not attend / But tell their own tale to the end." They are so rooted in malice "that seldom a man may of them hear / One good word in a whole long year." Their greed for clothes and jewelry is boundless and ruinous for a man: "Much they crave and nought give again." However,

7. Perhaps.
8. It does not matter at all.
9. Cross and troublesome whenever they please.
10. Surpassing abundance.

man cannot do without them "for many sundry commodities"[11] that they provide, including tricks such as kissing "with open mouth and rolling eyes, / Tongue to tongue." With a little persistence and entreaty, most women can be sexually wooed and won.]

> And while the wooing time doth last
> (I mean with them that maidens be
> Loath to displease), love sure and fast
> (Or what ye will), and speed may ye.[12]
> Few or none, for the most part,
> Gently entreated, deny you can
> Within her tables to enter your man.[13]
>
> That done, they say that ye did make
> Promise to them by good assurance
> Them to marry and to wives take,
> Else had ye not had such dalliance,
> And all is for fear of good utterance.[14]
> In case the belly do not swell,
> They hold them pleased and all is well.
>
> Yet must ye be at further danger
> If ye do intend to use them oft;
> Keep them both at rack and manger,[15]
> Array them well and lay them soft.
> Yet shall another man come aloft;[16]
> Have you once turned your eye and back,
> Another she will have to smick and smack.

["Perchance the belly may rise withal"; then, despite the number of other men who might have been responsible, the woman will name her lover as the father, pointing to the similarity of appearance: "Nature itself the father will try." If the man does not marry his mistress after the birth, as soon as she is able to travel he will have to pay her ex-

11. A sexual pun, since "commodity" was a slang term for the female genital.
12. You may attain your desire.
13. If asked gently, few women will deny you sexual intercourse. The metaphor comes from the game of backgammon; his "man" is his playing piece, while "her Tables" refers to her portion of the game board.
14. For fear of losing a good reputation.
15. Keep them in abundance and plenty.
16. Have sexual intercourse with her.

penses and send her away to a strange place "as good a maid as she before was"; there she will quickly take up with a new lover.]

Wed them once and then adieu,
Farewell all trust and housewifery.
Keep their chambers and themself mew
For staining of her physiognomy,[17]
And in their bed all day do lie.
Must once or twice every week
Feign themself for to be sick.

Send for this and send for that;
Little or nothing may them please.
"Come in, good gossip,[18] and keep me chat;
I trust it shall do me great ease."
Complain of many a sundry disease;
"A gossip's cup between us twain"[19]
Till she be gotten up again.

Then must she have maids two or three
That may them gossips together bring;
Set them to labor to blear the eye.
Themself will neither wash nor wring,
Bake nor brew, nor other thing.
Sit by the fire; let the maidens trot
Brew of the best in a halfpenny pot.

Play who will, the man must labor
And bring to house all that he may;
The wife again doth nought but glaver[20]
And hold him up with "yea" and "nay."
But of her cup he shall not assay;[21]
Either she saith it is too thin
Or else iwis[22] there is nothing in.

17. They keep themselves withdrawn in their chambers in order not to mar their complexions.
18. Friend (an affectionate term of address among women).
19. Two.
20. Chatter.
21. He shall not try her drink.
22. Indeed, certainly.

[When women gather together, they "babble fast" about all the news; indeed, such gossips' meetings serve as a schoolhouse of women: "Thus learn the younger of the elders' guiding; / Day by day, keeping such schools, / The simple men they make as fools." As these gossips "make good cheer," they tell tales about "whatsoever cometh to memory," especially delighting to criticize their husbands' behavior.]

> The young complaineth unto the old
> Somewhat to ease their hearts thereby;
> The elder saith, "Good gossip, be bold
> To show your mind wholly to me.
> Fear it not; ye know pardie[23]
> That I have been, both old and young,
> Both close and sure of tale and tongue."

> Then saith the younger, "I may tell you
> I am so matched as no woman is.
> Of all this night, till the cock crew,
> He would not once turn, me for to kiss;
> Every night he riseth to piss,
> And when he cometh, again unwarm,
> Doth turn his arse in to my barm.[24]

> "Lappeth[25] himself round all about
> And thrusteth me out of my place;
> Leaveth me scantly one rag or clout[26]
> To cover and cast over my face.
> Full little manner, gossip, he has;
> The most unkindest man have I
> That ever woman laid her by.

> "And be the day never so long,
> He doth nothing but chide and brawl;
> Yea, yea, gossip, the more is my wrong.
> 'Whore' and 'harlot' he doth me call
> And bids me, gossip, scrape and scrawl

23. Truly, verily.
24. Bosom, lap.
25. Wraps.
26. A small piece of cloth.

And for my living labor and sweat,
For as of him, no penny I get.

 "I was accurst or else stark mad,
And when I married with him, unwise;
I may tell you I might have had
Another manner of man than he is.
If I had followed my friends' advice,
I should have had a minion,[27]
A man of land, a gentleman.

 "The devil, gossip, ought me ashame,
And paid I am now, every penny.
Would God he had be[en] blind and lame
That day and hour he first wooed me.
Were not, gossip, these children three,
I would not tarry, ye may be sure,
Longer with him, day nor hour."

 Then saith the elder, "Do as I do;
Be sharp and quick with him again.
If that he chide, chide you also,
And for one word give you him twain.
Keep him short,[28] and have disdain
He should use you after such rate.[29]
Bid him be still with an evil dite.[30]

 "Cherish yourself all that ye may
And draw unto good company;
Cast not yourself, gossip, away
Because he playeth the churl[31] with thee.
And by your will keep him hungry,
And bid him go, when he would game,
Unto his customers,[32] God give him shame.

27. A gallant.
28. Press him hard (in a quarrel).
29. In such a manner.
30. Clamor.
31. A boorish and stingy person.
32. Common women, prostitutes (to "game" is to indulge in amorous play).

"Be ever with him at 'yea' and 'nay,'
And by your will begin the war.
If he would smite, then may ye say,
'Go to heartily, if thou so dare;
I beshrew[33] thy heart if that thou spare.
All the world shall wonder on thee,
How thou dost wreak thy ten of me.[34]

" 'Because thou hast be[en] at the dice
And played away all that thou hast,
Or from thy gillottes[35] thou couldst not rise,
Of all this day ye sat so fast.
And now, God give thee shame, at last
Comest drunken home with a mischief[36]
And wouldst be revenged upon thy wife.

" 'Better iwis to hold thy hand
And more is for thine honesty.
I had liefer thy neck were in a band
Than I would take it long of thee.[37]
Trust me, I will find remedy.
Smite and[38] thou dare; I make God a vow:
I will acquit it, I wot well how.'[39]

"In case there be no remedy
But that ye must have strokes sad,
Take up the babe that then is nigh,
Be it wench or be it lad,
And bid him strike if he be mad,
'Smite heartily and kill thy son;
And hang therefor[40] when thou hast done.' "

33. Curse.
34. Beat me with ten fingers (both hands).
35. Loose women, prostitutes.
36. With a vengeance (a common expletive).
37. I had rather your neck were in a noose than I would long endure such abuse from you.
38. If.
39. I will requite it, I know well how.
40. For the deed.

Thus among they keep such schools,
The young to draw after the old,
Moting[41] ever upon their stools
Of every matter that they have wold,[42]
By mean[s] whereof the young wax bold,
So that within a month they be
Quartermaster, or more than he.

Truly, some men there be
That live alway[s] in great horror
And say it goeth by destiny
To hang or wed: both hath one hour.
And whether[43] it be, I am well sure
Hanging is better of the twain:
Sooner done and shorter pain.

On pilgrimage, then, must they go
To Willesden, Barking, or to some hallows.[44]
Perchance be forth a night or two,
On foot for wearying of horse shows;[45]
A voyage make unto the stews,
And neither kneel to stones nor stocks,
But the offering take with a quick box.[46]

Sometime also license they crave
To be with some neighbor i[n] the midwives' stead,
And all to the end some other knave

41. Finding fault.
42. Have at their command.
43. Whichever.
44. They say they must go on a pilgrimage to some holy place like Willesden or Barking, boroughs outside of London with medieval monasteries or abbeys.
45. They will be gone from home a night or two because they are traveling on foot instead of on horseback.
46. They will actually go to the brothels ("stews") for some sexual pleasure and possibly profit. This passage contains a bold pun linking the religious and sexual spheres (to contrast the women's professed versus actual activity). To "kneel to stones and stocks" means to worship wood and stone images of divinity; moreover, in religious services an "offering" (monetary token of devotion) is made in the "collecting-box." An altogether different sort of offering would be made in the stews, however, and the author may also be hinting at the use of "box" as a vulgar term for the female genital.

Shall dub her husband a summer bird.[47]
The truth is so known; it cannot be hid:
Albeit that few men do him hear,
The cuckoo singeth every year.

They have also another cast:[48]
In case the husband be present,
The child, I warrant, shall be cast[49]
And to her lover therewith sent.
The silly man, none evil meant,[50]
Regardeth little or nothing this:
How by the babe she sends her kiss.

And for she would be reckoned true,
The matter to cloak more craftily,
Her "kinsman" call him, I warrant you,
And all to blear the husband's eye.[51]
God wot[52] the blind eateth many a fly;
So doth the husband often iwis
Father the child that is not his.

Trim themself every day new,
And in their glasses pore and pry,
Plait and plant, and their hairs hue,[53]
And all to make it for the eye
The finest wear[54] that they may buy.
And all that ever they may imagine[55]
Is to allure the masculine.

[Besides their costly apparel, women demand exotic foods and dainties which serve to increase their sexual appetites and "set on a heat."

47. A cuckoo (symbol of the cuckold, or man whose wife has been unfaithful to him).
48. A trick.
49. Readied for some action.
50. Imagining no evil.
51. To hoodwink the husband.
52. Knows.
53. Arrange (and possibly color) their hair.
54. Clothing.
55. Devise, plan.

As Teiresias[56] testified, "the woman is far more lecherous" than the man; although one cock supplies fifteen hens, fifteen men will not be sufficient for one woman. Moreover, men should never trust the tears of a woman, since these are merely crafty tricks to gull men.]

 And yet among, whoso will thrive
And office bear in town and city
Must needs be ruled by his wife,
Or else, in fay,[57] it will not be.
The wife must able him to the degree;[58]
Able or unable, little careth she,
Because herself would honored be.

 "Fear not," she saith unto her spouse,
"A man or a mouse whether be ye.
Should ye your honesty[59] refuse
And be as like as other men be
In person and in each degree?
Take it upon you; do not refuse,
And I myself will find[60] your house."

 So, by the mean[s] of her counsel,
The man may not the office forsake.
Because the wife would have a tail[61]
Come raking after, and a bonnet black,
A velvet head, and also be take[n]
With the best and not the worst,
The man must be ruled till all be in the dust.

 Of all the diseases that ever were,
Wedding is next unto the gout;
A salve there is for every sore
To help a man within or without,
But of these two I am in doubt.

56. In classical mythology, the blind prophet Teiresias was presented as the ultimate judge of male and female sexual activity and pleasure, since he spent seven years of his life as a woman.
57. In truth.
58. She must make it possible for him to reach high rank or office.
59. High rank; honorable position.
60. Maintain.
61. The train of a gown.

No pain so fervent, hot nor cold,
As is a man to be called Cuckold.

And be he never so fearful to fray,[62]
So stark a coward, yet will he rage
And draw his knife, even straightway;
Be he never so far in age,
Call him once Cuckold and his courage
Forthwith will kindle and force him strike
Worse than ye named him heretic.

And since there is no salve therefor,
It putteth many a man in fear
To be infect with the selfsame sore;
How well soever they them bear,
Good token have they also elsewhere
That whosoever weddeth a wife
Is sure of sorrow all his life.

Of Socrates, the patient,
Example good of his wives twain,[63]
Which on a time fell at dissent
And unto him did them complain.
He laughed thereat, and they again
Fall both on him; with an evil dite,
A piss-pot they break upon his pate.

He held him pleased and well content;
The piss ran down by his cheeks twain.
"Well wist[64] I," said he, "what it meant,
And true it is that all men sain[65]
That after thunder cometh rain."
Who hath a wife is sure to find
At home in his house many a sour wind.

["A certain wife" begins an argument with the author, claiming that woman, being drawn from the rib of Adam, was made to "be help to

62. Quarrel or fight.
63. According to some traditions, the ancient Greek philosopher Socrates had two wives, the notorious scold Xanthippe and a woman named Myrto.
64. Know.
65. Say.

the man in word and deed." Although men "babble / That women always are variable," their origin proves that women are "ever substantial." However, since man was made from the earth, which is less stable and unchanging than a rib, he is actually the more changeable creature, following the nature of "his first original." The author counters this argument with the charge that woman only helps man "evil to thrive and worse to fare," citing the first transgression of Eve. He continues by drawing his own conclusions about woman's original nature.]

> "Made of a bone ye said were ye;
> Truth it is I cannot deny.
> Crooked it was, stiff and sturdy,
> And that would bend no manner of way;
> Of nature like, I dare well say,
> Of that condition all women be,
> Evil to rule, both stiff and sturdy.[66]
>
> "And over that who listeth[67] to try,
> Put me two bones in a bag,
> Or mo[re] as it is of quantity.
> That done, hold it somewhat sag;[68]
> Shake it also that it may wag,
> And ye shall hear none other matter
> Of these bones but clitter clatter.
>
> "Like so of women in field and town:
> Assembled where that many be,
> A man may hear them by the sound
> Farther far than the eye may see.
> Wherefore men say most commonly,
> 'Where many geese be, are many turds,
> And where be women, are many words.'"

[For this reason, the "singular treasure" that a man receives from his wife is the fact that "he needeth never an ill word to crave / All the

66. This is a pun on the physical versus the psychological reference of "stiff and sturdy"; when applied to persons, these adjectives usually meant "obstinate and disobedient."

67. Desires.

68. Hanging or sagging down.

days of his long life," because he will hear plenty from his wife. In fact, the story of woman's creation from the rib of Adam is not quite accurate, for a dog ran away with the rib and ate it, forcing God to make woman out of the dog's rib. This is why the woman "at her husband doth bark and bawl, / As doth the cur, for nought at all."]

> Another reason, if ye mark well,
> Doth cause the woman of words be rife.
> A certain man, as fortune fell,
> A woman tongueless wedded to wife;
> Whose frowning countenance perceiving belive,[69]
> Till he might know what she meant, he thought long
> And wished full oft she had a tongue.

> The devil was ready and appeared anon;
> An aspen leaf he bade the man take
> And in her mouth should put but one.
> "A tongue," said the devil, "it shall her make."
> Till he had done, his head did ache;
> Leaves he gathered and took plenty,
> And in her mouth put two or three.

> Within a while, the medicine wrought,
> The man could tarry no longer time,
> But wakened her to th[e] end he mought[70]
> The virtue prove of the medicine.
> The first word she spoke to him,
> She said, "Thou whoreson, knave, and thief,
> How durst thou waken me with a mischief?"

> From that day forward, she never ceased;
> Her boister babble grieved him sore.
> The devil he met and him entreated
> To make her tongueless as she was before.
> "Not so," said the devil, "I will meddle no more.
> A devil a woman to speak may constrain,
> But all that in hell be cannot let[71] it again."

69. Eagerly.
70. Might.
71. Stop.

And by proof daily we see
What inclination nature maketh:
The aspen leaf, hanging where it be,
With little wind or none it shaketh;
A woman's tongue in like wise taketh
Little ease and little rest,
For if it should, the heart would brest.[72]

[Although men say that "woman to man is most comfort," what they actually mean is that she is an utter torment. A woman is variable and inconstant; like a mare which has been tamed, a woman will allow any man into the saddle. Therefore, a husband planning a journey ought first to offer a candle to the devil to oversee his wife in his absence, although even Satan cannot guarantee a woman's chastity.]

Another thing, as principle,
Be not with her in Jealousy
What misadventure soever befall;
Forbid her no man's company
Nor yet rebuke her singularly.
In case thou do, though thou hadst sworn,
A blast shalt thou blow in Ninerus' horn.[73]

For as we see by experience
Every day before our eye
And by report of men of credence,
For the most part the femini[ne],
By their innative[74] destiny,
First and foremost, when they be chid,
Will that thing do they be forbid.

And over that, thy wife present,[75]
I counsel thee, be wise, and ware[76]
Thou praise no other man's Instrument

72. Burst.
73. Ninerus may be a misspelling of Misenus, the Trojan trumpeter in Virgil's *Aeneid* who was drowned because he had rashly challenged the sea deity Triton to a horn-playing duel. "A blast on Misenus's horn" would thus be an invitation to disaster.
74. Innate, native.
75. When your wife is present.
76. Take heed.

Better than thine own bearing ware;[77]
For if thou do, she will not spare,
Were it never so natural a fool,
Till she have assayed the selfsame tool.

So frail they be of disposition,
So crooked, so crabbed, with that so ill,
So lewd, so shrewd, light of condition,
That sure it were impossible
To let[78] them of their own self will;
And but it come of their own mind,
A man were as good throw stones at the wind.

[As proof of the willfulness of women, the author relates a story about a man who decides to test his wife's obedience by commanding her to remove the pot from the fire when the dinner is nearly cooked. Calling him a madman, she at first refuses; when "for fear at last" she does remove the pot, she throws its contents on his head, swearing that "he might her trust, / She would with the potage do what her lust."[79] Thus it does no good "to prattle to them of reason or law," for women will always "follow their own will." Furthermore, women lack discretion and reason; instead, they always "bibble babble of every matter." They are also hypocrites, presenting themselves to the world as "holy saints" and angels, but leading "a devilish life" at home.]

And that more is, I dare avow,
That if thy wife displeasure take,
Be it right or wrong, yet thou
Must needs of force[80] for their wives' sake
Fight and fray and high words crake,[81]
Swear and stare, as who would say
Thou wouldst not let to kill and slay.

In case thou take the matter light,
As man of peace, love, and concord,

77. Penis.
78. Hinder.
79. She would do as she liked with the food.
80. Must necessarily and unavoidably.
81. Harshly utter loud words.

Then will she weep anon forthright[82]
And give thee many an evil word,
And bid thee gird to thee thy sword,
And say, "If I had married a man,
This thing should not be long undone."

Record the wicked Jezebel,
Which would have slain good Elias;[83]
Record also of the gospel
The wife of Philip, Herodias,[84]
Which through her daughter brought to pass
That Herod her granted, ere that they wist,
To give her the head of John Baptist.

Thus where themselves may little do
As in regard of corporal might,
Of cruelness they rest not so
But steer their husbands for to fight.
The proverb old accordeth right:
Women and dogs causeth much strife
And most occasion to be mischief.

[Although women are physically weak, "of body much impotent," if once they get the upper hand, they will act without pity. For example, with nothing but "crooked language" the maidservant in the New Testament caused Peter to deny Christ three times.]

Some men there be also that say
"Be she single or be she wed,
Too much she coveteth of chamber play."
As did Byblis the thing for bed
Presume to be in her mother's stead;

82. Immediately.
83. Jezebel was the pagan wife of Ahab, king of northern Israel; she tried unsuccessfully to destroy the Hebrew prophet Elias (Elijah). In the Old Testament her name is synonymous with lewdness and idolatry.
84. Herodias divorced her first husband, Herod Philip, to marry Herod Antipas, the tetrarch of Galilee; through the seductive dancing of her daughter, Salome, she persuaded Herod to behead the New Testament prophet John the Baptist, who had criticized her behavior.

Myrrha also inordinately
With her own father found means to lie.[85]

 The daughters twain of Lot the sage,
Having like tickle in their tail,
Could not refrain their willful rage[86]
To satisfy; with evil hail,[87]
Their father feasted with costly vittle,
Made him drunk, and so at last
Meddled with him, he sleeping fast.[88]

 Examples hereof divers there be
To approve[89] my saying, as straight as a line,
As first of the abominable Pasiphae,
And then the insatiate Messalina,
Pyrrha, Fabulla, and fair Helen,[90]
With other thousands, many mo[re],
Which all to recite would never be do[ne].

 I pray you, why was Adam shent[91]
Because he only did transgress?
Eve him moved first to consent;
To eat of the apple she did him dress,[92]
So all came of her willfulness.
And since that woman that offense began,
She is more to blame than is the man.

85. According to Ovid's mythological poem, the *Metamorphoses*, Myrrha tricked her father into unwittingly taking her to his bed; Byblis, however, conceived an incestuous passion for her brother, not her father.
86. Violent sexual passion.
87. With an unfortunate outcome.
88. As this story is told in Genesis 19:31–38, the two daughters of Lot slept with their father in order to bear sons and preserve the race after the destruction of the wicked cities of Sodom and Gomorrah.
89. Corroborate.
90. In this passage the author mixes mythological, literary, and historical examples. In classical mythology, Pasiphae was the Cretan queen who conceived an unnatural passion for a bull and gave birth to the Minotaur, while Helen was the cause of the Trojan War. Messalina was an historical figure, the promiscuous wife of the Roman emperor Claudius; she became a byword for sexual excess. Pyrrha was a literary figure; the Roman poet Horace uses this name in a famous ode about the inconstancy of women (*Odes* 1.5).
91. Blamed.
92. Direct.

[The Old Testament offers many examples of wicked and destructive women, such as Delilah and Lot's wife. The wife of Job was one of his chief torments, full of "scorns and mocks," constantly reviling his patient acceptance of the sufferings sent by God to test him: "And thou liest here with many a boil / Prating and praying to the divine / And worse then thou stinkest than a dead swine."[93] The "wanton wife of king Pharaoh" had Joseph cast in prison because he rejected her advances.]

> In women all, this property
> Is known sure and manifest:
> That if a man may come so nigh
> To show them game[94] that they love best
> And will not do it, then will they Jest;[95]
> But trust me sure that with the heart
> They will never love him afterward.
>
> The wise man saith in his proverbs,
> "A strumpet's lips are dulce[96] as honey,
> But in her dealing she is sour as herbs,
> Wormwood, or rue, or worse," saith he.
> For when them liketh to mock[97] with thee,
> With tongue and eye such semblance[98] they show
> That hard it were them to mistrow.[99]
>
> As though they spoke with mouth and heart,
> With face they make so good semblance
> That hard it were a man to start
> From their fair, glozing countenance;[100]
> Thus with their sugared utterance
> The simple men, that mean but just,
> Deceived are where they most trust.

93. This is a considerable expansion of the wife's role in Job 2:9, where she simply counsels him to "curse God and die."
94. Amorous sport or play.
95. Jeer, mock.
96. Sweet.
97. Sport.
98. Deceptive appearance.
99. Disbelieve, suspect.
100. It is hard to wrench a man away from their fair, flattering faces.

[Women will take a man for everything he has: "So they may be trimmed and fed of the best, / They have no remorse who beareth the name / Nor whom they put to open shame." This is demonstrated by the Old Testament story of the widow Tamar, who tricked her father-in-law into sexual intercourse so that she might have a son and then publicly revealed him as the father of her child.[101] Thus women will not even leave a man his good name: "Be thy back turned, anon they rail / And say for all your counsel good, / Ye had liefer[102] a bare arse than a furred hood." A woman can never keep anything to herself (except possibly when she is asleep), even when it is a "matter of limb and life." Moreover, women are "litigious," scolding, envious, and proud, as demonstrated by the Old Testament story of Jezebel and the book of Boccaccio.[103] According to a proverb of Solomon, there are three things "seldom or never saturate": the first is Hell; the second, "a woman's water gate"; the third, the ground.[104] Indeed, women are included in all the proverbial triads of evil things: "And ever, I warrant, the woman is one." For all these reasons, the author concludes, each man should plainly state that "in the woman / Is little thing of praise worthy, / Lettered or unlearned whether they be." Women have "two venial sins" which prevent them from being glorified: "They can neither do nor say well." Finally, the author appends to his poem an envoy ("Go forth, little book") in which he states that any woman who is displeased with his writing "because it toucheth her properly" ought to mend her ways instead of criticize. He did not write with any "ill intent," but rather that "the masculine might hereby / Have somewhat to jest with the femini[ne]."]

101. As this story is told in Genesis 38, Tamar is not greedy, lustful, or spiteful, but is rather courageously claiming her legal right to motherhood.

102. Rather.

103. Giovanni Boccaccio, the fourteenth-century Italian writer whose *De claris mulieribus* (biographies of famous women written in Latin) was an important source-book for Renaissance writers.

104. The author changes the emphasis of Proverbs 30:15–16 (which lists the three insatiable things as "the grave, and the barren womb, and the earth that is not filled with water"), shifting from a procreative to a genital image of desire.

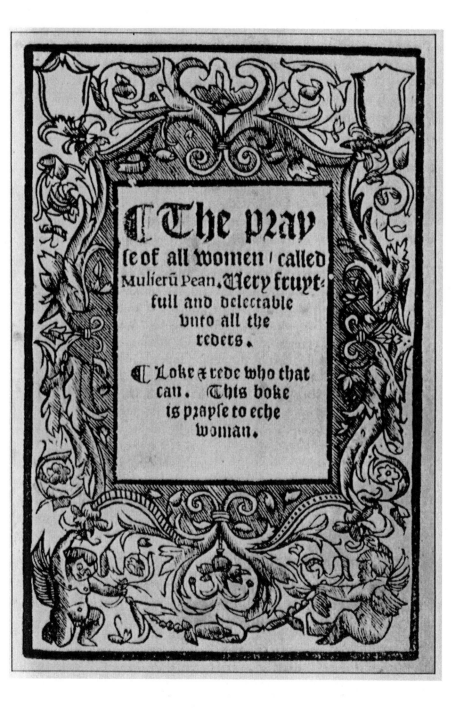

❡ The pray
se of all women / called
Mulierū Pean. Very fruyt-
full and delectable
vnto all the
reders.

❡ Loke & rede who that
can . This boke
is prayse to eche
woman.

§. The praise of all women,
called *Mulierum Paean*:
Very fruitful and delectable
unto all the readers.
Look and read who that can;
this book is praise
to each woman.
Edward Gosynhill
[1542?]

What time the crab[1] his course had passed
And Phoebus[2] attained the Aquarius,
The selfsame time when it froze fast
Amidst the month of January,
I in my bed and sleep in mine eye,
A sudden assembly before me did appear,
And women they seemed by habit and cheer.[3]

"Awake," they said, "sleep not so fast.
Consider our grief and how we be blamed,
And all by a book that lately is passed
Which by report by thee was first framed,
The school of women, none author named.[4]
In print it is passed, lewdly compiled;
All women whereby be sore reviled.

"Consider therein thine own good name;
Consider also our infamy.
Send forth some other, contrary the same,
For thine and ours, both honesty:

1. The constellation Cancer.
2. The sun.
3. Clothing and face.
4. Gosynhill is here referring to *The Schoolhouse of women*, published anonymously
in 1541 or 1542, which also contains a reference to the *Paean* in its second stanza.

157

The *Paean* thou wrote and lieth thee by.[5]
Be quick herein; prolong not thus:
As thou wouldst[6] our favor, now do for us."

 Amongst all other, one boldly pressed.
"Obey," said she, "shalt thou, be thou never so strong."
Her mace[7] and her mantle she threw on my breast.
"For I am she," said she, "thou hast do[ne] most wrong.
Awake, awake! Thou sleepest over long.
Venus am I clept;[8] my name shall not be hid.
Now sharpen thy pen and write as I thee bid."

[Venus begins by arguing that "the nature of man inclineth to sin /
Rather than virtue," for one of Adam's first acts was to try to deceive
God by shifting all the blame for his disobedience onto Eve. Ever
since, man has continued "to rail and jest" against women. All other
species live at rest with their own kind; only man, "of manner so rude,
/ Cannot say well by his similitude." Men shamefully denigrate "the
selfsame thing which most they should / Laud and love," for women
are essential to men, having been created by God specifically "to help
and assist" them. Despite this, men "fast pore and pry" to find criti-
cisms of women, mining the Scriptures and the poets for quotations
against women and even misinterpreting "with a lewd gloss" some
that do not suit their purpose. Venus promises that she will counter
this type of "faint and feeble" argument later; meanwhile she resumes
her defense of women.]

 "How should this world continued be,
 Man, I mean, in his most need;
 Were not women, what were ye?
 Examples many hereof may ye read,
 And over that ye see indeed
 How by the virtue of the feminine face
 Mirth increaseth and thoughts give place.[9]

 5. Is stored up; remains unpublished.
 6. Desire.
 7. Staff of office (laid on a person's shoulder to arrest him).
 8. Named. Venus, the Roman goddess of love and beauty, symbolizes the female sex-
uality so energetically attacked in the *Schoolhouse*.
 9. Joy increases and anxieties give way.

"Exampled in Saul,[10] when he should fight
Against the army Philistine,
Had neither heart, courage, nor might,
Nor wist[11] not what to do therein,
With hungry thought himself to pine;
Had not the woman him counseled and fed,
For fear in that fury Saul had be[en] dead.

"When ye lie sick and like to die,
Who then attendeth you unto?
Were not the woman, there might ye lie,
Dung in your den as beasts do.
The woman is every ready to go
For this and that, to watch and wake,
You to recover[12] many labors to take.

"If that your finger other[13] head ache,
Or else what aileth you, hand or foot,
There can no medicine the pain aslake[14]
Without the woman be your boot,[15]
Lap[16] you warm in clothes soft,
A kerchief bind unto your head,
And in her arms bear you to bed.

"Night and day then must she wake
And ready be at the first call,
A cullis or some caudle[17] make
As for the sick doth best befall;
Unless the woman come withal,

10. When Saul, the first king of Israel, was facing battle with the Philistines, he consulted a woman with special powers ("the witch of Endor") to discover the future. Upon his subsequent collapse from distress and lack of food, the woman revived his strength by preparing food and forcing him to eat.

11. Knew.

12. Bring back to health.

13. Or.

14. Alleviate.

15. Helper, bringer of relief.

16. Wrap.

17. A nourishing broth or a warm, sweetened drink mixed with wine or ale; both were primarily prepared for sick people.

No man can get him up to sit
Thereof to taste morsel or bit.

"Thus of the woman great pleasures ye have
Which man to man cannot suffice,
And yet ye do us all deprave,[18]
Saying we be neither sad[19] nor wise
And that no profit by us doth rise;
Whereas in truth record I can,
As many arise as by the man."

[Venus gives examples of benefits brought to the human race by women: the goddess Ceres invented agriculture; the goddess Carmenta, the alphabet; the goddess Pallas Athena, weaving and olive oil. The poet Sappho taught "the harp to sing the tune" which brings comfort to man, while the pagan sibyls prophesied that "the son of god should man become." Venus avers that she would offer many more such examples if poetry were not "taken now in such despite"; instead, therefore, she will draw her arguments from life, beginning with the woman's crucial role in the conception and rearing of children.]

"As soon as the woman doth conceive,
Full divers[20] is her appetite;
Both belly and heart doth rise and heave.[21]
The stomach seldom satisfied
For many sundry meats provide;
Long for more than she may get,
And many a sorry morsel eat.

"In case she may it not obtain,
Hard[22] she escapeth with the life,
And in her labor such is the pain
That (as God knoweth) the urgent grief,
Without a gracious prerogative,

18. Vilify.
19. Trustworthy and sober.
20. Varied (possibly with the additional suggestion of perversity).
21. Swell.
22. Hardly.

Were thing no doubt impossible
She should escape and after have hale.[23]

"And when she is delivered,
Sick and weep[24] continually,
And as ye know but little considered
With many a man (the more blame he).
Who but the woman must keeper be,
Provide for every rag and clout,[25]
And in her arms bear you about?

"In case the man such labor should take,
I mean to bear you to and fro,
His arms and shoulders would so ache
That lame he would be of both two.
The silly[26] woman hath never do[ne],
What in her arms and in her lap
Night and day she must you wrap.[27]

"Little or nothing may she rest,
But always busy you for to keep;
Arise and feed you with her breast,
And all to still you when ye weep,
Whereof yourself, ye can scant creep.
She must be ready to give you pap,
From wind and weather you warm to lap.

"The man may lie and snore full fast,
When that the wife must watch and wake,
Out of the bed her arms cast,
The cradle to rock till they both ache;
The babe also unto her take,
And when he is unclean beneath,
Must be content with many ill breath.[28]

23. Good health.
24. This may be a misprint for "weak."
25. A piece of cloth; here clearly swaddling clothes and diapers.
26. Deserving of compassion.
27. She can never finish her labors and must constantly carry the infant about.
28. Odor.

"Shift him oft, wipe and wash,
Clouts and clothes new prepare,
And be it hard or be it nesh,[29]
The woman must do away the ware.[30]
Thus hath the mother all the care,
All the labor and disease,
Whereas the father doth what him please.

"When that ye draw near twelve months old,
Then may the woman neither rest nor sit,
But ever dandle you in sure hold
Till time that ye have found your feet.
Her breasts ye tear with many a bite
And scratch also with your sharp nails;
And yet the woman you never fails.

"Whereas the man would sure disdain
And be therewith impatient,
And peradventure strike again,
Neither be eftsoons[31] so diligent,
If once ye did him discontent;
For, as ye see, when him misliketh,[32]
The man daily his children striketh.

"The mother tendeth them alway
And scant can suffer them in the wind;
Of them in doubt both night and day
Lest any malchance should them blind.[33]
Ought you not then to the woman to be kind?
Howbeit,[34] ye have no better sport
Than of the woman evil to report.

"Some say the woman had no tongue
After that god had her create[d],

29. Soft.
30. The woman must clean up the mess ("ware," or "matter," is clearly a euphemism for the baby's bowel movement).
31. Again.
32. When he is displeased.
33. Lest any ill fortune should suddenly meet them.
34. Nevertheless.

Until the man took leaves long
And put them under her palate;
An aspen leaf of the devil he got,
And for[35] it moveth with every wind,
They say women's tongues be of like kind.

 "I say the fable rehearsed before
(The truth well known) is but a lie;
All the clerks[36] that ever were
Do write the same and testify
That God made all thing perfectly.
How should the woman then tongue have none
And be of God's creation?

 "Because that Eve, our prime parent,
The will of God did once transgress,
They blame all women in like consent
And make themself always faultless.
There be of women, as of men doubtless,
Albeit that divers have offended,[37]
Yet ought not all to be reprehended.

 "All manner cloth is not like fine,
Nor yet all men complexioned like:
Some more of choler, some more sanguine,
Some melancholy, some phlegmatic,[38]
Some long and small, some short and thick.
Not every man of one complexion,
Nor every woman of one condition.

 "Why should the woman then be blamed
More than the man, and he like bad?
Methinks ye ought to be ashamed

35. Since.
36. Clergymen (with the added implication of scholars).
37. Admitting that some number have offended.
38. It was believed that the human liver produced four vital liquids, or "humors," whose balance was necessary for health. However, it was thought that one of these humors was usually dominant in each person, giving him his individual "complexion" or temperament: if choler was predominant, the individual was "choleric," or bad-tempered; if blood, he was "sanguine," or passionate; if black bile, he was "melancholic," or gloomy; if phlegm, he was "phlegmatic," or sluggish and unemotional.

And also in conscience sore adrade[39]
(In case that ye any conscience had);
Witness Saint Paul, it doth no man beseem
Worse of another than of himself to deem."[40]

[Although woman was the first to transgress, it was through a woman that redemption came. Moreover, man was made of "vile earth," but woman was made of a much more highly valued material, a rib. In creation, man is but the adjective, while woman is "the substantive" or noun: "The man in like effect also / Without the woman's helping hand / By himself may not long stand." The Bible shows many examples of God's special favor to women, especially in bringing forth children from women past the childbearing age: Elizabeth, Anne, and the mothers of Joseph, Isaac, Samuel, and Samson.]

"Over that, it may not be nay'ed:
When man had broken the precept,
Seeing himself so nakedly arrayed,
For shame among the leaves he crept.
God him called; he no foot stepped,
But blamed the woman for his consent
To fortify his evil intent.

"But what said God? Look and read:
'Maladicta terra in opere tuo,[41]
Cursed be the earth thou dost on feed,
And sweat for thy living thou shalt also.'
Mind had he none to call for grace, though;
So where God made him of earth, or then
If he cursed the earth, he cursed man.

"So of the woman it cannot be said,
For she of a rib was made before.
But for she was so lightly betrayed,
Penance she had, but not so sore.
Curst was she not; howbeit evermore,

39. Greatly frightened.
40. According to the Apostle Paul, it is not fitting for any man to judge another more stringently than himself.
41. "Cursed be the earth in your labor."

God said, in childing[42] when she did lie,
With sorrow her seed should multiply.

"That man was curst oft we read
Besides that I rehearsed have,
As Cain and Ham for their lewd deed,[43]
And those that the prophet did mock and deprave,
With other (no few), whereas God gave
Many times unto the woman
His blessing as well as to the man.

"Thus all thing pondered in balance plain,
God favoreth always the femininity;
We then to have them in disdain
Standeth not well with equity.
And whoso said the good rare be,
I durst adventure my head to lose[44]
To prove he lieth that maketh that gloss.

"Thousands or two, I dare well say,
Of them that yet here living be
In full record forth bring I may,
And seek not far out of the country;
I could also manifestly
Divers rehearse and their names tell,
The place affirming where they do dwell.

"Howbeit, as now it shall suffice
Of them that gone be many years past
Example to take, and this treatise
By their goodness to make sure and fast
That none hereafter presume to cast
Fables forged of willful mind
Against the devout feminine kind."

[Venus relates the story of Abraham's sojourn in Egypt, when his wife, Sarah, was so obedient to his wishes that she agreed to pretend to

42. Childbirth.
43. Cain, the first son of Adam and Eve, murdered his brother Abel out of envy; Ham, one of the three sons of Noah, "looked on the nakedness" of his father when Noah was in a drunken stupor.
44. I would dare to stake my life.

be his sister and submitted to the Pharaoh's embraces in order that Abraham might live and thrive. Likewise, Isaac persuaded his wife, Rebecca, to pose as his sister to save his life. These biblical examples demonstrate the benefits brought to men by women: "How say ye now by your lewd fable / Were not these women profitable?" In such cases God preserved the women from sin, as is also recorded in the story of Sarah, the daughter of Raguel.]

> "To seven, divers,[45] married was she
> And always maiden arose them fro[m],
> Because the man would by and by
> His carnal lust with her have do[ne],
> No reverence given the sacrament unto;
> At night the devil was there alway
> And strangled them before the day.

> "Preserved was the feminine
> Because she was so virtuous;
> Strangled were the masculine
> Because they were so vicious.
> Sodom and Gomorrah, the lecherous,
> In brimstone, we read, doth boil and bran[46]
> For the misliving[47] of the man.

> "The daughter of Jacob, amiable Dinah,[48]
> For the foul rape upon her done,
> Her brethren two brought to ruin
> The city and slew the masculine each one,
> Hamor, the father, and Shechem, the son;
> God willed they should such revel make
> And on the men such vengeance take.

45. Wicked, perverse. According to the Bible, the demon Asmodeus killed Sarah's first seven husbands on their wedding nights in order to preserve her for the virtuous Tobias, her kinsman and eighth husband.

46. Burn.

47. Evil living. The biblical cities of Sodom and Gomorrah were destroyed by God for their wickedness, especially the vice of male homosexuality.

48. When Shechem, the son of the local chieftain, Hamor, raped Dinah, the daughter of Jacob and Leah, her brothers swore vengeance. They promised Shechem, who had fallen in love with Dinah, that he could marry her if he and all the men of his tribe were circumcised. When this was done, Dinah's brothers took advantage of the men's weakened condition to slay them all and carry off their wealth, women, and children.

"Of David the daughter, fair Thamar,
Whom her own brother, Amnon by name,
Feigning himself sick and she not ware,[49]
Against her will, she not to blame,
Unlawfully used to his own shame,
Long time bewailed her evil chance;
In token plain she took repentance.

"Because Rahab[50] did them defend
From Joshua sent to Jericho,
Holy writ doth her commend
And justify her life also.
Mary Magdalene,[51] another of tho[se],
For her great faith and contrition,
Of all her crimes she had remission.

"Whereby appeareth plain and evident
What grace is given the feminine:
For small offense so sore to repent
Recorded in Thamar and in Dinah;
Where stubborn and stiff is the masculine:
Adam (to witness which) had no grace
Mercy to ask for his trespass.

"And furthermore admit the case
The many women have sore offended,
And thousands mo[re] done well oft has:
Should all the name be discommended
Because the best[52] number be reprehended?
If that should be report[ed] me then,
What might be spoken of the men?

49. On her guard. After Thamar was raped by her half-brother Amnon, her full brother Absalom avenged her by murdering Amnon.

50. Rahab was a prostitute of Jericho who gave aid and shelter to the spies which Joshua, the leader of the Israelites, had sent into that city. When the Israelites took the city, Rahab and all her kin were spared.

51. Mary Magdalene, a follower of Jesus from whom he had cast out seven demons, was considered an exemplar of the reformed prostitute because she was (probably erroneously) identified with the unnamed sinful woman whom Jesus forgave because of her great love and faith (Luke 7:36–50).

52. This is probably a misprint for "least."

"Large be the volumes in every nation
Forever in chronicle to remain;
If ye perceive and note the fashion,
Evidence enough ye shall have plain:
Against one woman, men twain,
(Yea, twenty, I dare avow doubtless)
Which be improved⁵³ for their lewdness."

[Citing chapter and verse, Venus draws from the Bible a long list of stories about virtuous women and wicked men. For example, Ishmael, who assassinated the governor of Judah, demonstrates that cruelty belongs to men, not women: "Oh, that ye men can fight and brawl / And kill each other commonly, / Which is not seen in the feminine." Women, however, have "by special grace" accomplished heroic feats to save others; witness the Old Testament heroines Judith, Deborah, Jael, Esther, and many more. God chose women rather than men to perform these great deeds as a mark of his particular esteem for the feminine: "I me repeat, now how say ye, / Be not the women praiseworthy?" In the New Testament there are also many examples of feminine virtue; although Christ was often disappointed in his male followers, the women were always faithful, as proved by the example of his mother Mary, "both wife and maid," as well as Mary Magdalene, Martha, and others. In fact, God chose women to be the first to see the risen Christ. Venus maintains that she has proved "by holy writ that women be no castaways";⁵⁴ she then turns to women "of later time" for "more witness." After mentioning the large number of Christian martyrs who were female, she relates classical examples of virtue: Lucretia, Veturia (the mother of Coriolanus), Portia (wife of Brutus), and Penelope. She returns to the Old Testament (actually the Apocrypha) for her final example, telling the story of Susanna, the virtuous woman unjustly accused of adultery by the elders because she had rejected their lecherous advances. This story vindicates the virtue of woman and casts doubt on the motives of the "ribalds" who attack her.]

Which things remembered with other mo[re]
That might perchance enlarge this book:

53. Blamed; condemned.
54. Reprobates.

Estates commonly where I[55] go
Trust their wives to overlook[56]
Baker, brewer, butler, and cook,
With other all; man meddleth no whit
Because the woman hath quicker wit.

My lady must receive and pay,
And every man in his office control,
And to each cause give "yea" and "nay,"
Bargain and buy, and set all sole
By indenture other by court-roll;[57]
My lady must order thus all thing,
Or small shall be the man's winning.

A further proof herein as yet
By common report we hear each day:
The child is praised for his mother wit;
For the father's conditions depraved alway.
And over that, yourself will say,
Surgeons' advantage, by women small
Because they be no fighters at all.[58]

An end therefore hereof to make:
Methinks these men do nothing well
So willfully to brag and crake,[59]
And against all women so to cavil.[60]
And yet whoso that longest doth revel

55. At this point Gosynhill is clearly speaking in his own voice, although he had earlier in the poem maintained (albeit fitfully) the fiction that the work was dictated to him by Venus.

56. Oversee.

57. She must settle all these matters by herself, including those involving contracts or court documents.

58. Gosynhill here cleverly turns proverbial expressions to his own advantage by taking them literally. Innate intelligence is called "mother wit" and so must come from the female, while an individual's bad character can be attributed to his "father's conditions." "Surgeons' advantage" (or profit) is very small from women because their peaceful natures lead to few physical injuries.

59. Boast.

60. Rail; find fault unfairly.

And this book readeth, I know plainly
Shall say or be shamed: "Tongue, I lie."[61]

[In an envoy ("Go forth, little book"), Gosynhill praises his work and emphatically claims authorship, presenting his name several times in acrostic as well as explicitly naming himself: "Say Edward Gosynhill took the labor / For womanhood thee for to frame; / . . . Thanks looks he none for, yet would he be glad / Staff to stand by that all women had."]

61. This poem will shame the greatest mockers of women into admitting the falsity of their charges.

IANE ANGER

her Protection

for VVomen.

To defend them against the

SCANDALOVS REPORTES OF
a late Surteiting Louer, and all other like
Venerians that complaine so to bee
ouercloyed with womens
kindnesse.

Written by Ia: A. Gent.

At London

Printed by Richard Iones, and Thomas
Orwin. 1589.

§. *Jane Anger, her Protection for Women*
To defend them against the Scandalous Reports
of a late Surfeiting Lover
and all other like Venerians [1]
that complain so to be overcloyed
with women's kindness.
Written by Jane Anger, Gentlewoman
1589

To the Gentlewomen of England, health.

Gentlewomen, though it is to be feared that your settled wits will advisedly condemn that which my choleric vein hath rashly set down, and so perchance ANGER shall reap anger for not agreeing with diseased persons; yet (if with indifferency of censure [2] you consider of the head of the quarrel) I hope you will rather show yourselves defendants of the defender's title than complainants of the plaintiff's wrong. I doubt judgment before trial, which were injurious to the Law, and I confess that my rashness deserveth no less, which was a fit of my extremity. I will not urge reasons because your wits are sharp and will soon conceive my meaning, nor will I be tedious lest I prove too, too troublesome, nor overdark in my writing, for fear of the name of a Riddler. But (in a word) for my presumption I crave pardon, because it was ANGER that did write it. Committing your protection and myself to the protection of yourselves, and the judgment of the cause to the censures of your just minds,

Yours ever at commandment,
Jane Anger

To all Women in general, and gentle Reader whatsoever.

Fie on the falsehood of men, whose minds go oft amadding,[3] and whose tongues cannot so soon be wagging but straight they fall arail-

1. Wanton, lustful individuals.
2. Impartiality of judgment.
3. Acting like a madman.

ing. Was there ever any so abused, so slandered, so railed upon, or so wickedly handled undeservedly as are we women? Will the Gods permit it, the Goddesses stay their punishing judgments, and we ourselves not pursue their undoings for such devilish practices? Oh Paul's steeple and Charing Cross! A halter hold all such persons! Let the streams of the channels in London streets run so swiftly as they may be able alone to carry them from that sanctuary! Let the stones be as Ice, the soles of their shoes as Glass, the ways steep like Aetna,[4] and every blast a Whirlwind puffed out of Boreas[5] his long throat, that these may hasten their passage to the Devil's haven! Shall Surfeiters rail on our kindness, you stand still and say nought, and shall not Anger stretch the veins of her brains, the strings of her fingers, and the lists[6] of her modesty to answer their Surfeitings? Yes, truly. And herein I conjure all you to aid and assist me in defense of my willingness, which shall make me rest at your commands. Fare you well.

Your friend,
Jane Anger

A PROTECTION FOR WOMEN

The desire that every man hath to show his true vein in writing is unspeakable, and their minds are so carried away with the manner as no care at all is had of the matter. They run so into Rhetoric as oftentimes they overrun the bounds of their own wits and go they know not whither. If they have stretched their invention so hard on a last as it is at a stand,[7] there remains but one help, which is to write of us women. If they may once encroach so far into our presence as they may but see the lining of our outermost garment, they straight think that Apollo honors them in yielding so good a supply to refresh their sore overburdened heads, through studying for matters to indite of.[8] And therefore, that the God may see how thankfully they receive his liberality (their

4. A volcano in Sicily.
5. The god of the north wind.
6. Limits.
7. "To be at a stand" meant to be in a state of perplexity, to be unable to proceed with thought, speech, or action. Anger uses a clever pun here, for the word *stand* in leather manufacturing signified leather brought to a state where it would not spring back if stretched, and the "last" was a wooden model of the foot on which shoemakers shaped the leather for boots and shoes.
8. Describe in a literary composition.

wits whetted and their brains almost broken with botching his bounty), they fall straight to dispraising and slandering our silly[9] sex. But judge what the cause should be of this their so great malice towards simple women: doubtless the weakness of our wits and our honest bashfulness, by reason whereof they suppose that there is not one amongst us who can or dare reprove their slanders and false reproaches. Their slanderous tongues are so short, and the time wherein they have lavished out their words freely hath been so long, that they know we cannot catch hold of them to pull them out and they think we will not write to reprove their lying lips. Which conceits have already made them cocks, and would (should they not be cravened) make themselves among themselves be thought to be of the game.[10] They have been so daintily fed with our good natures that, like jades,[11] (their stomachs are grown so queasy) they surfeit of our kindness. If we will not suffer them to smell on our smocks, they will snatch at our petticoats; but if our honest natures cannot away with[12] that uncivil kind of jesting, then we are coy. Yet if we bear with their rudeness and be somewhat modestly familiar with them, they will straight make matter of nothing, blazing abroad that they have surfeited with love, and then their wits must be shown in telling the manner how.

Among the innumerable number of books to that purpose of late, (unlooked-for) the new surfeit of an old Lover[13] (sent abroad to warn those which are of his own kind from catching the like disease) came by chance to my hands, which, because as well women as men are desirous of novelties, I willingly read over. Neither did the ending thereof less please me than the beginning, for I was so carried away with the conceit of the Gentleman as that I was quite out of the book before I thought I had been in the midst thereof: so pithy were his sentences, so pure his words, and so pleasing his style. The chief matters therein contained were of two sorts: the one in the dispraise of man's folly, and the other, invective against our sex. [Anger agrees with the lover's

9. Defenseless.

10. A "cock of the game" was a rooster that had been bred and trained for the sport of cock fighting; if the cock was "cravened," it had become spiritless and afraid to fight.

11. Ill-tempered, worthless horses.

12. Put up with, tolerate.

13. There is considerable controversy over the title of the work which prompted Anger to write her defense. The best suggestion seems to be a pamphlet, now lost, listed in the *Stationers' Register* as *Boke his Surfeyt in Love*, 1588 (Boke may be either an alternate spelling of "book" or the name of the author or hero).

criticism of the folly of men, maintaining that it proceeds from "their own flattery joined with fancy." If men like "the lascivious king Ninus" and "the slothful king Sardanapalus"[14] were brought down by women, this is only a fitting and just recompense for their "beastlike and licentious deeds."]

But that Menelaus[15] was served with such sauce it is a wonder; yet truly their Sex are so like to Bulls that it is no marvel though the Gods do metamorphose[16] some of them to give warning to the rest, if they could think so of it, for some of them will follow the smock as Tom Bull will run after a town Cow. But lest they should running slip and break their pates, the Gods, provident of their welfare, set a pair of tooters[17] on their foreheads to keep it from the ground. For doubtless so stood the case with Menelaus; he, running abroad as a Smell-smock, got the habit of a Cuckold, of whom thus shall go my verdict:

The Gods most just do justly punish sin
with those same plagues which men do most forlorn.
If filthy lust in men to spring begin,
That monstrous sin he plagueth with the horn:
 Their wisdom great whereby they men forewarn
 to shun wild lust, lest they will wear the horn.

Deceitful men with guile must be repaid,
And blows for blows who renders not again?
The man that is of Cuckold's lot afraid,
From Lechery he ought for to refrain;
 Else shall he have the plague he doth forlorn
 and ought (perforce constrained) to wear the horn.

14. Ninus, the legendary founder of Nineveh and the Assyrian Empire, was destroyed by his wife Semiramis, while the many concubines of the Assyrian king Assurbanipal (Sardanapalus) reputedly made him effeminate and contributed to the fall of his empire.

15. The mythical Spartan king whose wife, Helen, eloped with the Trojan prince Paris and precipitated the Trojan War.

16. Since so many men behave like bulls, the gods grow horns on some of their heads. Anger here refers to the common use of horns as a symbol for a cuckold (a derisive name for the husband of an unfaithful wife).

17. A clever pun, since the word "tooter" not only referred to anything projecting or prominent (like animal horns) but also signified the horn as a wind instrument.

The Greeks Actaeon's badge[18] did wear, they say,
And worthy too, he loved the smock so well.
That every man may be a Bull I pray
Which loves to follow lust (his game) so well,
 For by that means poor women shall have peace
 and want these jars.[19] Thus doth my censure cease.

The greatest fault that doth remain in us women is that we are too credulous, for could we flatter as they can dissemble, and use our wits well as they can their tongues ill, then never would any of them complain of surfeiting. But if we women be so perilous cattle as they term us, I marvel that the Gods made not Fidelity as well a man as they created her a woman, and all the moral virtues of their masculine sex as of the feminine kind, except their Deities knew that there was some sovereignty in us women which could not be in them men. But lest some snatching fellow should catch me before I fall to the ground (and say they will adorn my head with a feather,[20] affirming that I roam beyond reason, seeing it is most manifest that the man is the head of the woman and that therefore we ought to be guided by them), I prevent them with this answer. The Gods, knowing that the minds of mankind would be aspiring and having thoroughly viewed the wonderful virtues wherewith women are enriched, lest they should provoke us to pride and so confound us with Lucifer, they bestowed the supremacy over us to man, that of that Cockscomb he might only boast. And therefore, for God's sake let them keep it! But we return to the *Surfeit*.

Having made a long discovery of the Gods' censure concerning love, he leaves them (and I them with him) and comes to the principal object and general foundation of love, which he affirmeth to be grounded on women. And now beginning to search his scroll, wherein are taunts against us, he beginneth and saith that we allure their hearts to us, wherein he saith more truly than he is aware of. For we woo them with our virtues, and they wed us with vanities. And men, being of wit sufficient to consider of the virtues which are in us women, are ravished with the delight of those dainties which allure and draw the senses of

18. Animal horns, since the hero Actaeon had been turned into a stag because he had seen the naked body of the virgin goddess Artemis.

19. Lack these conflicts.

20. The badge of a fool.

them to serve us, whereby they become ravenous hawks, who do not only seize upon us, but devour us. Our good toward them is the destruction of ourselves; we, being well formed, are by them foully deformed. Of our true meaning they make mocks, rewarding our loving follies with disdainful flouts. We are the grief of man, in that we take all the grief from man: we languish when they laugh; we lie sighing when they sit singing, and sit sobbing when they lie slugging[21] and sleeping. "Mulier est hominis confusio"[22] because her kind heart cannot so sharply reprove their frantic fits as those mad frenzies deserve. "Aut amat aut odit; non est in tertio":[23] she loveth good things and hateth that which is evil; she loveth justice and hateth iniquity; she loveth truth and true dealing and hateth lies and falsehood; she loveth man for his virtues and hateth him for his vices. To be short, there is no *Medium* between good and bad, and therefore she can be *In nullo tertio*.[24] Plato[25] his answer to a Vicar of fools which asked the question, being that he knew not whether to place women among those creatures which were reasonable or unreasonable, did as much beautify his divine knowledge, as all the books he did write. For knowing that women are the greatest help that men have, without whose aid and assistance it is as possible for them to live as if they wanted meat, drink, clothing, or any other necessary; and knowing also that even then in his age, much more in those ages which should after follow, men were grown to be so unreasonable, as he could not decide whether men or brute beasts were more reasonable. Their[26] eyes are so curious, as be not all women equal with Venus for beauty, they cannot abide the sight of them; their stomachs so queasy, as do they taste but twice of one dish they straight surfeit, and needs must a new diet be provided for them. We are contrary to men because they are contrary to that which is good. Because they are purblind, they cannot see into our

21. Idly or lazily lying about.

22. "Woman is the consternation of man." Chaucer uses this Latin proverb for comic effect in *The Canterbury Tales* when he has Chanticleer mistranslate it as "Woman is man's joy and all his bliss" ("The Nun's Priest's Tale," line 4356).

23. "Either she loves or she hates; she is on no third course" (a paraphrase of a common Latin quotation).

24. There is no "middle ground," so she can be "on no third course."

25. In his dialogues on the *Republic* and the *Laws*, the Greek philosopher Plato advocated that women be educated, maintaining that women had much the same capacities as men (albeit weaker in all respects).

26. Men's.

natures, and we [see] too well (though we had but half an eye) into their conditions, because they are so bad. Our behaviors alter daily, because men's virtues decay hourly. If Hesiod[27] had with equity as well looked into the life of man as he did precisely search out the qualities of us women, he would have said that if a woman trust unto a man, it shall fare as well with her as if she had a weight of a thousand pounds tied about her neck and then cast into the bottomless seas. For by men are we confounded though they by us are sometimes crossed. Our tongues are light because earnest in reproving men's filthy vices, and our good counsel is termed nipping injury in that it accords not with their foolish fancies: our boldness rash, for giving Noddies[28] nipping answers; our dispositions naughty, for not agreeing with their vile minds; and our fury dangerous, because it will not bear with their knavish behaviors. If our frowns be so terrible and our anger so deadly, men are too foolish in offering occasions of hatred; which shunned, a terrible death is prevented. There is a continual deadly hatred between the wild boar and tame hounds; I would there were the like between women and men unless they amend their manners, for so strength should predominate where now flattery and dissimulation hath the upper hand. The Lion rageth when he is hungry, but man raileth when he is glutted. The Tiger is robbed of her young ones when she is ranging abroad, but men rob women of their honor undeservedly under their noses. The Viper stormeth when his tail is trodden on, and may not we fret when our body is a footstool to their vile lust? Their unreasonable minds, which know not what reason is, make them nothing better than brute beasts. [Anger continues in this vein, admitting that there were some wicked women in history and myth but pointing to examples of men who were even worse. If women bring sorrow to men, men bring greater griefs to women.]

Euthydemus[29] made six kinds of women, and I will approve that there are so many of men: which be poor and rich, bad and good, foul and fair. The great Patrimonies that wealthy men leave their children after their death make them rich, but dice and other mar-thrifts, happening into their companies, never leave them till they be at the beg-

27. An ancient Greek poet known for his misogyny, Hesiod maintained that anyone who trusts a woman is putting his trust in a deceiver (*Works and Days*, 375).

28. Fools, simpletons.

29. A Greek sophist philosopher after whom Plato named a satiric dialogue.

gar's bush, where I can assure you they become poor. Great eaters, being kept at a slender diet, never distemper their bodies but remain in good case; but afterwards, once turned forth to Liberty's pasture, they graze so greedily as they become surfeiting jades and always after are good for nothing. There are men which are snout-fair, whose faces look like a cream pot, and yet those not the fair men I speak of, but I mean those whose conditions are free from knavery; and I term those foul that have neither civility nor honesty. Of these sorts there are none good, none rich or fair long. But if we do desire to have them good, we must always tie them to the manger and diet their greedy paunches; otherwise they will surfeit. What shall I say? Wealth makes them lavish; wit, knavish; beauty, effeminate; poverty, deceitful; and deformity, ugly. Therefore of me take this counsel:

> Esteem of men as of a broken reed;
> Mistrust them still, and then you well shall speed.

[Anger quotes several proverbial statements, which she interprets to the dispraise of men. She advises men to strive to bridle their tongues and live modestly, with "virtuous and civil behaviors," but she despairs of ever curbing men's lechery: "If we clothe ourselves in sackcloth and truss up our hair in dishclouts,[30] Venerians will nevertheless pursue their pastime. If we hide our breasts, it must be with leather, for no cloth can keep their long nails out of our bosoms." Men should be able to follow advice as well as give it, and ancient writers should have "busied their heads about deciphering the deceits of their own sex" rather than writing continuously about the follies of women. However, Anger says that she will leave them to their "contrary vein" and with them "the surfeiting Lover, who returns to his discourse of love."]

Now while this greedy gazer is about his entreaty of love, which nothing belongeth to our matter, let us secretly (ourselves with ourselves) consider how and in what they that are our worst enemies are both inferior unto us and most beholden unto our kindness.

The creation of man and woman at the first, he being formed *In principio*[31] of dross and filthy clay, did so remain until God saw that in him his workmanship was good, and therefore by the transformation

30. Dishrags.
31. "In the beginning" (the first two words in the Latin text of John's Gospel).

of the dust which was loathsome unto flesh it became purified. Then lacking a help for him, God, making woman of man's flesh that she might be purer than he, doth evidently show how far we women are more excellent than men. Our bodies are fruitful, whereby the world increaseth, and our care wonderful, by which man is preserved. From woman sprang man's salvation. A woman was the first that believed, and a woman likewise the first that repented of sin. In women is only true Fidelity; except in her there is [no] constancy, and without her no Housewifery. In the time of their sickness we cannot be wanted,[32] and when they are in health we for them are most necessary. They are comforted by our means; they [are] nourished by the meats we dress; their bodies [are] freed from diseases by our cleanliness, which otherwise would surfeit unreasonably through their own noisomeness. Without our care they lie in their beds as dogs in litter and go like lost Mackerel swimming in the heat of summer.[33] They love to go handsomely in their apparel and rejoice in the pride thereof, yet who is the cause of it but our carefulness, to see that everything about them be curious?[34] Our virginity makes us virtuous; our conditions, courteous; and our chastity maketh our trueness of love manifest. They confess we are necessary, but they would have us likewise evil. That they cannot want us I grant, yet evil I deny: except only in the respect of man, who (hating all good things) is only desirous of that which is ill, through whose desire in estimation of conceit we are made ill.[35] But lest some should snarl on me, barking out this reason, "that none is good but God, and therefore women are ill," I must yield that in that respect we are ill, and affirm that men are no better, seeing we are so necessary unto them. It is most certain that if we be ill, they are worse; for "Malum malo additum efficit malum peius,"[36] and they that use ill worse than it should be are worse than the ill. And therefore if they will correct *Magnificat*, they must first learn the signification thereof.[37] That we

32. Dispensed with.

33. Mackerel were known to come in to shore in the summer to spawn in the shoals.

34. Carefully and exquisitely prepared.

35. Woman is not evil in herself; she can be said to be evil only in the sense that man, who hates all good things, desires her.

36. "Evil added to evil makes the evil worse."

37. "To correct *Magnificat*" was proverbial for presumptuous faultfinding; here Anger applies the proverb literally, since men who learn the signification of *Magnificat* ("my soul magnifies the Lord," which begins the Virgin Mary's hymn in Luke 1: 46–55) will of necessity realize the worth of women.

are liberal they will not deny, since that many of them have (*ex confesso*[38]) received more kindness in one day at our hands than they can repay in a whole year, and some have so glutted themselves with our liberality as they cry "No more." But if they shall avow that women are fools, we may safely give them the lie. For myself have heard some of them confess that we have more wisdom than need is (and therefore no fools) and they less than they should have (and therefore fools). It hath been affirmed by some of their sex that to shun a shower of rain and to know the way to our husband's bed is wisdom sufficient for us women; but in this year of '88, men are grown so fantastical[39] that unless we can make them fools, we are accounted unwise. And now (seeing I speak to none but to you which are of mine own Sex), give me leave like a scholar to prove our wisdom more excellent than theirs, though I never knew what sophistry meant. There is no wisdom but it comes by grace; this is a principle, and "Contra principium non est disputandum."[40] But grace was first given to a woman, because to our lady: which premises conclude that women are wise. Now "Primum est optimum,"[41] and therefore women are wiser than men. That we are more witty, which comes by nature, it cannot better be proven than that by our answers men are often driven to Nonplus.[42] And if their talk be of worldly affairs, with our resolutions they must either rest satisfied or prove themselves fools in the end.

[Anger relates "a pretty story" of two men who "proved themselves as very asses as they were fools." After much mutual misunderstanding, these men decide that they must seek a "wise woman"[43] to find the stolen ring of one of them: "they hope to find that through the wisdom of a woman which was lost by the folly of a man." Anger then draws a moral from this story: "Let men learn to be wise or account themselves fools, for they know by practice that we are none." Furthermore, although every animal has a special quality given to it by nature, men's qualities are unnatural, for their "tongues sting against nature," and they are "never out of the predicaments of Dishonesty and inconstancy." Because men strive against nature, "she rewards them with

38. Admittedly.
39. Irrational.
40. "There must be no argument against a principle."
41. "The first is the best."
42. An inability to say or do anything.
43. A woman skilled in magic or hidden arts; a beneficent witch.

crosses contrary to their expectations," and so the author of the *Surfeit* is not to be pitied if he has received some bitter experience from his "Italian Courtesans." Indeed, men's dishonesty is revealed by the fact that they often cloak their lustfulness in railing criticisms of women. They should be believed least when they "protest secrecy most solemnly," for "in a Friar's habit an old Fornicator is always clothed."]

It is a wonder to see how men can flatter themselves with their own conceits. For let us look, they will straight affirm that we love, and if then *Lust* pricketh them, they will swear that *Love* stingeth us. Which imagination only is sufficient to make them assay the scaling of half a dozen of us in one night, when they will not stick to swear that if they should be denied of their requests, death must needs follow. Is it any marvel, though, they surfeit, when they are so greedy? But is it not pity that any of them should perish, which will be so soon killed with unkindness? Yes, truly. Well, the onset given, if we retire for a vantage, they will straight affirm that they have got the victory. Nay, some of them are so carried away with conceit that, shameless, they will blaze abroad among their companions that they have obtained the love of a woman unto whom they never spoke above once, if that. Are not these froward fellows? You must bear with them, because they dwell far from lying neighbors. They will say "Mentiri non est nostrum,"[44] and yet you shall see true tales come from them, as wild geese fly under London bridge.[45] Their fawning is but flattery; their faith, falsehood; their fair words, allurements to destruction; and their large promises, tokens of death or of evils worse than death. Their singing is a bait to catch us; and their playings, plagues to torment us. And therefore take heed of them, and take this as an Axiom in Logic and a Maxim in the Law, "Nulla fides hominibus."[46] There are three accidents[47] to men, which of all are most inseparable: Lust, Deceit, and malice. Their glozing[48] tongues [are] the preface to the execution of their vile minds, and their pens, the bloody executioners of their barbarous manners. A little gall maketh a great deal of sweet sour, and a slanderous tongue poisoneth all the good parts in man.

44. "It is not ours to lie."
45. Migrating geese would of course fly above the bridge.
46. "Place no trust in men" (although the maxim refers to human beings in general, Anger takes it as applying specifically to males).
47. Attributes.
48. Flattering.

[It is the flattery and folly of men which have led a Venus or a Helen to flout their husbands, but many examples of loving and virtuous wives can be adduced from the history of ancient Rome to "condemn the indiscretions of men's minds, whose hearts delight in nought save that only which is contrary to good." Lechery is the worst form of voluptuousness: "it defileth the body and makes it stink," and yet some men "are not ashamed to confess publicly that they have surfeited therewith." To stop such surfeits, men should take as their models historical men noted for their abstinence, remembering that "rashness breeds repentance and treacherous hearts, tragical ends."]

I have set down unto you (which are of mine own Sex) the subtle dealings of untrue meaning men, not that you should contemn[49] all men, but to the end that you may take heed of the false hearts of all and still reprove the flattery which remains in all. For as it is reason that the Hens should be served first, which both lay the eggs and hatch the chickens, so it were unreasonable that the cocks which tread them should be kept clean without meat. As men are valiant, so are they virtuous; and those that are born honorably cannot bear horrible dissembling hearts. But as there are some which cannot love heartily, so there are many who lust incessantly; and as many of them will deserve well, so most care not how ill they speed[50] so they may get our company. Wherein they resemble Envy, who will be contented to lose one of his eyes that another might have both his pulled out. And therefore, think well of as many as you may, love them that you have cause, hear everything that they say (and afford them nods which make themselves noddies) but believe very little thereof or nothing at all,[51] and hate all those who shall speak anything in the dispraise or to the dishonor of our sex.

Let the luxurious life of Heliogabalus, the intemperate desires of Commodus and Proclus, the damnable lust of Chilperic and Xerxes, Boleslaus' violent ravishings, and the unnatural carnal appetite of Sigismundo Malatesta be examples sufficiently probable to persuade you that the hearts of men are most desirous to excel in vice.[52] There

49. Scorn.
50. Fare.
51. Keep nodding "yes" to men who act like fools but do not believe anything they say (a pun on "nods" and "noddies").
52. The Roman emperor Elagabalus (Heliogabalus) was infamous for his debauchery, as was the earlier emperor Commodus for his cruelty and dissipation. Proclus, a

were many good laws established by the Romans and other good kings, yet they could not restrain men from lechery; and there are terrible laws allotted in England to the offenders therein, all which will not serve to restrain men.

The Surfeiter's physic[53] is good could he and his companions follow it. But when the Fox preacheth, let the geese take heed: it is before an execution. "Fallere fallentem non est fraus,"[54] and to kill that beast whose property is only to slay is no sin. If you will please men, you must follow their rule, which is to flatter, for Fidelity and they are bitter enemies. Things far fetched are excellent, and that experience is best which cost most; crowns are costly, and that which cost many crowns[55] is well worth "God thank you," or else I know who hath spent his labor and cost foolishly. Then, if any man giveth such dear counsel gracefully, are not they fools which will refuse his liberality? I know you long to hear what that counsel should be which was bought at so high a price; wherefore if you listen, the Surfeiter his pen with my hand shall forthwith show you.

At the end of men's fair promises there is a Labyrinth, and therefore ever hereafter stop your ears when they protest friendship, lest they come to an end (before you are aware) whereby you fall without redemption. The path which leadeth thereunto is Man's wit, and the miles' ends[56] are marked with these trees: Folly, Vice, Mischief, Lust, Deceit, and Pride. These, to deceive you, shall be clothed in the raiments of Fancy, Virtue, Modesty, Love, True meaning, and Handsomeness. Folly will bid you welcome on your way, and tell you his fancy concerning the profit which may come to you by this journey, and direct you to Vice, who is more crafty. He with a company of protestations will praise the virtues of women, showing how many ways men are beholden unto us; but our backs once turned, he falls arailing. Then Mischief, he pries into every corner of us, seeing if he can espy a

Greek neoplatonic philosopher who attacked Christianity, and Xerxes, the Persian king who unsuccessfully invaded Greece, were less associated with sexual crimes, but the Frankish king Chilperic murdered his wife to marry his mistress. Boleslaus was a Polish king, and Sigismundo Malatesta was an Italian who warred against the pope.

53. Remedy.

54. "It is no deceit to deceive a deceiver."

55. Coins worth five shillings.

56. Many roads had posts or pillars placed at the end of each mile to mark off the distance.

cranny, that getting in his finger into it, he may make it wide enough for his tongue to wag in. Now being come to Lust: he will fall arailing on lascivious looks, and will ban[57] Lechery, and with the Collier[58] will say, "The devil take him!" though he never means it. Deceit will give you fair words and pick your pockets; nay, he will pluck out your hearts if you be not wary. But when you hear one cry out against lawns,[59] drawn-works,[60] Periwigs, against the attire of Courtesans, and generally of the pride of all women, then know him for a Wolf clothed in sheep's raiment and be sure you are fast by the lake of destruction. Therefore take heed of it, which you shall do if you shun men's flattery, the forerunner of our undoing. If a jade be galled,[61] will he not wince, and can you find fault with a horse that springeth when he is spurred? The one will stand quietly when his back is healed, and the other go well when his smart ceaseth. You must bear with the old Lover his surfeit, because he was diseased when he did write it; and peradventure hereafter, when he shall be well amended, he will repent himself of his slanderous speeches against our sex, and curse the dead man which was the cause of it, and make a public recantation. For the faltering in his speech at the latter end of his book affirmeth that already he half repenteth of his bargain. And why? Because his malady is past. But believe him not, though he should outswear you, for although a jade may be still in a stable when his gall back is healed, yet he will show himself in his kind when he is traveling. And man's flattery bites secretly, from which I pray God keep you, and me too. Amen.

A SOVEREIGN SALVE TO CURE THE LATE SURFEITING LOVER.

If once the heat did for thee beat
of foolish love so blind,
Sometime to sweat, sometime to fret
as one bestraught[62] of mind;

57. Curse.
58. A man who mines, transports, or sells coal.
59. Dresses made of fine linen fabric.
60. Fabrics adorned with elaborate patterns made by drawing out some of the threads.
61. Has a sore, chafed back.
62. Distraught.

If wits were take in such a brake[63]
 that reason was exiled,
And woe did wake but could not slake,
 thus love had thee beguiled;

If any wight[64] unto thy sight
 all other did excel,
whose beauty bright, constrained right
 thy heart with her to dwell;

If thus thy foe oppressed thee so
 that back thou could not start,
But still with woe did surfeit though,
 yet thankless was thy smart;

If nought but pain in love remain,
 at length this counsel win:
That thou refrain this dangerous pain,
 and come no more therein.

And since the blast is overpassed,
 it better were certain
From flesh to fast, whilst life does last,
 than surfeit so again.

Vivendo disce.[65]

Eiusdem ad Lectorem de Authore[66]

Though sharp the seed by Anger sowed,
 we all (almost) confess,
And hard his hap[67] we aye account,
 who Anger doth possess,
Yet hapless shall thou (Reader) reap
 such fruit from ANGER'S soil,

63. A trap.
64. A person.
65. "Learn from living."
66. "To the reader of the same, from the author."
67. Luck.

As may thee please, and ANGER ease
 from long and weary toil;
Whose pains were took for thy behoof[68]
 to till that cloddy ground,
Where scarce no place free from disgrace
 of female Sex was found.
If aught offend which she doth send,
 impute it to her mood,
For ANGER'S rage must that assuage,
 as well is understood.
If to delight aught come in sight,
 then deem it for the best,
So you your will may well fulfill,
 and she have her request.

68. Advantage.

THE
ARAIGNMENT

Of Lewde, idle, froward, and vncon-
ſtant women : Or the vanitie of them,
chooſe you whether.

With a Commendacion of wiſe, vertuous and
and honeſt Women.

Pleaſant for married Men, profitable for
young Men, and hurtfull
to none.

LONDON

Printed by *Edw : Alde* for *Thomas Archer*, and are to be ſolde at his ſhop
in Popes-head Pallace nere the Royall Exchange.
1615.

§. The Arraignment of Lewd, idle, froward, and unconstant women or the vanity of them, choose you whether,

With a Commendation of wise, virtuous,
and honest Women,
Pleasant for married Men, profitable for
young Men, and hurtful to none.
Joseph Swetnam
1615

Neither to the best nor yet to the worst, but to the common sort of Women.

Musing with myself, being idle, and having little ease to pass the time withal, and I being in a great choler against some women (I mean more than one); and so in the rough of my fury, taking my pen in hand to beguile the time withal, indeed I might have employed myself to better use than in such an idle business, and better it were to pocket up a pelting injury than to entangle myself with such vermin. For this I know, that because women are women, therefore many of them will do that in an hour which they many times will repent all their whole lifetime after. Yet for any injury which I have received of them, the more I consider of it, the less I esteem of the same. Yet perhaps some may say unto me that I have sought for honey, caught the Bee by the tail, or that I have been bit or stung with some of these wasps, otherwise I could never have been expert in betraying their qualities. For the Mother would never have sought her Daughter in the Oven but that she was there first herself. Indeed, I must confess I have been a Traveler this thirty and odd years, and many travelers live in disdain of women. The reason is for that their affections are so poisoned with the heinous evils of unconstant women which they happen to be acquainted with in their travels; for it doth so cloy their stomachs that they censure hardly of women ever afterwards. Wronged men will not be tongue-tied; therefore if you do ill, you must not think to hear well. For al-

though the world be bad, yet it is not come to that pass that men should bear with all the bad conditions that is in some women.

I know I shall be bitten by many because I touch many, but before I go any further, let me whisper one word in your ears, and that is this: whatsoever you think privately, I wish you to conceal it with silence, lest in starting up to find fault you prove yourselves guilty of these monstrous accusations which are here following against some women. And those which spurn if they feel themselves touched prove themselves stark fools in betraying their galled backs to the world, for this book toucheth no sort of women but such as when they hear it will go about to reprove it. For although in some part of this book I trip at your heels, yet I will stay you by the hand so that you shall not fall further than you are willing, although I deal with you after the manner of a shrew, which cannot otherwise ease her curst heart but by her unhappy tongue. If I be too earnest, bear with me a little; for my meaning is not to speak much of those that are good, and I shall speak too little of those that are nought. But yet I will not altogether condemn the bad, but hoping to better the good by the naughty examples of the bad, for there is no woman so good but hath one idle part or other in her which may be amended. For the clearest River that is hath some dirt in the bottom; Jewels are all precious, but yet they are not all of one price nor all of one virtue. Gold is not all of one picture; no more are women all of one disposition. Women are all necessary evils and yet not all given to wickedness; and yet many so bad, that in my conceit if I should speak the worst that I know by some women, I should make their ears glow that hears me, and my tongue would blister to report it. But it is a great discredit for a man to be accounted for a scold, for scolding is the manner of Shrews.

[Swetnam states that he will answer his detractors with silence, for he expects no praise for his labors: "I am weaned from my mother's teat and therefore nevermore to be fed with her pap." Thus no amount of criticism will stop him from "unfolding every pleat and showing every wrinkle of a woman's disposition." However, he confesses, "When I first began to write this book, my wits were gone awoolgathering, . . . and so in the rough of my fury I vowed forever to be an open enemy to women." Later reflection convinced him that he had written with his hand, not his heart, and in the process had prepared a sauce too sharp for a woman's diet and gathered flowers too strong for

her nose. Thus he concludes with a promise: "If I offend you at the first, I will make amends at the last." Swetnam signs the epistle, "Yours in the way of Honesty, Thomas Tell-Troth."]

Read it if you please and like as you list:[1] *neither to the wisest Clerk nor yet to the starkest Fool, but unto the ordinary sort of giddy-headed young men I send this greeting.*

If thou mean to see the Bearbaiting[2] of women, then trudge to this Bear garden apace and get in betimes. And view every room where thou mayest best sit for thy own pleasure, profit, and heart's-ease, and bear with my rudeness if I chance to offend thee. But before I do open this trunk full of torments against women, I think it were not amiss to resemble those which in old time did sacrifices to Hercules. For they used first to whip all their Dogs out of their City, and I think it were not amiss to drive all the women out of my hearing. For doubt lest this little spark kindle into such a flame and raise so many stinging Hornets humming about my ears that all the wit I have will not quench the one nor quiet the other. For I fear me that I have set down more than they will like of, and yet a great deal less than they deserve. And for better proof I refer myself to the judgment of men which have more experience than myself, for I esteem little of the malice of women. For men will be persuaded with reason, but women must be answered with silence. For I know women will bark more at me than Cerberus, the two-headed Dog, did at Hercules when he came into Hell to fetch out the fair Proserpina,[3] and yet I charge them now but with a bulrush in respect of a second book[4] which is almost ready. I do now but fret them with a false fire, but my next charge shall be with weapons, and my alarm with powder and shot. For then we will go upon these venomous Adders, Serpents, and Snakes and tread and trample them under our feet. For I have known many men stung with some of these Scorpions, and therefore I warn all men to beware the Scorpion. I know women will bite the lip at me and censure hardly of me, but I fear not

1. Wish.

2. A very popular sport in which dogs were set upon a bear chained to a stake.

3. One of the twelve labors of the Greek hero Hercules involved capturing the dog Cerberus (who actually had three heads) and bringing him out of the Underworld. It was the hero Theseus who tried unsuccessfully to carry off Hades' queen Proserpina, and Hercules had to rescue him.

4. This may be mere bluster on Swetnam's part, since no second book was apparently ever published.

the cursed Cow, for she commonly hath short horns. Let them censure of me what they will, for I mean not to make them my Judges, and if they shoot their spite at me, they may hit themselves. And so I will smile at them as at the foolish fly which burneth herself in the candle. And so, friend Reader, if thou hast any discretion at all, thou mayest take a happy example by these most lascivious and crafty, whorish, thievish, and knavish women, which were the cause of this my idle time spending. And yet I have no warrant to make thee believe this which I write to be true, but yet the simple Bee gathereth honey where the venomous Spider doth her poison. And so I will hinder thee no longer from that which ensueth, but here I will conclude lest thou hast cause to say that my Epistles are longer than my book: a Book, I hope I may call it without any offense, for the Collier[5] calls his horse a Horse, and the King's great Steed is but a Horse.

If thou Read but the beginning of a book thou canst give no judgment of that which ensueth; therefore I say as the Friar who in the midst of his sermon said often that the best was behind. And so if thou read it all over, thou shalt not be deluded, for the best is behind. I think I have shot so near the white that some will account me for a good Archer. And so, praying thee to look to thy footing that thou run not over thy shoes and so be past recovery before my second book come,

<div style="text-align: center">

Thy friend nameless,
To keep myself blameless.

</div>

CHAPTER I. This first Chapter showeth to what use Women were made; it also showeth that most of them degenerate from the use they were framed unto by leading a proud, lazy, and idle life, to the great hindrance of their poor Husbands.

Moses[6] describeth a woman thus: "At the first beginning," saith he, "a woman was made to be a helper unto man." And so they are indeed, for she helpeth to spend and consume that which man painfully getteth. He also saith that they were made of the rib of a man, and that their froward nature showeth; for a rib is a crooked thing good for nothing else, and women are crooked by nature, for small occasion will cause them to be angry.

Again, in a manner she was no sooner made but straightway her

5. One engaged in mining, transporting, or selling coal.
6. Traditionally considered the author of the first five books of the Bible.

mind was set upon mischief, for by her aspiring mind and wanton will she quickly procured man's fall. And therefore ever since they are and have been a woe unto man and follow the line of their first leader.

For I pray you, let us consider the times past with the time present: first, that of David and Solomon,[7] if they had occasion so many hundred years ago to exclaim so bitterly against women. For the one of them said that it was better to be a doorkeeper and better dwell in a den amongst Lions than to be in the house with a froward and wicked woman, and the other said that the climbing up of a sandy hill to an aged man was nothing so wearisome as to be troubled with a froward woman. And further he saith that the malice of a beast is not like the malice of a wicked woman, nor that there is nothing more dangerous than a woman in her fury.

The Lion being bitten with hunger, the Bear being robbed of her young ones, the Viper being trod on, all these are nothing so terrible as the fury of a woman. A Buck may be enclosed in a Park; a bridle rules a horse; a Wolf may be tied; a Tiger may be tamed; but a froward woman will never be tamed. No spur will make her go, nor no bridle will hold her back, for if a woman hold an opinion, no man can draw her from it. Tell her of her fault, she will not believe that she is in any fault; give her good counsel, but she will not take it. If you do but look after another woman, then she will be jealous; the more thou lovest her, the more she will disdain thee. And if thou threaten her, then she will be angry; flatter her, and then she will be proud. And if thou forbear her,[8] it maketh her bold, and if thou chasten her, then she will turn to a Serpent. At a word, a woman will never forget an injury nor give thanks for a good turn. What wise man then will exchange gold for dross, pleasure for pain, a quiet life for wrangling brawls, from the which the married men are never free?

Solomon saith that women are like unto wine, for that they will make men drunk with their devices.

Again in their love a woman is compared to a pumice stone, for which way soever you turn a pumice stone, it is full of holes; even so are women's hearts, for if love steal in at one hole it steppeth out at another.

They are also compared unto a painted ship, which seemeth fair

7. Ancient Hebrew kings. David is reputed to have written many of the psalms, and Solomon many of the proverbs.
8. Refrain from scolding her.

outwardly and yet nothing but ballast within her; or as the Idols in Spain which are bravely gilt outwardly and yet nothing but lead within them; or like unto the Sea which at some times is so calm that a cock-boat[9] may safely endure her might, but anon again with outrage she is so grown that it overwhelmeth the tallest ship that is.

A froward woman is compared to the wind and a still woman unto the Sun, for the sun and the wind met a traveler upon the way and they laid a wager, which of them should get his cloak from him first. Then first the wind began boisterously to blow, but the more the wind blew the more the traveler wrapped and gathered his cloak about him. Now when the wind had done what he could and was never the nearer, then began the Sun gently to shine upon him, and he threw off not only his cloak but also his hat and Jerkin. This moral showeth that a woman with high words can get nothing at the hands of her husband; never by froward means, but by gentle and fair means she may get his heart blood to do her good.

[Young men do not realize that women bring nothing but trouble. Men who "cudgel their wits and beat their brains" to obtain the favors of women will be speedily disillusioned: "They think they have gotten God by the hand, but within a while after they will find that they have but the Devil by the foot." For women are cunning dissemblers; their beauty is always matched with merciless cruelty and "heavenly looks with hellish thoughts." Thus women are "subtle and dangerous for men to deal with, for their faces are lures, their beauties are baits, their looks are nets, and their words are charms, and all to bring men to ruin." Men as diverse as Saint Paul, the Cynic philosopher Diogenes, and the Roman emperor Augustus have all advised against marrying, but the Greek philosopher Socrates expressed the conundrum best: if a man does not marry, he will "live discontented and die without issue," but if he does marry, he will have "continual vexations."]

A gentleman on a time said to his friend, "I can help you to a good marriage for your son." His friend made him this answer: "My son," said he, "shall stay till he have more wit." The Gentleman replied again, saying, "If you marry him not before he hath wit, he will never marry so long as he liveth."

For a married man is like unto one arrested, and I think that many a man would fly up into Heaven if this arrest of marriage kept them not

9. Dinghy.

back. It is said of one named Domettas that he buried three wives and yet never wet one handkerchief, no, nor shed not so much as one tear. Also Ulysses, he had a Dog which loved him well, and when that dog died he wept bitterly, but he never shed one tear when his wife died.[10] Wherefore, if thou marriest without respect but only for bare love, then thou wilt afterwards with sorrow say that there is more belongs to housekeeping than four bare legs in a bed. A man cannot live with his hands in his bosom nor buy meat in the market for honesty without money; where there is nothing but bare walls, it is a fit house to breed beggars into the world. Yet there are many which think when they are married that they may live by love, but if wealth be wanting, hot love will soon be cold, and your hot desires will be soon quenched with the smoke of poverty. To what end then should we live in love, seeing it is a life more to be feared than death? For all thy money wastes in toys and is spent in banqueting, and all thy time in sighs and sobs to think upon thy trouble and charge which commonly cometh with a wife. For commonly women are proud without profit, and that is a good purgation for thy purse; and when thy purse is light, then will thy heart be heavy.

The pride of a woman is like the dropsy, for as drink increaseth the drought of the one, even so money enlargeth the pride of the other. Thy purse must be always open to feed their fancy, and so thy expenses will be great and yet perhaps thy gettings small. Thy house must be stored with costly stuff, and yet perhaps thy Servants starved for lack of meat. Thou must discharge the Mercer's[11] book and pay the Haberdasher's man, for her hat must continually be of the new fashion and her gown of finer wool than the sheep beareth any. She must likewise have her Jewel box furnished, especially if she be beautiful, for then commonly beauty and pride goeth together, and a beautiful woman is for the most part costly and no good housewife. And if she be a good housewife, then no servant will abide her fierce cruelty, and if she be honest and chaste, then commonly she is jealous. A King's crown and a fair woman is desired of many.

But he that getteth either of them liveth in great troubles and hazard of his life. He that getteth a fair woman is like unto a Prisoner loaded

10. Although Homer in the *Odyssey* does report that Odysseus (Ulysses) wiped away a tear when his old dog died, the Greek myths recount that Odysseus himself died before his wife, Penelope.

11. Textile dealer's.

with fetters of gold, for thou shalt not so oft kiss the sweet lips of thy beautiful wife as thou shalt be driven to fetch bitter sighs from thy sorrowful heart in thinking of the charge which cometh by her. For if thou deny her of such toys as she stand not in need of, and yet is desirous of them, then she will quickly shut thee out of the doors of her favor and deny thee her person, and show herself as it were at a window playing upon thee. Not with small shot, but with a cruel tongue, she will ring thee such a peal that one would think the Devil were come from Hell, saying, "I might have had those which would have maintained me like a woman, whereas now I go like nobody. But I will be maintained if thou wert hanged." With suchlike words she will vex thee, blubbering forth abundance of dissembling tears (for women do teach their eyes to weep). For do but cross a woman, although it be never so little, she will straightway put finger in the eye and cry; then presently many a foolish man will flatter her and entreat her to be quiet. But that mars all, for the more she is entreated, she will pour forth the more abundance of deceitful tears, and therefore no more to be pitied than to see a Goose go barefoot. For they have tears at command, so have they words at will and oaths at pleasure; for they make as much account of an oath as a Merchant doth which will forswear himself for the getting of a penny. I never yet knew woman that would deny to swear in defense of her own honesty and always standing highly upon it, although she be ashamed to wear it in winter for catching of cold, nor in summer for heat, fearing it may melt away.

Many will say this which I write is true, and yet they cannot beware of the Devil until they are plagued with his Dam; the little Lamb skips and leaps till the Fox come, but then he quivers and shakes. The Bear dances at the stake till the Dogs be upon his back, and some men never fear their money until they come into the hands of thieves. Even so, some will never be warned, and therefore is not to be pitied if they be harmed. What are women that makes thee so greedily to gape after them? Indeed, some their faces are fairer and beautifuller than others; some again stand highly upon their fine foot and hand, or else all women are alike. "Joan is as good as my Lady" according to the Countryman's Proverb, who gave a great sum of money to lie with a Lady. And going homewards, he made a grievous moan for his money, and one, being on the other side the hedge, heard him say that his Joan at home was as good as the Lady. But whether this be true or no myself I do not know, but you have it as I heard it.

If thou marriest a woman of evil report, her discredit will be a spot in thy brow; thou canst not go in the street with her without mocks, nor amongst thy neighbors without frumps,[12] and commonly the fairest women are soonest enticed to yield unto vanity. He that hath a fair wife and a whetstone every one will be whetting thereon; and a Castle is hard to keep when it is assaulted by many; and fair women are commonly catched at. He that marrieth a fair woman everyone will wish his death to enjoy her, and if thou be never so rich and yet but a Clown in condition, then will thy fair wife have her credit to please her fancy. For a Diamond hath not his grace but in gold; no more hath a fair woman her full commendations but in the ornament of her bravery,[13] by which means there are divers women whose beauty hath brought their husbands into great poverty and discredit by their pride and whoredom. A fair woman commonly will go like a Peacock, and her husband must go like a woodcock.

That great Giant Pamphimapho, who had Bears waiting upon him like Dogs, and he could make tame any wild beast, yet a wanton woman he could never rule nor turn to his will.

Solomon was the wisest Prince that ever was, yet he lusted after so many women that they made him quickly forsake his God which did always guide his steps, so long as he lived godly.

And was not David the best beloved of God and a mighty Prince? Yet for the love of women he purchased the displeasure of his God. Samson was the strongest man that ever was, for every lock of his head was the strength of another man; yet by a woman he was overcome. He revealed his strength and paid his life for that folly. Did not Jezebel for her wicked lust cause her husband's blood to be given to dogs?

Job's wife gave her husband counsel to blaspheme God and to curse him.

Agamemnon's wife, for a small injury that her husband did her, she first committed adultery and afterwards consented to his death.

Also the wife of Hercules, she gave her husband a poisoned shirt, which was no sooner on his back, but did stick so fast that when he would have plucked it off, it tore the flesh with it.[14]

12. Jeers.

13. Finery.

14. Deianera, the wife of Hercules, sent him the poisoned shirt in the mistaken belief that it was a love charm. Agamemnon sacrificed his eldest daughter, Iphigenia, in order to procure favorable winds for the Greek fleet to sail for Troy; this was the "small in-

If thou wilt avoid these evils thou must with Ulysses bind thyself to the mast of the ship as he did, or else it would have cost him his life, for otherwise the Syrenian women[15] would have enticed him into the Sea if he had not so done.

[Women madly vacillate between emotions; it is death to deny them anything, but they will despise unsought gifts. They will use all of their wiles to obtain a thing, but once it is obtained they will become scornful and begin to desire something else.]

Women are called night Crows for that commonly in the night they will make request for such toys as cometh in their heads in the day, for women know their time to work their craft. For in the night they will work a man like wax and draw him like as the Adamant[16] doth the Iron. And having once brought him to the bent of their bow, then she makes request for a gown of the new fashion stuff, or for a petticoat of the finest stamell,[17] or for a hat of the newest fashion; her husband being overcome by her flattering speech and partly he yieldeth to her request, although it be a grief to him for that he can hardly spare it out of his stock. Yet for quietness sake he doth promise what she demandeth, partly because he would sleep quietly in his bed. Again, every married man knows this, that a woman will never be quiet if her mind be set upon a thing till she have it.

[handwritten margin note: power woman has over man (see this in Petrarch) Petrarchan metaphor.]

Now if thou drive her off with delays, then her forehead will be so full of frowns as if she threatened to make clubs trump, and thou never a black card in thy hand. For except a woman have what she will, say what she list, and go where she please, otherwise thy house will be so full of smoke that thou canst not stay in it.

It is said that an old Dog and a hungry flea bite sore, but in my mind a froward woman biteth more sorer; and if thou go about to master a woman in hope to bring her to humility, there is no way to make her good with stripes except thou beat her to death. For do what thou wilt, yet a froward woman in her frantic mood will pull, haul, swerve, scratch and tear all that stands in her way.

jury" that he did to his wife, Clytemnestra. The biblical examples noted here, especially Jezebel and Delilah (seducer of Samson), are commonly invoked representatives of the destructive woman.

15. The Sirens of Greek mythology, whose enchanting song lured sailors to shipwreck and death.

16. Magnet.

17. Red.

What wilt thou that I say more, O thou poor married man? If women do not feel the rain, yet here is a shower coming which will wet them to the skins! A woman which is fair in show is foul in condition; she is like unto a glowworm which is bright in the hedge and black in the hand. In the greenest grass lieth hid the greatest Serpents; painted pots commonly hold the deadly poison; and in the clearest water the ugliest Toad; and the fairest woman hath some filthiness in her.

[Swetnam maintains that women should be judged by their behavior, not their beauty. Innumerable good men have ruined their characters and their fortunes "for the love of wantons."]

CHAPTER II. The Second Chapter showeth the manner of such Women as live upon evil report; it also showeth that the beauty of Women hath been the bane of many a man, for it hath overcome valiant and strong men, eloquent and subtle men. And, in a word, it hath overcome all men, as by example following shall appear.

First that of Solomon, unto whom God gave singular wit and wisdom, yet he loved so many women that he quite forgot his God, which always did guide his steps, so long as he lived godly and ruled Justly. But after he had glutted himself with women, then he could say; "Vanity of vanity! All is but vanity!" He also in many places of his book of Proverbs exclaims most bitterly against lewd women, calling them all that nought is, and also displayeth their properties. And yet I cannot let men go blameless although women go shameless, but I will touch them both, for if there were not receivers, then there would not be so many stealers; if there were not some knaves, there would not be so many whores, for they both hold together to bolster each other's villainy. For always birds of a feather will flock together hand in hand to bolster each other's villainy.

Men, I say, may live without women, but women cannot live without men: for Venus, whose beauty was excellent fair, yet when she needed man's help, she took Vulcan, a clubfooted Smith.[18] And therefore, if a woman's face glitter and her gesture pierce the marble wall; or if her tongue be so smooth as oil or so soft as silk, and her words so sweet as honey; or if she were a very Ape for wit or a bag of gold for

Oppose!
Petrarch
→ men
seemed
to be
one
that
couldn't
live w̄
out
woman.

18. Classical mythology incongruously depicts Venus, the goddess of love, as married to Vulcan, the lame blacksmith of the gods.

wealth; or if her personage have stolen away all that nature can afford, and if she be decked up in gorgeous apparel, then a thousand to one but she will love to walk where she may get acquaintance. And acquaintance bringeth familiarity, and familiarity setteth all follies abroach;[19] and twenty to one that if a woman love gadding but that she will pawn her honor to please her fantasy.

Man must be at all the cost and yet live by the loss; a man must take all the pains, and women will spend all the gains. A man must watch and ward, fight and defend, till the ground, labor in the vineyard, and look what he getteth in seven years: a woman will spread it abroad with a fork[20] in one year, and yet little enough to scrve her turn, but a great deal too little to get her good will. Nay, if thou give her never so much and yet if thy personage please not her humor, then will I not give a halfpenny for her honesty at the year's end.

For then her breast will be the harborer of an envious heart, and her heart the storehouse of poisoned hatred; her head will devise villainy, *Petrarch-* and her hands are ready to practice that which their heart desireth. Then who can but say that women sprung from the Devil? Whose heads, hands, and hearts, minds and souls are evil, for women are called the hook of all evil because men are taken by them as fish is taken with the hook. *image of men beeing caught by hook*

For women have a thousand ways to entice thee and ten thousand ways to deceive thee and all such fools as are suitors unto them: some they keep in hand with promises, and some they feed with flattery, and some they delay with dalliances, and some they please with kisses. They lay out the folds of their hair to entangle men into their love; *Petrarch* betwixt their breasts is the vale of destruction; and in their beds there is hell, sorrow, and repentance. Eagles eat not men till they are dead, but women devour them alive. For a woman will pick thy pocket and empty thy purse, laugh in thy face and cut thy throat. They are ungrateful, perjured, full of fraud, flouting and deceit, unconstant, waspish, toyish,[21] light, sullen, proud, discourteous, and cruel. And yet they were by God created and by nature formed, and therefore by policy and wisdom to be avoided. For good things abused are to be refused, or else for a month's pleasure she may hap to make thee go

19. Astir.
20. A kind of agricultural implement; "a fork" was a common term for a spendthrift.
21. Foolish, senseless.

stark naked. She will give thee roast meat, but she will beat thee with the spit. If thou hast crowns in thy purse, she will be thy heart's gold until she leave thee not a whit of white money.[22] They are like summer birds, for they will abide no storm, but flock about thee in the pride of thy glory and fly from thee in the storms of affliction. For they aim more at thy wealth than at thy person and esteem more thy money than any man's virtuous qualities. For they esteem of a man without money as a horse doth of a fair stable without meat. They are like Eagles which will always fly where the carrion is.

They will play the horse-leech to suck away thy wealth, but in the winter of thy misery she will fly away from thee not unlike the swallow, which in the summer harboreth herself under the eves of an house and against winter flieth away, leaving nothing but dirt behind her.

[Swetnam cites numerous quotations from the Old and New Testaments excoriating whores and lewd women. He maintains that harlots weaken man's strength and take away the beauty of the body; they dim the eyesight, cause fever and gout, and even shorten life. A woman is a creature of extremes, with "no mean in her love nor mercy in her hate," and so she is simultaneously a source of pleasure and displeasure to man, causing him great delights and yet most cruelly deceiving him. Despite all this, some foolish men brag of women's beauty and stretch their wits to entertain women; they "weary themselves with dallying, playing, and sporting with women." However, the desire for a woman is both insatiable and ruinous: "If thy head be in her lap, she will make thee believe that thou art hard by God's feet, when indeed thou art just at hell gate." As proof of this, Swetnam relates stories about various real or legendary courtesans of antiquity, listing the famous and powerful men they are said to have ensnared, including the biblical figures of David, Solomon, Samson, Holofernes, and Herod, and the classical figures of Hercules, Socrates, Plato, Hannibal, and Julius Caesar.]

But yet happily some may say unto me, "If thou shouldst refuse the company or the courtesy of a woman, then she would account thee a soft-spirited fool, a milksop, and a meacock."[23] But alas, fond fool, wilt thou more regard their babble than thine own bliss, or esteem more their frumps than thine own welfare? Dost thou not know that women always strive against wisdom, although many times it be to

22. Silver coins.
23. A weakling, coward.

their utter overthrow? Like the Bee which is often hurt with her own honey, even so women are often plagued with their own conceit, weighing down love with discourtesy, giving him a weed which presents them with flowers, as their catching in jest and their keeping in earnest. And yet she thinks that she keeps herself blameless, and in all ill vices she would go nameless. But if she carry it never so clean, yet in the end she will be accounted but for a cony-catching quean.[24] And yet she will swear that she will thrive as long as she can find one man alive, for she thinks to do all her knavery invisible. She will have a fig leaf to cover her shame, but when the fig leaf is dry and withered, it doth show their nakedness to the world. For take away their painted clothes, and then they look like ragged walls; take away their ruffs, and they look ruggedly; their coifs and stomachers,[25] and they are simple[26] to behold; their hair untrussed, and they look wildly. And yet there are many which lays their nets to catch a pretty woman, but he which getteth such a prize gains nothing by his adventure but shame to the body and danger to the soul. For the heat of the young blood of these wantons leads many unto destruction for this world's pleasure. It chants[27] your minds and enfeebleth your bodies with diseases; it also scandaleth your good names, but most of all it endangereth your souls. How can it otherwise choose, when lust and uncleanness continually keeps them company, gluttony and sloth serveth them at the table, pride and vainglory appareleth them? But these servants will wax weary of their service, and in the end they shall have no other servants to attend them, but only shame, grief, and repentance. But then, oh then you will say, when it is too late, "Oh, would to God that we had been more careful of true, glorious modesty and less cunning to keep wantons company!" Oh therefore remember and think beforehand that every sweet hath his sour. Then buy not with a drop of honey a gallon of gall; do not think that this world's pleasure will pass away with a trifle and that no sooner done but presently forgotten. No, no, answer yourselves that the punishment remaineth eternally, and therefore better it were to be an addle[28] egg than an evil bird. For we are not

24. A swindling harlot.
25. Close-fitting caps and embroidered or jeweled garments covering the chest and stomach.
26. Plain, homely.
27. Bewitches, deludes.
28. Rotten.

born for ourselves to live in pleasure, but to take pains and to labor for the good of our Country. Yet so delightful is our present sweetness that we never remember the following sour, for youth are too easy won and overcome with the world's vanities. Oh too soon, I say, is youth in the blossoms devoured with the caterpillars of foul lust and lascivious desires. The black Fiend of Hell by his enticing sweet sin of lust draws many young wits to confusion, for in time it draws the heart blood of your good names, and that, being once lost, is never gotten again.

Again, Lust causeth you to do such foul deeds which makes your foreheads forever afterwards seem spotted with black shame and everlasting infamy, by which means your graves after death are closed up with time's scandal. And yet women are easily wooed and soon won, got with an apple and lost with the paring. Young wits are soon corrupted; women's bright beauty breeds curious thoughts; and golden gifts easily overcome wantons' desires, with changing modesty into pastimes of vanity, and being once delighted therein, continues in the same without repentance.[29] You are only the people's wonder and misfortune's bandying ball tossed up and down the world with woe upon woe. Yea, ten thousand woes will be galloping hard at your heels and pursue you wheresoever you go. For those of ill report cannot stay long in one place but roam and wander about the world, and yet ever unfortunate, prospering in nothing, forsaken and cast out from all civil companies, still in fear lest authority with the sword of Justice bar them of liberty. Lo, thus your lives are despised, walking like night Owls in misery, and no comfort shall be your friend, but only repentance coming too late and overdear bought: a penance and punishment due to all such hated creatures as these are.

Therefore believe, all you unmarried wantons, and in believing, grieve that you have thus unluckily made yourselves neither maidens, widows, nor wives, but more vile than filthy channel dirt fit to be swept out of the heart and suburbs of your Country. Oh, then suffer not this world's pleasure to take from you the good thoughts of an honest life! But down, down upon your knees, you earthly Serpents, and wash away your black sin with the crystal tears of true sorrow and repentance, so that when you wander from this enticing world, you may be washed and cleansed from this foul leprosy of nature.

29. Gifts easily turn women into wantons; once won, they continue in this life with no remorse.

Lo, thus in remorse of mind my tongue hath uttered to the wantons of the world the abundance of my heart's grief, which I have perceived by the unseemly behavior of unconstant both men and women. Yet men for the most part are touched but with one fault, which is drinking too much, but it is said of women that they have two faults: that is, they can neither say well nor yet do well.

For commonly women are the most part of the forenoon painting themselves, and frizzling their hairs, and prying in their glass like Apes to prank up themselves in their gaudies: like Puppets, or like the Spider which weaves a fine web to hang the fly. Amongst women, she is accounted a slut which goeth not in her silks. Therefore if thou wilt please thy Lady, thou must like and love, sue and serve, and in spending thou must lay on load. For they must have maintenance howsoever they get it, by hook or by crook, out of Judas's bag or the Devil's budget; thou must spare neither lands nor living, money nor gold.

[Women can find something to criticize in any man: if he is thrifty, he is a "pinchpenny"; if cautious, a "dastard"; if careless in dress, a "sloven." They will caress with one hand and steal with the other, depleting men's revenues to maintain their own "pomp and bravery." Men raise beasts and till the earth for some gainful purpose, but they gain nothing from women: "What labor or cost thou bestowest on a woman is all cast away, for she will yield thee no profit at all." Thus men are fools; they sell all they own for women and "bow at their becks and come at their calls," yet the women care "not a penny" for them. Many women are not even faithful, "holding up to all that come not much unlike a Barber's chair, that so soon as one knave is out another is in; a common hackney for everyone that will ride; a boat for everyone to row in." As soon as the money runs out, these women will leave, for "there is no love in them but from the teeth outward."

[It is difficult to judge the true nature of a woman from her appearance, since "many women are in shape Angels but in qualities Devils, painted coffins with rotten bones." They are like old trees with fair green leaves and decaying trunks. They have myriad devices to entice, bewitch, and deceive men; "if God had not made them only to be a plague to men, he would never have called them necessary evils." Lewd women bring nothing but repentance; "they do rather spend and consume all that which man painfully getteth." Woman is "nothing else but a contrary unto man," and all the pens in the world would not enable men to catalogue all her deceits.]

CHAPTER III. This third Chapter showeth a remedy against love, also many reasons not to be hasty in choice of a Wife. But if no remedy but thou wilt marry, then how to choose a wife, with a Commendations of the good, virtuous, and honest women.

Be not hasty to marry, for doubt lest thou marry in haste and repent by leisure. For there are many troubles which cometh galloping at the heels of a woman, which many young men beforehand do not think of. The world is not all made of oatmeal, nor all is not gold that glitters, nor a smiling countenance is no certain testimonial of a merry heart, nor the way to heaven is not strewed with rushes, no more is the cradle of ease in a woman's lap. If thou wert a servant or in bondage before, yet when thou marriest, thy toil is never the near ended. But even then and not before, thou changest thy golden life which thou didst lead before, in respect of the married, for a drop of honey which quickly turneth to be as bitter as wormwood. And therefore far better it were to have two plows going than one cradle, and better a barn filled than a bed; therefore cut off the occasion which may any way bring thee into fool's paradise. Then first and above all shun Idleness, for idleness is the beginner and maintainer of love. Therefore apply thyself about some affairs or occupied about some business, for so long as thy mind or thy body is in labor, the love of a woman is not remembered nor lust never thought upon. But if thou spend thy time idly amongst women, thou art like unto him which playeth with the Bee, who may sooner feel of her sting than taste of her honey. He that toucheth pitch may be defiled therewith. Roses inadvisedly gathered prickles our fingers; Bees ungently handled stings our faces. And yet the one is pleasant and the other is profitable. And if thou be in company of women, the Devil himself hath not more illusions to get men into his net than women have devices and inventions to allure men into their love. And if thou suffer thyself once to be led into fool's paradise (that is to say, the bed or closet[30] wherein a woman is), then I say thou art like a bird snared in a lime bush, which the more she striveth, the faster she is. It is impossible to fall amongst stones and not to be hurt, or amongst thorns and not be pricked, or amongst nettles and not be stung. A man cannot carry fire in his bosom and not burn his clothing; no more can a man live in love but it is a life as wearisome as hell, and he that mar-

30. Small, private chamber.

rieth a wife matcheth himself unto many troubles. If thou marriest a still and a quiet woman, that will seem to thee that thou ridest but an ambling horse to hell, but if one that is froward and unquiet, then thou wert as good ride a trotting horse to the devil. Herein I will not be my own carver,[31] but I refer you to the judgment of those which have seen the troubles and felt the torments. For none are better able to judge of women's qualities than those which have them; none feels the hardness of the Flint but he that strikes it; none knows where the shoe pincheth but he that wears it. It is said that a man should eat a bushel of Salt with one which he means to make his friend before he put any great confidence or trust in him. And if thou be so long in choosing a friend, in my mind thou hadst need to eat two bushels of Salt with a woman before thou make her thy wife; otherwise, before thou hast eaten one bushel with her, thou shalt taste of ten quarters of sorrow, and for every dram of pleasure an ounce of pain, and for every pint of honey a gallon of gall, and for every inch of mirth an ell[32] of moan. In the beginning, a woman's love seemeth delightful but endeth with destruction; therefore he that trusteth to the love of a woman shall be as sure as he that hangeth by the leaf of a tree in the later end of Summer.

[Swetnam advises men to avoid marriage altogether, for it will bring nothing but misery. He warns against marrying any of the six kinds of women: "good nor bad, fair nor foul, rich nor poor." A good wife will be quickly spoiled, and a bad wife will have to be supported in her wickedness. If the wife is fair, she must be watched continuously, "and if she be foul and loathsome, who can abide her?" A rich wife must be pampered, and a poor one maintained. "For if a woman be never so rich in dowry, happy by her good name, beautiful of body, sober of countenance, eloquent in speech, and adorned with virtue, yet they have one ill quality or other which overthroweth all the other, like unto that Cow which giveth great store of milk and presently striketh it down with her foot." Similarly, certain types of workingmen can be discredited by a single fault ("which commonly in some men is drunkenness").]

It is said of men that they have that one fault, but of women it is said that they have two faults: that is to say, they can neither say well nor do well. There is a saying that goeth thus: that things far fetched and

31. I will not rely on my own discretion.
32. A unit of measure (45 inches).

dear bought are of us most dearly beloved. The like may be said of women; although many of them are not far fetched, yet they are dear bought, yea and so dear that many a man curseth his hard penny-worths and bans[33] his own heart. For the pleasure of the fairest woman in the world lasteth but a honeymoon; that is, while a man hath glutted his affections and reaped the first fruit, his pleasure being past, sorrow and repentance remaineth still with him.

Therefore to make thee the stronger to strive against these tame Serpents, thou shalt have more strings to thy bow than one; it is safe riding at two anchors. Always look before thou leap lest thy shins thou chance to break. Now the fire is kindled; let us burn this other faggot and so to our matter again.

If a woman be never so comely, think her a counterfeit; if never so straight, think her crooked; if she be well set, call her a boss;[34] if slender, a hazel twig; if brown, think her as black as a crow; if well colored, a painted wall; if sad or shamefaced, then think her a clown; if merry and pleasant, then she is the liker to be a wanton. But if thou be such a fool that thou wilt spend thy time and treasure, the one in the love of women and the other to delight them, in my mind thou resemblest the simple Indians, who apparel themselves most richly when they go to be burned.

But what should I say? Some will not give their babble for the Tower of London.[35] He that hath sailed at sea hath seen the dangers, and he that is married can tell of his own woe, but he that was never burnt will never dread the fire. Some will go to dice although they see others lose all their money at play, and some will marry though they beg together. Is it not strange that men should be so foolish to dote on women, who differ so far in nature from men? For a man delights in arms and in hearing the rattling drums, but a woman loves to hear sweet music on the Lute, Cittern, or Bandore.[36] A man rejoiceth to march among the murdered carcasses, but a woman to dance on a silken carpet; a man loves to hear the threatenings of his Prince's enemies, but a woman weeps when she hears of wars. A man loves to lie

33. Chides, curses.
34. A fat woman.
35. Some men would risk imprisonment in the Tower of London rather than relinquish women's babble. This may also be a pun on the biblical tower of Babel.
36. Stringed instruments.

on the cold grass, but a woman must be wrapped in warm mantles; a man triumphs at wars, but a woman rejoiceth more at peace.

If a man talk of any kind of beast or fowl, presently the nature is known, as for example: the Lions are all strong and hardy; the Hares are all fearful and cowardly; the Doves are all simple; and so of all beasts and fowl the like (I mean few or none swerving from his kind). But women have more contrary sorts of behavior than there be women, and therefore impossible for a man to know all, no, nor one part of women's qualities all the days of thy life.

Some with sweet words undermine their husbands, as Delilah did Samson, and some with chiding and brawling are made weary of the world, as Socrates and others. Socrates, when his wife[37] did chide and brawl, would go out of the house till all were quiet again, but because he would not scold with her again, it grieved her the more. For on a time, she watched his going out and threw a chamber pot out of the window on his head. "Ha, ha!" quoth he, "I thought after all this thunder there would come rain."

[Women commonly have either "a long tongue or a longing tooth," and woe to the man whose wife has both. A woman's sharp tongue is the bane of many a man's existence, and he is therefore justified in beating her: "As a sharp bit curbs a froward horse, even so a curst woman must be roughly used, but if women could hold their tongues, then many times men would their hands." Her tongue is a woman's chief weapon; despite all her protestations to the contrary, she can never keep a secret (which Swetnam demonstrates by several apocryphal stories from antiquity).

[Although marriage thus brings many dangers and disquiets, Swetnam does not advise all men against it. Instead, he counsels that the choice of a wife be made very carefully. He maintains that beauty and riches are disastrous without virtue, and the parents as well as the girl must be scrutinized. If a man makes a mistake in the purchase of a horse, he may sell it again, but once married, he must stand by his word even if he was deceived about his wife.]

Now if thou ask me how thou shouldst choose thy wife, I answer that thou hast the whole world to make choice, and yet thou mayest be

37. Xanthippe, the wife of the Greek philosopher Socrates, was proverbial for her shrewish disposition.

deceived. An ancient Father, being asked by a young man how he should choose a wife, he answered him thus: "When thou seest a flock of maidens together, hoodwink[38] thyself fast and run amongst them. And look which thou choosest; let her be thy wife." The young man told him that if he went blindfolded, he might be deceived. "And so thou mayest," quoth the old man, "if thy eyes were open, for in the choice of thy wife, thou must not trust thy own eyes. For they will deceive thee and be the cause of thy woe. For she may seem good whose waist is like a wand; or she which hath a spider-fingered hand; or she which on her tiptoes still doth stand, and never read but in a golden book, nor will not be caught but with a golden hook; or such a one as can stroke a beard, or look[39] a head, and of every flea make herself afraid. If thou hadst a spring,[40] such a wench would make him a beggar if he were half a King; then this is no bargain for thee." But hark a little further. The best time for a young man to marry is at the age of twenty and five, and then to take a wife of the age of seventeen years or thereabout, rather a maid than a widow, for a widow she is framed to the conditions of another man and can hardly be altered, so that thy pains will be double. For thou must unlearn a widow and make her forget and forgo her former corrupt and disordered behavior, the which is hardly to be done. But a young woman of tender years is flexible and bending, obedient, and subject to do anything according to the will and pleasure of her husband.

And if thy state be good, marry near home and at leisure, but if thy state be weak and poor, then to better thyself (after inquiry of her wealth and conditions) go far off and dispatch it quickly; for doubt lest tattling speeches which commonly in these cases runs betwixt party and party and breaks it off even then when it is come to the upshot. But as I have already said, before thou put thy foot out of doors, make diligent inquiry of her behavior, for by the market folk thou shalt hear how the market goeth. For by inquiry thou shalt hear whether she be wise, virtuous, and kind, wearing but her own proper hair and such garments as her friends' estate will afford; or whether she love to keep within the house and to the servants have a watchful eye; or if she have a care when to spend and when to spare, and be

38. Blindfold.

39. Examine, inspect. Such a woman would be exceptionally dainty, since combing fleas and lice out of hair was a common occupation.

40. A young man.

content with what God doth send; or if she can shed no kind of unstained tears but when just cause of hearty sorrow is; and that in wealth and woe, in sickness and in health, she will be all alike. Such a wife will make thee happy in thy choice.

Although some happen on a devilish and unhappy woman, yet all men do not so, and such as happen ill, it is a warning to make them wise if they make a second choice. Not that all other shall have the like fortune: the sun shineth upon the good and bad, and many a man happeneth sooner on a shrew than a ship. Some thrive by dicing, but not one in an hundredth; therefore dicing is ill husbandry. Some thrive by marriage, and yet many are undone by marriage, for marriage is either the making or marring of many a man. And yet I will not say but amongst dust there is a Pearl found, and in hard rocks, Diamonds of great value. And so amongst many women there are some good, as that gracious and glorious Queen of all womenkind, the Virgin Mary, the mother of all bliss. What won her honor but an humble mind and her pains and love unto our Savior, Christ?

Sarah is commended for the earnest love that she bore to her husband, not only for calling him Lord, but for many other qualities; also Susanna, for her chastity and for creeping on her knees to please her husband. But there are meaner Histories which makes mention of many others, as that of Demetrias, how that she was content to run Lackey by her husband's side.

Likewise, Lucretia, for the love and loyalty that she bore to her husband. Being unkindly abused by an unchaste lecher against her will, she presently slew herself in the presence of many rather than she would offer her body again to her husband, being but one time defiled.[41]

[Swetnam continues to relate stories of virtuous women. One woman took her husband's place in prison so that he might escape, while the wife of Mausolus built for her husband such a fabulous sepulcher that it became one of the seven wonders of the world. A loving wife in Rome committed suicide with her husband because he was dying of an incurable disease. It is recorded that Alexander the Great bitterly

41. Sarah, wife of the Hebrew patriarch Abraham, is a conventional type of the virtuous, subservient wife, but the Old Testament Apocrypha mention nothing about Susanna "creeping on her knees," although her chastity is extolled. Lucretia's story is told by the Roman historian Livy.

mourned the death of his wife.[42] Adam was so fond of his wife that he disobeyed God's commandment in order to please her. Therefore, a man who happens upon a good wife is indeed fortunate, and he should not desire to change her in case he cannot find such another.]

Saint Paul saith those which marry do well, but he also saith those which marry not do better. But yet also he saith that it is better to marry than to burn in lust. A merry companion, being asked by his friend why he did not marry, he made this answer and said that he had been in Bedlam[43] two or three times and yet he was never so mad to marry. And yet there is no joy nor pleasure in the world which may be compared to marriage, so the parties are of near equal years and of good qualities. Then good fortune and bad is welcome to them; both their cares are equal and their joys equal. Come what will, all is welcome and all is common betwixt them. The husband doth honor and reverence her, and if he be rich, he committeth all his goods to her keeping. And if he be poor and in adversity, then he beareth but the one half of the grief, and furthermore she will comfort him with all the comfortable means she can devise. And if he will stay solitary in his house, she will keep him company. If he will walk into the fields, why she will go with him, and if he be absent from home, she sigheth often and wisheth his presence. Being come home, he findeth content sitting smiling in every corner of his house to give him a kind and hearty welcome home, and she receiveth him with the best and greatest joy that she can. Many are the joys and sweet pleasures in marriage, as in our children. Being young, they play, prattle, laugh, and showeth us many pretty toys to move us to mirth and laughter; and when they are bigger grown and that age or poverty hath afflicted the Parents, then they show the duty of children in relieving their old, aged parents with what they can shift for. And when their parents are dead, they bring them to the earth from whence they came.

Yet now consider on the other side: when a wrinkled and toothless woman shall take a beardless boy (a short tale to make of it), there can be no liking nor loving between such contraries, but continual strife and debate. So likewise when matches are made by the Parents and the dowry told and paid before the young couple have any knowledge of it

42. Since both of Alexander's wives survived him, one would question Swetnam's sources for this report.
43. A famous lunatic asylum in London.

(and so many times are forced against their minds, fearing the rigor and displeasure of their parents), they often promise with their mouths that which they refuse with their hearts.

[If a man marries a woman for beauty without dowry, he will soon tire of her, while riches maintain their attractiveness. When marriages are arranged, it is the duty of the father to investigate the qualities of his prospective son-in-law. The husband, then, must "satisfy the honest desires of his wife," keep her in health, give her his loving company, secrets, and counsel, gently rebuke her faults, and always behave toward her with civility.

[A wife must stay away from women of ill repute; she should behave in so sober and chaste a manner as never to encourage other men. She should always speak mildly to her husband and bear all his rebukes in silence. For his part, the husband ought never to beat his wife: "For with what face can a man embrace that body which his hands hath battered and bruised, or with what heart can a woman love that man who can find it in his heart to beat her?" The wife must be frugal and keep the house in good order, for "a light housewife who liveth without doing of anything" will ruin her husband's household and give bad example to the servants.]

But these men are to be laughed at who, having a wife and a sufficient wife to do all the work within doors which belongs for a woman to do, yet the husband will set hens abroad, season the pot, and dress the meat, or any the like work which belongeth not to the man. Such husbands many times offend their wives greatly, and they wrong themselves. For if they were employed abroad in matters belonging to men, they would be the more desirous, being come home, to take their ease than to trouble their wives and servants in meddling with their matters. For the rule and government of the house belongeth to the wife.

And he that hath a wife of his own and goeth to another woman is like a rich thief which will steal when he hath no need.

Amongst all the creatures that God hath created, there is none more subject to misery than a woman, especially those that are fruitful to bear children, but they have scarce a month's rest in a whole year, but are continually overcome with pain, sorrow, and fear. As indeed the danger of childbearing must needs be a great terror to a woman, which are counted but weak vessels in respect of men, and yet it is supposed that there is no disease that a man endureth that is one half so grievous or painful as childbearing is to a woman. Let it be the toothache, gout,

or colic: nay, if a man had all these at once, yet nothing comparable to a woman's pain in her travail with child.

[Swetnam concludes the chapter by referring the reader to Ovid's poem on the cures for love (*Remedia Amoris*).[44] Men who wish to avoid lust should abstain from excessive meat and drink; they should keep busy at all times and stay away from places of temptation. The lover should never even mention the name of his beloved, but he should contrive to love two or three simultaneously, or at least to spend his passion on other women. This Ovid said because he did not have the benefit of God's grace to prescribe more moral remedies for love.]

THE BEARBAITING OR THE VANITY OF WIDOWS, CHOOSE YOU WHETHER.

Woe be unto that unfortunate man that matcheth himself with a widow, for a widow will be the cause of a thousand woes. Yet there are many that do wish themselves no worse matched than to a rich widow. But thou dost not know what griefs thou joinest with thy gains, for if she be rich, she will look to govern, and if she be poor, then art thou plagued both with beggary and bondage. Again, thy pains will be double in regard of him which marrieth with a maid. For thou must unlearn thy widow and make her forget her former corrupt and disordered behavior; the which if thou take upon thee to do, thou hadst even as good undertake to wash a Blackamoor[45] white. For commonly widows are so froward, so waspish, and so stubborn that thou canst not wrest them from their wills. And if thou think to make her good by stripes, thou must beat her to death. One, having married with a froward widow, she called him these and many other unhappy names. So he took her and cut the tongue out of her head, but she ever afterwards would make the sign of the gallows with her fingers to him.

It is seldom or never seen that a man marrieth with a widow for her beauty nor for her personage, but only for her wealth and riches. And if she be rich and beautiful withal, then thou matchest thyself to a she-devil, for she will go like a Peacock and thou, like a Woodcock. For she

44. The *Remedies for Love* is a witty, tongue-in-cheek poem allegedly written because Ovid's poetic treatment of the art of seduction (*Ars Amatoria*) had been so successful that lovers were clamoring for advice on how to break up love affairs.

45. A negro.

will hide her money to maintain her pride, and if thou at any time art desirous to be merry in her company, she will say thou art merry because thou hast gotten a wife that is able to maintain thee, where before thou wast a beggar and hadst nothing. Anf if thou show thyself sad, she will say thou art sad because thou canst not bury her, thereby to enjoy that which she hath. If thou make provision to fare well in thy house, she will bid thee spend that which thou broughtest thyself.

If thou show thyself sparing, she will say thou shalt not pinch her of that which is her own, and if thou do anything contrary to her mind, she will say her other husband was more kind. If thou chance to dine from home, she will bid thee go sup with thy Harlots abroad; if thou go abroad and spend anything before thou comest home, she will say, "A beggar I found thee, and a beggar thou meanest to leave me." If thou stay always at home, she will say thou art happy that hast gotten a wife that is able to maintain thee idle. If thou carve her the best morsel on the table, though she take it, yet she will take it scornfully and say she had a husband that would let her cut where she liked herself.

And if thou come in well disposed, thinking to be merry and entreating her with fair words, she will call thee dissembling hypocrite, saying, "Thou speakest me fair with thy tongue, but thy heart is on thy minions[46] abroad." Lo, these are the frantic tricks of froward widows. They are neither well full nor fasting; they will neither go to Church nor stay at home (I mean in regard of their impatient minds). For a man shall neither be quiet in her sight nor out of her sight. For if thou be in her sight, she will vex thee as beforesaid, and out of her sight, thy own conscience will torment and trouble thy mind to think on the purgatory which perforce thou must endure when thou comest home.

She will make Clubs trump when thou hast never a black card in thy hand, for with her cruel tongue she will ring thee such a peal that one would think the devil were come from Hell. Besides this, thou shalt have a branded slut like a hell-hag with a pair of paps[47] like a pair of dung pots shall bring in thy dinner, for thy widow will not trust thee with a wench that is handsome in thy house. Now if that upon just occasion thou throwest the platters at the maid's head, seeing thy meat brought in by such a slut and so sluttishly dressed, then will thy widow

46. Darlings, mistresses.
47. Teats, breasts.

take pepper in the nose and stamp and stare, and look so sour as if she had come but even then from eating of Crabs, saying, "If thou hadst not married with me, thou wouldst have been glad of the worst morsel that is here." [Swetnam continues by describing the quarrel in detail; he then proceeds to tell several stories about men who married widows. One, on his deathbed, stated that he did not care whether he went to Heaven or Hell, as long as his wife was not there. Another, hearing a preacher say, "Take up thy cross and follow me," slung his wife upon his back and walked up to the minister. Another, amidst a great storm at sea, cast his wife overboard when the captain called for the heaviest goods to be thrown off the ship.]

Thou mayest think that I have spoken enough concerning Widows, but the further I run after them, the further I am from them. For they are the sum of the seven deadly sins, the Fiends of Satan, and the gates of Hell. Now methinketh I hear some say unto me that I should have told them this lesson sooner, for too late cometh medicine when the patient is dead. Even so, too late cometh counsel when it is past remedy, but it is better late than never, for it may be a warning to make others wise.

But why do I make so long a harvest of so little corn? Seeing the corn is bad, my harvest shall cease, for so long as women do ill, they must not think to be well spoken of. If you would be well reported of or kept like the Rose when it hath lost the color, then you should smell sweet in the bud as the Rose doth, or if you would be tasted for old wine, you should be sweet at the first like a pleasant Grape. Then should you be cherished for your courtesy and comforted for your honesty; so should you be preserved like the sweet Rose and esteemed of as pleasant wine. But to what purpose do I go about to instruct you, knowing that such as counsel the devil can never amend him of his evil?

And so, praying those which have already made their choice and seen the troubles and felt the torments that is with women to take it merrily and to esteem of this book only as the toys of an idle head.

Nor I would not have women murmur against me for that I have not written more bitterly against men, for it is a very hard winter when one Wolf eateth another; and it is also an ill bird that defileth her own nest; and a most unkind part it were for one man to speak ill of another.

Ester hath hang'd
Haman:
OR
AN ANSVVERE TO
a lewd Pamphlet, entituled,
The Arraignment of Women.

With the arraignment of lewd, idle,
froward, and vnconstant men, and
Hvsbands.

Diuided into two Parts.

The first proueth the dignity and worthinesse
of Women, out of diuine Testimonies.

The second shewing the estimation of the Fœ-
minine Sexe, in ancient and Pagan times ; all which
is acknowledged by men themselues in their
daily actions.

VVritten by *Ester Sowernam*, neither Maide,
Wife nor Widdowe, yet really all, and there-
fore experienced to defend all.

IOHN 8. 7.
He that is without sinne among you, let him first cast a stone at her.

Neque enim lex iusticior vlla
——— *Quàm necis Artificem arte perire sua.*

LONDON,
Printed for *Nicholas Bourne*, and are to be sold at his shop
at the entrance of the Royall Exchange. 1617.

§. *Esther hath hanged Haman;*[1]
or, An Answer to a lewd Pamphlet entitled
The Arraignment of Women,
With the arraignment of lewd, idle, froward,
and unconstant men and Husbands.
Divided into two Parts:
The first proveth the dignity and worthiness
of Women out of divine Testimonies;
The second showing the estimation
of the Feminine Sex in ancient and Pagan times,
all which is acknowledged by men
themselves in their daily actions.
Written by Esther Sowernam: neither Maid,
Wife, nor Widow, yet really all and therefore
experienced to defend all.[2]
1617

To all Right Honorable, Noble, and worthy Ladies, Gentlewomen,
and virtuously disposed of the Feminine Sex.

Right Honorable and all others of our Sex, upon my repair to London this last Michaelmas Term,[3] being at supper amongst friends

1. Haman, the chief minister of the Persian king Ahasuerus, plotted to destroy all the Jews residing in Persia, but Esther, the Jewish queen of Ahasuerus, revealed his treachery and caused him to be hanged.

2. Here Sowernam may be indicating that she has been successively a maid, a wife, and a widow but that she objects to the tendency to categorize women by defining them according to their relationships with men. However, she is certainly contemptuously dismissing Swetnam's description of "unmarried wantons" as "neither maidens, widows, nor wives."

3. The High Court of Justice in England was in session for four periods (or "terms") of the year, designated by the names of the religious feast days which fell near the beginning of each period: Hilary term (January 13), Easter term, Trinity term (eighth Sunday after Easter), and Michaelmas term (September 29). It appears from this and later statements that Sowernam resided in London during the terms when the court was in session but spent the intervals between sessions in the country, where she was apparently unable to write.

where the number of each sex were equal, as nothing is more usual for table talk there fell out a discourse concerning women, some defending, others objecting against our Sex. Upon which occasion, there happened a mention of a Pamphlet entitled *The Arraignment of Women*, which I was desirous to see. The next day a Gentleman brought me the Book, which when I had superficially run over, I found the discourse as far off from performing what the Title promised as I found it scandalous and blasphemous. For where the Author pretended to write against lewd, idle, and unconstant women, he doth most impudently rage and rail generally against all the whole sex of women. Whereupon I, in defense of our Sex, began an answer to that shameful Pamphlet; in which, after I had spent some small time, word was brought me that an Apology for women was already undertaken, and ready for the Press, by a Minister's daughter.[4] Upon this news I stayed my pen, being as glad to be eased of my intended labor as I did expect some fitting performance of what was undertaken. At last the Maiden's Book was brought me, which when I had likewise run over, I did observe that whereas the Maid doth many times excuse her tenderness of years, I found it to be true in the slenderness of her answer. For the undertaking to defend women doth rather charge and condemn women, as in the ensuing discourse shall appear. So that whereas I expected to be eased of what I began, I do now find myself double charged, as well to make reply to the one, as to add supply to the other.

In this my Apology, Right Honorable, Right Worshipful, and all others of our Sex, I do in the first part of it plainly and resolutely deliver the worthiness and worth of women both in respect of their Creation as in the work of Redemption. Next I do show in examples out of both the Testaments what blessed and happy choice hath been made of women as gracious instruments to derive God's blessings and benefits to mankind.

In my second part I do deliver of what estimate women have been valued in all ancient and modern times, which I prove by authorities, customs, and daily experiences. Lastly, I do answer all material objections which have or can be alleged against our Sex; in which also I do arraign such kind of men which correspond the humor and disposition of the Author: lewd, idle, furious and beastly disposed persons.

[handwritten margin note: how she will go about / prove her work.]

[handwritten margin note: Swetnam]

4. Rachel Speght, probably the daughter of schoolmaster Thomas Speght, published in 1617 a response to Swetnam entitled *A Muzzle for Melastomus.*

This being performed, I doubt not but such as heretofore have been so forward and lavish against women will hereafter pull in their horns and have as little desire, and less cause, so scandalously and slanderously to write against us than formerly they have.

The ends for which I undertook this enterprise are these. First, to set out the glory of Almighty God in so blessed a work of his Creation. Secondly, to encourage all Noble, Honorable, and worthy Women to express in their course of life and actions that they are the same Creatures which they were designed to be by their Creator and by their Redeemer, and to parallel those women whose virtuous examples are collected briefly out of the Old and New Testament. Lastly, I write for the shame and confusion of such as degenerate from womanhood and disappoint the ends of Creation and Redemption. *hopes her text might reach out to women who need guidance*

There can be no greater encouragement to true nobility than to know and stand upon the honor of Nobility, nor any greater confusion and shame than for Nobility to dismount and abase itself to ignoble and degenerate courses.

You are women: in Creation, noble; in Redemption, gracious; in use, most blessed. Be not forgetful of yourselves nor unthankful to that *God* — Author from whom you receive all.

[Sowernam addresses a second epistle to "all worthy and hopeful young youths of Great Britain, but respectively to the best disposed and worthy Apprentices of London." After attacking Swetnam, she pinpoints the differences between her approach and his: "The Author of the *Arraignment* and myself in our labors do altogether disagree. He raileth without cause; I defend upon direct proof. He saith women are the worst of all Creatures; I prove them blessed above all Creatures. . . . If you believe our adversary, no woman is good, howsoever she be used; if you consider what I have written, no woman is bad except she be abused." Sowernam also defends her right to answer Swetnam's pamphlet by standing upon the merits of what she has written: "Some will perhaps say I am a woman and therefore write more for women than they do deserve: to whom I answer, if they misdoubt[5] of what I speak, let them impeach my credit in any one particular." She closes by calling upon the youths, as "the hope of Manhood," to defend the reputations of women from *young men* "such old fornicators."]

Esther Sowernam

Sowernam very confidant

5. Are mistrustful.

CHAPTER I. An Answer to the First Chapter of *The Arraignment of Women*.

If the Author of this *Arraignment* had performed his discourse either answerable to the Title or the Arguments of the Chapters, he had been so far off from being answered by me that I should have commended so good a labor, which is employed to give vice just reproof and virtue honorable report. But at the very first entrance of his discourse, in the very first page, he discovereth himself neither to have truth in his promise nor religious performance. If in this answer I do use more vehement speeches than may seem to correspond the natural disposition of a Woman, yet all judicious Readers shall confess that I use more mildness than the cause I have in hand provoketh me unto.

I am not only provoked by this Author to defend women, but I am more violently urged to defend divine Majesty in the work of his Creation. In which respect I say with Saint Jerome, "Meam iniuriam patienter sustinui; impietatem contra deum ferre non potui."[6] For as Saint Chrysostom saith, "Iniurias Dei dissimulare impium est."[7]

If either Julian the Apostate or Lucian the Atheist[8] should undertake the like work, could the one devise to write more blasphemously, or the other to scoff and flout at the divine Creation of Woman more profanely than this irreligious Author doth?

Homer doth report in his *Iliad* that there was at the seige of Troy a Grecian called Thersites,[9] whose wit was so blockish he was not worthy to speak, yet his disposition was so precipitate he could not hold his tongue. Joseph Swetnam in all record of Histories cannot be so likely paralleled as with this Thersites. What his composition of body is I know not, but for his disposition otherwise, in this Pamphlet I know he is as monstrous as the work is misshapen, which shall plainly appear in the examination of the first page only.

The Argument of the first Chapter is "to show to what use Women

6. "I have patiently borne insult to myself; I have not been able to endure impiety against God."

7. "It is impious to ignore insults to God." Jerome and Chrysostom were Doctors of the early Christian church.

8. Julian was a Roman emperor who attempted to restore paganism after Constantine had declared Christianity the state religion; Lucian was an ancient Greek writer of satiric dialogues.

9. An ugly and troublesome Greek whom Homer calls "boundless in speech," a man "who knew in his mind many words, but all without order" (*Iliad* 2.212–23).

were made"; it also showeth "that most of them degenerate from the use they were framed unto," etc.

Now, to show to what use woman was made, he beginneth thus: "At the first beginning, a Woman was made to be an helper to Man. And so they are indeed, for they help to consume and spend," etc. This is all the use and all the end which the Author setteth down in all his discourse for the creation of woman. Mark a ridiculous jest in this: spending and consuming of that which Man painfully getteth is by this Author the use for which Women were made. And yet (saith he in the Argument) "most of them degenerate from the use they were framed unto." Woman was made to spend and consume at the first, but women do degenerate from this use. Ergo, Midas[10] doth contradict himself. Beside this egregious folly, he runneth into horrible blasphemy. Was the end of God's creation in Woman to spend and consume? Is "helper" to be taken in that sense, to help to "spend," etc.? Is spending and consuming "helping"?

He runneth on and saith: "They were made of a Rib, and that their froward and crooked nature doth declare, for a Rib is a crooked thing," etc.

Woman was made of a crooked rib, so she is crooked of conditions; Joseph Swetnam was made as from Adam of clay and dust, so he is of a dirty and muddy disposition. The inferences are both alike in either: woman is not more crooked in respect of the one, but he is blasphemous in respect of the other. Did Woman receive her soul and disposition from the rib or, as it is said in Genesis, "God did breathe in them the spirit of life"? Admit that this Author's doctrine be true, that woman receiveth her froward and crooked disposition from the rib; Woman may then conclude upon that Axiom in Philosophy, "Quicquid efficit tale, illud est magis tale" ("that which giveth quality to a thing doth more abound in that quality"), as fire which heateth is itself more hot; the Sun which giveth light is of itself more light. So, if Woman received her crookedness from the rib and consequently from the Man, how doth man excel in crookedness, who hath more of those crooked ribs! See how this vain, furious, and idle Author furnisheth woman with an Argument against himself and others of his Sex.

10. Sowernam is apparently naming Swetnam after the mythological king who turned everything he touched into gold; Midas became a symbol of stupidity because of the ass's ears given him by the god Apollo.

The Author, having desperately begun, doth more rashly and impudently run on in blasphemy, which he doth evidently show in the inference upon his former speeches: "And therefore," saith he, "ever since, they have been a woe unto Man and follow the line of the first leader." Now, let the Christian Reader please to consider how dishonestly this Author dealeth who, undertaking a particular, prosecuteth and persecuteth a general, under the cloak and color of lewd, idle, and froward women to rage and rail against all women in general.

Now, having examined what collections Joseph Swetnam hath wrested out of Scriptures to dishonor and abuse all women, I am resolved, before I answer further particulars made by him against our sex, to collect and note out of Scriptures: first, what incomparable and most excellent prerogatives God hath bestowed upon women in honor of them and their Creation; secondly, what choice God hath made of women in using them as instruments to work his most gracious and glorious designs for the general benefit of mankind both during the law of Nature and of Moses; thirdly, what excellent and divine graces have been bestowed upon our Sex in the law of Grace and the work of Redemption; with a conclusion that to manifest the worthiness of women, they have been chosen to perform and publish the most happy and joyful benefits which ever came to mankind.

CHAPTER II. What incomparable and excellent prerogatives God hath bestowed upon Women in their first Creation.

In this ensuing Chapter, I determine briefly to observe (not curiously to discourse at large) the singular benefits and graces bestowed upon Women. In regard of which it is first to be considered that the Almighty God in the world's frame in his Divine wisdom designed to himself a main end to which he ordained all the works of his Creation, in which he, being a most excellent workmaster, did so Create his works that every succeeding work was ever more excellent than what was formerly Created. He wrought by degrees, providing in all for that which was and should be the end.

It appeareth by that Sovereignty which God gave to Adam over all the Creatures of Sea and Land that man was the end of God's creation, whereupon it doth necessarily without all exception follow that Adam, being the last work, is therefore the most excellent work of creation. Yet Adam was not so absolutely perfect but that in the sight of God he

wanted an Helper. Whereupon God created the woman, his last work, as to supply and make absolute that imperfect building which was unperfected in man, as all Divines[11] do hold, till the happy creation of the woman. Now of what estimate that Creature is and ought to be which is the last work, upon whom the Almighty set up his last rest,[12] whom he made to add perfection to the end of all creation, I leave rather to be acknowledged by others than resolved by myself.

It is furthermore to be considered, as the Maid in her *Muzzle for Melastomus* hath observed, that God intended to honor woman in a more excellent degree, in that he created her out of a subject refined, as out of a Quintessence. For the rib is in Substance more solid, in place as most near (so in estimate most dear) to man's heart, which doth presage that as she was made for an helper, so to be an helper to stay, to settle all joy, all contents, all delights to and in man's heart, as hereafter shall be showed.

[Since man was created in the world, he is a worldling; since woman was created in Paradise, she is a "Paradisian." As both father and priest, God solemnized the marriage of the first man and woman, commanding that married love should be even more sacred than filial love. However, the woman was tempted by "a Serpent of the masculine gender"; "maliciously envying the happiness in which man was at this time, like a mischievous Politician, he practiced by supplanting[13] of the woman to turn him out of all." Although woman sinned first, the sin was not completed until Adam fell; he alone was responsible for bringing sin to the rest of mankind. Furthermore, he compounded his sin by arguing with God, trying to excuse himself by attacking the woman he was supposed to love: "so he may discharge himself, he careth little how he clog her."]

God having examined the offenders and having heard the uttermost they could allege for themselves, he pronounceth sentence of death upon them, as a punishment in justice due and deserved. Justice he administered to Adam; albeit the woman doth taste of justice, yet mercy is reserved for her. And of all the works of mercy which mankind may hope for, the greatest, the most blessed, and the most joyful is promised to woman.

11. Clergymen.
12. Made his final end.
13. Causing the downfall.

Woman supplanted by tasting of fruit, she is punished in bringing forth her own fruit. Yet what by fruit she lost, by fruit she shall recover.

What more gracious a gift could the Almighty promise to woman than to bring forth the fruit in which all nations shall be blessed? So that as woman was a means to lose Paradise, she is by this made a means to recover Heaven. Adam could not upbraid her for so great a loss, but he was to honor her more for a greater recovery. All the punishments inflicted upon women are countered with most gracious blessings and benefits; she hath not so great cause of dolor in one respect as she hath infinite cause of joy in another. She is commanded to obey her husband; the cause is the more to increase her glory. Obedience is better than Sacrifice, for nothing is more acceptable before God than to obey. Women are much bound to God to have so acceptable a virtue enjoined them for their penance.

Amongst the curses and punishments heaped upon the Serpent, what greater joy could she hear or what greater honor could be done unto her than to hear from the voice of God these words: "I will put enmity betwixt the woman and thee, betwixt thy seed and her seed," and that her seed should break the Serpent's head? This must perforce be an exceeding joy for the woman, to hear and to be assured that her fruit should revenge her wrong.

After the fall, and after they were all arraigned and censured (and that now Adam saw his wife's dowry and what blessings God hath bestowed upon her), he being now a bondslave to death and hell, struck dead in regard of himself, yet he comforts himself, he taketh heart from grace, he engageth his hope upon that promise which was made to the woman. Out of this most comfortable and blessed hope, he now calleth his wife by a name in whose effects not only he, but all mankind, should most blessedly share. He calleth her *Eve*, which is "the mother of the living," which is suitable as well in respect of the promise made to her and her seed as in respect of those employments for which in her creation she and all women are designed: to be helpers, comforters, Joys, and delights, and in true use and government they ever have been and ever will be, as hereafter shall be showed, maugre[14] the shameful, blasphemous, and profane speech of Joseph Swetnam, page 31, beginning line 15 as followeth: "If God had not made them

14. In spite of.

only to be a plague to a man, he would never have called them necessary evils."

Out of what Scripture, out of what record can he prove these impious and impudent speeches? They are only feigned and framed out of his own idle, giddy, furious, and frantic imaginations. If he had cited Euripides for his Author, he had had some color, for that profane Poet in *Medea* useth these speeches: "Quod si Deorum aliquis mulierem formavit, opificem se malorum sciat, maximum et hominibus inimicum" ("If any of the Gods framed woman, let him know he was the worker of that which is nought and what is most hurtful to men").[15] Thus a Pagan writeth profanely, but for a Christian to say that God calleth women "necessary evils" is most intolerable and shameful to be written and published.

CHAPTER III. What choice God hath made of women to be instruments to derive his benefits to Mankind.

[In this brief chapter, Sowernam cites seventeen examples of Old Testament women who showed courage and fortitude in aiding and preserving men. She supports her references by identifying the book and chapter of the Bible in which each woman appears; among the better known examples are Sarah, Rebecca, Judith, Esther, Susanna, and the mother of the Macchabees.]

CHAPTER IV. What excellent blessings and graces have been bestowed upon women in the Law of Grace.

[Sowernam gives examples of blessed women from the New Testament, again citing book and chapter; her examples include, among others, the Virgin Mary, Elizabeth, Anna, and Mary Magdalene. To avoid being "overtedious," Sowernam presents in summary form the benefits brought by women in the New Testament, avowing that women were chosen by God for "more glorious and gracious employments than men have been": the first promise of a Messiah was made to a

15. Sowernam apparently read the Greek tragedian Euripides in a Latin translation. This line does not appear in the Greek text of the play, although one character, Jason, does express similar sentiments. In the Renaissance and in earlier times, Euripides had an undeserved reputation as a misogynist; in fact, the main thrust of the *Medea* is sympathetic toward women's plight.

woman; it was a woman who gave birth to the Messiah; women never forsook Christ, even when all men fled from him; Christ's resurrection was first proclaimed by a woman. Furthermore, the early church was dignified by many virtuous wives, widows, and virgins who in their services and martyrdoms "have in no respect been inferior unto men."]

Thus out of the second and third Chapters of Genesis and out of the Old and New Testaments, I have observed in proof of the worthiness of our Sex: first, that woman was the last work of Creation (I dare not say "the best"); she was created out of the chosen and best refined substance; she was created in a more worthy country; she was married by a most holy Priest; she was given by a most gracious Father; her husband was enjoined to a most inseparable and affectionate care over her; the first promise of salvation was made to a woman; there is inseparable hatred and enmity put betwixt the woman and the Serpent; her first name, Eve, doth presage the nature and disposition of all women, not only in respect of their bearing, but further for the life and delight of heart and soul to all mankind.

I have further showed the most gracious, blessed, and rarest benefits in all respects bestowed upon women, all plainly and directly out of Scriptures.

All which doth demonstrate the blasphemous impudence of the author of the *Arraignment*, who would or durst write so basely and shamefully, in so general a manner, against our so worthy and honored a sex.

To the courteous and friendly Reader.

Gentle Reader, in my first Part I have (what I might) strictly observed a religious regard not to intermingle anything unfitting the gravity of so respective[16] an Argument.

Now that I am come to this second Part, I am determined to solace myself with a little liberty. What advantages I did forbear to take in the former, I mean to make use of in this second. Joseph Swetnam hath been long unanswered, which had been performed sooner if I had heard of his Book before this last Term or if the report of the Maiden's answer had not stayed me. I have not so amply and absolutely discharged myself in this Apology as I would have done if either my leisure had

16. Respectful.

been such as I could have wished or the time more favorable that I might have stayed. What my repair into the Country enforceth me to leave rather begun than finished, I mean (by God's grace) to make perfect the next Term. In the meantime (gentle Reader), I bid thee kindly farewell.

<div align="right">Esther Sowernam</div>

CHAPTER IV.[17] At what estimate Women were valued in ancient and former times.

Plato, in his Books *de Legibus*,[18] estimateth of Women, which do equal Men in all respects: only in body they are weaker, but in wit and disposition of mind nothing inferior, if not superior. Whereupon he doth in his so absolute a Commonwealth admit them to government of Kingdoms and Commonweals, if they be either born thereunto by Nature or seated in government by Election.

It is apparent that in the prime of antiquity women were valued at highest estimate,[19] in that all those most inestimable and incomparable benefits which might either honor or preserve Mankind are all generally attributed to the invention of women, as may appear in these few examples following.

[Sowernam draws upon Roman mythology for her examples, citing (among others) Bellona as the inventor of the sword and armor, Ceres as the inventor of agriculture, the nine Muses as inventors of the liberal arts and sciences, Carmenta as the inventor of the alphabet, and Diana as the inventor of hunting. She maintains that the ancients associated goddesses only with good things, while their gods represented the bad as well as the good. Even Venus, goddess of love, is good, for it is her son Cupid who presides over lust. Hell is ruled by a god, Pluto; it has a queen, Proserpina, only for half of the year, and then solely because Pluto forcibly ravished her.]

17. The pamphlet uses this number for two successive chapters.

18. The *Laws* is the last of the dialogues written by the Greek philosopher Plato. In this work he did not propose that women be admitted to government (except for the supervision of marriage), although he had envisaged female as well as male rulers in an earlier, more utopian work, the *Republic*. Although Plato gave more credit to women than most ancient Greek writers, he did not maintain that women were the equals of men, much less their superiors.

19. Sowernam again overstates her case, for women were generally considered inferior to men in classical antiquity, although the Romans were less misogynistic than the Greeks.

If I should recite and set down all the honorable records and Monuments for and of women, I might write more Books than I have yet written lines. I will leave and pass over the famous testimonies of foreign Kingdoms and Commonwealths in honor of our Sex, and I will only mention some few examples of our own Country and Kingdom, which have been incomparably benefited and honored by women.

Amongst the old Britains, our first Ancestors, the valiant Boadicea,[20] that defended the liberty of her Country against the strength of the Romans when they were at the greatest, and made them feel that a woman could conquer them who had conquered almost all the men of the then known world.

The devout Helena,[21] who besides that she was the Mother of that religious and great Constantine, who first seated Christian Religion in the Imperial throne, and in that respect may be styled the mother of Religion, is still more honored for her singular piety and charity towards him and his members, who died for us upon the Cross, than for her care and industry in finding out the wood of that Cross on which he died.

In the time of the Danes, chaste Emma,[22] whose innocence carried her naked feet over the fire-hot Plowshares unfelt; with the Saxons' Queen Ethelfleda,[23] the holy widow, the King's daughter Edith,[24] a Virgin Saint, both greater conquerors than Alexander the great, that men so much boast of, who could not conquer himself.

Since the Normans, the heroical virtues of Eleanor,[25] wife to Edward the first, who when her Husband in the Holy Land was wounded with

20. As the widow of Prasutagus, king of the tribe of the Iceni, Boadicea led a British revolt against the Romans in the first century A.D., won several bloody battles, but was eventually defeated and took her own life.

21. Saint Helena was the mother of the Roman emperor Constantine; she built several churches in Palestine and was reputed to have found the actual cross upon which Christ died.

22. The daughter of the duke of Normandy, Emma first married the Saxon king Ethelred II, by whom she became the mother of Edward the Confessor; after the king's defeat and death, she married King Canute, the Danish conqueror of England.

23. Ethelfleda, daughter of King Alfred the Great and wife of Ethelred, Count of Mercia, became famous as "the Lady of the Mercians" after her husband's death, when she successfully defended his dominions against the Danes, displaying notable courage and military ability.

24. Saint Edith was the daughter of Edgar, king of England; she is said to have declined all claims to the throne and taken monastic vows at the age of fifteen.

25. Eleanor of Castille accompanied her husband on the Crusades and according to popular legend saved his life by sucking poison from his wound.

a poisoned Arrow of which there was no hope of recovery from the Chirurgeons,[26] she sucked the poison into her own body to free him, together curing that mortal wound and making her own fame immortal. So that I think this one act of hers may equal all the acts that her great Husband did in those wars besides.

Philippa,[27] wife to Edward the third, no less to be honored for being the Mother of so many brave children than of so many good deeds, which worthily got her the title of "good."

Margaret the wise,[28] wife to Henry the sixth, who if her Husband's fortune, valor, and foresight had been answerable to hers, had left the Crown of England to their own Son and not to a stranger.

The other Margaret,[29] of Richmond, mother to Henry the seventh, from whose breasts he may seem to have derived as well his virtues as his life, in respect of her heroical prudence and piety whereof, besides other Monuments, both the Universities are still witnesses.

Besides this, it was by the blessed means of Elizabeth,[30] wife to Henry the seventh, that the bloody wars betwixt the houses of York and Lancaster were ended and the red Rose and the white united, etc.

It was by the means of the most renowned Queen,[31] the happy Mother of our dread Sovereign, that the two Kingdoms, once mortal foes, are now so blessedly conjoined.

And that I may name no more (since in one only were comprised all the qualities and endowments that could make a person eminent),

26. Surgeons.

27. Philippa of Hainault is said to have saved the lives of six French citizens whom her husband, Edward III, intended to put to death.

28. Margaret of Anjou was the virtual ruler of England because of the near imbecility of her husband, Henry VI. However, despite valiant efforts during the War of the Roses, she could not hold the throne for the house of Lancaster (symbolized by a red rose) and was defeated by Edward IV, who seized the throne for the house of York (symbolized by a white rose).

29. As the great-granddaughter of John of Gaunt, Margaret of Richmond passed the Lancastrian claim to the throne to her son, who became King Henry VII; she was also a noted benefactress of Cambridge and Oxford.

30. When Henry VII married Elizabeth of York, daughter of Edward IV, the Wars of the Roses were finally ended.

31. Mary Stuart, Queen of Scots, was the mother of James I, king of England at the time this pamphlet was written; however, she can be said to have united the kingdoms of Scotland and England only genealogically (she was the great-granddaughter of Henry VII and her son was king of Scotland before he also became the English sovereign in 1603). She herself did not contribute to the unity, having been executed on a charge of conspiracy against the English crown by Elizabeth I.

Elizabeth [32] our late Sovereign, not only the glory of our Sex, but a pattern for the best men to imitate, of whom I will say no more but that while she lived, she was the mirror of the world, so then known to be, and so still remembered, and ever will be.

Daily experience and the common course of Nature doth tell us that women were by men in those times highly valued, and in worth by men themselves preferred and held better than themselves.

I will not say that women are better than men, but I will say men are not so wise as I would wish them to be to woo us in such fashion as they do, except they should hold and account of us as their betters.

[Men go to great lengths to obtain the love of women, even to the point of threatening suicide. The vehemence of these suits indicates that men think women are better, not baser, than they themselves are: an Aristotelian maxim states that everything, by nature, seeks the good, and it is nature which ordains this pursuit of women. Men will seek to elude the truth of this maxim by saying that women are only apparently good, not truly good. However, heathen and Christian alike agree that a man who follows the true direction of nature will never be deceived by a good that is only apparent. Instead, men tacitly admit that the female is better than the male by their "obsequious duty and service" in attempting to obtain tokens from their mistresses: "If these were not relics from Saintly creatures, men would not sacrifice so much devotion unto them." Men's earnest pursuit of women stems further from the association of women with honesty, for a wife is "the sure sign and seal of honesty," as evinced by the fact that fathers with "wild and riotous" sons seek to find them good wives in order to reform them, thus acknowledging "a greater worthiness in women than in men."]

In no one thing men do acknowledge a more excellent perfection in women than in the estimate of the offenses which a woman doth commit; the worthiness of the person doth make the sin more markable. What a hateful thing it is to see a woman overcome with drink, when as in men it is noted for a sign of goodfellowship! And whosoever doth observe it, for one woman which doth make a custom of drunkenness, you shall find an hundred men. It is abhorred in women, and therefore they avoid it; it is laughed at and made but as a jest amongst men, and therefore so many do practice it. Likewise, if a man abuse a Maid and

32. Elizabeth I, daughter of Henry VIII, brilliantly ruled England from 1558–1603.

get her with child, no matter is made of it but as a trick of youth, but it is made so heinous an offense in the maid that she is disparaged and utterly undone by it. So in all offenses, those which men commit are made light and as nothing, slighted over, but those which women do commit, those are made grievous and shameful. And not without just cause: for where God hath put hatred betwixt the woman and the serpent, it is a foul shame in a woman to curry favor with the devil, to stain her womanhood with any of his damnable qualities, that she will shake hands where God hath planted hate.

Joseph Swetnam in his Pamphlet aggravateth the offenses of women in the highest degree, not only exceeding, but drawing men into all mischief. If I do grant that women degenerating from the true end of womanhood prove the greatest offenders, yet in granting that I do thereby prove that women in their creation are the most excellent creatures. For corruption *boni pessima*, "the best thing, corrupted, proveth the worst," as for example the most glorious creature in heaven is by his fall the most damned devil in hell.[33] All the Elements in their purity are most precious, in their infection and abuse most dangerous. So the like in women: in their most excellent purity of nature, what creature more gracious; but in their fall from God and all goodness, what creature more mischievous! Which the devil knowing, he doth more assault woman than man, because his gain is greater by the fall of one woman than of twenty men. Let there be a fair maid, wife, or woman in Country, town, or City, she shall want no resort[34] of Serpents nor any variety of tempter. Let there be in like sort a beautiful or personable man, he may sit long enough before a woman will solicit him! For where the devil hath good acquaintance, he is sure of entertainment there without resistance. The Serpent at first tempted woman; he dare assault her no more in that shape. Now he employeth men to supply his part, and so they do. For as the Serpent began with Eve to delight her taste, so do his instruments draw to wine and banqueting. The next, the Serpent enticed her by pride and told her she should be like to God; so do his instruments: first, they will extol her beauty, what a paragon she is in their eyes; next, they will promise her such maintenance as the best woman in the Parish or Country shall not have better. What care they if they make a thousand oaths and commit

33. The archangel Lucifer became Satan when he refused to serve God.
34. Lack no throng.

ten thousand perjuries, so they may deceive a woman? When they have done all and gotten their purpose, then they discover[35] all the woman's shame and employ such an Author as this (to whose Arraignment I do make haste) to rail upon her and the whole Sex.

CHAPTER V. The Arraignment of Joseph Swetnam, who was the Author of *The Arraignment of Women*, and under his person the arraignment of all idle, frantic, froward, and lewd men.

Joseph Swetnam having written his rash, idle, furious, and shameful discourse against Women, it was at last delivered into my hands; presently I did acquaint some of our Sex with the accident,[36] with whom I did advise what course we should take with him. It was concluded that (his unworthiness being much like to that of Thersites, whom I have formerly mentioned) we would not answer him either with Achilles' fist or Stafford law; neither pluck him in pieces as the Thracian women did Orpheus for his intemperate railing against women.[37] But as he had arraigned women at the bar of fame and report, we resolved at the same bar where he did us the wrong to arraign him, that thereby we might defend our assured right. And withal, respecting ourselves we resolved to favor him so far in his trial that the world might take notice there was no partial or indirect dealing, but that he had as much favor as he could desire and far more than he did or could deserve.

So that we brought him before two Judgesses, Reason and Experience, who being both in place, no man can suspect them with any indirect proceedings. For albeit Reason of itself may be blinded by passion, yet when she is joined with Experience, she is known to be absolute and without compare. As for Experience, she is known of herself to be admirable excellent in her courses. She knoweth how to use every man in her practice: she will whip the fool to learn him more wit; she will punish the knave to practice more honesty; she will curb

35. Reveal.
36. Incident.
37. According to tradition, Thersites was killed by the Greek warrior Achilles; Greek mythology relates that the Thracian women dismembered with their bare hands the bard Orpheus because he rejected all women after the death of his wife Eurydice. Sowernam is indicating that the women refuse to employ force against Swetnam; "Stafford law" is a humorous expression meaning "the law of the staff or club."

in the prodigal and teach him to be wary; she will trip up the heels of such as are rash and giddy and bid them hereafter look before they leap. To be short, there is not in all the world, for all estates, degrees, qualities, and conditions of men, so singular a Mistress, or so fit to be a Judgess, as she. Only one property she hath above all the rest: no man cometh before her but she maketh him ashamed, and she will call and prove almost every man a fool, especially such who are wise in their own conceits.

For his Jury, albeit we knew them to be of his dearest and nearest inward familiar friends, in whose company he was ever and did spend upon them all that he could get or devise to get, yet we did challenge no one of them but were well pleased that his five Senses and the seven deadly sins should stand for his jury.

The party which did give evidence against him we knew to be a sure Card, and one which would not fail in proof of anything, and such proof which should be without all exception: Conscience is a sure witness.

So all things being accordingly provided, the prisoner was brought to the bar, where he was called and bid hold up his hand, which he did (but a false hand, God he knows!). His indictment was read, which was this which followeth.

CHAPTER VI. Joseph Swetnam, his Indictment.

[In a parody of a formal indictment, Sowernam briefly repeats many of her charges against Swetnam. She then maintains that Swetnam entered a plea of "not guilty," but "Conscience did so confront him," that he threw himself upon the mercy of the judges rather than hazard the trial. In order to give Swetnam every chance to recant and also to forestall possible charges of irregularity, since the judges, jury, and accusers were mostly "of the feminine gender," the trial was postponed. However, it was concluded that Sowernam herself should deliver the following speech, publishing the wrongs done to women by Swetnam.]

THE ANSWER TO ALL OBJECTIONS WHICH ARE MATERIAL MADE AGAINST WOMEN.

Right Honorable and Worshipful, and you of all degrees: it hath ever been a common custom amongst Idle and humorous Poets, Pam-

phleteers, and Rhymers, out of passionate discontents or having little otherwise to employ themselves about, to write some bitter Satire-Pamphlet or Rhyme against women. In which argument, he who could devise anything more bitterly or spitefully against our sex hath never wanted the liking, allowance, and applause of giddy-headed people. Amongst the rabble of scurrile writers, this prisoner now present hath acted his part, whom albeit women could more willingly let pass than bring him to trial, and as ever heretofore rather contemn[38] such authors than deign them any answer, yet seeing his book so commonly bought up, which argueth a general applause, we are therefore enforced to make answer in defense of ourselves, who are by such an author so extremely wronged in public view.

You all see he will not put himself upon trial. If we should let it so pass, our silence might implead[39] us for guilty; so would his Pamphlet be received with a greater current and credit than formerly it hath been. So that as well in respect of our sex as for a general satisfaction to the world, I will take this course with our prisoner: I will at this present examine all the objections which are most material which our adversary hath vomited out against woman, and not only what he hath objected but what other authors of more import than Joseph Swetnam have charged upon women. Alas, silly man, he objecteth nothing but what he hath stolen out of English writers, as *Euphues, The Palace of Pleasure*,[40] with the like, which are as easily answered as vainly objected. He never read the vehement and professed enemies against our sex as, for Grecians, Euripides, Menander, Semonides, Sophocles, with the like; amongst Latin writers, Juvenal, Plautus, etc.[41]

But of all that ever I read, I did never observe such general scurrility in any as in this adversary, which you shall find I will make as manifest as the Sun to shine at midday.

It is the main end that our adversary aimeth at in all his discourse to prove and say that women are bad; if he should offer this upon partic-

38. Scorn.

39. Accuse.

40. *Euphues: The Anatomy of Wit* was a well-known prose romance written by John Lyly; *The Palace of Pleasure* was a popular collection of tales translated from classical, Italian, and French sources by William Painter. Both works date from the latter part of the sixteenth century.

41. Euripides and Sophocles were tragedians; Menander, an author of New Comedy; Semonides of Amorgos wrote an antifeminist poem comparing women to animals. Juvenal was a misogynistic writer of satires; Plautus, an author of Roman comedy.

ulars, no one would deny it, but to lavish generally against all women, who can endure it? You might, Mr. Swetnam, with some show of honesty have said some women are bad, both by custom and company, but you cannot avoid the brand both of blasphemy and dishonesty to say of women generally they are all nought, both in their creation and by nature, and to ground your inferences upon Scriptures.

I let pass your objections in your first page because they are formerly answered; only whereas you say, "Woman was no sooner made, but her heart was set upon mischief," if you had then said, "She had no sooner eaten of the fruit, but her heart was set upon mischief," you had had some color for your speeches, not in respect of the woman's disposition, but in consideration both of her first Tutor and her second instructor. For whereas scripture doth say, "Woman was supplanted by a Serpent," Joseph Swetnam doth say, "Woman was supplanted by the devil, which appeared to her in the shape of a beautiful young man."[42] Men are much beholden to this author, who will seem to insinuate that the devil would in so friendly and familiar a manner put on the shape of man when he first began to practice mischief. The devil might make bold of them whom he knew in time would prove his familiar friends. Hereupon it may be imagined it cometh to pass that Painters and Picture-makers, when they would represent the devil, they set him out in the deformed shape of a man, because under that shape he began first to act the part of a devil, and I doubt he never changed his suit since. Here it is observed that which is worst is expressed in the shape of a man, but what is the most glorious creature is represented in the beauty of a woman, as Angels. [Adam also taught women evil by his bad example: how to hide from God, to argue with God, and to excuse himself by attacking his wife. Moreover, all men are infected by evil through the original sin of Adam.]

In your first and second Page, you allege[43] David and Solomon for exclaiming bitterly against women, and that Solomon saith, "Women (like as Wine) do make men drunk with their devices." What of all this?

Joseph Swetnam, a man which hath reason, will never object that

42. Sowernam misquotes Swetnam here, for he actually attributes this claim to medieval theologians ("as our Schoolmen doth write").

43. Cite. David and Solomon were ancient Hebrew kings; David is reputed to have written many of the psalms, and Solomon many of the proverbs.

unto his adversary which when it cometh to examination will disadvantage himself. Your meaning is in the disgrace of women to exalt men, but is this any commendation to men, that they have been and are overreached by women? Can you glory in their holiness, whom by women prove sinful; or in their wisdom, whom women make fools; or in their strength, whom women overcome? Can you excuse that fall which is given by the weaker, or color that foil[44] which is taken from women? Is holiness, wisdom, and strength so slightly seated in your Masculine gender as to be stained, blemished, and subdued by women? But now, I pray you, let us examine how these virtues, in men so potent, came by women to be so impotent. Do you mean in comparative degree that women are more holy, more wise, more strong, than men? If you should grant this, you had small cause to write against them. But you will not admit this. What is or are the causes then why men are so overtaken by women? You set down the causes in your fourth Page; there you say, "They are dangerous for men to deal with, for their faces are Lures, their beauties baits, their looks are nets, and their words are charms, and all to bring men to ruin." "Incidit in Scyllam qui vult vitare Charybdim":[45] whilst he seeketh to avoid one mischief, he falleth into another. It were more credit for men to yield our sex to be more holy, wise, and strong than to excuse themselves by the reasons alleged, for by this men are proved to have as little wit as they are charged to exceed in wickedness. Are external and dumb shows such potent baits, nets, lures, charms to bring men to ruin? Why? Wild Asses, dotterels,[46] and woodcocks are not so easily entangled and taken. Are men so idle, vain, and weak as you seem to make them? Let me now see how you can free these men from dishonest minds, who are overtaken thus with beauty, etc. How can beauty hurt? How can it be a cause of man's ruin, of itself? What, do women forcibly draw? Why, men are more strong. Are they so eloquent to persuade? Why, men are too wise. Are they mischievous to entice? Men are more holy. How then are women causes to bring men to ruin? Direct causes they cannot be in any respect. If they be causes, they are

44. Disguise that defeat.
45. "He who wishes to avoid Charybdis falls into the clutches of Scylla." In Homer's *Odyssey*, the hero Odysseus must sail between the whirlpool Charybdis and the man-devouring monster Scylla; this phrase thus became proverbial for a choice of evils.
46. Birds named for the apparent ease with which they could be captured.

but accidental causes: a cause, as Philosophers say, *causa sine qua non*,[47] a remote cause, which cause is seldom alleged for cause but where want of wit would say somewhat and a guilty conscience would excuse itself by something. Philosophers say "Nemo laeditur nisi a se ipso" ("no man is hurt but the cause is in himself"). The prodigal person amongst the Grecians is called *Asōtos*[48] as a destroyer, an undoer of himself. When a heart fraught with sin doth prodigally lavish out a lascivious look out of a wanton eye, when it doth surfeit upon the sight, who is *Asōtos*? Who is guilty of his lascivious disease but himself? "Volenti non fit iniuria" ("he who is wounded with his own consent hath small cause to complain of another's wrong"). Might not a man as easily, and more honestly, when he seeth a fair woman which doth make the best use that she can to set out her beauty, rather glorify God in so beautiful a work than infect his soul with so lascivious a thought? And for the woman, who having a Jewel given her from so dear a friend, is she not to be commended rather that in the estimate which she showeth she will as carefully and as curiously as she may set out what she hath received from Almighty God, than to be censured that she doth it to allure wanton and lascivious looks?

[When men complain that "women's dressings and attire are provocations to wantonness and baits to allure men," they are simply displaying their own lascivious dispositions, for such judgments reveal more about the mind which passes the verdict than about the person judged. After all, some men "exceed in apparel" and preen themselves upon their appearance; they squander their patrimonies on their clothes, wearing "apparel and colors made of a Lordship, lined with Farms and Granges, embroidered with all the plate, gold, and wealth their Friends and Fathers left them." However, women do not therefore complain that they are "tempted and allured by men"; such men provide motives for laughter rather than love. So Swetnam and all like him should cease to criticize women's attire: "Do not say and rail at women to be the cause of men's overthrow, when the original root and cause is in yourselves." Since Swetnam and his friends are so weak that they are "scorched with the flames of love" whenever they look at a woman, Sowernam offers them as a remedy the "sovereign salve" first propounded by the Greek Cynic philosopher Diogenes: "First, try

47. "A cause without which no definite effect takes place."
48. "Beyond salvation."

with *Khronos;* next, with *Limos;* if both these fail, the third is sure, *Brokhos.*"[49]

[Sowernam next discounts Swetnam's interpretation of the fable of the wind and the sun, saying that the moral "ever hath been applied to men, to instruct them in the government of women." She quotes a poem, "written in English verse long since," which retells the fable and supports her version of the moral: women, mild by nature, become wild at the hands of "froward, crabbed Husbands," while tender treatment assures a sunny disposition.]

This is the true application of the Moral. As for that crookedness and frowardness with which you charge women, look from whence they have it; for of themselves and their own disposition it doth not proceed, which is proved directly by your own testimony. For in your 45th Page, Line 15, you say, "A young woman of tender years is flexible, obedient, and subject to do anything according to the will and pleasure of her Husband." How cometh it then that this gentle and mild disposition is afterwards altered? Yourself doth give the true reason, for you give a great charge not to marry a widow. But why? Because, say you in the same Page, "A widow is framed to the conditions of another man." Why then, if a woman have froward conditions, they be none of her own; she was framed to them. Is not our adversary ashamed of himself, to rail against women for those faults which do all come from men? Doth not he most greviously charge men to learn[50] their wives bad and corrupt behavior? For he saith plainly, "Thou must unlearn a widow and make her forget and forgo her former corrupt and disordered behavior." Thou must unlearn her: ergo, what fault she hath, she learned; her corruption cometh not from her own disposition but from her Husband's destruction. Is it not a wonder that your Pamphlets are so dispersed? Are they not wise men to cast away time and money upon a Book which cutteth their own throats? 'Tis a pity but that men should reward you for your writing, if it be but as the Roman Sertorius[51] did the idle Poet; he gave him a reward, but not for his writing but because he should never write more. As for women, they laugh that men have no more able a champion. This au-

49. First, "time"; next, "famine"; third, "the noose."
50. Does he not accuse men of teaching.
51. A Roman general who led a temporarily successful Spanish revolt against the Roman government.

thor cometh to bait women or, as he foolishly saith, the "Bearbaiting[52] of Women," and he bringeth but a mongrel Cur, who doth his kind, to brawl and bark but cannot bite. The mild and flexible disposition of a woman is in philosophy proved in the composition of her body, for it is a Maxim, "Mores animi sequuntur temperaturam corporis" ("the disposition of the mind is answerable to the temper of the body"). A woman in the temperature of her body is tender, soft, and beautiful; so doth her disposition in mind correspond accordingly: she is mild, yielding, and virtuous. What disposition accidentally happeneth unto her is by the contagion of a froward husband, as Joseph Swetnam affirmeth.

And experience proveth. It is a shame for a man to complain of a froward woman, in many respects all concerning himself. It is a shame he hath no more government over the weaker vessel. It is a shame he hath hardened her tender sides and gentle heart with his boisterous and Northern blasts. It is a shame for a man to publish and proclaim household secrets, which is a common practice amongst men, especially Drunkards, Lechers, and prodigal spendthrifts. These, when they come home drunk or are called in question for their riotous misdemeanors, they presently show themselves the right children of Adam. They will excuse themselves by their wives, and say that their[53] unquietness and frowardness at home is the cause that they run abroad, an excuse more fitter for a beast than a man. If thou wert a man, thou wouldest take away the cause which urgeth a woman to grief and discontent, and not by thy frowardness increase her distemperature. Forbear thy drinking, thy luxurious riot, thy gaming and spending, and thou shalt have thy wife give thee as little cause at home as thou givest her great cause of disquiet abroad. Men which are men, if they chance to be matched with froward wives, either of their own making or others' marring, they would make a benefit of the discommodity: either try his skill to make her mild or exercise his patience to endure her cursedness. For all crosses are inflicted either for punishment of sins or for exercise of virtues. But humorous[54] men will sooner mar a thousand women, than out of an hundred make one good.

And this shall appear in the imputation which our adversary

52. A very popular sport in which dogs attacked a bear chained to a stake.
53. The wives'.
54. Capricious.

chargeth upon our sex: to be lascivious, wanton and lustful. He saith, "Women tempt, allure, and provoke men." How rare a thing is it for women to prostitute and offer themselves? How common a practice is it for men to seek and solicit women to lewdness? What charge do they spare? What travail do they bestow? What vows, oaths, and protestations do they spend to make them dishonest? They hire Panders; they write letters; they seal them with damnations and execrations to assure them of love, when the end proves but lust. They know the flexible disposition of Women and, the sooner to overreach them, some will pretend they are so plunged in love that except they obtain their desire they will seem to drown, hang, stab, poison, or banish themselves from friends and country. What motives are these to tender dispositions? Some will pretend marriage; another offer continual maintenance. But when they have obtained their purpose, what shall a woman find? Just that which is her everlasting shame and grief: she hath made herself the unhappy subject to a lustful body and the shameful stall[55] of a lascivious tongue. Men may with foul shame charge women with this sin which they had never committed if she had not trusted, nor had ever trusted if she had not been deceived with vows, oaths, and protestations. To bring a woman to offend in one sin, how many damnable sins do they commit? I appeal to their consciences. The lewd disposition of sundry men doth appear in this: if a woman or maid will yield unto lewdness, what shall they want? But if they would live in honesty, what help shall they have? How much will they[56] make of the lewd; how base account of the honest? How many pounds will they spend in bawdy houses, but when will they bestow a penny upon an honest maid or woman, except it be to corrupt them?

Our adversary bringeth many examples of men which have been overthrown by women. It is answered before; the fault is their own. But I would have him, or anyone living, to show any woman that offended in this sin of lust but that she was first solicited by a man.

Helen was the cause of Troy's burning: first, Paris did solicit her; next, how many knaves and fools of the male kind had Troy, which to maintain whoredom would bring their City to confusion!

When you bring in examples of lewd women and of men which have been stained by women, you show yourself both frantic and a profane,

55. Bait.
56. The men.

241

irreligious fool to mention Judith for cutting off Holofernes' head,[57] in that rank.

You challenge women for untamed and unbridled tongues; there was never a woman was ever noted for so shameless, so brutish, so beastly a scold as you prove yourself in this base and odious Pamphlet. You blaspheme God, you rail at his Creation, you abuse and slander his Creatures. And what immodest or impudent scurrility is it which you do not express in this lewd and lying Pamphlet?

Hitherto I have so answered all your objections against Women that, as I have not defended the wickedness of any, so I have set down the true state of the question. As Eve did not offend without the temptation of a Serpent, so women do seldom offend but it is by provocation of men. Let not your impudence, nor your consorts'[58] dishonesty charge our sex hereafter with those sins of which you yourselves were the first procurers. I have in my discourse touched you and all yours to the quick. I have taxed you with bitter speeches; you will (perhaps) say I am a railing scold. In this objection, Joseph Swetnam, I will teach you both wit and honesty. The difference between a railing scold and an honest accuser is this: the first rageth upon passionate fury without bringing cause or proof; the other bringeth direct proof for what she allegeth. You charge women with clamorous words and bring no proof. I charge you with blasphemy, with impudence, scurrility, foolery, and the like; I show just and direct proof for what I say. It is not my desire to speak so much; it is your desert to provoke me upon just cause so far. It is no railing to call a Crow black, or a Wolf a ravener, or a drunkard a beast. The report of the truth is never to be blamed; the deserver of such a report deserveth the shame.

Now, for this time, to draw to an end: let me ask according to the question of Cassius, "Cui bono?"[59] What have you gotten by publishing your Pamphlet? Good I know you can get none. You have (perhaps) pleased the humors of some giddy, idle, conceited persons, but

57. Judith, a Jewish widow, pretended to seduce the Assyrian general Holofernes in order to gain admission to his tent. With the help of her maid, she then beheaded him, thus saving her people from capture.

58. Companions'.

59. The Roman orator Cicero attributed this phrase to a judge named Lucius Cassius, who always asked when trying a case, "Who benefits by it?" However, this phrase was popularly misinterpreted in English to mean, "What good will it do?"

you have dyed yourself in the colors of shame, lying, slandering, blasphemy, ignorance, and the like.

The shortness of time and the weight of business call me away and urge me to leave off thus abruptly, but assure yourself where I leave now, I will by God's grace supply the next Term,[60] to your small content. You have exceeded in your fury against Widows, whose defense you shall hear of at the time aforesaid. In the mean space, recollect your wits; write out of deliberation, not out of fury; write out of advice, not out of idleness; forbear to charge women with faults which come from the contagion of Masculine serpents.

[The pamphlet closes with a long poem entitled "A Defense of Women against the Author of *The Arraignment of Women*." Signed "Joan Sharp," the poem is essentially a versified recapitulation of many of the major arguments advanced by Sowernam.]

60. Sowernam apparently never published a further response to Swetnam.

THE
WORMING
of a mad Dogge:

OR,

A SOPPE FOR
CERBERVS THE
Iaylor of Hell.

NO CONFVTATION BVT A
ſharpe Redargution of the
bayter of Womeu.

By CONSTANTIA MVNDA
—— *dux fœmina faɛti.*

Virg: Æn: 1.

Si genus humanum & mortalia temnitis arma,
At ſperate Deos memores fandi atque nefandi.

LONDON
Printed for LAVRENCE HAYES, and are to be
ſold at his ſhop neere Fleet-bridge, ouer
againſt Sᵗ. *Brides* Lane.
1 6 1 7.

§. *The Worming of a mad Dog;*
or, A Sop for Cerberus,[1] the Jailor of Hell.

No Confutation but a sharp Redargution[2]
of the baiter of Women
by Constantia Munda:
"dux femina facti."[3]
1617

*To the Right Worshipful Lady her most dear Mother, the Lady
Prudentia Munda,[4] the true pattern of Piety and Virtue, Constantia
Munda wisheth increase of happiness.*

> As first your pains in bearing me was such
> a benefit beyond requital that 'twere much
> To think what pangs of sorrow you sustained
> In childbirth, when mine infancy obtained
> The vital drawing in of air, so your love
> Mingled with care hath shown itself above
> The ordinary course of Nature. Seeing you still
> Are in perpetual Labor with me even until
> The second birth of education perfect me,
> You Travail still though Churched[5] oft you be.
> In recompense whereof what can I give
> But what I take, even that I live?
> Next to the heavens, 'tis yours. Thus I pay
> My debt by taking up at interest, and lay
> To pawn that which I borrow of you: so

1. The three-headed dog who guarded the entrance to the underworld in Greek
mythology.

2. Reproof.

3. "A woman was leader of the exploit," said admiringly of the courageous Carthaginian queen Dido in Vergil's *Aeneid* 1.364. The pseudonym "Constantia Munda" is
Latin for "elegant constancy," obviously chosen to contradict Swetnam's attack on
women as "unconstant."

4. "Elegant wisdom or understanding."

5. Formally presented in a church ceremony after childbirth to give thanks for a safe
delivery.

The more I give, I take; I pay, I owe.
Yet lest you think I forfeit shall my bond,
I here present you with my writing hand.
Some trifling minutes I vainly did bestow
In penning of these lines that all might know
The scandals of our adversary, and
I had gone forward had not *Esther hanged
Haman*[6] before. Yet what here I wrote
Might serve to stop the cur's wide throat
Until the halter came, since which I ceased
To prosecute what I intended, lest
I should be censured that I undertook
A work that's done already. So his book
Hath 'scaped my fingers, but in like case
As a malefactor changeth place
From Newgate unto Tyburn,[7] whose good hope
Is but to change his shackles for a rope.
　　Although this be a toy scarce worth your view,
Yet deign to read it, and accept in lieu
Of greater duty, for your gracious look
Is a sufficient Patron to my book.
　　This is the worst disgrace that can be had:
　　A Lady's daughter wormed a dog that's mad.
　　　　　　　　　　　　Your loving Daughter,
　　　　　　　　　　　　Constantia Munda.

[Munda dedicates a second poem to Joseph Swetnam. Filled with invective, the poem castigates Swetnam's "barren-idle-dunghill brain" for attacking women "with sottish lies, with bald and ribald lines patched out of English writers," when the world's greatest writers have rather praised and glorified the merits of womankind:

Woman: the crown, perfection, and the means
Of all men's being and their well-being, whence
Is the propagation of all humankind;
Wherein the body's frame, the intellect and mind,
With all their operations do first find

6. The response to Swetnam published by Esther Sowernam in 1617.
7. Newgate was a London prison; Tyburn, a place of execution.

Their Essence and beginning; where doth lie
The mortal means of our eternity;
Whose virtues, worthiness, resplendent rays
Of perfect beauty have always had the praise
And admiration of such glorious wits
Which Fame, the world's great Herald, sits
Crowning with Laurel wreaths and Myrtle boughs,
The tribute and reward of learned brows.

Moreover, Swetnam's attack will actually make women stronger than ever, so Munda closes the poem with this advice:

Wherefore be advised: cease to rail
On them that with advantage can you quail.]

THE WORMING OF A MAD DOG.

The itching desire of oppressing the press with many sottish and illiterate Libels stuffed with all manner of ribaldry and sordid inventions, when every foul-mouthed malcontent may disgorge his Lycambean poison[8] in the face of all the world, hath broken out into such a dismal contagion in these our days that every scandalous tongue and opprobrious wit, like the Italian Mountebanks,[9] will advance their peddling wares of detracting virulence in the public Piazza of every Stationer's shop. And Printing, that was invented to be the storehouse of famous wits, the treasure of Divine literature, the pandect[10] and maintainer of all Sciences, is become the receptacle of every dissolute Pamphlet, the nursery and hospital of every spurious and penurious brat which proceeds from base phrenetical[11] brainsick babblers. When "scribimus indocti"[12] must be the motto of everyone that fools himself in Print, 'tis ridiculous; but when "scribimus insani"[13] should be the

8. Bitter and destructive satire, named for Lycambes, the ancient Greek who reputedly hung himself because he was the target of the biting invective of the satiric poet Archilochus.

9. Itinerant quacks who attracted audiences by telling stories and performing tricks on elevated platforms in public squares in order to sell worthless medicines.

10. Digest.

11. Frenzied.

12. "We, the untrained, write," a caustic comment by the Roman poet and satirist Horace stating that everyone in Rome thinks he can be a writer (*Epistles* 2.1.117).

13. "We, the insane, write," Munda's own addition to the quotation from Horace.

signature of every page, 'tis lamentable. Our times so stupidly possessed and benumbed with folly that we shall verify the Proverb, "L'usanza comune non è peccato";[14] sin's customhouse hath "non sine privilegio"[15] writ upon his doors, as though community in offense could make an immunity. No! Use of sin is the soul's extortion, a biting fenory[16] that eats out the principal. Yet woeful experience makes it too true "consuetudo peccandi tollit sensum,"[17] as may be seen by the works of diverse men that make their pens their pencils to limn out vice that it may seem delicious and amiable, so to detract from virtue and honesty, as though their essence were only in outward appearance of goodness, as if mortality were only circumscribed within the conditions of our sex. "Caelum ipsum petimus stultitia";[18] foolish man will reprehend his Creator in the admirable work of his generation and conservation. Woman, the second edition of the Epitome of the whole world, the second Tome of that goodly volume compiled by the great God of heaven and earth, is most shamefully blurred and derogatively erased by scribbling pens of savage and uncouth monsters. To what an irregular strain is the daring impudence of blindfold bayards[19] aspired unto that they will presume to call in question even the most absolute work composed by the world's great Architect? A strange blasphemy, to find fault with that which the Privy Council of the high and mighty Parliament of the inscrutable Trinity in Heaven determined to be very good, to call that imperfect, froward, crooked and perverse, to make an arraignment and Bearbaiting of that which the Pantocrator[20] would in his omniscient wisdom have to be the consummation of his blessed week's work, the end, crown, and perfection of the never sufficiently glorified creation. What is it but an exorbitant frenzy and woeful taxation of the supreme deity? Yet woman, the greatest part of the lesser world, is generally become the subject of every pedantical goose quill. Every fantastic Poetaster which thinks he hath licked the vomit of his Coryphaeus[21] and can but patch a hobbling verse together will strive

14. "What is common usage is no sin," an Italian proverb.
15. "Not without special privilege."
16. Interest.
17. "The habit of sinning destroys the sense of sin."
18. "In our folly we attack heaven itself," Horace Odes 1.3.38.
19. Ignorant fools.
20. The Almighty.
21. The leader of the chorus in ancient Greek drama.

to represent unseemly figments imputed to our sex as a pleasing theme to the vulgar on the public Theater.

[These "foul-mouthed railers" write not to reform but to "carp and cavil"; they should not thus "let tongue and pen run up and down like a weaponed madman" since, as stated in the Gallic proverb, "a blow from the tongue is more dangerous than a blow from the sword."]

Yet lest villainy domineer and triumph in fury, we will manacle your dissolute fist, that you deal not your blows so unadvisedly. Though feminine modesty hath confined our rarest and ripest wits to silence, we acknowledge it our greatest ornament;[22] but when necessity compels us, 'tis as great a fault and folly "loquenda tacere, ut contra gravis est culpa tacenda loqui,"[23] being too much provoked by arraignments, baitings, and rancorous impeachments of the reputation of our whole sex. "Stulta est clementia . . . periturae parcere chartae";[24] opportunity of speaking slipped by silence is as bad as importunity upheld by babbling: "lalein ha prepei kreitton ē siōpan."[25] Know therefore that we will cancel your accusations, traverse your bills,[26] and come upon you for a false indictment. And think not 'tis our waspishness that shall sting you; no sir, until we see your malapert[27] sauciness reformed, which will not be till you do make a long letter to us, we will continue Juno's

Non sic abibunt odia; vivaces aget violentus iras animus
Saevusque dolor aeterna bella pace sublata geret.[28]

Notwithstanding for all your injuries, as Gelon Syracusanus answered Syagrus the Spartan, "You shall not induce me, though stirred

22. Munda glosses this statement in the margin with a Greek line from the tragedian Sophocles, "Silence brings honor to women" (*Ajax* 293).

23. "To keep silent about things which should be spoken, as on the other hand it is a serious fault to speak about things which should be kept silent."

24. "It is a foolish clemency . . . to spare paper destined to perish anyway," written by the Roman satirist Juvenal as a critical comment on the proliferation of writers in ancient Rome (*Satires* 1.1.17–18).

25. "To speak that which is fitting is better than to keep silent," an ancient Greek quotation.

26. Formally deny your bills of complaint.

27. Impudent.

28. "Not in this way will my anger go away; my violent spirit will further my long-lived wrath, and my fierce grief, banishing peace, will wage eternal wars," said by the goddess Juno at the beginning of the Roman playwright Seneca's tragedy *Hercules Furens* (27–29) to justify her eternal hatred of Hercules.

with anger, to demean myself irreverently in the retribution of your injuries."[29] Your idol muse and "musing being idle" (as your learned Epistle beginneth) shall be no plea to make your viperous scandals seem pleasing; "ipsa excusatio culpa est."[30] Where, by the way, I note your untoward nature contrary to all men, for whereas in all others of your sex, by your confession, idleness engendereth love, in you, hate. You say in the dedication of your book to your mistresses, "the common sort of women," that you had "little ease to pass the time withal"; but now, seeing you have basely wronged our wearied and worried Patience with your insolent invective madness, you shall make a simple conversion of your proposition and take your "pastime" in "little ease." Why? If you delight to sow thorns, is it not fit you should go on them barefoot and barelegged? Your idle muse shall be franked up,[31] for while it is at liberty, most impiously it throws dirt in the face of half humankind. Coriolanus,[32] when he saw his mother and his wife weeping, natural love compelled him to leave sacking the City for their sakes; "ab hoc exemplum cape."[33] But your barbarous hand will not cease to ruin the fences and beleaguer the forces of *Gynaecia*,[34] not sparing the mother that brought forth such an untoward whelp into the world as thyself, playing at blindman's buff with all, scattering thy dissolute language at whomsoever comes next. You never heard of a boy, an unlucky gallows[35] that threw stones in the market place he knew not whither; the wisely cynic Philosopher bade him take heed lest he hit his father. "Nomine mutato narretur fabula de te."[36] You might easily, if you had had the grace, perceive what use to make of it. But you go forward, pretending you were in great "choler" against some women in the "rough" of your fury. Grant one absurdity; a thou-

29. When the Greeks sent envoys to Gelon, king of Syracuse, asking his aid against the attacking Persians, Gelon refused to help them unless they would give him the supreme command. This is his reply to the angry refusal of Syagrus, the envoy from Sparta, as reported by the Greek historian Herodotus (*Histories* 7.160); Munda quotes the Greek passage in the margin.

30. "The very excuse is a fault."

31. Shut up and fattened in a frank, or pigsty.

32. Legendary leader of the early Roman Republic who laid seige to Rome when he was banished from the city, relenting only upon the pleas of his mother and wife.

33. "Take an example from this."

34. "Womanhood."

35. A gallows-bird; one deserving hanging.

36. "With the name changed, let this story be told about you," a slight paraphrase of a line from Horace (*Satires* 1.1.69–70).

sand follow. Alas (good Sir), we may easily gather you were mightily transported with passion: anger and madness differ but in time. 'Twere a pleasant sight to see you in your great standing choler and furious rough[37] together; your choler (no doubt) was too great for a Spanish peccadillo, and your shaggy rough seemed so grisly to set forth your ill-looking visage that none of your she-adversaries durst attempt to confront your folly. But now let us talk with you in your cold blood. Now the lees of your fury are settled to the bottom and your turbulent mind is defecated and clearer; let's have a parle[38] with you. What if you had cause to be offended with some (as I cannot excuse all), must you needs shoot your paper pellets out of your potgun-pate at all women?

[Munda quotes Homer (in Greek) and Cicero (in Latin) on the folly of indiscriminate anger. Perhaps Swetnam himself had some trouble with women, but that does not justify an attack on all women: "a private abuse of your own familiar doxies[39] should not break out into open slanders of the religious matron together with the prostitute strumpet; of the nobly descended Ladies, as the obscure base vermin that have bitten you; of the chaste and modest virgins, as well as the dissolute and impudent harlot." Although the Roman satirist Juvenal spilled out his spleen on all women irrespective of their merits, he lived in a reprobate age, whereas Swetnam would see many examples of virtuous and admirable women if he but opened his eyes. (After quoting Juvenal, Munda translates the lines into English verse in case Swetnam "cannot understand" the Latin.)

[Munda states that Swetnam could have put his idleness to better use by telling some stories of his travels, explaining how he became so expert in the "subtle qualities" of loose women: "how politicly you caught the daughter in the oven yet never was there yourself." She asks how Swetnam has been able to travel so long and yet learn so little: "Is this all the profit your Country shall reap by your foreign endeavors—

37. This passage contains an elaborate pun on the words "choler"-"collar," "rough"-"ruff," and "peccadillo"-"picadillo"; in accordance with the looseness of Renaissance spelling, each pair of words could be spelled interchangeably, thus increasing the effectiveness of the pun. "Peccadillo" is Spanish for "a slight fault or venial sin," while the name "picadillo" was applied to a broad laced or perforated border which was inserted on a collar or ruff.

38. A talk.

39. Mistresses (slang term).

to bring home a company of idle humors of light housewives[40] which you have noted and divulge them in print to your own disgrace and perpetual obloquy?" She surmises that his travels must have enrolled him in "the school of vice," where he squandered his patrimony on wicked women and then turned to attack them "like a dog that bites the stone which had almost beat out his brains."]

Wherefore none either good or bad, fair or foul, of what estate soever, of what parentage or royal descent and lineage soever, how well soever nurtured and qualified, shall escape the convicious[41] violence of your preposterous procacity.[42] Why did you not snarl at them directly that wronged you? Why did not you collimate[43] your infectious Javelins at the right mark? If a thief take your purse from you, will you malign and swagger[44] with everyone you meet? If you be beaten in an Alehouse, will you set the whole Town afire? If some courtesans that you have met with in your travels (or rather that have met with you) have ill-treated you, must honest and religious people be the scope[45] of your malicious speeches and reproachful terms? Yet it may be you have a further drift, to make the world believe you have an extraordinary gift of continence: soothing yourself with this supposition, that this open reviling is some token and evidence you never were affected with delicate and effeminate sensuality; thinking this pamphlet should assoil[46] thee from all maner of levy and taxation of a lascivious life; as if, because you cynically rail at all, both good and bad, you had been hatched up without concupiscence; as if nature had bestowed on you all *thumos* and no *epithumia*.[47] 'Twas spoken of Euripides that he hated women in *choro* but not in *toro*, in *calamo* but not in *thalamo*,[48] and why cannot you be liable to the same objection? I would make this excuse for you, but that the crabbedness of your style, the unsavory periods of your broken-winded sentences, persuade your body

40. Wanton hussies.
41. Abusive.
42. Forwardness.
43. Aim.
44. Quarrel.
45. Target.
46. Absolve.
47. All "anger" and no "sexual desire."
48. He hated women "in the tragic chorus" but not "on the couch," "with the pen" but not "in the bedroom." Although modern scholars find sympathy for women in the tragedies of the ancient Greek playwright Euripides, his name was a byword for misogyny from his own times until the twentieth century.

to be of the same temper as your mind. Your ill-favored countenance, your wayward conditions, your peevish and pettish nature is such that none of our sex with whom you have obtained some partial conference could ever brook your dogged frumpard[49] frowardness: upon which malcontented desperation you hung out your flag of defiance against the whole world as a prodigious monstrous rebel against nature. Besides, if your currish disposition had dealt with men, you were afraid that *Lex talionis*[50] would meet with you; wherefore you surmised that, inveighing against poor illiterate women, we might fret and bite the lip at you, we might repine to see ourselves baited and tossed in a blanket, but never durst in open view of the vulgar either disclose your blasphemous and derogative slanders or maintain the untainted purity of our glorious sex. Nay, you'll put gags in our mouths and conjure us all to silence; you will first abuse us, then bind us to the peace. We must be tongue-tied, lest in starting up to find fault we prove ourselves guilty of those horrible accusations. The sincerity of our lives and quietness of conscience is a wall of brass to beat back the bullets of your vituperative scandals in your own face. 'Tis the resolved Aphorism of a religious soul to answer "ego sic vivam ut nemo tibi fidem adhibeat,"[51] by our own well-doings to put to silence the reports of foolish men, as the Poet speaks:

> Vivendum recte tum propter plurima tum de his
> Praecipue causis ut linguas mancipiorum contemnas.[52]

> Live well for many causes, chiefly this:
> To scorn the tongue of slaves that speak amiss.

Indeed, I write not in hope of reclaiming thee from thy profligate absurdities, for I see what a pitch of disgrace and shame thy self-pining envy hath carried thee to for thy greater vexation and more perplexed ruin. You see, your black, grinning mouth hath been muzzled by a modest and powerful hand[53] who hath judiciously betrayed and wisely laid open your singular ignorance, couched under incredible impudence; who hath most gravely (to speak in your own language) "un-

49. Scoffing.
50. "The law of retaliation."
51. "May I live in such a way that no one may grant you credence."
52. Juvenal *Satires* 9.118–119.
53. Rachel Speght, who published the first direct response to Swetnam, *A Muzzle for Melastomus*, in 1617.

folded every pleat and showed every wrinkle" of a profane and brutish disposition, so that 'tis a doubt whether she hath showed more modesty or gravity, more learning or prudence in the religious confutation of your indecent railings. But as she hath been the first Champion of our sex that would encounter with the barbarous bloodhound, and wisely dammed up your mouth and sealed up your jaws lest your venomed teeth like mad dogs should damage the credit of many, nay all innocent damsels; so, no doubt, if your scurrilous and depraving tongue break prison and falls to licking up your vomited poison to the end you may squirt out the same with more pernicious hurt, assure yourself there shall not be wanting store of Hellebore[54] to scour the sink of your tumultuous gorge. At least we will cram you with Antidotes and Catapotions,[55] that if you swell not till you burst, yet your digested poison shall not be contagious. I hear you foam at mouth and growl against the Author with another head like the triple dog of hell, wherefore I have provided this sop for Cerberus, indifferent well steeped in vinegar.

[Like the matricidal Roman emperor Nero, Swetnam has attacked his own mother, for it is a maxim in logic that whatever is said of a species applies to each individual in that species: "Is there no reverence to be given to your mother because you are weaned from her teat and nevermore shall be fed with her pap? . . . If she had crammed gravel down thy throat when she gave thee suck or exposed thee to the mercy of the wild beasts in the wilderness when she fed thee with the pap, thou couldst not have shown thyself more ungrateful than thou hast in belching out thy nefarious contempt of thy mother's sex." Moreover, Swetnam has indirectly branded himself by his attacks on the female sex: if women sprang from the devil, he has proven himself "the Devil's Grandchild." It is thus "a pleasing revenge" that his own soul arraigns him "at the bar of conscience" and his own sentences, stolen from other books, accuse him of robbery. Furthermore, the defenses prompted by his pamphlet (by Rachel Speght and Esther Sowernam) have stigmatized his name "like so many red-hot irons." Indeed, the indiscriminate nature of Swetnam's attacks is more likely to turn his readers against him than against women, for his vehemence raises suspicions about his own character and motivation: "Your prejudi-

54. A poisonous plant thought to have medicinal properties effective against madness.
55. Drugs to counter poisons.

cate[56] railing would rather argue an irreverent and lascivious inclination of a depraved nature than any love or zeal to virtue and honesty."]

Yet 'tis remarkable that ignorance and impudence were partners in your work. For as you have of all things under the sun selected the baiting, or (as you make a silly solecism) the bearbaiting of Women, to be the tenterhooks whereon to stretch your shallow inventions on the trival subject of every shake-rag[57] that can but set pen to paper; so in the handling of your base discourse you lay open your imperfections "arripiendo maledicta ex trivio,"[58] by heaping together the scraps, fragments, and reversions[59] of diverse English phrases, by scraping together the glanders[60] and offals of abusive terms and the refuse of idle-headed Authors and making a mingle-mangle gallimaufry[61] of them. Lord! How you have cudgeled your brains in gleaning multitudes of similes as 'twere in the field of many writers, and threshed them together in the floor of your own deviser,[62] and all to make a poor confused miscellany, whereas thine own barren-soiled soil is not able to yield the least congruity of speech. 'Tis worthy laughter what pains you have taken in turning over *Parismus*, what use you make of the Knight of the Sun, what collections out of *Euphues*, Amadis of Gaul, and the rest of Don Quixote's Library,[63] sometimes exact tracing of Aesopical Fables and Valerius Maximus,[64] with the like schoolboys' books; so that if these Pamphleteers would severally pluck a crow with

56. Biased.

57. A ragged, disreputable person.

58. "By snatching up insults from the crossroads," a paraphrase from Cicero *Pro Murena* 6.13.

59. Residues.

60. Diseased secretions.

61. Jumble, hodgepodge.

62. Here Munda uses an agricultural metaphor: "gleaning" involves gathering by hand the wheat left by reapers; the wheat is then "threshed" or beaten with a flail to separate the grain from the straw.

63. In his novel *Don Quixote de la Mancha* (1605–1615), Miguel de Cervantes Saavedra maintains that his hero lost touch with reality because of reading romances about such figures as the "Knight of the Sun" and "Amadis of Gaul" (the hero of a famous cycle of medieval chivalric romances); Cervantes lists many popular romances of the time in his satiric inventory of Don Quixote's library. *Parismus*, a romance by Emanuel Ford, was published in England in 1598; John Lyly's popular prose romance *Euphues* (1578) was a particularly fertile source for Swetnam, who lifted whole passages from this work.

64. Aesop was an ancient Greek writer of fables; Valerius Maximus was a Roman writer of anecdotes about historical figures.

you, "Furtivis nudata coloribus moveat cornicula risum":[65] let every bird take his own feather, and you would be as naked as Aesop's jay. Indeed, you have shown as much foolery as robbery in feathering your nest, which is a cage of unclean birds and a storehouse for the off-scourings of other writers. Your indiscretion is as great in the laying together and compiling of your stolen ware as your blockishness in stealing, for your sentences hang together like sand without lime. You bring a great heap of stony rubbish comparisons one upon the neck of another, but they concur no more to sense than a company of stones to a building without mortar. And 'tis a familiar Italian Proverb, "duro e duro non fa muro" ("hard and hard makes no wall"), so your hard dull pate hath collected nothing that can stand together with common sense or be pleasing to any refined disposition, rough and unhewn morsels digged out of others' quarries, potsherds picked out of sundry dunghills. Your mouth indeed is full of stones; "lapides loqueris,"[66] but not so wisely nor so warily crammed in as the geese that fly over the mountains in Cilicia, which carry stones in their beaks lest their cackling should make them a prey to the eagles, where you might learn wit of a goose. "Ē lege sigēs kreitton ē sigēn ekhe."[67] "Either speak peace or hold your peace." Is it not irksome to a wise and discreet judgment to hear a book stuffed with suchlike sense as this: "The world is not made of oatmeal"? I have heard of some that have thought the world to have been composed of atoms;[68] never any that thought it made of oatmeal. "Nor all is not gold that glitters, nor the way to heaven is strewn with rushes; for a dram of pleasure, an ounce of pain; for a pint of honey, a gallon of gall; for an inch of mirth, an ell of moan," etc. None above the scum of the world could endure with patience to read such a medley composed of discords. Sometimes your doggerel rhymes make me smile, as when you come,

65. "The little crow, stripped of his stolen colors, would rouse laughter." This quotation is from Horace (*Epistles* 1.3.19–20), who points to Aesop's fable of the jackdaw which decorated itself with feathers from many birds as an object lesson for writers, warning them against plagiarism and imitation of other writers.

66. "You are talking cobblestones," a disparaging exclamation of the Roman comic playwright Plautus (*Aulularia* 152).

67. "Either say something better than silence or keep silence," attributed to the Greek tyrant of Syracuse, Dionysius the Elder (Fragment 6).

68. In the fifth century B.C., the Greek philosophers Democritus and Leucippus maintained that matter was composed of constantly moving, indivisible particles called

Man must be at all the cost
And yet live by the loss.
A man must take all the pains,
And women spend all the gains.
Their catching in jest
And keeping in earnest.
And yet she thinks she keeps herself blameless,
And in all ill vices she would go nameless.
But if she carry it never so clean,
Yet in the end she will be counted for a cony-catching quean.
And yet she will swear that she will thrive
As long as she can find one man alive.

I stand not to descant on your plain-song,[69] but surely if you can make ballads no better, you must be fain[70] to give over that profession; for your Muse is wonderfully defective in the bandoleers,[71] and you may safely swear with the Poet,

> Nec fonte labra prolui caballino,
> Nec in bicipiti somniasse Parnas
> Memini.[72]

Sometimes you make me burst out with laughter when I see your contradictions of yourself; I will not speak of those which others have espied, although I had a fling at them, lest I should *actum agere*.[73] Methinks when you wrote your second Epistle neither to the wisest Clerk nor yet to the starkest fool, the giddiness of your head betrays you to be both a silly Clerk and a stark fool, or else the young men you

"atoms." This view never gained wide acceptance before its transformation into the modern atomic theory; Munda here proffers it only as a less ridiculous alternative to the "oatmeal" reference.

69. To comment at length on your poor poetry (a musical pun, for to "descant" also means to sing an ornamental melody above a musical theme, and "plain-song" is a type of monodic liturgical chant).

70. Obliged.

71. This may be a misprint for "bandore," a stringed musical instrument.

72. "I did not wash off my lips in the nag's fount, nor do I remember dreaming on twin-peaked Mount Parnassus." These are the opening lines of the prologue of the Roman satirist Persius, containing deliberately irreverent references to traditional symbols of poetic inspiration; the "nag's fount" is the spring of Hippocrene on Mount Helicon, which reputedly gushed up at the touch of the winged horse Pegasus's hoof.

73. "Do something already done."

write to must be much troubled with the megrim and the dizziness of the brain, for you begin as if you were wont to run up and down the Country with Bears at your tail: "If you mean to see the Bearbaiting of women, then trudge to this Bear garden apace, and get in betimes, and view every room where thou mayest best sit," etc.

Now you suppose to yourself the giddy-headed young men are flocked together and placed to their own "pleasure, profit, and heart's-ease." Let but your second cogitations observe the method you take in your supposed sport: instead of bringing your Bears to the stake, you say, "I think it were not amiss to drive all women out of my hearing, for doubt lest this little spark kindle into such a flame and raise so many stinging hornets humming about mine ears that all the wit I have [which is but little] will not quench the one nor quiet the other." Do ye not see your apparent contradiction? "Spectatum admissi risum teneatis amici":[74] you promise your spectators the Bearbaiting of women, and yet you think it not amiss to drive all women out of your hearing, so that none but yourself, the ill-favored hunks,[75] is left in the Bear garden to make your invited guests merry. Whereupon it may very likely be the eager young men, being not willing to be gulled and cheated of their money they paid for their room, set their dogs at you; amongst whom Cerberus, that Hellhound, appeared, and you bit off one of his heads. For presently after, you call him the two-headed dog, whom all the Poets would feign to have three heads. You, therefore, having snapped off that same head, were by the secret operation of that infernal substance converted into the same essence, and that may serve as one reason that I term you "Cerberus, the Jailor of hell." For certainly "quicquid dicitur de toto, dicitur de singulis partibus" ("that which is spoke of the whole is spoken of every part"), and every limb of the devil is an homogeneous part. Do ye not see (goodman woodcock) what a spring[76] you make for your own self? Whereas you say 'tis "a great discredit for a man to be accounted a scold," and that you deal "after the manner of a shrew, which cannot ease her curst heart

74. "When allowed to see the picture, can you, though friends, hold back your laughter?" This is a quotation from Horace's *Art of Poetry* (*Epistles* 2.3.5); in order to demonstrate the need for unity and coherence in a literary work, Horace compares an ill-fashioned poem to a picture which absurdly combines the features of many different animals, stating that such a picture can only arouse ridicule.

75. A surly, disagreeable person.

76. Snare.

but by her unhappy tongue," observe but what conclusion demonstratively follows these premises:

> A man that is accounted a scold hath great discredit.
> Joseph Swetnam is accounted a scold.
> *Ergo*, Joseph hath great discredit.

If you deny the Minor,[77] 'tis proved out of your own assertion, because you deal "after the manner of a shrew," etc., where we may note first a corrupt fountain whence the polluted puddles of your accustomed actions are derived, "A curst heart"; then the cursedness of your book (which, if you might be your own Judge, deserves no more the name of a book than a Collier's Jade[78] to be a King's Steed) to be the fruit of "an unhappy tongue"; thirdly, your commodity you reap by it, "discredit." Nay, if you were but a masculine scold, 'twere tolerable; but to be a profane railing Rabshakeh,[79] 'tis odious. Neither is this all your contrariety you have included; for presently after, you profess you wrote this book with your hand but not with your heart, whereas but just now you confessed yourself to deal after the manner of a shrew, which cannot otherwise ease your curst heart but by your unhappy tongue: so your hand hath proved your unhappy tongue a liar. This unsavory nonsense argueth you to be at that time possessed with the fault you say commonly is in men (to wit, drunkenness) when you wrote these jarring and incongruous speeches, whose absurdities accrue to such a tedious and infinite sum, that if any would exactly trace them out, they should find them like a Mathematical line, "Divisibilis in semper divisibilia."[80] 'Twould put down the most absolute Arithmetician to make a catalogue of them. Wherefore I could wish thee to make a petition that you might have your books called in and burnt, for were it not better that the fire should befriend thee in purifying the trash and eating out the canker of thy defamation, than thy execrable designs and inexcusable impudence should blazon abroad thy

77. A syllogism like the above is a form of deductive logic which reasons from a major and a minor premise to a conclusion; the "minor" is the second statement of the syllogism.

78. The worthless horse of a man in the coal trade.

79. A high court official of the ancient Assyrian king; Munda is here referring to the scene in Isaiah 36 when Rabshakeh delivers a long, blasphemous speech reviling God and threatening the Jews.

80. "Divisible into all divisibilities"; according to mathematical principles, a line is infinitely subdivisible.

drunken temerity and temulent[81] foolhardiness to future ages, than thy book should peremptorily witness thy open and Atheistical blasphemy against thy Creator even in the very threshold and entrance? But above all, where thou dost put a lie on God himself with this supposition: "If God had not made them only to be a plague to man, he would never have called them necessary evils." Which I thus anticipate: but God never called them necessary evils; therefore, God made them not to be a plague to man. Or else, turning the conclusion to the mean[82] thus: but God did not make them to be plague, but a helper and procurer of all felicity; therefore, God never called them necessary evils. Were it not (I say) far better for you that your laborious, idle work should be abolished in the flames, than it should publicly set forth the apert[83] violation of holy writ in sundry places? One in the beginning (as I remember), where you falsely aver that the blessed Patriarch David exclaimed bitterly against women, and like the tempting devil you allege half Scripture, whereas the whole makes against yourself. For thus you affirm he saith: "It is better to be a doorkeeper than to be in the house with a froward woman." In the whole volume of the book of God, much less in the Psalms, is there any such bitter exclamation?[84] But this is the ditty of the sweet singer of Israel, whereby he did intimate his love unto the house of God and his detestation of the pavilions of the unrighteous by this Antithesis: "It is better to be a doorkeeper in the house of the Lord than to dwell in the Tabernacles of the ungodly." Now, if you have a private spirit that may interpret by enthusiasms,[85] you may confine the Tabernacles of the ungodly only to froward women; which how absurd and gross it is, let the reader judge. Dost thou not blush (graceless) to pervert (with Elymas[86]) the

81. Intoxicated.

82. The middle term in a syllogism, which appears in both premises but not in the conclusion.

83. Manifest.

84. Munda is right about this psalm, but she ignores the fact that the book of Proverbs does contain many such "bitter exclamations" against women. Swetnam probably confused the beginning of this verse (Psalms 84 : 10) with the end of the following proverb: "It is better to dwell in the corner of the housetop than with a brawling woman and in a wide house" (Proverbs 25 : 24).

85. Interpret the Scriptures by special personal communications from God.

86. When the Jewish false prophet and sorcerer Bar-Jesus, also called Elymas, tried to turn the proconsul of Cyprus away from Christianity, Saint Paul cursed and blinded

straight ways of God by profaning the Scriptures and wreathing their proper and genuine interpretations to by-senses,[87] for the bolstering and upholding of your damnable opinion? Besides thy pitifully wronging of the Philosophers, as Socrates, Plato, and Aristotle, etc., whom your illiterate and clownish Muse never was so happy to know whether they wrote anything or no.

[Munda accuses Swetnam of fathering his own "quirks and crotchets" on the ancient philosophers when in actuality both Plato and Aristotle were "chiefest establishers of Matrimony." Indeed, Plato in the *Laws* advocated imposing a fine on anyone not married by the age of thirty-five. Munda quotes several Greek writers, among them the poet Theognis and the philosopher Protagoras, in praise of marriage; she then sums up with the Roman poet Horace's resounding praise of the felicity of the married state (*Odes* 1.13.17–20). Furthermore, among his numerous mistakes, Swetnam tells a story that he says happened to the Roman anecdotal writer Valerius Maximus, when Maximus had actually related the tale about the Roman statesman Tiberius Gracchus. Swetnam's story about Theodora, "a Strumpet in Socrates' time," seems to be another figment of his "dull pate," but Munda has read of "a glorious Martyr of this name" whose "persuasive oratory" saved her from rape and imprisonment in Antioch during the reign of the Roman emperor Diocletian.]

I would run through all your silly discourse and anatomize your baseness, but as some have partly been bolted[88] out already and are promised to be prosecuted, so I leave them as not worthy rehearsal or refutation. I would give a *supersedeas*[89] to my quill, but there is a most pregnant place in your book which is worthy laughter that comes to my mind, where you most graphically describe the difference and antipathy of man and woman; which being considered, you think it strange there should be any reciprocation of love. "For a man," say you, "delights in arms and hearing the rattling drum, but a woman loves to hear sweet music on the Lute, Cittern, or Bandore." I prithee,

him, saying, "Wilt thou not cease to pervert the right ways of the Lord?" (Acts of the Apostles 13:6–12).

87. Distorted meanings.
88. Sifted.
89. "Forbear!"

who but the long-eared animal had rather hear the Cuckoo than the Nightingale? Whose ears are not more delighted with the melodious tunes of sweet music than with the harsh sounding drum? Did not Achilles delight himself with his harp as well as with the trumpet?[90] Nay, is there not more men that rather affect[91] the laudable use of the Cittern, and Bandore, and Lute for the recreation of their minds than the clamorous noise of drums? Whether is it more agreeable to human nature to march "amongst murdered carcasses," which you say man rejoiceth in, than to enjoy the fruition of peace and plenty, even "to dance on silken Carpets," as you say is our pleasure? What man soever maketh wars, is it not to this end, that he might enjoy peace? Who marcheth among murdered carcasses but to this end, that his enemies being subdued and slain, he may securely enjoy peace? "Man loves to hear the threatening of his Prince's enemies, but woman weeps when she hears of wars." What man that is a true and loyal subject loves to hear his Prince's enemies threaten: is it not more humane to bewail the wars and loss of our countrymen than to rejoice in the threats of an adversary? But you go forward in your paralleling a man's love "to lie on the cold grass," but "a woman must be wrapped in warm mantles." I never heard of any that had rather lie in the cold grass than in a feather-bed, if he might have his choice; yet you make it a proper attribute to all your sex. Thus you see your chiefest elegance to be but miserable patches and botches: this Antithesis you have found in some Author betwixt a warrior and a lover, and you stretch it to show the difference betwixt a man and a woman.

[Although in his pamphlet Swetnam threatened a "second volley of powder and shot" against women, he had better remain silent, for the *Arraignment* is certainly enough to make him infamous: "Thou that art extolled amongst clowns and fools shall be a hissing and a byword to the learned and judicious." Munda concludes by "transcribing some verses that a Gentleman wrote to such an one" as Joseph Swetnam; near its end, the poem describes the fate which Swetnam deserves:

> May thy rude quill
> Be always mercenary and write still
> That which no man will read, unless to see

90. In Homer's *Iliad*, the Greek warrior Achilles is depicted as "delighting his heart with a lyre" (9.186) after he has withdrawn from battle.
91. Enjoy.

Thine ignorance and then to laugh at thee.
And mayest thou live to feel this, and then groan
Because 'tis so, yet cannot help, and none
May rescue thee till your checked conscience cry,
"This, this I have deserved!" then pine and die.]

HIC MVLIER:
Or,
The Man-Woman:

Being a Medicine to cure the Coltish Diſeaſe of
the Staggers in the Maſculine-Feminine
of our Times.

Expreſt in a briefe Declamation.

Non omnes poſſumus omnes.

Miſtris, will you be trim'd or truſſ'd?

London printed for I.T. and are to be ſold at Chriſt Church gate. 1620.

§. *Hic Mulier;* or, The Man-Woman:
Being a Medicine
to cure the Coltish Disease of the Staggers
in the Masculine-Feminines of our Times,
Expressed in a brief Declamation:
Non omnes possumus omnes.[1]
1620

Hic Mulier:[2] How now? Break Priscian's[3] head at the first encounter? But two words, and they false Latin? Pardon me, good Signor Construction, for I will not answer thee as the Pope did, that I will do it in despite of the Grammar. But I will maintain, if it be not the truest Latin in our Kingdom, yet it is the commonest. For since the days of Adam women were never so Masculine: Masculine in their genders and whole generations, from the Mother to the youngest daughter; Masculine in Number, from one to multitudes; Masculine in Case, even from the head to the foot; Masculine in Mood, from bold speech to impudent action; and Masculine in Tense,[4] for without redress they were, are, and will be still most Masculine, most mankind, and most monstrous. Are all women then turned Masculine? No, God forbid, there are a world full of holy thoughts, modest carriage, and severe chastity. To these let me fall on my knees and say, "You, oh you women, you good women, you that are in the fullness of perfection, you that are the crowns of nature's work, the complements of men's excellences, and the Seminaries[5] of propagation; you that maintain the world, support mankind, and give life to society; you that, armed with

1. "We cannot all be everybody." This is a clever variation on Vergil, *Eclogue* 8.63 ("non omnia possumus omnes," "we cannot all do everything"), underlining the author's contention that women who dress like men are really trying to *become* men. "The Staggers" is a disease of horses and other animals which causes reeling and falling.

2. Deliberately incorrect Latin for "this woman," coupling the masculine form of the adjective with the feminine noun ("this mannish woman").

3. Priscian was a sixth-century A.D. Roman grammarian; "to break his head" was to violate his rules of grammar.

4. A series of puns on the root meaning of the grammatical terms *gender, number, case, mood,* and *tense* (at this time the word *case* could refer to clothing).

5. Seed plots, nurseries.

the infinite power of Virtue, are Castles impregnable, Rivers unsailable, Seas immovable, infinite treasures, and invincible armies; that are helpers most trusty, Sentinels most careful, signs deceitless, plain ways fail-less, true guides dangerless, Balms that instantly cure, and honors that never perish. Oh do not look to find your names in this Declamation, but with all honor and reverence do I speak to you. You are Seneca's Graces,[6] women, good women, modest women, true women—ever young because ever virtuous, ever chaste, ever glorious. When I write of you, I will write with a golden pen on leaves of golden paper; now I write with a rough quill and black Ink on iron sheets the iron deeds of an iron generation."

Come, then, you Masculine women, for you are my Subject, you that have made Admiration an Ass and fooled him with a deformity never before dreamed of; that have made yourselves stranger things than ever Noah's Ark unloaded or Nile engendered;[7] whom to name, he that named all things might study an Age to give you a right attribute; whose like are not found in any Antiquary's study, in any Seaman's travel, nor in any Painter's cunning. You that are stranger than strangeness itself; whom Wise men wonder at, Boys shout at, and Goblins themselves start at; you that are the gilt dirt which embroiders Playhouses, the painted Statues which adorn Caroches,[8] and the perfumed Carrion that bad men feed on in Brothels: 'tis of you I entreat[9] and of your monstrous deformity. You that have made your bodies like antic Boscadge or Crotesco work,[10] not half man/half woman, half fish/half flesh, half beast/half Monster, but all Odious, all Devil; that have cast off the ornaments of your sexes to put on the garments of Shame; that have laid by the bashfulness of your natures to gather the impudence of Harlots; that have buried silence to revive slander; that are all things but that which you should be, and nothing less than[11] friends to

6. In his treatise *On Benefits (de Beneficiis)*, Seneca, an ancient Roman moral philosopher and playwright, presented the mythological Graces (three beautiful virgins depicted dancing hand in hand) as symbols of kindness and gratitude.

7. According to Ovid's *Metamorphoses*, some strange and monstrous creatures emerged from the slime left by the receding waters after the great flood, creatures similar to those thought to be produced in the mud of the Nile's annual floods.

8. Stately coaches.

9. Treat.

10. Boscadge is a decorative design imitating branches and foliage; crotesco is painting or sculpture that fantastically combines human and animal forms interwoven with foliage and flowers.

11. Anything rather than.

virtue and goodness; that have made the foundation of your highest detested work from the lowest despised creatures that Record can give testimony of: the one cut from the Commonwealth at the Gallows; the other is well known.[12] From the first you got the false armory of yellow Starch (for to wear yellow on white or white upon yellow is by the rules of Heraldry baseness, bastardy, and indignity), the folly of imitation, the deceitfulness of flattery, and the grossest baseness of all baseness, to do whatever a greater power will command you. From the other you have taken the monstrousness of your deformity in apparel, exchanging the modest attire of the comely Hood, Cowl, Coif, handsome Dress or Kerchief, to the cloudy Ruffianly broad-brimmed Hat and wanton Feather; the modest upper parts of a concealing straight gown, to the loose, lascivious civil embracement of a French doublet, being all unbuttoned to entice, all of one shape to hide deformity, and extreme short waisted to give a most easy way to every luxurious action; the glory of a fair large hair, to the shame of most ruffianly short locks; the side, thick gathered, and close guarding Safeguards[13] to the

12. Some background is necessary to understand this reference to a scandal that rocked English society in the early seventeenth century. The scandal revolved around Lady Frances Howard who, although married to the earl of Essex while both were still children, had by January 1613 embarked on an affair with Robert Carr, earl of Somerset and the king's favorite. Somerset's political and personal mentor, the writer Sir Thomas Overbury, convinced of the fundamental wickedness of Lady Frances, determined to end the relationship, but Somerset was deeply infatuated with his mistress and broke with Overbury over the issue. Both King James and his queen detested Overbury for his intrusive arrogance, and in April 1613 James found an excuse to have him imprisoned in the Tower. In September 1613 Lady Frances succeeded in obtaining an annulment of her marriage to Essex on grounds of his supposed impotence, and three months later, with the king's blessing, she married Robert Carr at Whitehall in a lavish ceremony. In September of the same year Sir Thomas Overbury had died in the Tower, but not until the summer of 1615 did the fact emerge that he had been murdered by Lady Frances with the help of her close friend Mrs. Anne Turner. History leaves no doubt as to the guilt of the two women, for eventually all who had assisted them confessed freely. Mrs. Turner, a dressmaker who had introduced the fashion of the yellow ruff and cuffs into the court (a fashion that James despised), was sentenced to be hung. Lady Frances was also sentenced to death, but her sentence was commuted by James and after a term of imprisonment she was pardoned. The author of *Hic Mulier* links the crime of these two women with their mode of dress. James insisted that Mrs. Turner, "the one cut from the Commonwealth at the Gallows," go to her death wearing a dress, cuffs, and a ruff that had been starched with yellow; although Lady Frances may not have worn all the masculine fashions attributed to her by the author, we know from a famous portrait in the National Gallery that she wore ruffs with extremely low-cut, revealing gowns.

13. Long outer petticoats.

short, weak, thin, loose, and every hand-entertaining short bases; [14] for Needles, Swords; for Prayerbooks, bawdy legs; for modest gestures, giantlike behaviors; and for women's modesty, all Mimic and apish incivility. These are your founders, from these you took your copies, and, without amendment, with these you shall come to perdition.

Sophocles, being asked why he presented no women in his Tragedies but good ones and Euripides none but bad ones, answered he presented women as they should be, but Euripides, women as they were. [15]

[These "Mermaids or rather Mer-Monsters" who dress bizarrely in men's fashions probably never practiced "comeliness or modesty." Although they may associate with or be related to persons of gentle birth, they themselves are "but rags of Gentry, [16] torn from better pieces for their foul stains." Some are not even descended from gentry but are rather "the stinking vapors drawn from dunghills"; these people may exist on the fringes of good society for a time, but eventually they will fall back "to the place from whence they came, and there rot and consume unpitied and unremembered."]

And questionless it is true that such were the first beginners of these last deformities, for from any purer blood would have issued a purer birth; there would have been some spark of virtue, some excuse for imitation. But this deformity hath no agreement with goodness, nor no difference against the weakest reason. It is all base, all barbarous: base, in respect it offends man in the example and God in the most unnatural use; barbarous, in that it is exorbitant from Nature and an Antithesis to kind, [17] going astray with ill-favored affectation both in attire, in speech, in manners, and, it is to be feared, in the whole courses and stories of their actions. What can be more barbarous than with the gloss of mumming Art [18] to disguise the beauty of their creations? To mould their bodies to every deformed fashion, their tongues

14. Plaited, knee-length, open skirts.

15. The author twists this reference to his own purpose, for the Greek philosopher Aristotle in his *Poetics* actually quotes Sophocles as saying that he presented men as they ought to be and Euripides, men as they were.

16. The society of Renaissance England consisted of the titled, leisured classes (the nobility and the gentry) and the commons (yeomen, husbandmen, craftsmen, etc.), who worked for their living and were not considered "wellborn." The distinction was a real and important one, though somewhat fuzzy at the dividing line between gentry and commons, and merchants and yeomen in the upper echelons of the commonalty were sometimes quite wealthy.

17. Natural disposition, nature.

18. Like actors in costume and mask.

to vile and horrible profanations, and their hands to ruffianly and un-civil actions? To have their gestures as piebald and as motley-various as their disguises, their souls fuller of infirmities than a horse or a prostitute, and their minds languishing in those infirmities? If this be not barbarous, make the rude Scythian, the untamed Moor, the naked Indian, or the wild Irish, Lords and Rulers of well-governed Cities.[19]

But rests this deformity then only in the baser, in none but such as are the beggary of desert, that have in them nothing but skittishness and peevishness, that are living graves, unwholesome Sinks, quartan Fevers for intolerable cumber,[20] and the extreme injury and wrong of nature? Are these and none else guilty of this high Treason to God and nature?

Oh yes, a world of other—many known great, thought good, wished happy, much loved and most admired—are so foully branded with this infamy of disguise. And the marks stick so deep on their naked faces and more naked bodies that not all the painting in Rome or Fauna[21] can conceal them, but every eye discovers them almost as low as their middles.

It is an infection that emulates the plague and throws itself amongst women of all degrees, all deserts, and all ages; from the Capitol to the Cottage are some spots or swellings of this disease. Yet evermore the greater the person is, the greater is the rage of this sickness; and the more they have to support the eminence of their Fortunes, the more they bestow in the augmentation of their deformities. Not only such as will not work to get bread will find time to weave herself points[22] to truss her loose Breeches; and she that hath pawned her credit to get a Hat will sell her Smock to buy a Feather; she that hath given kisses to have her hair shorn will give her honesty to have her upper parts put into a French doublet. To conclude, she that will give her body to have her body deformed will not stick to give her soul to have her mind satisfied.

But such as are able to buy all at their own charges, they swim in the excess of these vanities and will be manlike not only from the head to the waist, but to the very foot and in every condition: man in body by

19. Many Elizabethans considered these nationalities to be fundamentally uncivilized.
20. Destruction.
21. Probably signifies "nature" here.
22. Ties ending in metal tags.

attire, man in behavior by rude complement,[23] man in nature by apt-
ness to anger, man in action by pursuing revenge, man in wearing
weapons, man in using weapons, and, in brief, so much man in all
things that they are neither men nor women, but just good for nothing.

[Neither great birth nor great beauty nor great wealth can save these
foolish women from "one particle of disgrace." To support this point,
the author includes two stanzas by the poet S. T. O.;[24] the speaker in
the poem attests that he would love a virtuous woman above one of
high birth, beauty, or wealth.]

Remember how your Maker made for our first Parents coats—not
one coat, but a coat for the man and a coat for the woman, coats of
several fashions, several forms, and for several uses—the man's coat fit
for his labor, the woman's fit for her modesty.[25] And will you lose the
model left by this great Workmaster of Heaven?

The long hair of a woman is the ornament of her sex, and bashful
shamefastness her chief honor; the long hair of a man, the vizard[26] for
a thievish or murderous disposition. And will you cut off that beauty
to wear the other's villainy? The Vestals[27] in Rome wore comely gar-
ments of one piece from the neck to the heel; and the Swordplayers,[28]
motley doublets with gaudy points. The first begot reverence; the lat-
ter, laughter. And will you lose that honor for the other's scorn? The
weapon of a virtuous woman was her tears, which every good man
pitied and every valiant man honored; the weapon of a cruel man is his
sword, which neither Law allows nor reason defends. And will you
leave the excellent shield of innocence for this deformed instrument of
disgrace? Even for goodness' sake, that can ever pay her own with her
own merits, look to your reputations, which are undermined with
your own Follies, and do not become the idle Sisters of foolish Don
Quixote,[29] to believe every vain Fable which you read or to think you

23. Personal quality or accomplishment.

24. The stanzas are from "A Wife" by Sir Thomas Overbury, probably written in an
effort to dissuade his friend Robert Carr from marrying the divorced Frances Howard
(see note 12 above).

25. In fact the passage in Genesis 3 : 21 does not differentiate clothing by sex: "Unto
Adam also and to his wife did the Lord God make coats of skins and clothed them."

26. Mask.

27. Virgin priestesses who tended the sacred fire of the goddess Vesta in ancient Rome.

28. Probably Roman gladiators.

29. The hero of Miguel de Cervantes's satiric romance who tries to act out all the
fantasies of chivalry.

may be attired like Bradamant, who was often taken for Ricardetto, her brother; that you may fight like Marfiza and win husbands with conquest; or ride astride like Claridiana and make Giants fall at your stirrups.[30] The Morals[31] will give you better meanings, which if you shun and take the gross imitations, the first will deprive you of all good society; the second, of noble affections; and the third, of all beloved modesty. You shall lose all the charms of women's natural perfections, have no presence to win respect, no beauty to enchant men's hearts, nor no bashfulness to excuse the vilest imputations.

The fairest face covered with a foul vizard begets nothing but affright or scorn, and the noblest person in an ignoble disguise attains to nothing but reproach and scandal. Away then with these disguises and foul vizards, these unnatural paintings and immodest discoveries! Keep those parts concealed from the eyes that may not be touched with the hands; let not a wandering and lascivious thought read in an enticing Index the contents of an unchaste volume. Imitate nature, and, as she hath placed on the surface and superficies of the earth all things needful for man's sustenance and necessary use (as Herbs, Plants, Fruits, Corn and suchlike) but locked up close in the hidden caverns of the earth all things which appertain to his delight and pleasure (as gold, silver, rich Minerals, and precious Stones), so do you discover[32] unto men all things that are fit for them to understand from you (as bashfulness in your cheeks, chastity in your eyes, wisdom in your words, sweetness in your conversation, and severe modesty in the whole structure or frame of your universal composition). But for those things which belong to this wanton and lascivious delight and pleasure (as eyes wandering, lips billing, tongue enticing, bared breasts seducing, and naked arms embracing), oh, hide them, for shame hide them in the closest prisons of your strictest government! Shield them with modest and comely garments, such as are warm and wholesome, having every window closed with a strong Casement and every Loophole furnished with such strong Ordinance that no unchaste eye may come near to assail them, no lascivious tongue woo a forbidden passage, nor

30. These are heroines of romances who play masculine roles. In the romantic epic *Orlando Furioso* by the Italian poet Ariosto, Bradamant is a brave and virtuous woman who engages in feats of knighthood, and Marfiza is a pagan warrior.

31. Allegories (the author advises women to view these female figures as symbols rather than as literal role models).

32. Reveal.

no profane hand touch relics so pure and religious. Guard them about with Counterscarps[33] of Innocence, Trenches of humane Reason, and impregnable walls of sacred Divinity, not with Antic disguise and Mimic fantasticalness, where every window stands open like the *Subura*,[34] and every window a Courtesan with an instrument, like so many Sirens, to enchant the weak passenger to shipwreck and destruction. Thus shall you be yourselves again and live the most excellent creatures upon earth, things past example, past all imitation.

Remember that God in your first creation did not form you of slime and earth like man, but of a more pure and refined metal, a substance much more worthy: you in whom are all the harmonies of life, the perfection of Symmetry, the true and curious consent of the most fairest colors and the wealthy Gardens which fill the world with living Plants. Do but you receive virtuous Inmates (as what Palaces are more rich to receive heavenly messengers?) and you shall draw men's souls unto you with that severe, devout, and holy adoration, that you shall never want praise, never love, never reverence.

But now methinks I hear the witty offending great Ones reply in excuse of their deformities: "What, is there no difference among women? No distinction of places, no respect of Honors, nor no regard of blood or alliance? Must but a bare pair of shears pass between Noble and ignoble, between the generous spirit and the base Mechanic?[35] Shall we be all coheirs of one honor, one estate, and one habit? Oh Men, you are then too tyrannous and not only injure Nature but also break the Laws and customs of the wisest Princes. Are not Bishops known by their Miters, Princes by their Crowns, Judges by their Robes, and Knights by their spurs? But poor Women have nothing, how great soever they be, to divide themselves from the enticing shows or moving Images which do furnish most shops in the City. What is it that either the Laws have allowed to the greatest Ladies, custom found convenient, or their bloods or places challenged, which hath not been engrossed into the City with as great greediness and pretense of true

33. The exterior slopes of a ditch. In this somewhat confused metaphor, female sexuality is compared to precious metals to be buried, shameful evils to be imprisoned, and the contents of a besieged city to be defended—all by the proper clothing.

34. A poor district abounding in prostitutes in ancient Rome.

35. A member of the lower classes; a manual worker.

title as if the surcease from the Imitation were the utter breach of their Charter everlastingly?[36]

"For this cause these Apes of the City have enticed foreign Nations to their cells and, there committing gross adultery with their Gewgaws, have brought out such unnatural conceptions[37] that the whole world is not able to make a Democritus[38] big enough to laugh at their foolish ambitions. Nay, the very Art of Painting,[39] which to the last Age shall ever be held in detestation, they have so cunningly stolen and hidden amongst their husbands' hoards of treasure that the decayed stock of Prostitution, having little other revenues, are hourly in bringing their action of Detinue[40] against them. Hence, being thus troubled with these Popinjays and loath still to march in one rank with fools and Zanies, have proceeded these disguised deformities, not to offend the eyes of goodness but to tire with ridiculous contempt the never-to-be-satisfied appetites of these gross and unmannerly intruders. Nay, look if this very last edition of disguise, this which is so full of faults, corruptions, and false quotations, this bait which the Devil hath laid to catch the souls of wanton Women, be not as frequent in the demi-Palaces of Burgers and Citizens as it is either at Masque, Triumph, Tilt-yard,[41] or Playhouse. Call but to account the Tailors that are contained within the Circumference of the Walls of the City and let but their Hells[42] and their hard reckonings be justly summed together, and it will be found they have raised more new foundations of this new disguise and metamorphosized more modest old garments to this new manner of short base and French doublet only for the use of Freeman's[43]

36. Noblewomen (the "offending great Ones") defend their masculine style of dress as a response to the fact that there is no distinction of attire to separate high- and low-born women; women of the mercantile classes in the City of London constantly ape their betters' fashions and carry them to ridiculous extremes. Hence the nobility invented this style of dress to bring contempt on their lower-class imitators.

37. A sexual metaphor—their outlandish costumes are the offspring ("conceptions") of adultery with foreign styles of dress and gross imitations of court styles.

38. A fifth-century B.C. philosopher who laughed at the pretensions of his time.

39. The coloring of the face with cosmetics.

40. An action at law to recover something wrongfully detained by the defendant; in other words, prostitutes are suing these women for wrongful use of their stock in trade, cosmetics.

41. Public celebrations and tournaments especially frequented by the upper classes.

42. Containers for a tailor's discarded material.

43. Here the term *freeman* apparently designates a freeborn individual who is not a member of the gentry.

wives and their children in one month than hath been worn in Court, Suburbs, or County since the unfortunate beginning of the first devilish invention.

"Let therefore the powerful Statue of apparel[44] but lift up his Battle-Ax and crush the offenders in pieces, so as everyone may be known by the true badge of their blood or Fortune. And then these Chimeras[45] of deformity will be sent back to hell and there burn to Cinders in the flames of their own malice."

Thus, methinks, I hear the best of offenders argue, nor can I blame a high blood to swell when it is coupled and counterchecked with baseness and corruption. Yet this shows an anger passing near akin to envy and alludes much to the saying of an excellent Poet:

> Women never
> Love beauty in their Sex, but envy ever.

They have Caesar's ambition and desire to be one and alone, but yet to offend themselves to grieve others is a revenge dissonant to Reason. And, as Euripides saith, a woman of that malicious nature is a fierce Beast and most pernicious to the Commonwealth, for she hath power by example to do it a world of injury.

[A woman's disposition should be gentle; her thoughts, according to a poet cited by the author, should be "attended with remorse." In contrast to the ideal woman, those who indulge in the new fashion have given "a shameless liberty to every loose passion." In their attempt to control the men who should rule them, they endanger their personal fortunes and reputations as well as those of their families and their sex. The author includes a stanza by Edmund Spenser from the Book of Justice of *The Faerie Queene*:

> Such is the cruelty of womenkind,
> When they have shaken off the shamefast band
> With which wise Nature did them strongly bind
> T'obey the hests[46] of man's well ruling hand,

44. Laws governing what each class may or may not wear; the noblewomen claim that the fashion of masculine attire would disappear if dress distinctions between classes of women were maintained and enforced by law.

45. In Greek mythology, the chimera was a fire-breathing female monster with the head of a lion, the body of a goat, and a serpent for a tail.

46. Behests, commands.

That then all rule and reason they withstand
To purchase a licentious liberty.
But virtuous women wisely understand
That they were born to base humility,
Unless the heavens them lift to lawful sovereignty.[47]]

To you therefore that are Fathers, Husbands, or Sustainers of these new Hermaphrodites belongs the cure of this Impostume.[48] It is you that give fuel to the flames of their wild indiscretion; you add the oil which makes their stinking Lamps defile the whole house with filthy smoke, and your purses purchase these deformities at rates both dear and unreasonable. Do you but hold close your liberal hands or take strict account of the employment of the treasure you give to their necessary maintenance, and these excesses will either cease or else die smothered in the Tailor's Trunk for want of Redemption.

Seneca, speaking of liberality, will by no means allow that any man should bestow either on friend, wife, or children any treasure to be spent upon ignoble uses, for it not only robs the party of the honor of bounty and takes from the deed the name of a Benefit, but also makes him conscious and guilty of the crimes which are purchased by such a gratuity. Be, therefore, the Scholars of Seneca, and your Wives, Sisters, and Daughters will be the Coheirs of modesty.

Lycurgus[49] the law-giver made it death in one of his Statutes to bring in any new custom into his Commonwealth. Do you make it the utter loss of your favor and bounty to have brought into your Family any new fashion or disguise that might either deform Nature or be an injury to modesty. So shall shamefastness and comeliness ever live under your roof, and your Wives and Daughters, like Vines and fair Olives, ever spread with beauty round about your Tables.

The Lacedaemonians,[50] seeing that their children were better taught

47. Book 5, canto 5, stanza 25. The stanza describes the tyranny of the Amazon queen Radigund over Artegall, the hero of the Book of Justice. As a symbol of Artegall's enslavement, Radigund forces him to wear women's clothing and to spend his time spinning and carding. The relationship causes both of them misery, for Radigund is secretly in love with Artegall but cannot bring herself "to serve the lowly vassal of her might." The last line of the stanza cited refers, of course, to Queen Elizabeth, regarded by most Elizabethan thinkers as a legitimate exception to the ideal of female submission.

48. Pride or insolence.

49. Traditional founder of the constitution of ancient Sparta.

50. Citizens of ancient Sparta.

by examples than precepts, had hanging in their houses in fair painted tablets all the Virtues and Vices that were in those days reigning with their rewards and punishments. Oh, have you but in your houses the fashions of all attires constantly and without change held and still followed through all the parts of Christendom! Let them but see the modest Dutch, the stately Italian, the rich Spaniard, and the courtly French with the rest according to their climates, and they will blush that in a full fourth part of the world there cannot be found one piece of a Character to compare or liken with the absurdity of their Masculine Invention. Nay, they shall see that their naked Countryman, which had liberty with his Shears to cut from every Nation of the World one piece or patch to make up his garment, yet amongst them all could not find this Miscellany or mixture of deformities which, only by those which whilst they retained any spark of womanhood were both loved and admired, is loosely, indiscreetly, wantonly, and most unchastely invented.

And therefore, to knit up this imperfect Declamation, let every Female-Masculine that by her ill examples is guilty of Lust or Imitation cast off her deformities and clothe herself in the rich garments which the Poet bestows upon her in these Verses following:

> Those Virtues that in women merit praise
> Are sober shows without, chaste thoughts within,
> True Faith and due obedience to their mate,
> And of their children honest care to take.

HÆC-VIR:
OR
The Womanish-Man:

Being an Anſwere to a late Booke intituled
Hic-Mulier.

Expreſt in a briefe Dialogue betweene *Hæc-
Vir* the Womaniſh-Man, and *Hic-Mulier* the
Man-Woman.

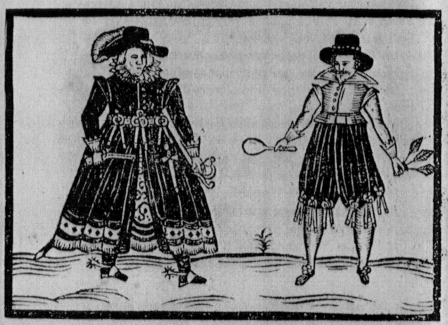

London printed for *I.T.* and are to be ſold at Chriſt Church gate. 1620.

§. *Haec Vir;* or, The Womanish Man:
Being an Answer to a late Book entitled
Hic Mulier, Expressed in a brief Dialogue between
Haec Vir, the Womanish Man, and
Hic Mulier, the Man-Woman.
1620

Haec Vir:[1] Most redoubted and worthy Sir (for less than a Knight I cannot take you), you are most happily given unto mine embrace.

Hic Mulier:[2] Is she mad or doth she mock me? Most rare and excellent Lady, I am the servant of your virtues and desire to be employed in your service.

Haec Vir: Pity of patience, what doth he behold in me, to take me for a woman? Valiant and magnanimous Sir, I shall desire to build the Tower of my Fortune upon no stronger foundation than the benefit of your grace and favor.

Hic Mulier: Oh, proud ever to be your Servant.

Haec Vir: No, the Servant of your Servant.

Hic Mulier: The Tithe of your friendship, good Lady, is above my merit.

Haec Vir: You make me rich beyond expression. But fair Knight, the truth is I am a Man and desire but the obligation of your friendship.

Hic Mulier: It is ready to be sealed and delivered to your use. Yet I would have you understand I am a Woman.

Haec Vir: Are you a Woman?

Hic Mulier: Are you a Man? O Juno Lucina,[3] help me!

Haec Vir: Yes, I am.

Hic Mulier: Your name, most tender piece of Masculine.

Haec Vir: Haec Vir, no stranger either in Court, City, or Country.

1. Deliberately incorrect Latin for "this man," coupling the feminine form of the adjective with the masculine noun ("this womanish man").

2. Deliberately incorrect Latin for "this woman," coupling the masculine form of the adjective with the feminine noun ("this mannish woman").

3. The Roman goddess of childbirth.

But what is yours, most courageous counterfeit of Hercules and his Distaff?[4]

Hic Mulier: Near akin to your goodness, and compounded of fully as false Latin. The world calls me Hic Mulier.

Haec Vir: What, Hic Mulier, the Man-Woman? She that like an Alarm Bell at midnight hath raised the whole Kingdom in Arms against her? Good, stand and let me take a full survey, both of thee and all thy dependents.

Hic Mulier: Do freely and, when thou hast daubed me over with the worst colors thy malice can grind, then give me leave to answer for myself, and I will say thou art an accuser just and indifferent.[5] Which done, I must entreat you to sit as many minutes that I may likewise take your picture, and then refer to censure whether[6] of our deformities is most injurious to Nature or most effeminate to good men in the notoriousness of the example.

Haec Vir: With like condition of freedom to answer, the Articles are agreed on. Therefore, stand forth, half Birchenlane, half Saint Thomas Apostle's (the first lent thee a doublet, the latter a nether-skirt);[7] half Bridewell, half Blackfriars (the one for a scurvy Block, the other for a most profane Feather);[8] half Mulled Sack the Chimney Sweeper, half Garrat the Fool at a Tilting (the one for a Yellow Ruff, the other for a Scarf able to put a Soldier out of countenance);[9] half Bedlam, half

4. For one of his misdeeds, the strongman hero Hercules was condemned to serve for one year as the slave of Omphale, queen of Lydia. To humiliate him, he was dressed in women's clothes and made to sit spinning and weaving with the female slaves (a distaff is an implement used in spinning).

5. Impartial.

6. Which.

7. Your doublet (or the fabric from which it was made) was purchased in Birchenlane (a lane in London which boasted many drapers' shops); your nether-skirt (underskirt) was purchased in the parish of St. Thomas the Apostle (an area associated with hosiers).

8. You obtained your hat in Bridewell (an area in London near the famous prison of that name) and the feather for your hat in the Blackfriars area ("block" is a pun referring both to the wood on which criminals were beheaded and the wood on which hats were formed). The insult is heightened by the fact that prostitutes were imprisoned in Bridewell.

9. The yellow ruff, an object of scorn and ridicule at the court of King James, was made popular in England by Anne Turner, who was executed in 1615 for her part in the murder of Sir Thomas Overbury. James insisted that Mrs. Turner wear her yellow ruff to the gallows. Mulled Sack, a kind of hot, spiced wine, is also the title of another pamphlet purporting to answer *Hic Mulier* (*Mulled Sack; or, The Apology of Hic Mulier to the late Declamation against her*, 1620); moreover, "the sack" was a method of execution

Brimendgham (the one for a base sale Boot, the other for a beastly Leaden gilt Spur);[10] and, to conclude, all Hell, all Damnation for a shorn, powdered, borrowed Hair; a naked, lascivious, bawdy Bosom; a Leadenhall Dagger; a Highway Pistol; and a mind and behavior suitable or exceeding every repeated deformity. To be brief, I can but in those few lines delineate your proportion for the paraphrase or compartment to set out your ugliness to the greatest extent of wonder.[11] I can but refer you to your Godchild that carries your own name—I mean the Book of *Hic Mulier*. There you shall see your character and feel your shame with that palpable plainness, that no Egyptian darkness[12] can be more gross and terrible.

Hic Mulier: My most tender piece of man's flesh, leave this lightning and thunder and come roundly to the matter; draw mine accusation into heads, and then let me answer.

Haec Vir: Then thus. In that Book you are arraigned and found guilty, first, of Baseness, in making yourself a slave to novelty and the poor invention of every weak Brain that hath but an embroidered outside; next, of unnaturalness, to forsake the Creation of God and Customs of the Kingdom to be pieced and patched up by a French Tailor, an Italian Babymaker, and a Dutch Soldier beat from the Army for the ill example of Ruffianly behavior;[13] then of Shamefulness, in casting off all modest softness and civility to run through every desert and wilderness of men's opinions like careless untamed Heifers or wild Savages; lastly, of foolishness, in having no moderation or temper[14] either in passions or affections, but turning all into perturbations and sicknesses of the soul, laugh away the preciousness of your Time and at

involving drowning in a sack. Garrat, while probably a real person, is also a pun on garrotte, the Spanish method of capital punishment by strangulation. Thus the "Scarf able to put a Soldier out of countenance" is the garrotte—a reference both to the stick twisted to effect the execution and to the weapon carried by Hic Mulier.

10. Bedlam was an institution for the insane in London; Hic Mulier apparently bought her boots "on sale" near this asylum. This may also contain a reference to "the boot," an instrument of torture used to extract confessions. Brimendgham may possibly be Birmingham.

11. I will sketch the outline of your ugliness; it must remain for others to fill in the details (a "paraphrase" is an amplification of a passage or a commentary on a text).

12. In Renaissance England, comparing someone's dark complexion to that of an Egyptian was a way of calling him shamefully ugly.

13. Hic Mulier's style of attire is not only irreligious, it is also foreign; a "Babymaker" is probably a maker of dolls.

14. Restraint within due limits.

last die with the flattering sweet malice of an incurable consumption. Thus Baseness, Unnaturalness, Shamefulness, Foolishness are the main Hatchments[15] or Coat-Armors which you have taken as rich spoils to adorn you in the deformity of your apparel; which, if you can execute, I can pity and thank Proserpina[16] for thy wit, though no good man can allow of the Reasons.

Hic Mulier: Well then, to the purpose. First, you say I am Base, in being a Slave to Novelty. What slavery can there be in freedom of election, or what baseness to crown my delights with those pleasures which are most suitable to mine affections? Bondage or Slavery is a restraint from those actions which the mind of its own accord doth most willingly desire, to perform the intents and purposes of another's disposition, and that not[17] by mansuetude or sweetness of entreaty, but by the force of authority and strength of compulsion. Now for me to follow change according to the limitation of mine own will and pleasure, there cannot be a greater freedom. Nor do I in my delight of change otherwise than as the whole world doth, or as becometh a daughter of the world to do. For what is the world but a very shop or warehouse of change? Sometimes Winter, sometimes Summer; day and night; they hold sometimes Riches, sometimes Poverty; sometimes Health, sometimes Sickness; now Pleasure, presently Anguish; now Honor, then contempt; and, to conclude, there is nothing but change, which doth surround and mix with all our Fortunes. And will you have poor woman such a fixed Star that she shall not so much as move or twinkle in her own Sphere? That were true Slavery indeed and a Baseness beyond the chains of the worst servitude! Nature to everything she hath created hath given a singular delight in change: as to Herbs, Plants, and Trees a time to wither and shed their leaves, a time to bud and bring forth their leaves, and a time for their Fruits and Flowers; to worms and creeping things a time to hide themselves in the pores and hollows of the earth, and a time to come abroad and suck the dew; to Beasts liberty to choose their food, liberty to delight in their food, and liberty to feed and grow fat with their food; the Birds have the air to fly in, the waters to bathe in, and the earth to feed on;

15. Panels bearing the coat of arms of a man who has recently died, displayed before his house.

16. Daughter of the goddess Demeter/Ceres, she was carried off by Hades and became queen of the underworld for part of each year.

17. Original text reads "not *but* by mansuetude."

but to man both these and all things else to alter, frame, and fashion, according as his will and delight shall rule him. Again, who will rob the eye of the variety of objects, the ear of the delight of sounds, the nose of smells, the tongue of tastes, and the hand of feeling? And shall only woman, excellent woman, so much better in that she is something purer, be only deprived of this benefit? Shall she be the Bondslave of Time, the Handmaid of opinion, or the strict observer of every frosty or cold benumbed imagination? It were a cruelty beyond the Rack or Strappado.[18]

But you will say it is not Change, but Novelty, from which you deter us, a thing that doth avert the good and erect the evil, prefer the faithless and confound desert, that with the change of Opinions breeds the change of States, and with continual alterations thrusts headlong forward both Ruin and Subversion. Alas, soft Sir, what can you christen by that new imagined Title, when the words of a wise man are, "That what was done, is but done again; all things do change, and under the cope of Heaven there is no new thing." So that whatsoever we do or imitate, it is neither slavish, Base, nor a breeder of Novelty.

Next, you condemn me of Unnaturalness in forsaking my creation and contemning[19] custom. How do I forsake my creation, that do all the rights and offices due to my Creation? I was created free, born free, and live free; what lets[20] me then so to spin out my time that I may die free?

To alter creation were to walk on my hands with my heels upward, to feed myself with my feet, or to forsake the sweet sound of sweet words for the hissing noise of the Serpent. But I walk with a face erect, with a body clothed, with a mind busied, and with a heart full of reasonable and devout cogitations, only offensive in attire, inasmuch as it is a Stranger to the curiosity of the present times and an enemy to Custom. Are we then bound to be the Flatterers of Time or the dependents on Custom? Oh miserable servitude, chained only to Baseness and Folly, for than custom, nothing is more absurd, nothing more foolish.

It was a custom amongst the Romans that, as we wash our hands before meals, so they with curious and sweet ointments anointed all their arms and legs quite over, and by succession of time grew from

18. Instruments of torture.
19. Scorning.
20. Hinders.

these unguents to baths of rich perfumed and compound waters in which they bathed their whole bodies, holding it the greatest disgrace that might be to use or touch any natural water, as appears by these Verses:

> She shines with ointments to make hair to fall,
> Or with sour Chalk she overcovers all.
>
> (Martial[21])

It was a custom amongst the Ancients to lie upon stately and soft beds when either they delivered Embassies or entered into any serious discourse or argument, as appears by these Verses:

> Father Aeneas thus gan say,[22]
> From stately Couch whereon he lay.
>
> (Virgil, *Aeneid*)

Cato Junior[23] held it for a custom never to eat meat but sitting on the ground; the Venetians kiss one another ever at the first meeting; and even at this day it is a general received custom amongst our English that when we meet or overtake any man in our travel or journeying, to examine him whither he rides, how far, to what purpose, and where he lodgeth. Nay, and with that unmannerly boldness of inquisition that it is a certain ground of a most insufficient quarrel not to receive a full satisfaction of those demands which go far astray from good manners or comely civility. And will you have us to marry ourselves to these Mimic and most fantastic customs? It is a fashion or custom with us to mourn in Black; yet the Aegean and Roman Ladies ever mourned in White[24] and, if we will tie the action upon the signification of colors, I see not but we may mourn in Green, Blue, Red, or any simple color used in Heraldry. For us to salute strangers with a kiss is counted but civility, but with foreign Nations immodesty; for

21. Martial was an ancient Roman poet known for his biting and often scurrilous epigrams. Although the Romans copiously rubbed oils on their bodies, they did frequently bathe in plain water; in fact, this line (6.93.9) appears in a poem highly critical of the hygiene of the lady in question.

22. Spoke. Virgil's *Aeneid* was the great national epic of ancient Rome; this is a translation of *Aeneid* 2.2.

23. Marcus Porcius Cato the Younger, the conservative Roman statesman of the first century B.C.

24. Actually, black was associated with mourning in Greece and Rome, although there was no mandate or fixed period for its wearing.

you to cut the hair of your upper lips, familiar here in England, every-where else almost thought unmanly. To ride on Sidesaddles at first was counted here abominable pride, etc. I might instance in a thousand things that only Custom and not Reason hath approved. To conclude, Custom is an Idiot, and whosoever dependeth wholly upon him with-out the discourse of Reason will take from him his pied coat and be-come a slave indeed to contempt and censure.

But you say we are barbarous and shameless and cast off all softness to run wild through a wilderness of opinions. In this you express more cruelty than in all the rest. Because I stand not with my hands on my belly like a baby at Bartholomew Fair that move not my whole body when I should, but only stir my head like Jack of the Clockhouse which hath no joints;[25] that am not dumb when wantons court me, as if, Asslike, I were ready for all burdens; or because I weep not when injury grips me, like a worried Deer in the fangs of many Curs, am I therefore barbarous or shameless? He is much injurious that so bap-tized us. We are as freeborn as Men, have as free election and as free spirits; we are compounded of like parts and may with like liberty make benefit of our Creations. My countenance shall smile on the worthy and frown on the ignoble; I will hear the Wise and be deaf to Idiots; give counsel to my friend, but be dumb to flatterers. I have hands that shall be liberal to reward desert, feet that shall move swiftly to do good offices, and thoughts that shall ever accompany freedom and severity. If this be barbarous, let me leave the City and live with creatures of like simplicity.

To conclude, you say we are all guilty of most infinite folly and in-discretion. I confess that Discretion is the true salt which seasoneth every excellence, either in Man or Woman, and without it nothing is well, nothing is worthy; that want[26] disgraceth our actions, staineth our Virtues, and indeed makes us most profane and irreligious. Yet it is ever found in excess, as in too much or too little. And of which of these are we guilty? Do we wear too many clothes or too few? If too many, we should oppress Nature; if too few, we should bring sickness to

25. The baby dolls sold at the stalls of Bartholomew Fair, a huge annual fair held in August in the suburbs west of London, were apparently designed with the doll's hands resting on its abdomen; they resembled Jack of the Clockhouse, a male figure which struck the bell of a clock, in that only their heads moved.
26. Lack (of discretion).

Nature; but neither of these we do, for what we do wear is warm, thrifty, and wholesome. Then no excess, and so no indiscretion—where is then the error? Only in the Fashion, only in the Custom. Oh, for mercy sake, bind us not to so hateful a companion, but remember what one of our famous English poets says:

> Round-headed Custom th' apoplexy is
> Of bedrid Nature, and lives led amiss,
> And takes away all feelings of offense.
> (G. C.[27])

Again, another as excellent in the same Art saith:

> Custom the World's Judgment doth blind so far,
> That Virtue is oft arraigned at Vice's Bar.
> (D'Bart.[28])

And will you be so tyrannous then to compel poor Woman to be a mistress to so unfaithful a Servant? Believe it, then we must call up our Champions against you, which are Beauty and Frailty, and what the one cannot compel you to forgive, the other shall enforce you to pity or excuse. And thus myself imagining myself free of these four Imputations, I rest to be confuted by some better and graver Judgment.

[Haec Vir responds by claiming that the freedom that Hic Mulier has assumed is merely "a willful liberty to do evil." According to Divines of the Church, a woman may dress like a man only to avoid persecution, and Hic Mulier does not have this excuse. It would be better had "the first inventor of your disguise perished with all her complements about her," for her invention has caused infinite scandal and sin. To delight in sin is to yield to baseness, and to yield to baseness is foolish and barbarous. Thus, until Hic Mulier returns to traditional dress, she is base, unnatural, shameful, and foolish.]

Hic Mulier: Sir, I confess you have raised mine eyelids up, but you have not clean taken away the film that covers the sight. I feel, I confess, cause of belief and would willingly bend my heart to entertain belief, but when the accuser is guilty of as much or more than that he

27. Probably George Chapman, a poet and playwright best known for his translations of Homer's *Iliad* and *Odyssey* into rhymed couplets.

28. Probably Guillaume DuBartas, a French religious poet admired and translated by the English in the sixteenth century.

accuseth, or that I see you refuse the potion and are as grievously infected, blame me not then a little to stagger.[29] And till you will be pleased to be cleansed of that leprosy which I see apparent in you, give me leave to doubt whether mine infection be so contagious as your blind severity would make it.

Therefore, to take your proportion[30] in a few lines, my dear Feminine-Masculine, tell me what Charter, prescription, or right of claim you have to those things you make our absolute inheritance? Why do you curl, frizzle, and powder your hairs, bestowing more hours and time in dividing lock from lock, and hair from hair, in giving every thread his posture, and every curl his true sense and circumference, than ever Caesar did in marshalling his Army, either at Pharsalia, in Spain, or Britain? Why do you rob us of our Ruffs, of our Earrings, Carcanets,[31] and Mamillions,[32] of our Fans and Feathers, our Busks, and French bodies,[33] nay, of our Masks, Hoods, Shadows, and Shapinas?[34] Not so much as the very Art of Painting,[35] but you have so greedily engrossed it that were it not for that little fantastical sharp-pointed dagger that hangs at your chins, and the cross hilt which guards your upper lip, hardly would there be any difference between the fair Mistress and the foolish Servant. But is this theft the uttermost of our Spoil? Fie, you have gone a world further and even ravished from us our speech, our actions, sports, and recreations. Goodness leave me, if I have not heard a Man court his Mistress with the same words that Venus did Adonis, or as near as the Book could instruct him.[36] Where are the Tilts and Tourneys and lofty Galliards[37] that were danced in the days of old, when men capered in the air like wanton

29. Begin to doubt or waver (probably also a reference to the pamphlet *Hic Mulier*, which accuses the masculine women of being afflicted with the disease of the staggers).
30. Form, shape.
31. Ornamental collars or necklaces usually set with gold and jewels.
32. Items of clothing that covered the breasts.
33. Corsets and whalebone bodices.
34. Various headdresses; "Shadows" projected forward to shade the face.
35. The coloring of the face with cosmetics.
36. The book is doubtless Shakespeare's *Venus and Adonis*, a popular narrative poem which had been reprinted in nine successive quartos by 1616. In this erotic Ovidian poem Venus woos the bashful Adonis with conventional feminine wiles, including sighs, tears, and considerable self-pity. The goddess of love stresses her physical charms, pointing out to Adonis that her "flesh is soft and plump" and offering to "like a fairy, trip upon the green" if he will but respond to her entreaties.
37. Lively dances in triple time for two dancers.

kids on the tops of Mountains and turned above ground as if they had been compact of Fire or a purer element? Tut, all's forsaken, all's vanished.

[Hic Mulier claims that men have stolen women's pastimes, especially shuttlecock,[38] which had been "a very Emblem of us and our lighter despised fortunes." Having relinquished the arms that "would shake all Christendom with the brandish," men now languish in "softness, dullness, and effeminate niceness."] To see one of your gender either show himself in the midst of his pride or riches at a Playhouse or public assembly: how, before he dare enter, with the Jacob's Staff[39] of his own eyes and his Page's, he takes a full survey of himself from the highest sprig in his feather to the lowest spangle that shines in his Shoestring; how he prunes and picks himself like a Hawk set aweathering, calls every several garment to Auricular confession,[40] making them utter both their mortal great stains and their venial and lesser blemishes, though the mote be much less than an Atom. Then to see him pluck and tug everything into the form of the newest received fashion, and by Dürer's[41] rules make his leg answerable to his neck, his thigh proportionable with his middle, his foot with his hand, and a world of such idle, disdained foppery. To see him thus patched up with Symmetry, make himself complete and even as a circle and, lastly, cast himself amongst the eyes of the people as an object of wonder with more niceness than a Virgin goes to the sheets of her first Lover, would make patience herself mad with anger and cry with the Poet:

O Hominum mores, O gens, O Tempora dura,
Quantus in urbe Dolor; Quantus in Orbe Dolus![42]

Now since according to your own Inference, even by the Laws of Nature, by the rules of Religion, and the Customs of all civil Nations, it is necessary there be a distinct and special difference between Man and Woman, both in their habit and behaviors, what could we poor weak women do less (being far too weak by force to fetch back those

38. A game similar to badminton.
39. An instrument for measuring height and distance.
40. Confession told privately in the ear (a pun on religious confession, since "stains," "blemishes," and "mote" can refer to moral flaws as well as spots on clothing).
41. Albrecht Dürer was a painter and engraver of Renaissance Germany.
42. "O morals of men, O race, O harsh times! How much anguish in the city; how much treachery in the world!"

spoils you have unjustly taken from us), than to gather up those garments you have proudly cast away and therewith to clothe both our bodies and our minds?

[Hic Mulier asserts that women adopted masculine clothing and behavior reluctantly, only to preserve "those manly things which you have forsaken." To prove that men were dressing in an effeminate manner long before women assumed masculine dress, she recites two stanzas by the Italian poet Ariosto[43] describing a bejeweled man who "was himself in nothing but in name." Because the "deformity" of the effeminate man has a longer history than that of the masculine woman, it will be more difficult to eradicate; men must return to traditional dress and behavior, however, before women can be expected to do so.]

Cast then from you our ornaments and put on your own armor; be men in shape, men in show, men in words, men in actions, men in counsel, men in example. Then will we love and serve you; then will we hear and obey you; then will we like rich Jewels hang at your ears to take our Instructions, like true friends follow you through all dangers, and like careful leeches[44] pour oil into your wounds. Then shall you find delight in our words, pleasure in our faces, faith in our hearts, chastity in our thoughts, and sweetness both in our inward and outward inclinations. Comeliness shall be then our study, fear our Armor, and modesty our practice. Then shall we be all your most excellent thoughts can desire and having nothing in us less than[45] impudence and deformity.

Haec Vir: Enough. You have both raised mine eyelids, cleared my sight, and made my heart entertain both shame and delight in an instant—shame in my Follies past, delight in our Noble and worthy Conversion. Away then from me these light vanities, the only Ensigns of a weak and soft nature, and come you grave and solid pieces which arm a man with Fortitude and Resolution: you are too rough and stubborn for a woman's wearing. We will here change our attires, as we have changed our minds, and with our attires, our names. I will no more be Haec Vir, but Hic Vir; nor you Hic Mulier, but Haec Mulier. From henceforth deformity shall pack to Hell, and if at any time he

43. Lodovico Ariosto was an Italian Renaissance poet best known for his long narrative poem *Orlando Furioso.*

44. Physicians.

45. Anything in us rather than.

hide himself upon the earth, yet it shall be with contempt and dis-
grace. He shall have no friend but Poverty, no favorer but Folly, nor no
reward but Shame. Henceforth we will live nobly like ourselves, ever
sober, ever discreet, ever worthy: true men and true women. We will
be henceforth like well-coupled Doves, full of industry, full of love.
I mean not of sensual and carnal love, but heavenly and divine love,
which proceeds from God, whose inexpressable nature none is able to
deliver in words, since it is like his dwelling, high and beyond the reach
of human apprehension, according to the saying of the Poet in these
Verses following:

> Of love's perfection perfectly to speak,
> Or of his nature rightly to define,
> Indeed doth far surpass our reason's reach
> And needs his Priest t'express his power divine.
> For long before the world he was yborn[46]
> And bred above its highest celestial Sphere,
> For by his power the world was made of yore,
> And all that therein wondrous doth appear.

46. Born.

A Iuniper

Lecture.

With the description
of all sorts of women,
good, and bad:

From the modest to
the maddest, from the
most Civil, to the scold Ram-
pant, their praise and dispraise
compendiously related.
*The second Impression, with
many new Additions.*

Also the authors advice how to
tame a shrew, or vexe her.

LONDON:
Printed by I.O. for William Ley,
and are to be sold at his shop in
Pauls Churchyard, neere
Pauls Chaine. 1639.

§. *A Juniper Lecture*, With the description
of all sorts of women, good and bad:
From the modest to the maddest,
from the most Civil to the scold Rampant,
their praise and dispraise compendiously related.
The Second Impression, with many new Additions.
Also, the Author's advice how to
tame shrew or vex her.
John Taylor
1639

*To as many as can Read, though but reasonably; it makes no great
matter whether they understand or no.*

[In this epistle Taylor explains the "sundry small reasons" for the
title of his lecture. As juniper wood will burn for a year if "the fire of it
be raked up in the Embers or Ashes," so the anger of vengeful women
"will hardly be quenched in their Ashes or Graves." Furthermore, as
the juniper tree is "full of prickles, so are a curst woman's words very
piercing to the ears and sharp to the heart." The juniper can also rep-
resent good women, for just as it provides an antidote to snakebite,
"so a virtuous woman is the honor and preservation of her husband's
person and estate."

[The epistle is followed by a poem to the reader in which Taylor ac-
knowledges that some women are good and begs pardon of "you vir-
tuous, worthy women, few that be." As a final prefatory piece Taylor
includes a poem allegedly by "Margery Quiet of Tame in Oxfordshire
to her Ingenious friend, the Author." Margery blames men for praising
only the beauty of women, claiming, "If goodness with men's praises
were but graced, / We should be then more modest and more chaste."
She approves of *A Juniper Lecture*, calling the author "Ingenious, just,
impartial," for "thou dost commend the good, condemn the ill, / For
which all women of all sorts shall still / Remain thy friends and foes."]

A Juniper Lecture

1. A Lecture of a Mistress to her Apprentice something early in the Morning.

[The angry woman scolds her apprentice for sleeping so late: "Hey ho, what the Sun so high already and not the Boy up nor the Shop open?" She also complains about having to prepare his breakfast, claiming that while Barley bread would have satisfied him when he lived in the country, now nothing but plum pudding will please his "fine chops." Having thoroughly chastised and threatened the apprentice, she turns to the kitchen maid, whom she accuses of sloppy work. When the maid responds to her by muttering under her breath, the mistress vents more anger: "Nay, Hussy, grumble and mumble as long as you will; . . . I'll make your bones rattle in your skin." Throughout her diatribe, the mistress blames her master for setting a bad example for the servants through his own laziness.]

2. A Lecture of a Wife to her Husband, that hath been married three or four years.

In truth Husband, I can hold no longer, but I must speak. I see you still follow this vein of ill Husbandry, never keep at home: is the house a wildcat[1] to you? Here I sit all the day long with the Children, sighing and looking every minute when you will return home; in faith this course of life must be left. Do you think I can sell your Wares or know the prices of them when your Customers come? Let them look to your shop that will, for I will not. Keep your shop, and then it will keep you, I say; keep home with a wanion[2] to you, or else let all go at sixes and sevens. You begin the week well for this day and no longer; so soon as you were up and ready, then to the Alehouse to your companions, to some Game or other for your Morning's Draught of strong liquor, when I (poor wretch) must be at home with a cup of small Beer of four shillings price and be glad of it, too, or else I must drink water. I dare say, and put a Warrant to it, that I may sit at home long enough before you will send me a cup of good drink, which you guzzle down, making yourselves beasts and not men. For a man, if he had or bore

1. An ill-tempered or spiteful person, usually a woman.
2. With a vengeance.

any love to his Wife at all (which hath brought him so many children), would some time remember her and say, "Carry this home to my Wife, and remember me to her." But your children and I must be content with anything. I would I were dead, that you might have another wife, and then you should see it, she would not be made such a fool as I am by you. I am sure I take no pleasure at all like my other Neighbors' Wives, for they can go abroad with their Husbands every day, but I (poor I) once in a year, and glad of it then, too. I would I had been made a man, for Women are nothing but your Drudges and your Slaves, to make you clean and to wash and starch your clothes, when you go whither you please and take no care at all for anything. A woman's work is never at an end and never done, but like a wheel, still turning round and hath no end. I am forced as soon as I rise in the Morning to make a fire, sweep the house, and get the children's and your servants' Breakfast; no sooner that done and they out of the way, think upon Dinner; then no sooner Dinner eaten, than I must make all the dishes clean again and sweep the House. Then, because I would be thought a good Housewife, I sit me down to spin, then think upon your Supper and study what will please your dainty chops, and make it ready against you come home, when you are half foxed.[3] Then the children must be straightway thought upon, or else there's nothing but crying and brawling, which makes my brains ache again. Then all being satisfied, put the children to sleep, then to bed myself; and thus a woman's work is never done.

The Husband's answer: "I do verily think, when you are abed you do wish that work were never done."

3. Lecture by a young gentlewoman, being a widow, to an old man who offered to be a suitor to her.

[Upon receiving from her aged suitor a poem which praises her "eye-dazzling beauties," the young woman responds with annoyance and contempt: "Old age to match with Youth? 'Tis monstrous; fie, fie, 'tis Lust in doting age." She tells him that despite his fantasies he would surely be impotent, a condition she could not tolerate: "I will have a Husband that shall be always provided like a Soldier . . . with his Match lighted and cocked bolt upright and ready to do execu-

3. Drunk, stupefied.

tion, not like a Dormouse, always sleeping." She sends him away with a poem about the unhappy marriage of "cheerful May and frozen January."]

4. Lecture by an old rich widow to a young Gallant who came awooing to her, that had little or no means.

[In this brief lecture addressed to "Base fellow, that dares be so bold to ask a Gentlewoman to thy bed," the rich widow informs the young man that he is scarcely worthy to be her groom; she expresses shock at his impudence in proposing marriage to her. The lecture is followed by two poems: one advising a young man how to treat an old, rich wife to ensure her death, and the other discoursing on the bitterness of women's tongues.]

5. A Lecture of a Country Farmer's wife, being a shrew to her husband for being late abroad at night.

[The wife berates her husband for going hunting and leaving her to look after all his business: "your horses in the stable, your kine⁴ in the field, your swine in the yard, your poultry about the house, your cramming of your Capons, your brewing and your baking." She also mocks his clownish manners and his illiteracy ("thy Horses are better Scholars than thou art, for they understand *G* and *O*"), and chastises him for returning home drunk each night and awakening each morning with a hangover ("You, you drunken sot, you piss-pot, know not when you have sufficient").]

6. A Lecture of a Wife which was very jealous of her Husband.

[A woman who has recently discovered her husband's infidelities regrets her previous trust of him: "I thought it had been your modesty and your temperance when you told me you would lie alone because of the hot weather, and by reason of the Dog days, but let me tell you, though there be Dog days, yet there are no dog's nights. You shall lie no more alone, I will warrant you." She reminds him that she refused "many a good match only for thy sake," and warns him, "You shall not stir a foot out of doors, but I will be at your heels."]

4. Cattle.

7. A Lecture of a Widow which was newly married to a Widower.

[The speaker complains that her new husband does not allow her sufficient funds even though his money comes from her estate. She also compares his manners unfavorably with those of her first husband: "Thou art a very sloven and a nasty beast to him and art not worthy to carry guts to a Bear."[5] In concluding, she determines to obtain money from him "by hook or by crook."]

8. A Lecture between a jealous old woman and her young husband.

[The wife complains that although her husband is always ready to go out with his friends, he seldom takes her anywhere, and when he does he pays more attention to other women than to her. She announces her plan to replace their pretty maid with "a homely, housewifely wench" and tries to shame her young mate: "I'll not be thus plagued long; out upon it, an old woman that hath outlasted the Date of four Husbands, and now come to be slighted by a Boy of four and twenty?"]

9. A Lecture of a proud Dame to her husband because he would not allow her all the new fashions that are worn.

[The proud woman scolds her husband for his stinginess. Other women whose husbands are of lesser rank "can go gallant and brave," she claims, while her wardrobe is limited to "a Gown and a Hat of the fashion which was worn in Eighty-eight and a pair of hose and shoes at Easter." She closes with a familiar threat: "If thou wilt not bestow a new-fashioned Hat on me, I'll bestow an old fashioned Cap[6] upon thee."]

10. A Mother's Lecture to her daughter concerning Marriage.

[This long lecture opens with the mother's announcement to her daughter that her parents have arranged for her to marry Oliver Littlegood, the son of a wealthy usurer. When the daughter protests that he is "a brainless lump of ignorance," her father reminds her that "Matrimony is matter of money, and without money marriage is a mi-

5. Probably to carry feed to a bear. Bears were kept in captivity for use in the popular Renaissance sport of bearbaiting.
6. The proverbial horns of the cuckold, or deceived husband.

rage and not merry-age." When the girl still protests, her mother ex-
pounds to her the advantages of marrying a rich fool. The wives of
fools have far more freedom than the wives of wise men, she claims,
for they may come and go at will and spend as much as they wish; in
short, they may be "scolding, clamorous, proud, lascivious, volup-
tuous, high fed, rich clad, commanding all, not to be commanded by
any." To obtain this freedom, the wife must employ "the virtue and
volubility of the tongue with the help of lowering, pouting, frowning,
disdainful scorning, taunting, slandering, scoffing," for such behavior
will force the husband to make any concessions "for a little quiet life."
To become a skillful scold, "you may whet your wits with a Cup or two
extraordinary of nappy Ale, strong waters, Sack,[7] . . ."

[The mother then recounts the history of her own marriage to the
girl's father. For eight years she suffered "most miserable slavery with
him: my habit no other but old and unfashionable, my diet no other
but such as he did eat of, and I bound to nobody's bed but his." But
then an old gossip tutored her in the art of scolding, so that after a
year's practice "I could bend him which ways I listed; I hammered him
and made him Malleable; I turned him, wrought him, and Wire-
drawed him." The mother concludes by advising her daughter that it
is easier to marry a fool than to turn a wise man into a fool after
marriage.]

11. A Lecture-Dialogue between a man and his wife, which is the
scold rampant.

[In this lecture the wife puts into practice the advice given by the
mother in the previous lecture: she becomes a scold, accusing her
husband of infidelity (although he patiently protests his innocence),
drunkenness, and stinginess. The object of the wife's tirade is mastery
over him: "Dost thou think that I, to the ill example of all women, will
be an underling to such a Blockheaded fool as thou art?" The lecture
is followed by an epitaph addressed by the husband to the scold after
her death. The poem expresses his conviction that she is in heaven,
since "the Devil could never abide her."

[At this point, Taylor interrupts the series of lectures to speak di-
rectly to the reader. He warns the unwary man against marriage, "for
though good matches are made in Heaven, yet some men perhaps have

7. A white wine imported from Spain and the Canary Islands.

few or no friends there at the matchmaking." He bids the reader take care in his choice of a wife, for marriage will bind him fast. He comments on the disadvantages of two kinds of marriage: that of a poor young man to an old rich widow (dramatized in Lecture 8) and that of an old rich man with a poor young woman. Finally, returning to the dominant theme of the *Juniper Lecture*, the torments of life with a shrew, he argues that shrewishness is worse than any other fault in a wife.]

He that doth marry with a whore, although his lot be bad, yet age and time may make her turn honest.

He that weds a drunken woman (as there are too many of them that are most liquorishly[8] addicted to Wine, strong waters, Ale, and the like), there may be some hope of her mending or ending.

He that is matched to one that will steal and pilfer, there may be hope that she may be taken and by admonishment or punishment reformed; or else that in the end the Hangman may take such order with her that her husband may be eased of his trouble.

It is better for a man to have a fair Wife that himself and every man else will love (provided that she be not a scold withal), or a deformed wife that would hire others to make much of her (for foul water will quench fire as well as fair), or a drunken Wife that would make much of herself, or an old wife that were bedridden of her tongue, or a thievish wife that should steal from himself and others, or a proud one that would waste all his estate in fashions, or a liquorish wife, a daily feast-hunter, or a lazy wife like Joan Easy, that loved her Bed better than her Distaff,[9] or a sluttish wife that would poison him and end all his miseries: I say it were better for a man to marry with any of all these fore-named wicked kind of women than to be matched and overmatched with a scold. For a scold will be all these and worse: she will be melancholy malicious, and her most study shall be to be ill-conditioned;[10] she will mump,[11] hang the Lip, swell like a Toad that hath lain a year under a woodpile, pout, lower, be sullen, sad, and dogged; she will knit the brows, frown, be wayward, froward, cross, and untoward on purpose to torment her husband. Her delight is chiefly to make debate abroad and to be unquiet at home. In her house she will be waspish,

8. With great fondness for liquor.
9. An implement used in spinning wool.
10. Of an evil disposition.
11. Mumble, mutter.

peevish, testy, tetchy, and snappish.[12] It is meat and drink to her to exercise her spleen and envy, and with her twittle-twattle[13] to sow strife, debate, contention, division, and discordant heartburning amongst her neighbors. I have heard a husband ask a wife such a mild question, and she hath snapped him up so disdainfully with an answer, that no Mistress would have used her apprentice boy so scornfully. The pride of such a Jade[14] is not to be endured; her crossness is to be jeered at and her contempt to be derided. And such of them are most to be despised that do make a seeming show of Religion and a good life abroad, and when they are at home at dinner or supper, whilst the Husband is saying Grace sitting on one stool, his virtuous, vexatious wife hath sat upon another stool by him, cursing and swearing. Therefore I advise all men—young and old, rich and poor—to marry any woman of any bad condition rather than a scold.

[After an anecdotal account of one man's futile efforts to tame his shrewish wife, the author promises that "now again I will treat a little of some few good women."]

12. A Lecture of a woman to her husband in the morning as soon as he awakes, for a ramble overnight.

[Irritated at her husband for staying out late the previous night, the woman scolds him for showing "no measure, no reason, no government" in his drinking. She attests that the meat she had prepared for his supper "stood flopping before the fire till it was hard and dried to nothing." Unlike the women in the earlier lectures, this speaker, although she is disturbed, does not curse her husband or accuse him of all manner of evil.]

13. A Lecture of a kind and loving Wife to her Husband.

["Sweet Husband, I am sorry to see you are so vainly given to drinking," begins this patient woman, who proceeds to present four reasons why he should relinquish his habitual carousing. First, she points out, it wastes time. Second, it wastes money. Third, excessive drinking is unhealthy: "The best of the wine doth disperse itself through little veins into all the parts of the body for its nourishment; then the re-

12. Marked by sharpness of speech.
13. Idle talk, tittle-tattle.
14. A scolding or saucy woman.

mainder of those dregs and grounds which are left behind in the stomach causes Vapors[15] to fly up into your brain, makes your head ache, and there injures the Pia mater and Dura mater,[16] and so stupifies your Pericranium[17] that all your vital parts and ventricles[18] are almost suffocated, and your life in hazard also." Here the wife digresses to expound the evils of tobacco, which may not only "burn you within," but also has the potential to interfere with male sexual performance. Finally, she tells her husband that he should forswear drinking because he has an excellent wife who understands woman's place: "You men are the Head and must govern us women; we must be guided by you in all things."

[After concluding this lecture, the author states that he had thought of writing a book about "the bad courses and misbehavior of such as go in the shapes of men," but that he relinquished his plan upon hearing that "there are divers women set their helping hands to publish such a Book themselves in their own praise, with an answer to this Book, called by the Name of *Sir Seldom Sober or the woman's sharp revenge*[19] against the author."

[Having devoted two lectures to virtuous women, Taylor now embarks upon a catalogue of evil and virtuous women from history and myth. He occasionally interrupts the lengthy list with a general comment: "Though all women be womenkind, all are not kind women." He concludes by advising any man married to a shrew to respond to her scolding with calm silence.]

A strange familiar daily and hourly Lecture,
most rare and ordinary, very easy and extremely hard to be
understood,
pronounced by an Ancient Grand Gossip[20]
over a Cup of Sack and Strong Waters

Mistress Jane Twittle, Mrs. Cicely Twattle, Mrs. Dorothy Smallworth, Mistress Fewwords, and Mistress Manybetter went all ashriv-

15. Exhalation rising by natural causes from a damp place.
16. The pia mater and dura mater are membranes that cover the brain and spinal cord.
17. The membrane enveloping the skull—loosely, the brain.
18. Small cavities within the body that serve as places of organic function.
19. The treatise which follows, by Mary Tattlewell and Joan Hit-him-home.
20. A woman who delights in idle talk.

ing[21] on a good Friday to old Mistress Littlegood's where, after the expense of half an hour's time in impertinent and unnecessary courtesies, howdies, and welcomes, the young Woman having brought a fat Capon and Conies[22] with a Gallon of Canary in Bottles, they all sat down; where after a while that the Jack,[23] the Spit, and the Cups had gone round, they began to talk of many things whereof they had nothing to do. But the old Mistress of the House prayed them to be merry and wise, and that Pitchers had ears, and therefore, to avoid danger, she entreated them to clamor[24] their tongues and to have a care to speak no more than they said. And with that, good Creature, she called for her Hum Bottle[25] and kindly drank to them, desiring that it might go about, saying it was the spirit of horehound[26] and a rare preservative to drive away Melancholy. That Bout being past, they began to change their discourse, as the inspiration of good drink and the Volubility of their tongues gave them utterance. Some talked of their husbands; some prated of the fashions; some backbit their Neighbors; some commended the Sack; some extolled the Hum Bottle; and all drank round still. "Well, well," said Mistress Twattle, "all this Corn shakes no Wind,[27] nor doth any of our Husbands know what great pains we poor women take." With that word *Husband*, old Mistress Littlegood began to start, saying, "In good time be it spoken, I have not been troubled these thirty-two years with so grievous a burden as a Husband. I tell you, loving Daughters, I am threescore and fifteen Winters old at the next Grass or Hock-monday,[28] and before I was forty I had buried four. I remember the first was a Tailor,[29] as honest a man of a Protestant as need to be and as true a man of his Trade as ever broke Bread; and indeed Bread was his Bane, for he was choked with eating fourteen Pennyworth of hot buns upon a Good Friday morning. His death was very grievous to me, for he was a man of fair behavior,

21. To confess and be absolved.
22. Rabbits.
23. A vessel of waxed leather coated with tar, used to hold liquor.
24. Silence.
25. A bottle containing strong or double ale.
26. An herb whose bitter juice was used as a remedy for coughs.
27. Perhaps because she has drunk too much, Mistress Twattle misquotes the familiar proverb of the day, "All this wind shakes no corn."
28. "Grass" refers to the season of spring; Hock Monday was the second Monday after Easter.
29. With a pun on Taylor.

and his credit was so good everywhere that he might have been trusted with untold Millstones.[30] He got more by half by his Shears than by his Needle, for he was a large Cutter; his Bodkin[31] was one of his Military Weapons, but for his Yard it was somewhat scant and very short of London measure.

"I had not been a Widow above five days, but a Shoemaker would needs know the length of my foot. I remember he came to me upon a Monday, persuading me it was one of St. Hugh's Holy days,[32] by whose Bones, with the aid of St. Crispin,[33] he swore he would have me. And, alas, I being a weak woman, seeing his boldness, I had no power to hold out. So the next day we got a License and were married; but to see what a sudden alteration was befallen me, I think a Woman could never have chanced upon two husbands of such different qualities. For as the Tailor was addicted to Bread, the Shoemaker was altogether for Drink; the one was a pint of small Beer and threepenny loaves, and the other was a dozen Pots and a Halfpenny crust. Indeed I think he got our House rent and part of our bread by stretching and gnawing his Leather with his teeth, but for his drink he could hardly bring both ends together at the year's end. Truly he was a very proper man but for his face, and for the King of Goodfellows, he was worth his weight in burnt Silk; but within two years Death came upon him, and with a *Habeas Corpus* brought him from his All to his Last.[34] But before he died he was as lean as any Rake, for he was a small eater, and you know that all drink (or swill and wash) and no Grains will never fatten a Hog. He being laid fast in his Grave, I was almost a fortnight before I could perceive any wooer or Lovestruck suitor to make towards me. I mused and grieved at such a neglect at that time, for (I tell you, Daughters) I then thought myself as fine as the proudest, and I am sure

30. Since millstones have little value, we can assume that Mistress Littlegood's statement about her former husband's excellent credit rating is sarcastic.

31. A sharp instrument used to pierce holes in cloth; at this time the word could also refer to a dagger. Although this passage is clearly meant to suggest that the tailor was less than totally honest, it may be a sexual pun, since "yard" was a very common term for the penis.

32. The holy day of one of the many Saint Hughs. The author may intend ironic reference to Saint Hugh of Grenoble, a bishop who guarded his eyes so carefully that he could not recognize any woman by sight.

33. Patron saint of shoemakers.

34. From all things of this life to his last days (with puns on *awl*, the tool used by the shoemaker to pierce holes in leather, and *last*, the wooden model of the foot on which he shaped shoes).

I was as proud as the finest, and esteemed my penny to be as good Silver as the best of them. At the fortnight's end of my second Widowhood, to drive away grief I would sometimes see a Play and hear a Bearbaiting,[35] whereas a handsome formal Bearded man made me room to sit down by him; and he took such good notice of my Civility in laughing at the sport that indeed Love struck him to the heart with the glances of mine eyes in such sort as within short space we met at a Tavern, where with a Contract we made ourselves as sure as Sack and Sugar could tie us. In a word, the Marriage was ended, and Giblets were joined[36]—as we thought, to both our contents. But all is not Gold that glistens, and oftentimes a fair morning doth usher a foul day." [When her marriage to the merchant was only six months old, he suffered financial reverses which caused him to serve a six months' sentence in debtor's prison. Released from prison, he made a living by using his expert knowledge of penal statutes to threaten lawbreakers with exposure unless they paid him to keep silent. Eventually his practice of blackmail was found out, and for punishment "he was mounted on a Market day on the Pillory and . . . his faults written in his Forehead." Soon after his public humiliation, the merchant died from a "pocky[37] blow with a French Cowlstaff."[38]]

"He, being Dead, was much bemoaned, for indeed he did as much good here whilst he lived and was as necessary a member as the fifth Wheel in a Coach. It was my Fortune within one month to marry with one Achitophel Littlegood, in which match we were both cozened, for he took me for a rich Widow, and I was in great hope that his Bags were lined with Gold and Silver Rubbish. But it fell out otherways, for he was as poor as any boasting Knave need to be, for he owed for the very Clothes that he wore; and so we two, being both in one case, had most plentiful store of hunger and ease. And yet though he had neither means or Trade, he was so diligent to look out that he would make hard shift to be drunk almost every night; and then when he came home, he would most familiarly and lovingly kick me, calling me "Whore" and many other pretty Surnames. And sometimes he would play with my hair, winding it about his fist and kindly draw me by it all about the house, and withal sometimes he would embrace me in

35. The sport of setting dogs to attack a bear chained to a stake.
36. We were married ("ended" here means "carried through").
37. A coarse expression of dislike.
38. A stout stick used to carry burdens.

great affection (out of his own good Nature) with a Wand, a Cudgel, or a Rope's end. I, being as then not very old, began to take these kindnesses to heart, and to requite him I would walk as well as he and stay abroad as late; insomuch that for my better maintenance I Traded so well and had such good comings in that I made him wear an invisible Cuckoo's Feather in his Cap, and if occasion had been he could have made Hay with his head as well as with a Pitchfork.[39] And I would raise my voice to him in the chiding vein, that all the house and street would have rung of it, for I had a very shrill high voice and I would talk on purpose to no purpose but to vex him (for women are not bound to speak sense to senseless fools, nor Reason to unreasonable drunken Beasts). Our best knowledge, for the most part, is not to be understood in anything that we mean, say, or do; and yet I understand this much, that a Crowing Hen is better than a Craven Cock. And truly if I could have found out but where any good behavior was to be had in England, I would have had my Husband bound to it as strongly as the Devil mended his Breeches when he sewed them with a Bellrope. He had a Wife and two Children before he married me, but (as I heard say) he was a better Husband then to them than to me; for as his house was on fire once, he was so careful that all should not be burnt that he cast his Wife and Children into a Well, saying he would save somewhat. Indeed he was a Melancholy, merry, sad, malapert[40] conditioned fellow, and I loved him so dearly that it struck him inwardly with such joy that he died of the Pip.[41] And I hearing that a Projector[42] was about to get a Monopoly to have all the Goods and possessions of all such Widows who died with grief for their Husband's decease, I thought it the safest way to deceive the Projector not so much to grieve or shed a tear. And for his sake I vowed never to be married again. And so, good neighbors and Gossips, I drink to you all, and you are welcome all."

The Author's advice how to tame a shrew

[If she scolds, "rather seem to slight her, by doing some action or other, as singing, dancing, whistling, or clapping thy hands on thy

39. Using the proverbial horns of the cuckold.
40. Presumptuous, impudent.
41. Applied vaguely (often humorously) to various diseases in human beings.
42. Projectors were middlemen between the business community and the court who, to advance business ventures that needed protection by monopoly, bribed courtiers to

sides, for this will make her vex extremely, because you give her not word for word." Do not attempt to avoid her scolding by leaving; it will simply be worse when you return. If all else fails, buy a drum and lock it up; when she scolds, "do then begin to beat aloud, which she, hearing, will presently be amazed, hearing a louder voice than her own." The advice concludes with some brief "catches"[43] that may be sung by the man married to a shrew. Finally, the *Juniper Lecture* closes with ten bawdy and cynical epigrams about women.]

use their influence to obtain a royal charter. Taylor is here ridiculing the abuses sometimes created by this system.

43. Musical compositions for three or more voices.

The womens sharpe revenge:

Or an answer to Sir *Seldome Sober* that writ those railing Pamphelets called the *Iuniper* and *Crab-tree* Lectures, *&c.*

Being a found Reply and a full confutation of those *Bookes*: with an *Apology* in this case for the defence of us women.

Performed by Mary Tattle-well, *and* Ioane Hit-him-home, Spinsters.

Imprinted at *London* by I. O. and are to be sold by Ia. *Becket* at his shop in the inner Temple-gate.
1640.

§. *The women's sharp revenge*
Or an answer to Sir Seldom Sober
that writ those railing Pamphlets called
the *Juniper* and *Crabtree Lectures*, etc.
Being a sound Reply and a full confutation
of those Books, with an Apology
in this case for the defense of us women.
Performed by Mary Tattlewell and
Joan Hit-him-home, Spinsters[1]
1640

The Epistle of the Female Frailty
to the Male Gender[2] in General

[In this epistle Tattlewell addresses the masculine reader with back-handed praise: "*Affable* we call thee because so apt . . . to prattle with us; . . . *Kind,* that you will not meet us without Congees,[3] not part from us without Kisses; and *Courteous* because so willing to bring yourselves upon your knees before us." The reader is urged to acknowledge honestly his habitual pursuit of women: "Which of you hath not met us coming, followed us flying, . . . waited on us walking, and ambushed us lying?" Although men relentlessly court women, they have failed to defend them against Sir Seldom Sober:[4] "Yet suffer you us to be reviled and railed at, taunted and even terrified, under-valued and even vilified, when among you all we cannot find one Champion to oppose so obstinate a Challenger." Since men refuse to actively oppose Sir Seldom Sober, Tattlewell entreats them to become

1. Although this term may denote the women's occupation, it is more likely to be a reference to their marital status. In the seventeenth century, "spinster" was appended to a name as the proper legal designation of an unmarried woman, without necessarily carrying any derogatory connotations.

2. Spelled "Mal-Gender" by Tattlewell to suggest through a pun the "badness" of men (*mal-* as a prefix has the force of "bad" or "evil").

3. Ceremonious bowings.

4. This insulting epithet for John Taylor may have been chosen because so many husbands in *A Juniper Lecture* are scolded by their wives for drunkenness.

"competent judges to censure indifferently[5] between the Accuser and the Accused." If men judge in women's favor, then they are wished "if Bachelors, beautiful mistresses;[6] if husbands, handsome wives and good housewives; if widowers, wise and wealthy widows." The epistle is signed "Mary Tattlewell, Joan Hit-him-Home, Spinsters."

[In a second epistle "to the Reader," Long Meg of Westminster[7] rises from her grave to defend women in rhyming couplets. After expressing shock that "any one who was a mother's son / Should thus affront our sex," she urges Sir Seldom Sober to "confess thine error, fall upon thy knees, / From us to beg thy pardon by degrees." She reminds him of the extraordinary military feats she performed against the French in the service of King Henry, and threatens to turn this prowess against him if he fails to rectify the wrong he has done to women.]

The women's sharp Revenge
or An Answer to Sir Seldom Sober
that writ those scandalous Pamphlets
called the *Juniper* and *Crabtree Lectures*

As from several causes proceed sundry effects, so from several actions arise sundry honors with the addition of Names and Titles annexed unto them. Neither need we stand to prove that by argument which we find by daily experience, as for example, some are raised for their wealth, others for their worth; some by the Law, others by their learning; some by Martial Discipline, and (by your favor, too) others for malicious detraction, as thinking to rise by others' ruins and by supplanting others to support themselves. In which number we must rank you, Master Satirist, the passionate Author of those most pitiful pamphlets called the *Juniper Lectures* and *Crabtree Lectures*, who by your mere Knavery, ambitious to purchase Knighthood and to add a sir-reverence to your name, are now arrived to the height of your Aim and from plain Seldom Sober are now come to the Title of Sir Seldom

5. Judge impartially.
6. Sweethearts, girlfriends.
7. Long Meg was a serving maid in the reign of Henry VIII, infamous as a scold and possibly a procuress, whose escapades were described in ballads and pamphlets for a century. However, a popular semifictional biography (*The Life of Long Meg of Westminster*, first printed in 1582) presented her as an essentially good-hearted and generous person as well as a valiant heroine in the wars against the French at the Battle of Boulogne (1544), so her designation here as women's champion need not be ironic.

Sober, who we term so for he is ashamed to set his name to books, a Name fitting his Nature and well complying with his condition.[8]

And as there have been formerly by your means, Sir Seldom Sober, many railing, bitter, invective Pasquils[9] and Scurrilous Libels, some written, some printed, and all dispersed and scattered abroad, all of them made and forged on purpose to calumniate, revile, despise, jeer, and flout women. And now lately one or two of the sons of Ignorance[10] have penned three several, sweet, filthy, fine, ill-favored Pamphlets, which are Printed, and (out of the most deep shallowness of the Author's abundant want of Wisdom) they are called "Lectures," as the *Juniper Lecture*, the *Crabtree Lecture*, and the *Wormwood Lecture*, wherein they have laid most false aspersions upon all women generally. Some they have taxed with incontinence, some with incivility, some with scolding, some with drinking, some with backbiting and slandering their neighbors, some with a continual delight in lying, some with an extraordinary desire of perpetual gossiping. In a word, we are each of us accused and blazed to be addicted and frequently delighted with one grievous enormity or other; wherein, although it be true that we are all the daughters of Eve in frailty, yet they might have remembered that they likewise are all the sons of Adam in failing, falling, and offending.

We are not so partial in the defense of all Women's virtues that we thereby do hold none to be vicious. Some are incontinent by Nature or inheritance from their Mothers; some through extreme want and poverty have been forced to make more bold with that which is their own than to beg, steal, or borrow from others. Some (by the harsh usage of their too unkind husbands) have been driven to their shifts hardly; some, having had the hard fortune to match with such Coxcombs as were jealous without a cause, have by their suspicious, dogged, and crabbed dealing towards their wives given too often and too much cause to make their jealousy true. And whereas a Woman's reputation is so poor that if it be so much as suspected, it will be long before the

8. Taylor was known as the "Water Poet," probably for two reasons: he had worked as a waterman on the Thames, and he published a series of pamphlets describing his trips about England by water. The "condition" that fits his name is presumably drunkenness.

9. Circulated or published lampoons.

10. At this time, the "lecture" form was a popular mode of satire, particularly against women; although Tattlewell singles out Taylor for attack, the pamphlet is intended as a broadside against all writers of such "lectures."

suspicion will be cleared, but if it be once blemished or tainted, the stains and spots are of such a tincture that the dye of the blemishes will stick to her all her lifetime and to her Children after her. But for the man, he takes or assumes to himself such a loose liberty, or liberty of licentious looseness, that though he be (as they call it) a Common Town Bull or a runner at sheep,[11] though he pass the censures of spiritual courses or high Commissions,[12] yet (by custom) his disgrace will be quickly worn out, and say it was but a trick of youth. For the shame or scandal of a whoremonger is like a nine days' wonder, or a Record written in sand, or like a suit of Tiffany or Cobweb Lawn[13] soon worn out, but the faults of a weak woman are an alarm against her. They are engraved in brass, and like a suit of Buff,[14] it may be turned, and scoured, and scraped, and made a little cleanly, but it lasts the whole lifetime of the wearer.

[The authors announce that they have selected a jury of "twelve good women and true" to bring Sober's "lying lectures" to trial.] And yet further to make the cause more plain and evident of our sides, we thought it good in our better consideration not only to publish unto the world the calumnies and slanders aspersed upon us, but our just Articles objected against him, and by comparing them together to distinguish so betwixt them that the truth may grow apparent.

But first touching the person who put these foul and calumnious aspersions upon us: if he were a Tailor,[15] most sure he was [not][16] a woman's Tailor, or (if so) no good Artist, because not being able to take the measure of a woman's body, much less was he powerful to make a true dimension of her mind (and therein you are gone,[17] Master Taylor). Nay, what Artist soever you were (for in one I include all), most of you have Wives and Children, and love them and are indulgent over them, and wherefore then do you encourage such invectives against us? If you being of yourselves lewd, we be loving; we well tutored, you untoward; we familiar, you froward; we doting, and you dogged. And what we get by spinning in the day, you spend in the night

11. A sexual pursuer of women (in tilting, "to run at" was to charge the mark with a lance or spear).

12. Ecclesiastical courts which imposed punishments for sexual offenses.

13. Very thin, delicate fabrics.

14. Leather.

15. With a pun on the author's name.

16. Omitted in the original text.

17. Undone.

and come reeling from the Tavern or the Alehouse. Is the fault ours, or are we worthy any to be blamed for this?

Next in our Curious Inquisition and search, we find him moreover to be no scholar at all, as neither understanding us in our Gender, Number, nor Case, etc.

Not in one Gender, for in all the Creatures that were ever made, there is a mutual love and an alternate[18] affection betwixt the Male and the Female, for otherwise there would be no Generation at all. But this most approved consociety[19] by all his industry and endeavor he striveth to annihilate and annul, forgetting that even he himself by the same Unity and Unanimity had his first original and beginning.

Then he faileth in Number, by making all of us in general not only to be wayward, but wicked; tedious, but troublesome; lazy, but loathsome, with many of the like enormities. And indeed we know not what his inveterate malice or madness would stretch unto when, if perchance there may be found a singular Number of such delinquents, yet there may be a plural (and that stretcheth beyond all limit and account) who never transgressed or fell into those gross errors of which he so Satirically accuseth our Sex.

But in our Cases he is most horrible out and directly opposeth all the Rules of Grammar. For instance:

In the Nominative,[20] by calling us out of our Names, and in the stead of Maidenly Modest, Matronlike, etc. to brand us with the Characters of scolds, vixens, praters, prattlers, and all the abusive Epithets that spleen or malice can invent or devise.

In the Genitive, by making us to be loose, lascivious, wanton, willful, inconstant, incontinent, and the Mothers of misbegotten Children, by which he unadvisedly bringeth himself within the doubtful suspicion of spuriousness and Bastardy.

In the Dative, by giving and conferring upon our general Sex such strange and almost unheard of aspersions (which as we have little desired, so we never deserved), forgetting that he includeth his Mother, Sisters, and Nieces, Daughters, nay his own bosom wife (if he have any) in the same Catalogue.

In the Accusative, by false calumnies and unjust Accusation con-

18. Reciprocal.
19. Union.
20. In the following passage Tattlewell creates a series of puns on these terms, contrasting their specific grammatical reference with the root meanings of the words: nomi-

trary to all Scholarship, as ignorant that "femineo generi tribuuntur Propria quae maribus."[21]

In the Vocative, because it is like to the nominative.

In the Ablative, because he striveth to take away our credits, reputations, Fame, good Name, etc. All which argue and approve that he was in a bad Mood and worse Tense[22] at the Writing of those malicious Lectures.

A Poet sure he could not be, for not one of them but with all his industry strived to celebrate the praises of some Mistress or other: as for example, Amongst the Greeks, Aristophanes, Menander,[23] etc. Amongst the Romans, Catullus his Lesbia, Gallus his Lycoris, and Ovid his Corinna.[24] Amongst the Spaniards, Jorge de Montemayor his Diana and Ausias March his Teresa.[25] Amongst the Italians, Petrarch his Laura,[26] etc. And of our own Nation, Learned Master Spenser his Rosalind and Samuel Daniel his Delia,[27] etc.

Now to make the case more plain and evident of our sides, we have thought it good to publish unto the World those matters of which he was arraigned and now justly convicted. The first was scoffing and taunting at our Sex in general. Now who knows not but that Quips and Scoffs are nothing else but the depraving of the Actions of others, the overflowing of wits, and the superfluous scums of conceit,[28] and for the most part, asking others of those errors of which themselves stand

native, "to name"; genitive, "to generate or give birth"; dative, "to give"; accusative, "to accuse"; vocative, "to call"; ablative, "to take away."

21. "Qualities which are proper to men are assigned to the feminine gender." This may be a quote from a Latin grammar, referring to the fact that many Latin abstract nouns are feminine in gender despite their designation of masculine qualities (as *virtus*, "manliness"). Tattlewell, however, humorously takes the sentence literally.

22. Another pun on the root meanings of grammatical terms.

23. Aristophanes was an ancient Greek writer of Old Comedy; Menander was a Hellenistic Greek writer of New Comedy. Neither celebrated a particular mistress, although romance was an important motive in Menander's comedy.

24. These were love poets of ancient Rome, celebrating mistresses under the pseudonyms mentioned.

25. Jorge de Montemayor is best known for his pastoral romance *Diana*; Ausias March celebrated the virtues of Teresa in *Cants d'amor*.

26. Francesco Petrarca praised the beautiful and virtuous Laura in his influential collection of lyric poems entitled *Rime*.

27. Rosalind is the beautiful woman who rejects the shepherd and poet Colin Clout in Edmund Spenser's series of pastoral eclogues *The Shepheardes Calender; Delia* is the title of Samuel Daniel's sonnet sequence.

28. Imagination.

most guilty; and he that playeth the scoffing fool best, though it may be in him a sign of some wit, yet it is an argument of no wisdom at all. Adders keep their venom in their tails, but the poison of a Buffoon lieth in his tongue, and faults willfully committed by mocking cannot be satisfied or recompensed by repentance. But better it is for a man to be born foolish than to employ his wit unwisely; for mockery is nothing else but an Artificial injury,[29] and we find by proof that there be more mockers than well meaners and more that delight in foolish prating than that practice themselves in wholesome precepts. We must confess that to jest is tolerable, but to do harm by jesting is insufferable; for it is too late to prevent ill after ill committed, or to amend wrong after injury received. Many things that are sweet in the Mouth may prove bitter in the stomach, and scoffs pleasant to the ear may be harsh to the better understanding.

[Sir Seldom Sober's mocking of women is a sign of "his own insufficiency and folly," one that renders him ridiculous. In addition to mocking, he is also accused and convicted of "detraction and slander" for his "scandalous and reproachful speeches" against women. The slanderer feels hatred for himself as well as for the person he slanders. In fact, he may be said "to murder three at once: first, himself; next, him that gives ear to his scandals and reports them after him; and lastly, him whose good name he seeketh to take away." The third charge against Sir Seldom Sober is lying, for he has "branded us with many a false and palpable untruth." Fourth, he is arraigned for "heresy and false opinion," a serious offense which is the "Spring and Fountain of sedition." Finally, he is accused of perjury for failing to fulfill his marriage vow to his wife "to have and to hold, for better and worse." He has abused his wife by attacking the female sex in general.]

Say that she was given to gadding and gossiping, to reveling or rioting (so that he might very well sing, "I cannot keep my wife at home") or say that, not without just cause, she might make him jealous: what is this to the generality of the Female Gender? One Swallow makes not a Summer, nor for the delinquency of one are all to be delivered up to censure. As there was a Lais, so there was a Lucretia; and a wise Cornelia, as there was a wanton Corinna.[30] And the same Sex that hath bred Malefactors hath brought forth Martyrs.

29. Injury inflicted through artifice.

30. Lais was an ancient Greek courtesan infamous for the high fees she charged for her services; Lucretia, on the other hand, was a legendary Roman wife who prized her

And this is an argument which we might amplify even from the Original[31] of all History, nay, and would not spare to do it, had we but the benefit of your breeding.

But it hath been the policy of all parents, even from the beginning, to curb us of that benefit by striving to keep us under and to make us men's mere Vassals even unto all posterity. How else comes it to pass that when a Father hath a numerous issue of Sons and Daughters, the sons forsooth they must be first put to the Grammar school, and after perchance sent to the University, and trained up in the Liberal Arts and Sciences, and there (if they prove not Blockheads) they may in time be book-learned? And what do they then? Read the Poets perhaps, out of which, if they can pick out anything maliciously devised or malignantly divulged by some mad Muse discontented with his coy or disdainful Mistress, then in imitation of them he must devise some passionate Elegy and pitiful "ah-me!" And in the stead of picking out the best Poets, who have strived to right us, follow the other, who do nothing but rail at us, thinking he hath done his Mistress praise, when it may be he hath no Mistress at all but only feigns to himself some counterfeit Phyllis or Amaryllis,[32] such as had never any person but a mere airy name. And against them he must volley out his vain Enthusiasms and Raptures to the disgrace and prejudice of our whole Sex.

When we, whom they style by the name of weaker Vessels, though of a more delicate, fine, soft, and more pliant flesh and therefore of a temper most capable of the best Impression, have not that generous and liberal Education, lest we should be made able to vindicate our own injuries, we are set only to the Needle, to prick our fingers, or else to the Wheel to spin a fair thread for our own undoing, or perchance to some more dirty and debased drudgery. If we be taught to read, they then confine us within the compass of our Mother Tongue, and that limit we are not suffered to pass; or if (which sometimes happeneth) we be brought up to Music, to singing, and to dancing, it is not for any benefit that thereby we can engross[33] unto ourselves, but

chastity so highly that she committed suicide after she was raped. Cornelia was the mother of the Roman political reformers Tiberius and Gaius Gracchus, famous for her learning, integrity, and virtue, while Corinna was the fickle and capricious mistress to whom Ovid addressed many of his love poems.

31. Beginning.

32. Conventional female names frequently employed in pastorals and love lyrics.

33. Take.

for their own particular ends, the better to please and content their licentious appetites when we come to our maturity and ripeness. And thus if we be weak by Nature, they strive to make us more weak by our Nurture; and if in degree of place low, they strive by their policy to keep us more under.

Now to show we are no such despised matter as you would seem to make us, come to our first Creation, when man was made of the mere dust of the earth. The woman had her being from the best part of his body, the Rib next to his heart, which difference even in our complexions may be easily decided. Man is of a dull, earthy, and melancholy aspect, having shallows[34] in his face and a very forest upon his Chin, when our soft and smooth Cheeks are a true representation of a delectable garden of intermixed Roses and Lilies.

[Women do have faults, but men are subject to the same vices. In fact, scholars have stated that a pure and beautiful woman is "the perfect image of her Creator, the true glory of Angels, the rare miracle of Earth; . . . the man who is married to a peaceable and virtuous wife, being on earth hath attained Heaven." Although Sir Seldom Sober considers women contemptible, ancient and modern poets have addressed to them "Odes, Hymns, Love songs, and Laudatories."[35]

[Some men who write attacks on women are bitter because virtuous women have refused their seduction attempts; others have simply had the misfortune "to light upon a bad match, a Shrew, a Wanton, or the like." If women were as bad as they are depicted in these attacks, "how comes this seeking, this suing, this Courting, this cogging,[36] this prating, this protesting, this vowing, this swearing, but only to compass a smile, a kind look, a favor, or a good word from one of us?" Surely men are not so foolish as to seek their own destruction.

[History serves to vindicate the character of women. No woman ever plotted "a devilish and damned Stratagem" like the Gunpowder treason plot, yet in honorable wars women have always been courageous—unlike men, who have often shown cowardice. When women lie, it is only to conceal their husbands' faults. Although women are often accused of uncivilized behavior, it is men who "swear, blas-

34. Shallow depressions in the earth (here, in the face). The linking of men's appearance with earth was hardly complimentary, since earth was considered the most lowly of the four elements.
35. Poetry or prose following certain conventions of praise.
36. Deceiving.

pheme, quarrel, be drunk, game, Roar, Whore, murder, steal, cheat."]

If women be proud (or addicted to pride), it is ten to one to be laid that it is the men that makes them so; for, like enchanters, they do never leave or cease to bewitch and charm poor women with their flatteries, persuading us that our beauty is incomparable; our complexion of white and red like Strawberries and Cream; our cheeks like damask Roses covered with a veil of Lawn; our lips are Coral; our teeth Ivory; our hairs Gold; our eyes Crystal or Suns or Lodestars or Love's Darts; our glances Lances; our voices, our breaths perfumed Music; our virtues Immortal; and our whole frame, feature, and composure Celestial.

When I was a young maid of the age of fifteen, there came to me in the wooing way very many of those Flyblown Puffpaste Suitors.[37] Amongst the rest, one of them was as brave[38] a Gentleman as any Tailor could make him. He underwent the noble Title of a Captain, and if I had made trial of him, I doubt not but I might have found him a most desperate Chamber Champion, for he did scent of the Muskcat instead of the Musket. He was an Ambergris[39] gallant that once was a valiant Tilting Rushbreaker[40] at the marriage of the Lady Josinqua, daughter to the Duke of Calabria. Verily he was a dainty perfumed carpet Captain,[41] a powdered Potentate, a painted Periwig frizzled, frounced,[42] Geometrical[43] curious Glass-gazer,[44] a combed, curled, and curried Commander, a resolute professed chaser or hunter of fashions, and a most stiff, printed,[45] bristled, beard-starcher.

This Captain Compliment with his page Implement laid hard siege to the weak Fortress of my frail Carcass. He would swear that his life or death were either in my accepting or rejecting his suit. He would lie and flatter in prose, and cog and foist[46] in verse most shamefully. He

37. Impure and characterless suitors.
38. Finely and showily dressed.
39. An odoriferous secretion in the intestines of the sperm whale used in perfumes.
40. Green rushes were strewn on the floor for special occasions; hence, a "Tilting Rush-breaker" may be a dancer so aggressive as to break the rushes (as opposed to a proper knight who jousts, or "tilts," at tournaments).
41. A contemptuous term for a captain who was more active in a lady's carpeted bedroom than on the battlefield.
42. Curled.
43. Wearing stiff, angular clothes.
44. One who spends much time before a mirror.
45. Wearing a ruff with the pleats pressed.
46. Cheat.

would sometimes salute me with most delicious Sentences, which he always kept in syrup, and he never came to me empty mouthed or handed, for he was never unprovided of stewed Anagrams, baked Epigrams, soused Madrigals, pickled Rondelets, broiled Sonnets, parboiled Elegies,[47] perfumed poesies for Rings, and a thousand other such foolish flatteries and knavish devices which I suspected. And the more he strived to overcome me with Oaths, promises, and protestations, still the less I believed him; so that at last he grew faint at the Siege, gave over to make any more Assaults, and vanquished with despair, made a final Retreat. In like manner I wish all women and maids in general to beware of their gilded Glosses;[48] an enamored Toad lurks under the sweet grass, and a fair tongue hath been too often the varnish or Embroidery of a false heart. What are they but lime twigs of Lust and Schoolmasters of Folly? Let not their foolish fancy prove to be your brainsick frenzy, for if you note them, in all their speech or writings you shall seldom or never have any word or syllable in the praise of goodness or true virtue to come from them. Their talk shall consist either of wealth, strength, wit, beauty, lands, fashions, Horses, Hawks, Hounds, and many other trivial and transitory toys which, as they may be used, are blessings of the left Hand[49] wherewith they entice and entrap poor silly,[50] young, tenderhearted Females to be enamored of their good parts (if they had any). But if men would lay by[51] their tricks, flights, falsehoods, and dissimulations and, contrarily, in their conversing with us use their tongues and pens in the praise of meekness, modesty, chastity, temperance, constancy, and piety, then surely women would strive to be such as their discourses did tend unto. For we do live in such an age of pollution that many a rich, wicked man will spend willingly and give more to corrupt and make spoil of the chastity and honor of one beautiful, untainted Virgin, than they will bestow in charity towards the saving of an hundred poor people from perishing by famine here or from perdition in a worser place. And because they say women will always lie, I do wish that (in this last point I touched upon) they would make or prove me a liar.

[History shows men to have been the "Authors of all mischiefs," for

47. These are all forms of poetry, mostly brief.
48. Deceptive appearances.
49. Blessings of this world as opposed to spiritual blessings.
50. Defenseless.
51. Lay aside.

they execute "vices and villainies which the weak hands or brains of women could never broach." Men have been traitors, extortionists, usurers, oppressors, and authors of "pestiferous Pamphlets, Emblems,[52] and Pictures of Scurrility and nasty obscenity."]

In one of their late, wise, ridiculous Lectures they do cast an aspersion upon us that we are mighty Gossips and exceeding Scolds. To the first, I Answer that the most part of our meetings at Gossipings are long of[53] the men rather than to be imputed to us. For when children are born into the world (although men feel none of the misery), yet women have a more known sympathy and feeling of one another's pains and perils, and therefore in Christianity and neighborly love and Charity women do meet to visit and comfort the weakness of such as in those dangerous times do want it. And whereas they say that we tipple and tittle-tattle more than our shares, I shall before this discourse is ended cast that Ball back again in their teeth and emblazon them truly to be most vain and idle talkers, and that no living thing Created is so sottish, senseless, brutish, and beastly as most of them have been and are daily, nightly, and hourly in their drink. For their much talk (to no purpose) doth show that there is a running issue or Fistula[54] in their minds.

Man might consider that women were not created to be their slaves or vassals; for as they had not their Original out of his head (thereby to command him), so it was not out of his foot to be trod upon, but in a *medium*[55] out of his side to be his fellow feeler, his equal, and companion.

[Like the Devil, who can be at the same time the "Prince of darkness and an Angel of Light," men are not what they seem. "Doctors of Deviltry," they deceive women with flattery, a pleasing appearance, and "mimic marmosetical[56] Gestures." Everything on earth except man "doth naturally incline to be in his proper place."[57] Stones sink down, fire rises, trees grow from the ground, birds fly in the air. "Only men are inconstant and seldom or never doth keep his constant course."

52. Pictures with mottos or brief verses that represent a moral truth allegorically.
53. Owing to.
54. A long, narrow ulcer.
55. Mid-point.
56. Apishly foolish.
57. It was believed at this time that every natural object occupied a divinely appointed place.

Animals are more virtuous than men: the lamb is meeker, the dog more faithful, the lion more magnanimous. They are also more moderate in their appetites: cows are satisfied with a meadow, horses with a field, fish with the sea. Men have taken the vices of animals (the ferocity of the lion, the obstinacy of the ox) rather than their virtues; furthermore, they have imported vices from every foreign nation: gluttony from Greece, wantonness from Italy, pride from Spain. Men reprehend women, yet history abounds with evil men. (Tattlewell lists a catalogue of evil men, beginning with the Roman emperor Nero and ending with two British villains: Macbeth and Richard III[58]). There are some men with intelligence and virtue, however, for "many of that noble Sex" detest writings which impugn women. The authors of the attacks on women are not true poets, but rather "mongrel Rhymesters"[59] and "most deadly enemies to the Muses."]

Although some few (and those few too many) women do profess goodness in Hypocrisy, yet that is not a General disparagement to such as are truly virtuous in sincerity. For if I may be so bold as to speak that which is Recorded in holy Writ, I shall prove presently out of the best Authors that ever lived that women have been, and are, and will be, must be, and shall be either men's betters or their equals or (at the least) not to be so much undervalued, as not to be abused, vilified and traduced by every idle and paltry Potcompanions.[60]

As for the first man, he was made of Earth, Clay (yea, of the very slime of the earth); also, he was created in the open wide field[61] (as all other the rest of earthly Creatures were). And being made, I must confess, he was perfect and full of perfection, yet doth his very Name demonstrate that he was of a mean and pure[62] substance, for the Word (or Name) *Adam* doth signify Clay or red earth. But when that earth and slime was purified and made perfect with being fully possessed with a Reasonable Soul, then man being in Paradise, a most pleasant and de-

58. In the seventeenth century, both Macbeth and Richard III were viewed as men driven by ambition to commit monstrous crimes. Macbeth, king of Scotland in the eleventh century, was thought to be a regicide and tyrant; Richard III, king of England for two years in the late fifteenth century, was thought to have murdered his two young nephews in order to secure his throne. Historians now take a more kindly view of both rulers.

59. Poets lacking ability and seriousness.

60. Companions in drinking.

61. The world before it became Paradise.

62. Unmixed.

lectable place, there in that choicest and principal Garden of delight (man being refined from his dross) was woman Created. There was she named *Eve* (or *Hevah*), which is as much as to say "Life," because she was the Mother of all men and women that should ever live or have living. She was made out of the side of the man near to his heart because he should heartily love her. And as all the rest of the Creatures were created before man to show that he was not brought into a bare and naked world (although himself was so), but it was Gloriously and Magnificently adorned and beautified with all things fitting for the entertainment of so glorious an Image (or Deputy to the Greatest). Yet in that great state he was alone without anyone to have a participation or joyful fellow sympathetic feeling of his felicity. Then did it please the Great Creator to Create the noble Creature Woman to be his Helper, associate, and companion. Therefore, I conclude that, as man was made of pollution, earth, and slime, and woman was formed out of that earth when it was first Refined, as man had his Original in the rude wide field and woman had her frame and composure[63] in Paradise, so much is the woman's Honor to be regarded and to be held in estimation amongst men.

To these few I could add infinite, but I study to avoid prolixity: only I desire of you, Sir Seldom Sober, and the rest of your most pitiful partisans, to be resolved in this one Question—How cometh the world to be thus peopled? And whence groweth this goodly Generation upon the earth, which from the first Creation hath continued to this present and shall last to all Posterity? We are not like these swift Spanish Genets[64] which, some write, engender only by the wind.

[The value of women to men is shown in the zeal with which men court and pursue them. Not only is Sir Seldom Sober guilty of slandering women, but his lectures are so stale that they "stink in our noses." Tattlewell then proceeds to mock (and in some cases attack the assumptions of) several of Taylor's lectures, beginning with the Lecture of a Mistress to her Apprentice.]

When the Mistress calls up her Apprentice, she saith if she be cross, she will make him leap at a Crust: as if Citizens kept such penurious Houses that they were ready upon the least occasion to starve their Servants. Nay, that she, taking her Husband's Authority out of his

63. The act of making.
64. Small Spanish horses.

hands, will beat her Boy the Rogue and baste the Kitchen maid who rules the Roast until she make their bones rattle in their skins; and when she hath gotten her will, then, "Rattle, Rattle, Baby, Rattle."[65]

Then in your Lecture of the Wife to her Husband, "Is the house a wildcat[66] to you?" And why a Wildcat, you tame fool, unless you study to set odds betwixt man and wife and to make them agree in a house like Dogs and Cats together?

Then comes in the Country Farmer's Wife with her couple of Capons, when all her she-neighbors dare take their Oaths that her Husband is a Cock of the Game.[67] Yet she must call him "Francis Frumenty-pot,"[68] "Barnard Bagpudding," or "Baconface," "William Woodcock," "Dirty Dotterel,"[69] or "Dunstable," "Harry Horsehead," "Simon Supbroth," "Ralph Roast-a-Crow," "Tom Turd" in thy teeth, and the most beastly and bastardly names merely of your own dirty devising, as knowing what belongs to yourselves, when we cannot find in our hearts to foul our mouths with any such filthy language.

But, sure, Sir Seldom (or never) Sober, your Father was some Jakes-farmer[70] and your Mother a Midwife, or he some Rakeshame[71] or Rag-gatherer[72] and she the daughter of a Dunghill, that their Son is forced to patch out his Poetry with such pitiful Proverbs.[73]

[Tattlewell threatens to use proverbial statements as weapons against Sir Seldom Sober (e.g., "Little said, soon amended"), boasting of the power to "anatomize you into Atoms[74] and dissect you into Diminutives, to make you less than nothing." Tattlewell offers him a truce if he recants; if he refuses, "we will make thy own pen thy Poniard; thy Ink thy baneful potion; thy paper thy winding-sheet."

[Wiser people than Sir Seldom Sober have exalted women by representing as females the four parts of the world (Asia, Africa, Europe,

65. Wag your tongue.
66. An ill-tempered or spiteful person, usually a woman.
67. A cock bred and trained for cockfighting; hence, a swaggering, amorous male ("game" was also a common term for lovemaking).
68. Frumenty was a kind of pudding.
69. A foolish person, a dupe.
70. A man employed to clean out privies.
71. An ill-behaved or dissolute person.
72. A shabby, beggarly person.
73. Common words or phrases of contempt.
74. Minute particles of a substance.

and America) as well as the nine Muses, the three Graces, the four car-
dinal virtues and the three theological virtues.[75] Having been thus cele-
brated throughout history, women refuse now to be judged by one
"censorious and supercilious cynic." They demand to be judged by
their peers, who include "Sovereigns and Subjects, Court, City, Camp,
and Country, . . . the Virgins, the Vestals, the Wives, the Widows, the
Country wench, the Countess, the Laundress, the Lady, the Maid-
Marion, the Matron, even from the Shepherdess to the Scepter." All
of these women stand ready to exonerate women and condemn the
Juniper Lecture. If any of the ancient Greek or Roman women poets
had survived, they would drive "this petulant Poet" to suicide with
"one of their invective iambics."[76]

[In response to the long list of prostitutes in the *Juniper Lecture,*
Tattlewell points out that for every whore "there must be Whore-
master to make her so." Helen[77] would no doubt have lived a chaste
life with Menelaus had not Paris seduced her, and the reason that Lais
charged a thousand drachmas a night was "the better to conserve her
Chastity."]

I will not meddle with your pitiful Poetry and rime Dotterel,[78] bor-
rowed out of Ballads—and yet why should I say "borrowed," when I
can Answer them in this one Distich:[79]

> Though borrowing now be into fashion grown,
> Yet I dare swear what thou writest was thy own.

For indeed I know not who else will Challenge[80] them.

In your Lecture of an old rich Widow to a young Gallant, where you
think to task her of her wit, what do you else but approve her wisdom
who will not suffer her modest Gravity to be fooled by his youthful

75. The three Graces of classical mythology were beautiful young virgins who at-
tended the goddess of love; the cardinal virtues, usually represented as women, were
prudence, courage, temperance, and justice, while the theological virtues were faith,
hope, and charity.

76. Lines written in the poetic meter especially associated with biting satire and lam-
poon in classical literature.

77. Queen of Sparta, Helen ran off with the Trojan prince Paris and thus caused the
Trojan War.

78. Foolish, stupid.

79. A rhyming couplet.

80. Lay claim to.

Prodigality? And so what you strive to condemn as a vice, in effect you crown for a virtue.

You make your Country Farmer's wife to call Wiseacre her Husband "Wittol,"[81] "Mopus"[82] and "Mooncalf"; "Hobbinoll" and "Hobnails";[83] "Lurdan" and "Looby";[84] "Francis Fillgut" and "Frumenty-pot"; "Booby" and "Blockhead"; "Dunce" and "Dotard"; "Bullbeef", "Barley pudding," "Sim Slabberchops" and the like; and like enough he may be all these, and she in this gives but the Devil his due and the Clownish Corydon[85] his own true Character. And what disparagement can this be to us? Or what great honor to you of the Male Sex that amongst men there can be found such a monster?

An answer to the Lecture of the jealous old Woman: can you blame the jealous woman for having such care over her Husband's health, purse, and Person? For what is jealousy but a too much indulgence and over-Love? And I fear ten at this time of twenty are not much troubled with it.

Your Lecture of your kind, loving wife to her Husband we allow, and none so shameless in their slanders but sometimes or other are constrained to tell truth and shame the Devil. And if you had only followed the same Theme, you might have escaped from being thus threatened; but many who have strived to make have marred, and in shunning Scylla have fallen into Charybdis.[86] And this our impudent Poet hath imitated such ignorant Pilots; where if he had the skill to steer his Vessel in the mild Channel, he might have arrived at an happy Harbor and so escaped that shame and shipwreck which his silliness hath made him to suffer.

[Tattlewell accuses Sir Seldom Sober of himself choosing the "dirty language" in the Lecture of the young Widow to an old Widower. He should have told instead a tale which made the two "equal sharers in their own simplicity"—for example, the story of the married widow and widower who each (to vex the other) give a poor man one half of

81. A man who tolerates his wife's adultery.
82. A dull, stupid person.
83. Contemptuous names for rustics.
84. Loafer and lout.
85. A conventional name given to a rustic in pastoral poetry.
86. In Homer's *Odyssey*, the hero Odysseus must sail between the whirlpool Charybdis and the man-devouring monster Scylla; thus the terms have come to refer to a narrow strait between two evils or dangers.

their dinner, asking him as they do so to pray for the souls of their respective deceased mates. Sir Seldom Sober's lectures are unrealistic as well as unfair, for they portray all women as shrews and all men as "simple and sottish."]

A word or two more concerning the virtue and Chastity of women: there was never any man could generally compare with women. To speak of the best and most blest, the one and only Virgin Mother, she that was at one time Maid, Mother, Wife, Child, and Sister to her Son, she that most happily was elected from all Eternity to be the blessed bringer forth of a Savior for all repenting and true believing sinners: she was so fully filled and replenished with grace that she is justly styled "blessed among women," and for a further proclaiming of her happiness, "All Generations shall call her Blessed."[87] She was the World's only wonder and most rare and sovereign mirror of Chastity. Many thousands more are mentioned for that only famous virtue of Continency in Divine and profane Histories, whose honorable and Venerable memories shall outlive time and flourish in Glorious Eternity. Besides, as there have been and are innumerable of our notable Sex that have lived and died Virgins, so likewise millions of them who have been married and after marriage became Widows, they have been so inclined to the love of chastity that they would never be won to accept of a second marriage. And for an inimitable example of a worthy Matron, it is Recorded that Anna the Prophetess was but seven years a married wife, but that after her Husband was dead, she lived a Widow fourscore and four years,[88] an example above any you men can show.

Moreover, women were so chaste that, though they did marry and were married, it was more for propagation of Children than for any carnal delight or pleasure they had to accompany with men. They were content to be joined in Matrimony with a greater desire of Children than of Husbands; they had more joy in being Mothers than in being Wives. For in the old Law[89] it was a curse upon Women to be Barren; and surely if there had been any lawful way for them to have had Children without Husbands, there hath been, and are, and will be a numberless number of Women that would or will never be troubled

87. The words of Elizabeth to Mary, as recorded in Luke 1:42, and of Mary herself in her hymn of praise (*Magnificat*, Luke 1:48).
88. Luke 2:36–37.
89. Old Testament.

with wedlock nor the knowledge of man. Thus good and modest Women have been content to have none or one man (at the most) all their whole lifetime, but men have been so addicted to incontinency that no bounds of Law or reason could restrain them. For if we read the Story of the Kings of Judah, there we may find the wisest that ever reigned, Solomon,[90] had no fewer than three hundred Wives and seven hundred Concubines, and that his Son Rehoboam had eighteen Wives and sixty Concubines by whom he begat twenty-eight Sons and three-score Daughters. There have been some good women that, when they could have no Children, they have been contented that their Husbands should make use of their Maidservants, as Sarah and Rachel and Leah[91] did. But I never heard or read of any man that, though he were old, diseased, decrepit, gouty, or many and every way defective and past ability to be the Father of any Child, hath been so loving to his wife as to suffer her to [be] made a Teeming[92] Mother by another man. There was once a Law in Sparta amongst the Lacedaemonians that if the husband were deficient for propagating or begetting of Children, that then it was lawful for the wife to entertain a friend or a Neighbor. But the women were so given to chastity that they seldom or never did put the said Law in practice, and I am persuaded that that Decree is quite abolished and out of use and force all the World over.

[Tattlewell cites numerous women from the Old and New Testaments who serve as exemplars of courage, piety and chastity.]

Thus have I truly and impartially proved that for Chastity, Charity, Constancy, Magnanimity, Valor, Wisdom, Piety, or any Grace or Virtue whatsoever, women have always been more than equal with men, and that for Luxury, Surquidant[93] obscenity, profanity, Ebriety, Impiety, and all that may be called bad we do come far short of them. Now we think it meet only to tell them a little of one fault which we are sure they do know already, and that our repetition of it will be no means to Reform it. Yet to show the World that Women have great cause to find fault and be discontented with their odious general vice of Drunkenness, we will relate unto you the delicate, dainty, Foppish,

90. Israel's third king, a lover of women and husband to many wives.
91. Sarah, Rachel, and Leah were Old Testament women who gave their hand-maidens to their husbands for the purpose of bearing children.
92. Pregnant.
93. Arrogant.

and ridiculous conceits[94] of Sir Seldom Sober, with the most foolish, idle, and sottish tricks and feats of his idle and addlepated followers.

94. Tricks, fanciful actions. *The women's sharp revenge* is divided into three parts. Only the first part, which contains the most cogent reply to *A Juniper Lecture* and can stand alone as a feminist treatise, is transcribed here. The second part is a series of rhetorical questions addressed to Sir Seldom Sober; all are designed to prove women superior to men, and most repeat ideas found in the first part. The last part opens with an attack on men for drunkenness and closes with several anecdotes illustrating the antics of drunken men. The fact that the prose style changes dramatically in the second part (becoming less witty and much less alliterative) suggests a shift of author after the first part.

Eulogies and Condemnations

MONODIA.

An Elegie, in commemoration of the
Vertuous life, and Godlie Death of the
right Worshipfull & most religious Lady, Dame
Hellen Branch *Widdowe , (late Wife to the right*
worshipfull Sir *Iohn Branch* knight, sometimes L. Mayor
of this Honorable Citty, and daughter of M. *W. Nichol-
son* sometimes of London Draper *)* who deceased the
10. of *Aprill* last, and lieth interred in Saint
Mary Abchurch in London, the 29.
of the same, 1 5 9 4.

Sith vnto me vnworthy, you commit
This worthy taske (for better muses fit)
To sing (nay rather sadlie to deplore)
This common losse, that nothing can restore :
You sacred brood, borne of celestiall race,
You virgin Ladies which powre down the grace
Of Arts and learning on your seruants deere,
Vouchsafe assistance to my moornings heer.
Teach me sad accents & a weeping measure
To straine foorth pittie, not to stir-vp pleasure.
 And you my priuate cares, (althogh the cause
Of your dispaires doo neuer, neuer pawse)
Pawse you a little, and giue leaue a-while,
Mid publike griefs my priuate to beguile;

A.2. Giue

§. *Monodia,*
An Elegy in commemoration of
the Virtuous life and Godly Death of
the right Worshipful and most religious Lady
Dame Helen Branch, Widow,
late Wife to the right worshipful Sir John Branch,
knight, sometimes Lord Mayor of this
Honorable City,
and daughter of Mr. W. Nicholson, sometimes of
London Draper,[1]
who deceased the tenth of April last and lieth
interred in Saint Mary Abchurch in London,
the twenty-ninth of the same, 1594.
Joshua Sylvester
1594

Since unto me, unworthy, you commit
This worthy task (for better muses fit)
To sing, nay rather sadly to deplore
This common loss that nothing can restore,
You sacred brood, born of celestial race,
You virgin Ladies[2] which pour down the grace
Of Arts and learning on your servants dear,
Vouchsafe assistance to my mournings here.
Teach me sad accents and a weeping measure
To strain forth pity, not to stir up pleasure.
 And you my private cares (although the cause
Of your despairs do never, never pause),
Pause you a little and give leave awhile
Mid public griefs my private to beguile;
Give leave I pray you, for a private case

1. A dealer in textiles, a maker of cloth.
2. The nine Muses.

Unto a public ever must give place.
 Alas, how fitly is this life of ours
Compared to field grass and to fading flowers,
Fresh, green, and gallant in the morning sun,
Withered and dead before the day be done.
Did ever yet the world's bright eye behold
(Since first the Eternal, earthly slime enfold)
A frame of flesh so glorious here beneath
But hath been ruined by the rage of Death?
Of Death, dread victor of all earthly things,
Who in a moment equals clowns with kings.
For majesty can nothing him dismay;
No strength nor courage can his coming stay;
No wealth can wage[3] him, nor no wit prevent him;
No lovely beauty can at all relent him;
Nay (which is more) no virtue can avail.
Ay me, that death on virtue should prevail!
But 'tis decreed, death is the meed[4] for sin:
This by ambition did our grandsire win,
And we, the heirs both of his work and wages,
Must all die once throughout all after ages.
 And here for instance see this sable hearse
Shrouding the subject of my mournful verse,
The breathless body of a worthy Dame,
The Lady Branch, a Nicholson by name,
A godly, virtuous, and religious Matron:
For maids, and wives, and widows all a pattern.
Worship and wealth adorned her parentage;
Favor and beauty graced her personage;
But virtuous manners, by good education,
Brought to her youth the greatest commendation,
Wherein so well she spent her virgin days
That Envy's self saw nothing to dispraise.
 Now when her age had made her apt to marry,
With friends' advice that of her choice were chary
She was espoused to one of special sort,

3. Hire.
4. Recompense.

Wealthy in purse and worshipful in port,[5]
Master John Minors, praised for zeal and piety,
One of the Drapers' worshipful society;
To him she bore four children: one a boy,
The rest all daughters, all, their parents' joy.
But all these joys (alas) but little lasted;
All these fair blossoms were untimely blasted.
All died young, for what draws lively breath
But young or old must yield at last to death?

 But they, long mourning for their mutual loss,
Frame mutual comforts to each other's cross,
Till time, that all things wears, had worn away
Their sorrow's edge, uneasy[6] to allay.
Then happily many fair days they spent,
To others' comfort and their own content,
In all the practice of a Christian life
And mutual duties meet for man and wife;
He happy in his chance, she in her choice,
Both jointly blessed in themselves rejoice.
But ah, these earth-joys do not ever last:
After long clearness clouds will overcast;
After long calms still follows stormy weather.
When they had lived full forty years together,
He died (alas), for what draws lively breath
But young or old must yield at last to death?

 Then desolate and comfortless alone,
Like to the Turtle[7] when her mate is gone,
With sigh-swollen heart and sorrow-clouded eyes
She wails her lost love in a woeful wise
Till time, that all things wears, had worn away
Her sorrow's edge, uneasy to allay.

 Then after modest and meet intermission,
Becoming well her years and her condition,
In second wedlock she was linked again
Unto another wealthy Citizen,

5. Deportment.
6. Difficult.
7. Turtledove.

To Master Branch who afterwards became
Lord Mayor of London, worthy well the same;
In which high office he him so acquitted
That for his service he was after knighted.
He was her husband twenty years or more
And much increased her style, her state, and store.
But boughs and Branches, shrubs, and Cedars tall
Wither and die and into ashes fall;
So fell this Branch, for what draws lively breath
But old or young must yield at last to death?
 Then all forlorn, thus having lost her knight,
This doleful Lady left all world's delight,
All shows of pleasure and all pomp forsaking,
Herself to sadness and to soleness taking,
With inward sighs and outward tears lamenting
His death whose life was all her life's contenting.
Even like unto the sad and woeful Winter,
Who (soon as ever the bright season-stinter[8]
Hath left her widow of his wonted rays
Whilst to another world he takes his ways),
Casting aside her rich enameled crowns,
Flower-powdered mantles, and embroidered gowns,
Of grass green silk-shag, and the gaudy pride
Of all her jewels and her gems beside,
Her mirthless self in mournful manner shrouds
Down to the ground in robe of sable clouds,
And from her swollen heart sighs a thousand stours,[9]
And from her drowned eyes weeps a thousand showers.
 But now become herself her self's commander,[10]
To shield her life safe from all shot of slander,
(As 'twere) sequestered from much conversation,[11]
She passed her time in holy meditation
In thanks and prayer unto Christ our Lord

8. The sun, which controls each season by its proximity or distance from the earth.
9. Storms.
 10. As a wealthy widow who chose not to remarry, Helen Branch became mistress of her own life.
 11. Society.

And often hearing of his sacred word,
In godly alms and liberal pensions rife
And all the duties of a Christian life,
Laying up treasure with the joyful just,
Safe from the force of thieves and fret of rust;
So that her threefold godly life alludeth
To virgin Ruth, wife Sarah, widow Judith.[12]
This life she led, but this life will away.
We are but pilgrims; here we may not stay.
No more might she: for when thrice thirty year
(A goodly age) she had expired[13] here,
She also died, for what draws lively breath
But young or old must yield at last to death?

Such life, such death: well ends the well begun,
And by the even[14] the fair day's praise is won.
Well she began and wondrous well she ended;
Fair rose this sun, and fairly it descended
To rise again to glory at the last,
At that great angel's all-awaking blast.

And therefore, dear friends, do not wail nor weep
For her that is so happy fallen asleep,
But wail our loss, our common cause of grief,
The rich's lodestar, and the poor's relief.
For to the rich in life she gave example,
And to the poor in life and death was ample.
Weep rich; weep poor. Let high and low lament,
But most, you poor, let your salt tears be spent,
For you (alas) have lost your liberal Lady,
Your nurse, your mother. But (alas) why wade I
With my poor style in so profound a stream?
You springs of arts, eyes of this noble Realm,
Cambridge and Oxford, lend your learned tears
To wail your own loss and to witness theirs.

12. Old Testament women who are presented as ideal types of the three stages in a woman's life.

13. Breathed, lived.

14. Evening.

Tell you, that have the voice of eloquence,
This bounteous Lady's large beneficence:
First to yourselves, for love unto your lore,
Then severally to every kind of poor
Within this City, to the Drapers' Hall,
To every Prison, every Hospital,
To Lunatics, and poor Maids' marriages,
And many other worthy legacies.
And when you have drawn all your tear-springs dry
For her decease, here let your comfort lie,
That of this Phoenix'[15] ashes there revives
Another where her virtue still survives.

15. A mythical bird which consumed itself in flames only to rise again from its ashes.

A
PATTERNE
For Women:

Setting forth the moſt
Chriſtian life, & moſt com-
fortable death of Mrs. LVCY
late wife to the worſhipfull
Roger Thornton Eſquire, of
Little Wratting in
Suffolke.

Whereunto is annexed a moſt
pithy and perſwaſiue diſcourſe of that
moſt learned & holy Father IEROM,
being his laſt ſpeech before his death,
which is able to rouze vp the moſt
drowſy and dead'in ſinne.

And finally, the laſt moſt heauenly
prayer of the ſayd IEROM, a ſingular help
for a poore ſoule, wreſtling with the
pangs of death, to addreſſe
herſelfe vnto her
SAVIOVR.

By I. M. Bachelour of Diuinity.

LONDON,
Printed by Edw. Griffin for Iohn Marriot, and
are to be ſold at his ſhop in S. Dunſtanes
Church-yard in Fleet-ſtreet. 1619.

§. A *Pattern for Women*, Setting forth the most Christian life and most comfortable death
of Mrs. Lucy, late wife to the worshipful
Roger Thornton, Esquire, of Little Wratting
in Suffolk
John Mayer.
1619

[John Mayer, pastor of the church in Little Wratting, dedicates "this slender paper monument" to Lucy Thornton "as his last bounden duty towards her, his loving patroness." In a lengthy "epistle consolatory" to Mrs. Thornton's husband, Mayer expresses hope that his eulogy will find a place in the long tradition of monuments and commendations which present the dead "as patterns before our eyes." He apologizes for the delay in publishing the work,[1] explaining that his failure to do justice to Mrs. Thornton's virtues "hath hitherto deterred me from making it public," but he has finally decided to publish it lest he "be blamed at many hands for neglect of so great good deserts." To compensate for his "defect of memory in setting down her speeches and prayers," Mayer states that he is appending to the pamphlet translations of the last discourse and prayer of Saint Jerome, a "most learned and holy Father" of the early Christian church, since the sentiments in these documents were "all in effect spoken by her."

[Mayer then opens his eulogy of Lucy Thornton by comparing her to Simeon, the aged man who, seeing the infant Jesus in the temple, stated that he could die happy because he had seen his salvation. Lucy Thornton saw Christ with the eyes of the spirit rather than those of the flesh, but she also was anointed with holiness, "there being in her a most fragrant smell of all Christian graces." First, she was anointed with a religious zeal, so that neither foul weather nor "the businesses of the world" could keep her from church; indeed, she was always "seen with the forwardest about the Lord's Service." At home, she was

1. Mrs. Thornton died on December 21, 1618, but the pamphlet was not entered in the *Stationers' Register* until August 20, 1619.

diligent in conducting prayers and Scripture readings as well as in carrying out the religious instruction of children and servants.]

Secondly, she was anointed with wisdom, as Abigail,[2] who is said to be of excellent understanding. She did not lose her time in hearing, reading, discourse, and meditation, but profited more than many more ancient: to apply that of David unto her, "I am become wiser than the ancient, because I keep thy commandments." Such was her understanding as that she could readily recite fit texts of Scripture for any purpose and find them out; and for harder places, by singular labor she attained good skill herein. She was not like the dull Hebrews, that were like babes in understanding when by reason of the time they might have been Doctors;[3] but her knowledge with the time increased, so as that like a teacher she was capable of great mysteries. Old nature was not so in her as that she should be blinded from perceiving the things of God, but the new Spirit gave her an understanding of all things, as it is said, "The natural man perceiveth not the things of God, but the spiritual man discerneth all things." She had doubtless then a clear sight of her salvation given by God, seeing that they which are thus enlightened have received the Spirit of God, whereby they know the things given them of God.

Thirdly, she was anointed with true love, causing in her plenty of good works; as in Dorcas,[4] her love was exceeding great both towards God and towards her neighbor. Of God, her love was so great as that she burnt with the fire of earnest zeal for his glory, stoutly (even beyond the strength of her sex) opposing sin and maintaining virtue in those that were about her. As David, in setting forth his zeal, so it may truly be said of her: "A wicked person shall not stand in my sight." If any were near in alliance or great in worldly respects, yet if they were notorious for sin, she took no delight but rather a loathing of their company. For the love of God, she kept a continual watch over her ways, lest she should offend against his holy will; no child is more afraid of offending the father or master than she of offending God. Because that, notwithstanding all watches, sin cannot altogether be kept out, she was not a little troubled for her frailties and falls, being always glad when the Lord took the matter into his own hands by chastising

2. One of the wives of David, greatest of the ancient Hebrew kings and reputed author of many of the psalms.

3. Learned scholars and teachers.

4. An early Christian disciple known for her charitable works.

her with sickness; for then, and in health time also, she did much complain of her sins and forgetfulness for which it was necessary to be corrected. Her continual bewailing and often mourning, even with tears, when wicked, cursed speakers were in presence did plainly show such an heart as Lot's,[5] so taken up with the love of God as that hearing and seeing anything against God could not but vex the heart inwardly with sorrow.

Of her neighbor she had also a true love, not in word but in deed. She had love of almsdeeds, which she plentifully performed to the poor, as Job,[6] not eating her morsels alone but the fatherless did eat part with her. From her youth up, the poor were nourished up with her; their lives blessed her, for that they were kept warm with her fleeces. Whilst she lived, the hungry could not go unfed, the naked unclothed, the sick unvisited. Plentifully the Lord had dealt unto her; plentifully she gave to the Lord again in his poor members, appointing continual relief to be given to the sick and needy in such places of great poverty as wherein she lived not. She showed love by admonishing the disorderly, instructing the ignorant, and exhorting the backward in religion, by all means provoking to love and good works. [Mayer states that Mrs. Thornton performed this service for her neighbors as well as her own household. Furthermore, she rejoiced to be in the company of God's ministers, and her love for others forbade her either to listen to or repeat gossip. Thus her religion was animated with such true love that "her life was a continual laying up of treasure in heaven, and therefore she could not but see heaven to be her dwelling place."]

Fourthly, she was anointed with humility, as Mary the blessed mother of Christ who, being so highly graced by God, yet acknowledgeth herself his humble handmaiden. Although she had something whereof others are proud (as birth, riches, and estimation), yet she was the same lowly handmaiden of the Lord. Through humility, she made herself equal to those that be of low degree, being even a companion of the poor ones that fear the Lord. She despised the ornaments of vanity, which other women so much delight in; her outward habit did show the inward lowliness and modesty of her mind. She strove against the sharpness of her natural disposition, and by striving did attain a great measure of meekness and gentleness, learning of him that said, "Learn

5. A just man who escaped the destruction visited on the wicked city of Sodom.
6. An Old Testament figure who typifies the suffering of the righteous.

of me that I am meek and gentle, and ye shall find rest unto your souls." Like the poor Publican, she was always humbled in the sight of her sins, in health and sickness never flattering herself with anything which she had done, but always bewailing her unworthiness and sins with which she said that she always found herself compassed about. Because she thought herself worthy of greater punishments, she did humbly in all her sufferings submit herself to whatsoever it should please the Lord to lay upon her, verily persuading herself that no sickness or grief came by chance but by God's providence. Without murmuring or impatient complaining, she buckled her shoulders to the yoke, often affirming that she respected not any sufferings here so that she might go to heaven hereafter. [At this point, Mayer quotes the Bible, Saint Augustine, and Saint John Chrysostom, Doctors of the early Christian church, on the benefits of humility and its necessity for salvation.]

Fifthly, she was anointed with due subjection to her own husband, as Sarah,[7] who reverenced her husband, whose example is most earnestly by Saint Peter commended to all wives, promising that thus they become the daughters of Sarah, not being terrified with any fear. Wherefore, having this virtue also added, she was doubtless without fear steadfast in the faith of her salvation.

Unruly wives, like unto Rachel, the wife of Jacob, quarreling with their husbands; or like Michal, the wife of David, mocking their husbands; or like Jezebel, the wife of Ahab, imperious over their husbands and helping them forward in sin; or like Peninnah, the wife of Elkanah, puffed up because of their fruitfulness; or like the daughters of Jerusalem, vainly decking themselves without end in superfluous implements to the needless cost of their husbands:[8] these and the like have such a mist or dark cloud of black sins before their eyes as that they cannot see this salvation. They may have hope indeed, but their hope is presumption, the end of which is damnation.

Now as this elect servant of God was beautified with these graces in her health, so they remained in her without being dimmed in her last sickness.

For heavenly zeal, she gave a sure instance hereof in the beginning of

7. Wife of the Hebrew patriarch Abraham.

8. All of the women cited in this paragraph are Old Testament wives who, in the various ways mentioned, did *not* manifest "due subjection" to their husbands.

this sickness by commanding her servants not to trouble her with any worldly affairs, for now she would wholly be settled to heaven. And indeed she lay in her sickbed as in heaven, full of heavenly speeches and of heavenly comfort. Now all her practice was praying, confessing of sins, singing Psalms, and godly conference.

For wisdom, when strength of body failed her, this was strong yet in her even unto the end; most wisely she spoke to everything, with much understanding producing sundry places of the holy Scriptures. Being much troubled for her sins and buffeted by the temptations of Satan, she said that she had yet much assurance because that "Come unto me," saith the Lord, "all you that are weary and heavy laden, and I will refresh you."

[After quoting many "excellently applied" sayings with which Lucy Thornton comforted herself and others in her illness, Mayer notes that she also manifested the "true love that still abounded in her towards God." She attempted to suppress any complaints that might be drawn from her by suffering and might be construed as a criticism of God. When she was not totally successful in this suppression, she showed "great remorse and sorrow for any behavior amiss in her greatest extremity; no heart could be pricked more for sins than her tender heart was for her slips in her greatest passions."]

She exceeded also still in love of her neighbors; as her alms were always great, so [she was] now much more willing that both money and cloth should be plentifully given to the poor round about. She showed a right motherlike affection to her children, commending to them in particular the fear of God, and the love of the virtuous, and charity to the poor, with many other good exhortations; to her maidens, likewise, she had memorable speeches of instruction and admonition and the like.

For Humility, she did with all patience bear her sickness. No discontented speeches, no impatient complainings, no distempered groanings were heard to come from her; but when she had greatest pangs, her mourning was inward, and when she had any little time of respite, she was very cheerful, singing and talking comfortably.

[Mayer again compares Lucy Thornton to Simeon because of the joy and peace of her death. In a long digression, he expounds the reasons why Christians ought not to fear death. Nevertheless, many of the faithful, as they near their end, "are wonderfully uncomfortable and oftentimes loath to depart." This occurs because they want more time

to perform God's service in the world, or because of a painful disease ("the faithful soul being scorched with the heat of extreme pangs"), or because of the temptations of Satan, who attacks when the individual is weakest. Despite these problems, God always brings peace to those who die in faith.]

Had we not an instance of this in our faithful sister? She had brunts of temptations, brunts of pangs, and part of her day yet in the course of nature remaining, and young children amongst whom she might think profitably to spend her time to God's glory; yet howsoever these things might trouble her joy, yet they could not all take it from her. For upon the Saturday growing very weak and being much troubled for a time, she yet professed her steadfast assurance, willing one that was then about to go to a friend of hers (a Gentlewoman that had labored but could not find assurance) to commend her unto her and certify her what joy she had, saying that she undoubtedly should rather have the like. Soon after this, being through this joy revived in her spirit, she arose from her bed and sang most sweetly, saying that it put her in mind of the singing in heaven. The next day being the Lord's day, when she heard the family singing below in the house, she said that she should be singing ere long in heaven. That night, being prayed for sundry times, when mention was made of restitution to health in prayer, she seemed not to be much moved, but when heaven was mentioned and being received thither, she said aloud, "Amen." Soon after midnight, she said that she had a great conflict, neither could we conceive what she felt, but soon after most comfortably, "He is come," said she. "He is come, the Devil is overcome, the world is overcome, and the flesh is overcome; into thy hands, O father, I commend my spirit." And so [she] fell asleep, her eyes being shut and teeth set. But breath being perceived to be in her, they strove to revive her, which was a great trouble unto her. Yet through the mercy of God she obtained her old comfort again, by many signs testifying her assurance to the end, and departed upon the Monday night, quietly falling, as it were, into a sleep. And so she is departed in peace and resteth in joy with her beloved Savior. So then happy is she, but woe is us from whom she is departed; we may justly weep and lament.

[Mayer concludes by describing the effects of her death on others. Her husband has lost "a heavenly, wise, humble, loving, and obedient wife"; her children have lost "a mother by nature, a mother by grace." The poor lament the departure of "a faithful Patroness, full of good

works towards them," while the ministers mourn the loss of "a careful hearer," and a helper in their labors. "Women may lament, from whom is departed the ornament of women," and all the neighbors have lost "a great light" from their midst. However, the memory of Lucy Thornton shall live as an example for others, an "image of heavenliness, wisdom, love, and humility."]

THE
HONOVR
OF
VERTVE.

OR

The Monument erected by the forowfull
Husband, and the Epitaphes annexed
by learned and worthy men, to the im-
mortall memory of that worthy
Gentle-woman M^{rs} *Elizabeth*
Crashawe.

Who dyed in child-birth and was buried in whit-
Chappell: Octob. 8. 1620. In the 24 yeare
of her age.

Pfal. 112. 6.
The Righteous fhall be had in euerlafting remembrance.
Prou. 10 7.
*The memorie of the iuft is bleffed, But the name of the
wicked fhall rotte.*

A

§. *The Honor of Virtue*; or, The Monument
erected by the sorrowful Husband and
the Epitaphs annexed by learned and worthy men
to the immortal memory of that worthy
Gentlewoman Mrs. Elizabeth Crashaw,
Who died in childbirth and was buried in
Whitechapel October 8, 1620, in the
twenty-fourth year of her age.
1620

THE MONUMENT

To the honor of Christ Jesus,
To the praise of Piety,
To the example of Posterity,
And for the preservation of the
 Godly memory
OF
ELIZABETH,
His most worthy, beloved Wife:
A Woman of a hundred,
A Wife of a thousand,
Descended of the worshipful families,
the Skinners and Emersons.

In whom (by a rare conjunction,
So happy was she and so highly beloved of God)
 Godliness with Comeliness,
 Wisdom with Virtue,
 Beauty with Chastity, and
 Discretion with Devotion
 were most sweetly combined.

Who, in the Prime of her years,
 upon her first child

by her first husband,
 even in the very birth,
yielded up by untimely death
 Her Soul to God,
 Her life to Nature,
 Her Body to the earth,
 Her memory to the world,
 And left
To the pensive father a dear-bought son,
To her friends heaviness hard to be removed,
To her husband Sorrow not to be expressed,
And to all that knew Her a longing desire after
Her never (in this world) to be satisfied.

WILLIAM CRASHAW,[1]

Her most sad and sorrowful Husband,
Unworthy Pastor of this Church,
Unworthy Husband of such a wife,
Mourning for his own unworthiness
Yet rejoicing in Her happiness,
Most unwilling to part with Her
But most willing to Honor Her,
 with many sighs and Tears
 Dedicated this Monument
In assurance of Her glorious Resurrection.

"I know that my Redeemer liveth." (Job 19)

———————

The Funeral Sermon was made by Doctor Ussher[2] of Ireland, then in England, and now Lord Bishop of Meath in Ireland. It was her own earnest request to him that he would preach at the Baptism of her Son,

1. A Puritan clergyman and scholar, formerly preacher at the Inner Temple in London and at this time minister of the church of St. Mary Matfellon (Whitechapel).

2. James Ussher was a prominent Irish prelate and scholar who later became archbishop of Armagh. He is most famous today for his long-accepted chronology of the Old and New Testaments, which fixed the date of creation at 4004 B.C.

as he had eight years afore (being then also in England) at the Baptism of her husband's elder son.[3] Now, because it proved to be both the baptism of the son and burial of the mother, as she often said it would, he therefore spoke out of this text (I Samuel 4 : 20): "And about the time of her death, the women that stood about her said unto her, 'Fear not, for thou hast borne a son,' but she answered not, neither did she regard it."

At which Sermon and Funeral was present one of the greatest Assemblies that ever was seen in man's memory at the burial of any private person.

This Text, His Sermon, and that Spectacle made many a heavy heart and such a Churchful of weeping eyes as have been seldom seen.

He used to be very wary and moderate in commendation, but of her he said Holiness and the truth itself forbade him to be silent. That which he observed in her was:

That besides her piety, chastity, devotion, modesty, sobriety, housewifery, and other worthy qualities wherein she equalled the best, peculiarly in these she excelled:

1. Being young, healthful, and living in great content and with a husband after her own heart, yet she longed to leave this life and rejoiced to think or speak or hear of the life to come.

2. Being young, fair, comely, brought up as a Gentlewoman in music, dancing, and like to be of great estate (and therefore much sought after by young gallants and rich heirs, and good jointures[4] offered), yet she chose a Divine,[5] twice her own age.

3. Her extraordinary love and almost strange affection to her husband, expressed in such excellent and well-tempered passages of kindness as is too rare to find in one of her age, person, and parts.

4. Her singular motherly affection to the child of her predecessor: a rare virtue (as he noted) in stepmothers at this day.

5. Her excellent disposition from her infancy, in that from a child she never offended her parents nor was ever heard to swear an oath.

6. Her husband's discretion being questioned by some for such a choice, and it being the common conceit that by this marriage they had lost a good Preacher; contrariwise, her comeliness in attire and

3. Richard Crashaw, who became an important religious metaphysical poet.
4. Marital property settlements.
5. A clergyman. The marriage was short lived, for she was buried only seventeen months after she was wed.

excellence of behavior graced him everywhere. And her zeal in religion, her kindness to him, her care of his health, and her honorable estimation of his profession encouraged him to do more than ever he did, insomuch as she was a principal cause of his beginning that Morning Exercise there for which so many hundred poor souls do daily praise God.

The Tears of Friends, flowing from their love of the living and the Honor they bear to the deceased:

A Word of Consolation to the Sorrowful Husband
of this most worthy Wife

> Beauty and virtue both together dwelt
> in her fair breast;
> Religious charity her gentle heart so felt
> that no unrest
> Could stay her works from lovely piety,
> nursed in her breast
> Until Reward of Immortality
> brought Her to rest.
> Then mourn no more; wash off all Tears.
> She enjoys Her Hopes and's past all Fears.
> Timoth. Leucadelph., M.D.

A poor memorial of the rich worth of
that Matchless Mistress Crashaw

> Marble never wept for woman
> In whom Goodness took more pleasure;
> Juster grief yet fell to No man
> Than to Him that lost this Treasure.
> What his Joy a while did borrow
> Heaven was pleased to take again
> To match His patience with a Sorrow
> That might show His worth to men.
> For Instance let this sad frame tell
> The virtues decked this Mirror's life,

And then the Reader may Judge well
What 'twas to part with such a wife.
Religion was her soul's delight;
Good works her Recreations were:
To the poor as free as air and light
That shed their comforts everywhere.
Young, fair, wise, comely, yet refused
Both youth and bravery's[6] golden Rays,
And double her own age she choosed
With a Divine to spend her days.
Her Husband in her Truth rejoiced;
Her Parents, in her fair Respect,
Which makes her ever to be voiced
A blessed part of God's Elect.
Her memory fills all good men's eyes;
Her Soul, in her Creator's keeping;
And here that Body only lies
(Glory will wake) in peace now sleeping.
 R. Boothe, Cambridge

To the never dying Memory of that most virtuous
Gentlewoman, and ever worthy to be remembered,
Mrs. Elizabeth Crashaw

The Phoenix[7] rare, from whom the Sun alone
can truly boast of a Conception:
Her spiced nest being kindled by His fire,
Her dear-bought young one's life makes hers expire.
What here the Poets feign of her to please withal
Is truly paralleled in this sad funeral.
This rare blest wife Her Infant Birthright gave
And (loving mother) digged herself a grave:
A Phoenix sure she was, if virtuous merit
may what she's heir to without wrong inherit.
If love, if zeal, if ever chaste desires

6. Finery's.
7. A mythical bird which consumed itself on a funeral pyre ignited by the sun, to be born again (or to generate a new phoenix) from its own ashes.

kept virtue's lore and quenched the Paphian fires[8]
That boil in the veins of wanton Beauties, she
engrossed all this by her fair modesty.
If then thou weepest not, Reader, yet thou wilt say
Death hath in her snatched too much good away.
And if thy needy Muse can force no verse,
Yet to Her memory this or the like rehearse:
 Her life was virtue's friend; virtue and she
 lived here a while, and now eternally.
 Geo. Williams, Oxford

To my dear Cousin, Master W. C.,
A consolatory Elegy upon the untimely and deplorable death
of the truly virtuous and worthy of eternal memory
Mistress Elizabeth Crashaw, his late sweet yokefellow

 Mild, gracious, modest, comely, constant, wise,
 Matchless for piety and spotless fame:
 All words want force her merit to comprise,
 Complete in all Grace, Art, or Nature claim.

 An honor of her Sex: blest virtue's pride,
 True beauty's pattern, mighty nature's wonder.
 In Her, Pandora-like,[9] there did reside
 All Graces others do possess asunder.

 Great Jove, resolving that this lustrous star
 Should hence unto Its proper Orb ascend,
 Caused nature first to wage untimely war,
 The Parca[10] then her thread of time to end.

 One Bird of paradise this Phoenix left
 To consolate her Turtle-mourning[11] mate,

8. The flames of lust (from Paphos, a Cyprian city sacred to Aphrodite).

9. The author is referring to the root meaning of this name in Greek: "all gifts." However, the comparison is an unfortunate one, since Pandora (in the well-known myth related by Hesiod in the *Works and Days* and *Theogony*) was the embodiment of feminine evil—the first woman, created by the gods specifically to bring ills to mankind.

10. One of the three Fates (*Parcae*), who spun, measured, and cut the thread of each person's life.

11. The turtledove, known for its affection for its mate and its plaintive call.

Whereof stern Death Him hastily bereft
To Test his faith and show the worst of fate.

Great is His loss, yet may he not repine[12]
That these the death of all the world have died,
Since they are best (more, they are now divine);
He, happy that enjoyed so blest a bride.

<div align="right">Fr. Smith, Cambridge</div>

[Eight more elegies, four of them in Latin, mourn the passing of Elizabeth Crashaw. In these, she is called "the best of Females" and praised as the embodiment of feminine virtues: "One modest, humble, fair, discreet, / Where *true* and *seeming* worth did meet." However, these elegies especially stress her religious merits, extolling her piety and her "most holy life," and terming her "a Saint on earth": "Dear to the Heavens, too dear on Earth to rest, / Though both desired and loved of every creature." They use her death as an occasion for reflections on the vanity and uncertainty of this life, maintaining that she has now found a better life in heaven and urging her husband to bear his loss with Christian fortitude and acceptance.]

Her Answer to them all

It is not I that die; I do but leave an Inn
Where harbored was with me, against my will, much sin.

It is not I that die; I do but now begin
Into eternal life by Death to enter in.

Why mourn you then for me, dear Husband, friends, and kin?
Lament you when I lose; why weep you when I win?

12. Express discontent, complain.

THE
Araignement & bur-
ning of *Margaret Ferne-feede*,
for the Murther of her late Husband
Anthony Ferne-feede, found deade in Peck-
ham Field neere Lambeth, hauing once be-
fore attempted to poyfon him with broth,
being executed in S.Georges-field the
laft of Februarie,
1608

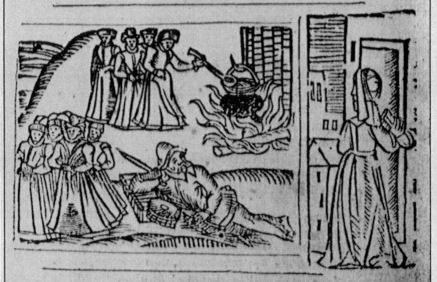

LONDON
Printed for *Henry Goffon*, and are to be folde at the Signe
of the Sunne in Pater-nofter-rowe.
1608

§. *The Arraignment and burning*
of *Margaret Ferneseede* for the Murder
of her late Husband Anthony Ferneseede,
found dead in Peckham Field
near Lambeth, having once before attempted
to poison him with broth,
being executed in Saint George's field
the last of February, 1608.
1608

The grossest part of folly (and the most repugnant even unto our own natural reason) is to think that our hidden abominations can be concealed from the eye of the Almighty or that he, seeing our bloody and crying sins, will not either reveal them before his Ministers of public justice or in his best pleased time pour down sharp vengeance for such presumptuous and rebellious offenses. Oh! The miracles in these Revelations are such (and so infinite) that the thought of man or his wisdom is but mere weakness going about to comprehend such unspeakable judgments: and of this we have before our eyes a most notable example in this wretched woman of whom my present discourse entreateth, named Margaret Ferneseede, a woman that even from her time of knowledge (if the general report of the world, according to the old adage, may be taken for an Oracle) was given to all the looseness and lewdness of life which either unlawful lust or abominable prostitution could violently call upon her, with the greatest infamy, yea, and with such a public and irrespective[1] unchastity that neither being chaste nor cautious she regarded not either into what care the loathsomeness of her life was founded or into what bed of lust her lascivious body was transported. In this more than bestial lasciviousness having consumed the first part of her youth, finding both the corruption of her blood to check the former heat of her lust, and the too general ugliness of her prostitution to breed a loath in her ordinary customers, being then confirmed in some more strength of

1. Disrespectful.

352

years, took a house near unto the Irongate of the Tower, where she kept a most abominable and vile brothel house, poisoning many young women with that sin wherewith her own body long before was filthily debauched. From this house at the Irongate she was married unto one Anthony Ferneseede, a Tailor dwelling in Ducke lane but keeping a shop upon Addle hill near Carter lane. This Anthony was amongst his neighbors reputed to be both sober and of very good conversation.[2]

Now it happened that some few months ago in the fields of Peckham near London there was found a man slain, having his throat cut, a knife in his hand, gold rings upon his fingers, and forty shillings in money in his purse, his wounds of so long continuance that it was not only corrupted, but there was also maggots or suchlike filthy worms engendered therein, which gave testimony to the beholders that he had not slain himself in that place, as well because the place was free from such a spectacle the day before, as also that such corruption could not proceed from a present slaughter. Again, what the person slain no man knew,[3] both because his physiognomy was altered in his death and because his acquaintance was little or none in those parts about Peckham. In the end, searching his pockets and other parts of his apparel, amongst other notes and reckonings they found an Indenture wherein a certain youth which did serve him was bound unto him; this Indenture gave them knowledge both of his name and of the place of his dwelling. Whereupon certain discreet persons of Peckham, sent to London to Ducke lane and inquiring for the house of one Anthony Ferneseede, delivered to his wife the disaster and mischance which had befallen her husband—which her hardened heart received not as a message of sorrow, neither did the grudging of an afflicted countenance gall her remembrance; but as if it had been the report of some ordinary or vulgar news, she embraced it with an irrespective neglect and carelessness, and demanded instantly (before the message would tell her how he died) whether his throat were cut or that he had cut his own throat, as either knowing or prophesying how he died. Yet to observe a customary fashion or (as the proverb is) to carry a candle before the devil, she prepares herself and her servant in all haste to go to Peckham to behold her husband. And in the way as she went, it was her chance to

2. Mode of life, behavior.
3. No one knew who the slain man was.

meet with one of her Husband's ancient acquaintance, who, feeling that in charity which she ought to have felt in nature, began to complain her misfortune, telling her she had lost a most honest and good husband. She, whom the devil now would not suffer to dissemble (though his greatest art be in dissimulation), told him her fear was she should not hear so well of him. He, wondering at her ungodly carelessness, let her pass, when presently she met another of her acquaintance, who with like charity to the former began to pity her griefs (though grief was never further from her heart) and to wish her those comforts which are fit for affliction. But she, as careless as before, gave him by the neglect of her words true testimony how far sorrow was from her heart, which when he noted he said, "Why Mistress Ferneseede, is the loss of a good husband so slightly to be regarded? For mine own part, had such a mischance fallen to my fortune, I should ere this have wept out mine eyes with true sorrow." But she quickly made him answer, "Tut sir, mine eyes are ill already and I must now preserve them to mend my clothes, not to mourn for a husband." After that, in her going the wind blowing the dust in her face, she takes her scarf and wiped her eyes, and said she should scarce know her husband when she saw him. These courtesanlike speeches made her acquaintance leave her and wished her more grace. So she and her boy came where the body was, where more for awe of the Magistrate than any terror she felt, she made many sour faces, but the dryness of her brain would suffer no moisture to descend into her eyes. Many questions were asked her, to which she answered with such constancy that no suspicion could be grounded against her. Then was her boy taken and examined, who delivered the abomination of her life, and that since her marriage with his master she had lived in all disquietude, rage, and distemperature, often threatening his life and contriving plots for his destruction; that she had ever since her marriage in most public and notorious manner maintained a young man with whom (in his view) she had often committed adultery; that the same young man since his master's loss was fled he knew not whither; and that his mistress had even then before the message of his master's death sold all his goods (as he supposed) to fly also after him whom she loved. All these speeches were not only seconded, but almost proved by some of her neighbors which lived near unto her, insomuch that she was the second time taken into a more strict examination: wherein albeit she

could not deny any of her[4] general assertions, yet touching the death of her husband that she forswore and renounced the fact or practice thereof to be hers with such a shameless constancy that she struck amazement into all that heard her. In the end by authority of Justice she was committed to the White Lion in Southwark, during the time of which imprisonment till her time of trial, thinking to outface truth with boldness and sin with impudence, she continued out[5] all her examinations taken before several Justices in her former denials. And whereas the Rod of imprisonment laid upon others is received as a gentle correction whereby to look into themselves, it was to her rather the bellows of indignation than a temperer to patience; rather a kind of frenzy than a cooler of fury; and rather a provoker to evil than a persuader to goodness, for she was seldom found to be in charity with any of her fellow prisoners nor at any time in quiet with herself; rather a provoker than an appeaser of dissensions: given to much swearing, scarce praying but continually scolding, so that she was as hateful to all them that dwelt with her in that her last home the prison as she was to people of honest conversation, having deserved the name of a Bawd while she lived abroad.

In this uncivil order spending her hours, the time of trial coming on when such offenders were to appear before the earthly Judge to give account of their lives past, amongst many others this Margaret Ferneseede was one; and at the assizes last, according to the order of law, she was indicted and arraigned, the purpose[6] of which indictment was to have practiced the murder of her late husband Anthony Ferneseede, who as before was found dead in Peckham field near Lambeth. To the indictment she pleaded not guilty, putting her cause to God and the Country, which were a credible Jury impaneled and had there made their personal appearance for that purpose. Then were these several witnesses produced against her: namely of the incontinence of her life past, her attempt to poison her husband before his murder as also to prepare broth for him and put powder in it, her slight regard of him in his life and her careless sorrow for him after death, with other circumstances, as the flight of the fellow whom she had lived long in adultery with, her present sale of her goods upon her

4. These.
5. Throughout.
6. Subject.

husband's murder (as it may be justly thought) with purpose to fly after him. On which lawful evidence she was convicted and after judgment given her to be burned, and from thence she was conveyed back to the White Lion till the time appointed for her execution.

How Margaret Ferneseede spent her time in prison from Saturday, the day of her conviction, till Monday, the last of February when in Saint George's field she was executed.

Being come back to the prison, for the first night she disposed herself according to her ancient habit, being as it were so rooted and accustomed to evil that as even death itself had not power to make her forget it and endeavor a better course. But being at the same time in the prison with her three Gentlemen who likewise were condemned and who, though the course of their lives had not taught them to live well, yet the care of their souls remembered them to die well, these Gentlemen having heard how ill her life past had been and that her countenance was as resolute, importuned the keeper that they might have her company, partly to instruct her, but especially that she might see them and by the reformation of their lives she might learn to amend her own and, as they did, to prepare herself fit for death. Whose persuasion and wholesome counsels of their own with comfortable promises of our merciful Savior Jesus Christ to them that unfeignedly believe in him and by unfeigned repentance make way to their salvation, as also with threatening her with the terrible Judgments of Hell which are prepared for them that perish through lack of grace, they so wrought in her [that] she was at last drawn to make a confession of her former life past and to repent her of the same, the form of which was in this manner.

The Confession and repentance of Margaret Ferneseede after her condemnation in the White Lion

To prepare the reader for this confession of hers, know that I was credibly satisfied that when the heat of her fury was past to which she was much subject unto, she [was] a woman well spoken, of fair delivery and good persuasion. And so to her confession:

"To excuse myself, O Lord, before thee who knows the conspiracies of our thoughts even to the utmost of our actions (however so private

or publicly committed) were folly, or to justify myself were sin, since no flesh can appear pure in thy sight. I here therefore with prostrate knees and dejected eyes as unworthy to look up unto thy divine Majesty, with a contrite heart and penitent soul also, here voluntarily confess I am the greatest of sinners which have deserved thy wrath and indignation." In this good manner she proceeded and withal satisfied all that came and desired to have private conference with her of the whole course of her life that in her youth, even from the age of aptness, she had been a prostitute whore, but growing into disabled years, to please the loose desires of such customers she after turned bawd, a course of life more hateful in tempting and seducing youth than the other in committing sin. The one makes but spoil and ruin of herself, and the other of a multitude: "For," quoth she, "I myself have had ten several women retaining[7] to my house for that purpose. Some were men's wives, which repaired thither both by appointment and at convenient hours when their husbands might least suspect or have knowledge of their absence, and these women did I first tempt to their fall: some, by persuading them they were not beloved of their husbands, especially if I could at any time have note of any breach or discontent between them; others, that their husbands maintained them not sufficiently to express their beauty and according to their own deserts. Of these (they having brought my purpose to effect and that I knew they had offended) I made this booty,[8] that they were as fearful to offend me as their husbands should have knowledge of their offenses; and these allowed me a weekly pension for coming to my house and durst not at all times but find opportunity to come whensoever myself or such loose friends whom either they had been familiar with or now desired to be acquainted with them should send for any of them. To supply my house and make spoil of young maids who were sent out of the country by their friends here with hope to advance themselves, I went weekly to the Carriers[9] where, if the maid liked me, I so wrought with the Carrier that she seldom left me till I had brought her to be as bad as I purposed; which effected, every one of them I compelled to give me ten shillings a week out of their gettings, having as I said seldom less than ten whose bodies and souls I kept in this bondage. Besides, I

7. Attached.
8. Gain.
9. Transporters.

confess I was a continual receiver of theft stolen; but in all this, as it was badly got, so was it worse consumed, for nothing of it did prosper with me, whereby (quoth she) I acknowledge I have deserved death and in the highest degree. But for this which I am condemned, Heaven that knoweth best the secrets of our hearts knows I am innocent."

But who knows not that in evil there is a like impudence to deny, as there is a forwardness to act: in which we will leave her whom the law hath found guilty, and having thus truly related her own confession, we proceed to the manner of execution.

First only touching the evidence of two Sailors given to the Jury at her arraignment (among other circumstances that was availablest to condemn her this was one and the chiefest): during the time while she kept a bad house about the Irongate by Lowerditch, there happened a couple of Bargemen to come to revel at her house with such Guests as she kept to entertain loose customers; and having spent the whole day in large riot and much expense, the night being late, for that time they made their lodging there. They being abed, it happened that night (which was seldom) her husband came to make his lodging there also and being chambered with his wife but a wall between where these Bargemen lay, they could expressly hear them every word that passed between them: the effect of which was the reproving of her for her bad life, his persuading her to amendment, which she, not willing to listen unto, fell ascolding at him and so left both his bed and chamber some time passing.

At last Master Ferneseede heard these Bargemen cough and, wondering to have strangers lodged in his house (for it was not common to his knowledge), arose out of his bed and demanded of them what they were: who asked of him also wherefore he questioned them. "Marry," [10] quoth he, "for if you be honest men and have a care either of your bodies or souls, avoid this house as you would do poison, lest it be the undoing of you all." They, seeing him of a comely personage and that his words tended to some purpose, demanded of him what he was that gave them such wholesome counsel. "I am," quoth he, "the master of this house if I had my right, but I am barred of the possession and command thereof by a devilish woman who makes a stews [11] of it to exercise her sinful practices," so with some other admonish-

10. An exclamation of surprise.
11. Brothel

ment left the room. When these Bargemen told mistress Ferneseede what they had heard of her husband, to which she replied, "Hang him slave and villain! I will before God be revenged of him (nay ere long) by one means or other, so worked that I will be rid of him"; which making good in the judgment of the Judge together with her life and practices, she as aforesaid was condemned.

On Monday, being the last of February, she had notice given her that in the afternoon she must suffer death and a Preacher commended unto her to instruct her for her soul's health, who labored much with her for the confession of the fact which she still obstinately denied but made great show of repentance for her life past. So that about two of the clock in the afternoon she was stripped of her ordinary wearing apparel and upon her own smock put a kirtle[12] of Canvas pitched clean through, over which she did wear a white sheet, and so was by the keeper delivered to the Shrive,[13] on each hand a woman leading her and the Preacher going before her. Being come to the place of execution, both before and after her fastening to the Stake with godly exhortations he admonished her that now in that minute she would confess that fact for which she was now ready to suffer, which she denying, the reeds were planted about, unto which fire being given, she was presently dead.

12. Dress. In this mode of execution, the condemned is dressed in a garment saturated with pitch in order to facilitate combustion.
13. Confessor.

A pittilesse Mother.

That moſt vnnaturally at one time, murt|
two of her owne Children at Acton within ſixe miles f|
London vppon holy thurſday laſt 1616. The ninth of May,
Beeing a Gentlewonan named *Margret Vincent*, wife of
M^r. *Iaruss Vincent*, of the ſame Towne.

With her Examination, Confeſſion and true diſcouery of a|
proceedings in the ſaid bloody accident.

Whereunto is added *Anderſons* Repentance,
was executed at Tiburne the 18. of May being Whitſon-Eue. |
Written in the time of his priſonment in Newgate.

§. A *pitiless Mother* That most unnaturally at one time murdered two of her own Children

at Acton, within six miles of London,
upon holy thursday last, 1616, the ninth of May,
being a Gentlewoman named Margaret Vincent,
wife of Mr. Jarvis Vincent of the same Town,
With her Examination, Confession,
and true discovery of all the proceedings
in the said bloody accident.[1]

1616

How easy are the ways unto evil and how soon are our minds (by the Devil's enticement) withdrawn from goodness! Leviathan,[2] the Archenemy of mankind, hath set such and so many bewitching snares to entrap us that unless we continually stand watching with careful diligence to shun them we are like to cast the principal substance of our reputation upon the wrack of his ensnaring engines.[3] As for example a Gentlewoman, ere now fresh in memory, presents her own ruin amongst us, whose life's overthrow may well serve for a clear looking Glass to see a woman's weakness in: how soon and apt she is won unto wickedness, not only to the body's overthrow but [also to] the soul's danger. God of his mercy keep us all from the like willfulness!

At Acton, some six miles westward from London, this unfortunate Gentlewoman dwelled, named Margaret Vincent, the wife of Mr. Jarvis Vincent, Gentleman; who (by unhappy destiny marked to mischance) I here now make the subject of my Pen and publish her hard hap unto the world, that all others may shun the like occasions by which she was overthrown.

This Margaret Vincent before named, of good parentage, born in the County of Hartford, at a town named Rickmansworth, her name from her parents Margaret Day, of good education, graced with good

1. Incident, occurrence.
2. Satan.
3. The ruin of his evil machinations.

parts from her youth that promised succeeding virtues in her age if good luck had served: for, being discreet, civil, and of a modest conversation, she was preferred in marriage to this Gentleman Mr. Vincent, with whom she lived in good estimation, well beloved and much esteemed of all that knew her for her modest and seemly carriage, and so might have continued to her old age had not this bloody accident committed upon her own children blemished the glory of the same.

But now mark, gentle Reader, the first entrance into her life's overthrow and consider with thyself how strangely the Devil here set in his foot and what cunning instruments he used in his assailments.[4] The Gentlewoman, being witty and of a Ripe understanding, desired much conference in religion and, being careful (as it seemed) of her soul's happiness, many times resorted to Divines[5] to have instructions to salvation, little thinking to fall into the hands of Roman Wolves[6] (as she did) and to have the sweet Lamb, her soul, thus entangled by their persuasions.

Twelve or Fourteen Years had she lived in marriage with her husband well beloved, having for their comforts divers pretty children between them, with all other things in plenty (as health, riches, and suchlike) to increase concord, and no necessity that might be hindrance to contentment. Yet at last there was such traps and engines set that her quiet was caught and her discontent set at liberty; her opinion of the true faith (by the subtle sophistry of some close Papists) was converted to a blind belief of bewitching heresy. For they have such charming persuasions that hardly the female kind can escape their enticements, of which weak sex they continually make prize of and by them lay plots to ensnare others, as they did by this deceived Gentlewoman. For she, good soul, being made a bird of their own feather, desired to beget more of the same kind, and from time to time made persuasive arguments to win her husband to the same opinion, and deemed it a meritorious deed to charge his conscience with that infectious burden of Romish opinions, affirming by many false reasons that his former life had been led in blindness and that she was appointed by

4. Assaults.
5. Clergymen.
6. Roman Catholics. In the reign of Henry VIII, Parliament broke with the pope in Rome and established the Church of England with the reigning monarch as its supreme head. During the Renaissance, therefore, Roman Catholics (often called Papists) were viewed with disfavor and at times actually persecuted.

the holy Church to show him the light of true understanding. These and suchlike were the instructions she had given her to entangle her husband in and win him, if she might, to their blind heresies.

But he, good Gentleman, overdeeply grounded in the right Faith of Religion than to be thus so easily removed, grew regardless of her persuasions, accounting them vain and frivolous and she undutiful to make so fond[7] an attempt, many times snubbing her with some few unkind speeches which bred in her heart a purpose of more extremity. For, having learned this maxim of their Religion, that it was meritorious (yea and pardonable) to take away the lives of any opposing Protestants (were it of any degree whatsoever), in which resolution or bloody purpose she long stood upon and at last (only by the Devil's temptation) resolved the ruin of her own children, affirming to her conscience these reasons: that they were brought up in blindness and darksome errors, hoodwinked[8] by her husband's instructions from the true light. And therefore, to save their soul (as she vainly thought), she purposed to become a Tigerous Mother and so wolfishly to commit the murder of her own flesh and blood, in which opinion she steadfastly continued, never relenting according to nature but casting about to find time and place for so wicked a deed, which unhappily fell out as after followed.

It so chanced that a discord arose between the two towns of Acton and Willesden about a certain common, bordering between them, where the town of Acton (as it seems having the more right to it) by watching defended it a time from the others' Cattle, whereupon the women of the same town, having likewise a willingness to assist their husbands in the same defense, appointed a day for the like purpose, which was the Ascension-day[9] last past, commonly called holy Thursday, falling upon the ninth of the last passed month of May; which day (as ill chance would have it) was the fatal time appointed for her to act this bloody Tragedy whereon she made her husband fatherless of two as pretty children as ever came from woman's womb.

Upon the Ascension-day aforesaid, after the time of Divine service, the women of the town being gathered together about their promised business, some of them came to Mistress Vincent and according to

7. Foolish.
8. Blindfolded.
9. The fortieth day after Easter, called in England "Holy Thursday."

promise desired her company; who, having a mind as then more settled on bloody purposes than country occasions, feigned an excuse of ill at ease and not half well, desired pardon of them, and offering her Maid in her behalf (who, being a good, apt, and willing Servant, was accepted of). And so the Townswomen, misdoubting[10] no such hard accident as after happened, proceeded in their aforesaid defenses, the Gentlewoman's husband being also from home; in whose absence, by the fury and assistance of the Devil, she enacted this woeful accident in form and manner following.

This Mistress Vincent, now deserving no name of Gentlewoman, being in her own house fast locked up only with her two small Children (the one of the age of five years, the other hardly two years old, unhappily brought to that age to be made away by their own Mother, who by nature should have cherished them with her own body, as the Pelican that pecks her own breast to feed her young ones with her blood), but she, more cruel than the Viper, the envenomed Serpent, the Snake, or any Beast whatsoever, against all kind[11] takes away those lives to whom she first gave life.

Being alone (as I said before), assisted by the Devil, she took the youngest of the two, having a countenance so sweet that might have begged mercy at a tyrant's hand; but she, regarding neither the pretty smiles it made, nor the dandling before the mother's face, nor anything it could do, but like a fierce and bloody Medea,[12] she took it violently by the throat and with a Garter taken from her leg, making thereof a noose and putting the same about her Child's sweet neck, she in a wrathful manner drew the same so close together that in a moment she parted the soul and body. And without any terror of Conscience she laid the lifeless Infant, still remaining warm, upon her bed and with a relentless countenance looking thereon, thinking thereby she had done a deed of immortality. Oh blinded ignorance! Oh inhuman devotion! Purposing by this to merit heaven, she hath deserved (without true repentance) the reward of damnation.

This Creature not deserving Mother's name (as I said before), not yet glutted nor sufficed with these few drops of Innocent blood (nay,

10. Suspecting.

11. Nature, natural disposition.

12. A sorceress of Greek mythology. When her husband, Jason, divorced her to marry a king's daughter, Medea slew her own two sons by Jason in order to avenge herself upon their father.

her own dear blood bred in her own body, cherished in her own womb with much dearness full forty weeks), not satisfied, I say, with this one murder but she would headlong run unto a second and to heap more vengeance upon her head, she came unto the elder Child, of that small age that it could hardly discern a Mother's cruelty nor understand the fatal destiny fallen upon the other before, which as it were seemed to smile upon her as though it begged for pity; but all in vain, for so tyrannous was her heart that without all motherly pity she made it drink of the same bitter cup as she had done the other. For with her garter she likewise pressed out the sweet air of life and laid it by the other upon the bed, sleeping in death together, a sight that might have burst an iron heart asunder and made the very Tiger to relent.

These two pretty children being thus murdered without all hope of recovery, she began to grow desperate and still to desire more and more blood, which had been a third murder of her own babes had it not been abroad at Nurse and by that means could not be accomplished. Whereupon she fell into a violent rage, purposing as then to show the like mischief upon herself, being of this strange opinion, that she herself by that deed had made Saints of her two children in heaven. So taking the same garter that was the instrument of their deaths and putting the noose thereof about her own neck, she strove therewith to have strangled herself; but nature being weak and flesh frail, she was not able to do it. Whereupon in a more violent fury (still animated forward by the instigation of the Devil) she ran into the yard, purposing there in a pond to have drowned herself, having not one good motion of Salvation left within her.

But here, good Reader, mark what a happy prevention chanced to preserve her in hope of Repentance, which at that time stayed her from that desperate attempt: the maid by great fortune, at the very instant of this deed of desperation, returned from the field or Common where she had left most of the neighbors. And coming in at the back side, perceiving her mistress by her ghastly countenance that all was not well and that some hard chance had happened [to] her or hers, demanded how the Children did. "Oh Nan," quoth she, "never, oh never, shalt thou see thy Tom more," and withal she gave the maid a box upon the ear, at which she laid hold upon her Mistress, calling out for help into the Town, whereat divers came running in and after them her husband, within a while after; who, finding what had happened, were all so amazed together that they knew not what to do. Some

wrung their hands; some wept; some called out for Neighbors. So general a fear was struck amongst them all that they knew not whither to go nor run, especially the good Gentleman her husband, that seeing his own Children slain, murdered by his Wife and their own Mother (a deed beyond nature and humanity), in which Ecstasy of grief at last he broke out in these speeches: "Oh Margaret, Margaret, how often have I persuaded thee from this damned Opinion, this damned Opinion that hath undone us all!" Whereupon with a ghastly look and fearful eye she replied thus: "Oh Jarvis, this had never been done if thou hadst been ruled and by me converted; but what is done is past, for they are Saints in heaven, and I nothing at all repent it." These and suchlike words passed between them till such time as the Constable and others of the townsmen came in and according to law carried her before a Justice of the peace, which is a Gentleman named Master Roberts of Willesden; who, understanding these heinous offenses rightly according to law and course of Justice, made a *Mittimus*[13] for her conveyance to Newgate in London, there to remain till the Sessions of her trial. Yet this is to be remembered, that by examination she voluntarily confessed the fact, how she murdered them to save their souls and to make them Saints in heaven, that they might not be brought up in blindness to their own damnation. Oh willful heresy, that ever Christian should in Conscience be thus miscarried! But to be short she proved herself to be an obstinate Papist, for there was found about her neck a Crucifix, with other relics which she then wore about her, that by the Justice was commanded to be taken away and an English bible to be delivered her to read, the which she with great stubbornness threw from her, not willing as once to look thereupon nor to hear any divine comforts delivered thereout for the succor of her Soul.

But now again to her conveyance towards prison: it being Ascension-day and near the closing of the evening, too late as then to be sent to London, she was by Commandment put to the Constable's keeping for that night, who with a strong watch lodged her in his own house till morning, which was at the Bell in Acton where he dwelled; who, showing the part and duty of a good Christian with divers other of his Neighbors, all that same night plied her with good admonitions, tending to repentance and seeking with great pains to convert her from

13. A warrant committing an arrested person to the keeping of a jailor; Newgate was a famous London prison.

those erroneous Opinions which she so stubbornly stood in. But it little availed, for she seemed in outward show so obstinate in Arguments that she made small reckoning of repentance nor was a whit sorrowful for the murder committed upon her children but maintained the deed to be meritorious and of high desert.

Oh that the blood of her own body should have no more power to pierce remorse into her Iron-natured heart, when Pagan women that know not God nor have any feeling of his Deity will shun to commit bloodshed, much more of their own seed! The Cannibals that eat one another will spare the fruits of their own bodies; the Savages will do the like; yea, every beast and fowl hath a feeling of nature and according to kind will cherish their young ones. And shall woman, nay a Christian woman, God's own Image, be more unnatural than Pagan, Cannibal, Savage, Beast, or Fowl? It even now makes a trembling fear to beset me to think what an error this unhappy Gentlewoman was bewitched with, a Witchcraft begot by hell and nursed by the Romish Sect, from which enchantment God of heaven defend us.

[After Margaret Vincent was taken to Newgate prison on the following day, many people attempted to bring her to repentance "with sweet and comfortable persuasions," but she "continued still in her former stubbornness, . . . being here possessed with such bewitching willfulness." However, after three days "certain Godly Preachers" at last convinced her that "she had eternally deserved hellfire for the murder of her children."]

And now to come to a conclusion, as well of the discourse as of her life: she deserved death, and both Law and Justice hath awarded her the same, for her examination and free confession needed no Jury. Her own tongue proved a sufficient evidence and her conscience a witness that condemned her; her judgment and execution she received with a patient mind. Her soul no doubt hath got a true penitent desire to be in heaven, and the blood of her two innocent Children so willfully shed according to all charitable judgments is washed away by the mercies of God. Forgive and forget her, good Gentlewomen; she is not the first that hath been blemished with blood nor the last that will make a husband wifeless. Her offense was begot by a strange occasion but buried, I hope, with true repentance.

[The author closes the pamphlet with a final warning against the "Popish persuasions" of "that dangerous sect."]

THE
WONDERFVL
DISCOVERIE OF THE

Witchcrafts of *Margaret* and *Phillip*
Flower, daughters of *Ioan Flower* neere *Beuer*
Caſtle: Executed at Lincolne, *March* 11. 1618.

Who were ſpecially arraigned and condemned before Sir
Henry Hobart, and Sir *Edward Bromley*, Iudges of Aſ-
ſiſe, for confeſſing themſelues actots in the deſtruction
of *Henry L. Roſſe*, with their damnable practiſes againſt
others the Children of the Right Honourable
FRANCIS Earle of *Rutland*.

Together with the ſeuerall Examinations and Confeſſions of *Anne*
Baker, *Ioan Willimot*, and *Ellen Greene*, Witches in *Leiceſterſhire*.

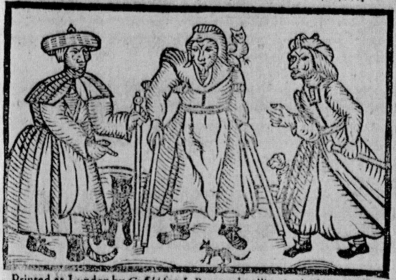

Printed at London by *G. Eld* for *I. Barnes*, dwelling in the long Walke
neere Chriſt-Church. 1 6 1 9.

§. *The Wonderful Discovery of the Witchcrafts of Margaret and Philippa Flower,*
daughters of Joan Flower, near Belvoir Castle;
Executed at Lincoln
March 11, 1618.
1619

My meaning is not to make any contentious Arguments about the discourses, distinction, or definition of Witchcraft, the power of Devils, the nature of Spirits, the force of Charms, the secrets of Incantation, and suchlike, because the Scriptures are full of prohibitions to this purpose and proclaims death to the presumptuous attempters of the same. Besides, both Princes (yea, our own learned and most judicious King), Philosophers, Poets, Chronologers, Historiographers, and many worthy Writers have concurred and concluded in this: that divers impious and facinorous[1] mischiefs have been effectuated[2] through the instruments of the Devil, by permission of God, so that the actors of the same have carried away the opinion of the world to do that which they did by Witchcraft, or at least to be esteemed Witches for bringing such and such things to pass. For howsoever the learned have charactered delinquents in this kind by titles of sundry sorts and most significant attributes, as *Pythoness* dealing with artificial Charms; *Magi* anciently reputed so for extraordinary wisdom and knowledge in the secrets of simples and herbs; *Chaldei* famous for Astronomy and Astrology; *Necromancers* for practicing to raise dead bodies; *Geomantici* for conversing with Spirits and using Incantations; *Genethliaci* for presuming on the calculating of Nativities or, if you will, assuming the credit of Figure-casting; *Ventriloqui* for speaking with hollow voices as if they were possessed with Devils; *Venefici* for dealing with Poison and either killing or curing that way (for you must understand however the Professors aforesaid practice murder and mischief, yet many times they Pretend cures and preservation, with many others carrying

1. Wicked, vile.
2. Effected.

the show of great learning and admired knowledge): yet have they all but one familiar term with us in English called "Witches." As for the conceit of wise men or wise women, they are all merely cozeners and deceivers; so that if they make you believe that by their means you shall hear of things lost or stolen, it is either done by Confederacy or put off by protraction to deceive you of your money.

[Certain people afflicted with "Melancholy and Atheism" and motivated by malicious envy or a desire for revenge study "exotic practices of loathsome Arts and Sciences." Others seek a reputation for Godlike power and knowledge, "making you believe with Medea[3] that they can raise tempests, turn the Sun into blood, pull the Moon out of her Sphere, and sail over the Sea in a cockle shell." The devil presents himself to these people, showing them how to achieve their desires and offering to attend them "in some familiar shape of Rat, Cat, Toad, Bird" or other animal. They enter into a contract with the devil, forfeiting their souls to be avenged on their neighbors' bodies or to enjoy a reputation for possessing supernatural power. However, God will not allow them indefinitely "to abuse his holy name nor deceive others by their profane lives"; sooner or later the law convicts and executes them.

[The author cites several recent works on witchcraft: "that learned Discourse of Demonology . . . by the High and mighty Prince James, by the grace of God King of England, Scotland, France, and Ireland"; a treatise by a Norfolk preacher, Alexander Roberts, on the witchcraft of Mary Smith; a work by John Cotta, a Northampton doctor who exposed women professing to help the sick; and a dialogue concerning witchcraft by a Maldon minister named George Gifford. He then notes further cases of English witches who were tried and executed, including Mother Sutton and her daughter Mary from Bedford, the infamous Lancashire witches, and Janet Preston from York, convicted of the murder by witchcraft of one Mr. Lister. These treatises on witchcraft and actual trials of witches serve to refute the erroneous opinions of some people "who suppose there be none at all, or at least that they do not personally or truly effect such things as are imputed unto them."]

But yet because the mind of man may be carried away with many idle conjectures—either that women confessed these things by extremity of torture, or that ancient examples are by this time forgotten

3. A famous sorceress in Greek mythology.

(although the particulars are upon record for the benefit of all pos-
terity), or that they were beside themselves or subject to some weak
device or other—rather to bring in question the integrity of Justice
than to make odious the lives of such horrible offenders, I have pre-
sumed to present on the Stage of verity for the good of my Country
and the love of truth the late woeful Tragedy of the destruction of the
Right Honorable the Earl of Rutland's Children, who to his eternal
praise proceeded yet both religiously and charitably against the offend-
ers, leaving their prosecution to the law and submitting himself and
deplorable case to the providence of God, who afflicteth his best ser-
vants with punishments and many times sendeth extraordinary ven-
geance as well on the innocent as the bad deserver to manifest his
glory. Therefore by way of Caution I advise thee, gentle Reader, who-
soever thou art, to take heed how thou dost either despise the power of
God in his Creatures or vilipend[4] the subtlety and fury of the Devil as
God's instrument of vengeance, considering that truth in despite of
gainsayers will prevail, according to that principle, "Magna est veritas
et prevalebit."[5]

The Story follows:
 After the right honorable Sir Francis Manners succeeded his brother
in the Earldom of Rutland, and so not only took possession of Belvoir
Castle but of all other his domains, Lordships, Towns, Manors, Lands
and Revenues appropriate to the same Earldom, he proceeded so hon-
orably in the course of his life (as neither displacing Tenants, discharg-
ing servants, denying the access of the poor, welcoming of strangers,
and performing all the duties of a noble Lord) that he fastened as it
were unto himself the love and good opinion of the Country: wherein
he walked the more cheerfully and remarkably because his honorable
Countess marched arm in arm with him in the same race, so that
Belvoir Castle was a continual Palace of entertainment and a daily re-
ceptacle for all sorts, both rich and poor, especially such ancient
people as neighbored the same. Amongst whom one Joan Flower with
her daughters Margaret and Philippa were not only relieved[6] at the first
from thence, but quickly entertained as Charwomen,[7] and Margaret

4. Underestimate.
5. "Great is the truth and it will prevail."
6. Rescued from poverty.
7. Employed as domestic workers.

admitted as a continual dweller in the Castle, looking both to the poultry abroad and the washhouse within doors; in which life they continued with equal correspondency[8] till something was discovered to the noble Lady which concerned the misdemeanor of these women. And although such honorable persons shall not want of all sorts of people either to bring them news, tales, reports, or to serve their turn in all offices whatsoever (so that it may well be said of them, as it is of great Kings and Princes, that they have large hands, wide ears, and piercing sights to discover the unswept corners of their remotest confines, to reach even to their furthest borders and to understand the secrets of their meanest subjects), yet in this matter neither were they busybodies, flatterers, malicious politicians, underminers nor supplanters one of another's good fortune, but went simply to work as regarding the honor of the Earl and his Lady, and so by degrees gave light to their understanding to apprehend[9] their complaints. First, that Joan Flower, the Mother, was a monstrous malicious woman, full of oaths, curses, and imprecations irreligious and, for anything they saw by her, a plain Atheist. Besides, of late days her very countenance was estranged;[10] her eyes were fiery and hollow, her speech fell[11] and envious, her demeanor strange and exotic, and her conversation sequestered,[12] so that the whole course of her life gave great suspicion that she was a notorious Witch. Yea, some of her neighbors dared to affirm that she dealt with familiar spirits and terrified them all with curses and threatening of revenge if there was never so little cause of displeasure and unkindness. Concerning Margaret, that she often resorted from the Castle to her mother, bringing such provision as they thought was unbefitting for a servant to purloin, and coming at such unseasonable hours that they could not but conjecture some mischief between them; and that their extraordinary riot and expenses tended both to rob the Lady and to maintain certain debauched and base company which frequented this Joan Flower's house (the mother) and especially her youngest daughter. Concerning Philippa, that she was lewdly transported with the love of one Thomas Simpson, who presumed to say that she had bewitched him, for he had no power to leave her and was,

8. Mutual agreement.
9. Comprehend.
10. Changed from its normal appearance.
11. Fierce, cruel.
12. Behavior unsociable.

as he supposed, marvellously altered both in mind and body since her acquainted company. These complaints began many years before either their conviction or public apprehension. Notwithstanding, such was the honor of this Earl and his Lady; such was the cunning of this monstrous woman in observation towards them; such was the subtlety of the Devil to bring his purposes to pass; such was the pleasure of God to make trial of his servants; and such was the effect of a damnable woman's wit and malicious envy that all things were carried away in the smooth Channel of liking and good entertainment on every side until the Earl by degrees conceived some mislike against her, and so peradventure estranged himself from that familiarity and accustomed conferences he was wont to have with her; until one Peak offered her some wrong, against whom she complained, but found that my Lord did not affect[13] her clamors and malicious information; until one Mr. Vavasour abandoned her company, as either suspicious of her lewd life or distasted with his own misliking of such base and poor Creatures, whom nobody loved but the Earl's household; until the Countess, misconceiving of her daughter Margaret, and discovering some indecencies both in her life and neglect of her business, discharged her from lying[14] any more in the Castle, yet gave her forty shillings, a bolster, and a mattress of wool, commanding her to go home; until the slackness of her repairing to the Castle, as she was wont, did turn her love and liking toward this honorable Earl and his family into hate and rancor. Whereupon, despited[15] to be so neglected, and exprobated[16] by her neighbors for her Daughter's casting out of doors and other conceived displeasures, she grew past all shame and Womanhood and many times cursed them all that were the cause of this discontentment and made her so loathsome to her former familiar friends and beneficial acquaintance.

When the Devil perceived the inficious[17] disposition of this wretch, and that she and her Daughters might easily be made instruments to enlarge his Kingdom and be as it were the executioners of his vengeance, not caring whether it lighted upon innocents or no, he came more nearer unto them, and in plain terms (to come quickly to the

13. Like, show a liking for.
14. Sleeping.
15. Enraged.
16. Reproached.
17. Negative, given to opposition.

purpose) offered them his service, and that in such a manner as they might easily command what they pleased; for he would attend you in such pretty forms of dog, cat, or Rat, that they should neither be terrified nor anybody else suspicious of the matter. Upon this they agree and (as it should seem) give away their souls for the service of such spirits as he had promised them; which filthy conditions were ratified with abominable kisses and an odious sacrifice of blood, not leaving out certain charms and conjurations with which the Devil deceived them, as though nothing could be done without ceremony and a solemnity of orderly ratification. By this time doth Satan triumph and goeth away satisfied to have caught such fish in the net of his illusions; by this time are these women Devils incarnate and grow proud again in their cunning and artificial power to do what mischief they listed;[18] by this time they have learned the manner of incantations, Spells and Charms; by this time they kill what Cattle they list and under the cover of flattery and familiar entertainment keep hidden the stinging serpent of malice and a venomous inclination to mischief; by this time is the Earl and his family threatened and must feel the burden of a terrible tempest which from these women's Devilish devices fell upon him, he neither suspecting nor understanding the same; by this time both himself and his honorable Countess are many times subject to sickness and extraordinary convulsions, which they, taking as gentle corrections from the hand of God, submit with quietness to His mercy and study nothing more than to glorify their Creator in heaven and bear his crosses on earth.

At last, as malice increased in these damnable Women, so his family felt the smart of their revenge and inficious disposition, for his eldest Son, Henry Lord Ros, sickened very strangely and after a while died. His next, named Francis, Lord Ros accordingly, was severely tormented by them and most barbarously and inhumanly tortured by a strange sickness. Not long after, the Lady Katherine was set upon by their dangerous and devilish practices and many times in great danger of life through extreme maladies and unusual fits; nay (as it should seem and they afterwards confessed) both the Earl and his Countess were brought into their snares as they imagined[19] and indeed deter-

18. Wished.
19. Planned.

mined to keep them from having any more children. Oh unheard-of wickedness and mischievous damnation! Notwithstanding all this did the noble Earl attend his Majesty both at Newmarket before Christmas and at Christmas at Whitehall, bearing the loss of his Children most nobly and little suspecting that they had miscarried by Witch-craft or suchlike inventions of the Devil, until it pleased God to discover[20] the villainous practices of these Women and to command the Devil from executing any further vengeance on innocents but leave them to their shames and the hands of Justice that they might not only be confounded for their villainous practices but remain as a notorious example to all ages of His judgment and fury. Thus were they apprehended about Christmas and carried to Lincoln Jail after due examination before sufficient Justices of the Peace and discreet Magistrates, who wondered at their audacious wickedness. But Joan Flower, the Mother, before conviction (as they say) called for Bread and Butter and wished it might never go through her if she were guilty of that whereupon she was examined;[21] so mumbling it in her mouth, never spake more words after, but fell down and died as she was carried to Lincoln Jail with a horrible excrucation[22] of soul and body, and was buried at Ancaster. When the Earl heard of their apprehension, he hastened down with his brother Sir George and, sometimes examining them himself and sometimes sending them to others, at last left them to the trial of Law before the Judges of Assize at Lincoln; and so they were convicted of murder and executed about the eleventh of March, to the terror of all the beholders and example of such dissolute and abominable Creatures. And because you shall have both cause to glorify God for this discovery and occasion to apprehend the strangeness of their lives and truth of their proceedings, I thought it both meet and convenient to lay open their own examinations and evidences against one another, with such apparent circumstances as do not only show the cause of their misliking and distasting against the Earl and his family, but the manner of their proceedings and revenges, with other particulars belonging to the true and plain discovery of their villainy and Witchcraft.

20. Reveal.
21. In this form of ordeal an accused witch could prove her innocence by swallowing bread and butter.
22. Torment.

The Examinations of
Anne Baker, Joan Willimot, and Ellen Greene,
as followeth, etc.

[This part of the pamphlet consists of the "confessions" of five women: Anne Baker, Joan Willimot, Ellen Greene, and Margaret and Philippa Flower. Although Anne Baker, a spinster from Bottesford, was examined by the earl of Rutland and his brother, the charges against her do not involve the earl's family. On the first day of her examination she testifies to seeing a vision and hearing voices in the air but pleads innocent to the charge of bewitching a child to death. On the second day of her examination she admits that about three years ago she heard from some members of the earl's household that "my young Lord Henry was dead, and that there was a glove of the said Lord buried in the ground and as that glove did rot and waste, so did the liver of the said Lord rot and waste." The examination of Anne Baker is followed by three examinations of Joan Willimot taken by various Justices of the Peace and a Doctor of Divinity. In the first she testifies that Joan Flower had confided in her that "she had spied my Lord's Son and had stricken him to the heart." In the third she admits that at Joan Flower's house she saw "two spirits, one like a Rat and the other like an Owl, and one of them did suck under her right ear." Willimot swears that she used her own spirit only to help people "which were stricken or forspoken."[23] Ellen Greene of Stathern contends in her examination that Joan Willimot persuaded her to "forsake God and betake her to the Devil." Greene does not mention the Flowers, but she admits to murdering by witchcraft a total of six persons who had offended her or her friends.]

The examination of Philippa Flower,
Sister of Margaret Flower and Daughter of Joan Flower,
before Sir William Pelham and Mr. Butler, Justices of the Peace,
February 4, 1618
which was brought in at the Assizes as evidence against her
sister Margaret

She saith that her mother and her sister maliced the Earl of Rutland, his Countess, and their Children, because her Sister Margaret was put

23. Bewitched.

out of the Lady's service of Laundry and exempted from other services about the house; whereupon her said sister, by the commandment of her mother, brought from the Castle the right-hand glove of the Lord Henry Ros, which she delivered to her Mother, who presently rubbed it on the back of her Spirit Rutterkin and then put it into hot boiling water. Afterward she pricked it often and buried it in the yard, wishing the Lord Ros might never thrive; and so her sister Margaret continued with her mother, where she often saw the cat Rutterkin leap on her shoulder and suck her neck.

She further confessed that she heard her mother often curse the Earl and his Lady, and thereupon would boil feathers and blood together, using many Devilish speeches and strange gestures.

The examination of Margaret Flower, Sister of Philippa Flower, etc., about the twenty-second of January, 1618

[Several parts of Margaret's testimony echo that of her sister; she admits to bringing the glove of Henry, Lord Ros, to her mother and describes her mother's use of the glove in the bewitching of Lord Ros. She expands upon Philippa's confession, however, by recounting how her mother (with the help of her two daughters) bewitched other members of the earl's family. She reports that her mother also exercised her evil power against Francis, Lord Ros, again by using the boy's glove. She testifies that she and her mother and sister took wool from the mattress given her by the Countess, mixed it with blood, and rubbed it on Rutterkin's belly, hoping thereby to afflict the couple with sterility. Her mother also tried her devilish practices against Katherine, the earl's daughter, but concluded that "Rutterkin had no power over the Lady Katherine to hurt her."]

The Examination of Philippa Flower, the twenty-fifth of February, 1618, before Francis, the Earl of Rutland; Francis, Lord Willoughby of Eresby; Sir George Manners; and Sir William Pelham

She confesseth and saith that she hath a Spirit sucking on her in the form of a white Rat, which keepeth her left breast and hath so done for three or four years; and concerning the agreement betwixt her Spirit

and herself, she confesseth and saith that when it came first unto her she gave her Soul to it and it promised to do her good and cause Thomas Simpson to love her if she would suffer it to suck her, which she agreed unto; and so the last time it sucked was on Tuesday at night, the twenty-third of February.

The Examination of Margaret Flower
at the same time, etc.

She confesseth that she hath two familiar Spirits sucking on her, the one white, the other black-spotted; the white sucked under her left breast and the black-spotted within the inward parts of her secrets. When she first entertained them she promised them her soul, and they covenanted to do all things which she commanded them, etc.

She further saith that about the thirtieth of January last past, being Saturday, four Devils appeared unto her in Lincoln jail at eleven or twelve o'clock at midnight. The one stood at her bed's feet with a black head like an Ape and spoke unto her, but what, she cannot well remember, at which she was very angry because he would speak no plainer or let her undertand his meaning; the other three were Rutterkin, Little Robin, and Spirit, but she never mistrusted them nor suspected herself till then.

[In her final examination, taken February 4, 1618, Margaret concedes that she and her mother and sister sought revenge against the earl's family "for turning her out of service"; she then rehearses again the steps taken by her mother that caused Lord Ros to sicken and die.]

These Examinations and some others were taken and charily preserved for the contriving of sufficient evidences against them, and when the Judges of Assize came down to Lincoln about the first week of March (being Sir Henry Hobart, Lord Chief Justice of the Common Pleas, and Sir Edward Bromley, one of the Barons of the Exchequer) they were presented unto them; who not only wondered at the wickedness of these persons, but were amazed at their practices and horrible contracts with the Devil to damn their own souls. And although the right honorable Earl had sufficient grief for the loss of his Children, yet no doubt it was greater to consider the manner and how it pleased God to inflict on him such a fashion of visitation. Besides, as it amazed the hearers to understand the particulars and the circumstances of this

devilish contract, so was it as wonderful to see their desperate impenitency and horrible distraction, according to the rest of that sort exclaiming against the Devil for deluding them and now breaking promise with them when they stood in most need of his help.

Notwithstanding all these aggravations, such was the unparalleled magnanimity, wisdom, and patience of this generous Nobleman that he urged nothing against them more than their own confessions, and so quietly left them to judicial trial, desiring of God mercy for their souls and of men charity to censure them in their condemnation. But God is not mocked and so gave them over to judgment, nor man so reformed but for the Earl's sake they cursed them to that place which they themselves long before had bargained for.

[The author draws several religious and moral lessons from the history of these witches. God is omnipotent; even the devil is His "mere servant and agent." God chastises the godly as well as the wicked: "the very just shall be tried like gold and no man exempted from castigation whom God doth love." Man must submit patiently to His will, as the noble earl has done. The wicked will be punished, either in this life, the life to come, or both; furthermore, they are condemned by their own utterances, as these witches were. The law of England will not suffer anyone to converse with spirits or blaspheme God's name with spells and incantations. After a warning to the "sons of men" to be instructed by the terrible example of the witches, the author concludes by regretting that exposure of a lie is easier than discovery of the truth.]

Selected Bibliography of Pamphlets from the Controversy

The following bibliography contains the pamphlet titles in their original form (except for the modernization of *u*'s, *v*'s, *i*'s, and *j*'s), printers' names, dates of publication, and STC reference numbers (A. W. Pollard and G. R. Redgrave, comps., *A Short-Title Catalogue of Books Printed in England, Scotland, & Ireland and of English Books Printed Abroad 1475–1640* [1926; reprint ed., London: Bibliographical Society, 1946]). We have listed the first edition available on microfilm in all cases except *The Schoolhouse of women*, for which we list the two editions we have collated. The pamphlets included in this anthology have been marked with an asterisk in the bibliography.

*Anger, Jane. *Jane Anger her Protection for Women. To defend them against the Scandalous Reportes of a late Surfeiting Lover, and all other Venerians that complaine so to be overcloyed with womens kindnesse.* R. Jones and T. Orwin, 1589 (STC 644).

Austin, William. *Haec Homo Wherein The Excellency of the Creation of Woman is described, By way of an Essaie.* R. Olton for R. Mabb, 1637 (STC 974).

Aylmer, John. *An Harborowe for Faithful and Trewe Subjectes, agaynst the Late Blowne Blaste, concerninge the Governmēt of Women.* [Published anonymously]. Strasborowe [J. Daye, London], 1559 (STC 1005).

The Batchelars Banquet: or a banquet for batchelars. . . . Pleasantly discoursing the variable Humours of Women, their quicknesse of wittes, and unsearchable deceits. [Thomas Dekker?]. T. C[reed], solde by T. P[avier], 1603 (STC 6476).

Brathwait, Richard. *Ar't asleepe Husband? A Boulster Lecture.* R. Bishop for R. B[est], or his asignees, 1640 (STC 3555).

Breton, Nicholas. *The Praise of vertuous Ladies. An invective against the discourteous discourses, of certain Malicious persons, written against Women.* Published in *The Will of Wit.* T. Creed, 1597 (STC 3705).

Darcie, Abraham. *The Honour of Ladies: or, A True Description of their Noble Perfections.* T. Snodham, 1622 (STC 6271).

The deceyte of women, to the instruction and ensample of all men, yonge and olde, newly corrected. A Vele, [1560?] (STC 6451).

A Discourse of the Married and Single Life. For J. Man, 1621 (STC 6908).

Elyot, Sir Thomas. *The Defence of Good Women.* In aed. T. Bertheleti, 1545 (STC 7658).

Ferrers, Richard. *The Worth of Women.* W. Jones, 1622 (STC 10832).

G., I. *An Apologie for Women-Kinde.* Edw. Allde for Wm. Ferebrand, 1605 (STC 11497).

Gibson, Anthony. *A Womans Woorth, defended against all the men in the world.* J. Wolfe, 1599 (STC 11831).

Gosson, Stephen. *Quippes for Upstart Newfangled Gentlewomen. A Glasse to view the Pride of vainglorious Women.* [Published anonymously]. R. Johnes, 1595 (STC 12096).

*Gosynhill, Edward. *The prayse of all women, called Mulierū Pean. Very fruytfull and delectable unto all the reders.* W. Myddylton, [1542?] (STC 12102).

*[Gosynhill, Edward?] *Here begynneth a lytle boke named the Schole house of women: wherin every man may rede a goodly prayse of the condicyons of women.* T. Petyt, [1541?] (STC 12106).

*[Gosynhill, Edward?] *Here Begynneth the Scole house of women: wherein every man may reade a goodly prayse of the condicyons of women.* J. Kynge, 1560 (STC 12105).

Haec-Vir: or The Womanish-Man: Being an Answere to a late Booke intituled Hic-Mulier. Exprest in a briefe Dialogue betweene Haec-Vir the Womanish-Man, and Hic-Mulier the Man-Woman. For J. T[rundle], 1620 (STC 12599).

Heale, William. *An Apologie for Women: or An Opposition to Mr. Dr. G. his assertion. Who held in the Act at Oxforde. Anno. 1608. That it was lawfull for husbands to beate their wives.* Oxford: Jos. Barnes, 1609 (STC 13014).

Heywood, Thomas. *The Exemplary Lives and memorable Acts of nine the most worthy Women of the World.* T. Cotes for R. Royston, 1640 (STC 13316).

Heywood, Thomas. *Gunaikeion: or, Nine Bookes of Various History Concerning Women.* A. Islip, 1624 (STC 13326).

*Hic Mulier: or, The Man-Woman: Being a Medicine to cure the Coltish Disease of the Staggers in the Masculine-Feminines of our Times. [G. Purslowe] for J. T[rundle], 1620 (STC 13374).

Knox, John. The First Blast of the Trumpet against the monstruous regiment of Women. [Geneva: J. Crespin], 1558 (STC 15070).

Lloyd, Lodowick. The Choyce of Jewels. T. Purfoot, 1607 (STC 16618).

More, Edward. A Lytle and Bryefe treatyse, called the defence of women, and especially of Englyshe women, made agaynst the Schole howse of women. J. Kynge, 1560 (STC 18067).

Muld Sacke: or The Apologie of Hic Mulier: to the late Declamation against her. For R. Meighen, 1620 (STC 21538).

*Munda, Constantia. The Worming of a mad Dogge: or, A Soppe for Cerberus the Jaylor of Hell. No Confutation but a sharpe Redargution of the bayter of Women. For L. Hayes, 1617 (STC 18257).

Nash, Thomas. The Anatomie of Absurdity: Contayning a breefe confutation of the slender prayses to feminine perfection. J. Charlewood for T. Hacket, 1589 (STC 18364).

Newstead, Christopher. An Apology for Women: or, Womens Defence. E. G[riffen] for R. Whittakers, 1620 (STC 18508).

Pyrrye, C. The praise and Dispraise of Women, very fruitfull to the well disposed minde, and delectable to the readers thereof. W. How, [1569?] (STC 20523).

Rich, Barnaby. The Excellencie of good women. T. Dawson, 1613 (STC 20982).

*Sowernam, Ester. Ester hath hang'd Haman: or An Answere To a lewd Pamphlet, entituled, The Arraignment of Women. With the arraignment of lewd, idle, froward, and unconstant men, and Husbands. [T. Snodham] for N. Bourne, 1617 (STC 22974).

Speght, Rachel. A Mousell for Melastomus, The Cynicall Bayter of, and foule mouthed Barker against Evahs Sex: or an Apologeticall Answere to that Irreligious and Illiterate Pamphlet made by Jo. Sw[etnam] and by him Intituled, The Arraignment of Women. N. Okes for T. Archer, 1617 (STC 23058).

*Swetnam, Joseph. The Araignment of Lewde, idle, froward, and unconstant women: Or the vanitie of them, choose you whether. [Tho. Tel-troth, pseudonym]. E. Allde for T. Archer, 1615 (STC 23533).

Swetnam, the Woman-hater, Arraigned by Women. A new Comedie, Acted at the Red Bull by the late Queenes Servants. For R. Meighen, 1620 (STC 23544).

Tasso, Ercole. *Of Marriage and Wiving. An Excellent, pleasant, and Philosophicall Controversie, betweene the two famous Tassi now living, the one Hercules the Philosopher, the other, Torquato the Poet.* T. Creede, sold by J. Smythicke, 1599 (STC 23690).

*Tattle-well, Mary, and Hit-him-home, Joane. *The womens sharpe revenge: Or an answer to Sir Seldome Sober that writ those railing Pamphelets called the Juniper and Crabtree Lectures, etc. Being a sound Reply and a full confutation of those Bookes: with an Apology in this case for the defence of us women.* J. O[kes] for J. Becket, 1640 (STC 23706).

Taylor, John. *Divers Crab-tree Lectures.* J. Okes for S. Sweeting, 1639 (STC 23747).

*Taylor, John. *A Juniper Lecture, With the description of all sorts of women, good, and bad: From the modest to the maddest, from the most Civil, to the scold Rampant, their praise and dispraise compendiously related. The Second Impression, with many new Additions.* J. O[kes] for W. Ley, 1639 (STC 23766).

Tuvil, Daniel. *Asylum Veneris; or A Sanctuary for Ladies. Justly Protecting Them, their virtues and sufficiencies from the foule aspersions and forged imputations of traducing Spirits.* E. Griffin for L. L'isle, 1616 (STC 24393).

Vaughan, Robert. *A Dyalogue defensyve for women, agaynst malycyous detractours.* [Robert Burdet?]. R. Wyer for R. Banckes, 1542 (STC 24601).

Eulogies and Condemnations

The Araignement & burning of Margaret Ferne-seede, for the Murther of her late Husband Anthony Ferne-seede, found deade in Peckham Field neere Lambeth, . . . being executed in S. Georges-field the last of Februarie, 1608. For H. Gosson, 1608 (STC 10826).

The Honour of Vertue. or The Monument erected by the sorowfull Husband, and the Epitaphes annexed by learned and worthy men, to the immortall memory of that worthy Gentle-woman Mrs. Elizabeth Crashawe. [n.p.], 1620 (STC 6030).

*Mayer, John. *A Patterne for Women: Setting forth the most Christian life, & most comfortable death of Mrs. Lucy late wife to the worshipfull Roger Thornton Esquire, of Little Wratting in Suffolke.* E. Griffin for J. Marriot, 1619 (STC 17742).

*A pittilesse Mother. That most unnaturally at one time, murthered two of her owne Children at Acton within six miles from London uppon holy thursday last 1616. The ninth of May. Being

a Gentlewoman named Margaret Vincent, wife of Mr. Jarvis Vincent, of the same Towne. [London, 1616] (STC 24757).

*Sylvester, Joshua. *Monodia. An Elegie, in commemoration of the Vertuous life, and Godlie Death of the right Worshipfull & most religious Lady, Dame Hellen Branch Widdowe, (late Wife to the right worshipfull Sir John Branch knight, sometimes L. Mayor of this Honorable City) . . . who deceased the 10. of Aprill last.* P. Short, [1594] (STC 23579).

The Wonderful Discoverie of the Witchcrafts of Margaret and Phillip Flower, daughters of Joan Flower neere Bever Castle: Executed at Lincolne, March 11. 1618. G. Eld for J. Barnes, 1619 (STC 11107).

Index to Part 1